EROTIC ART

EROTIC ART

*A survey of
erotic fact and fancy
in the fine arts*

Compiled by

Drs. Phyllis and Eberhard Kronhausen

GROVE PRESS, INC., NEW YORK

THIS BOOK IS DEDICATED TO THE PEOPLE OF SWEDEN AND DENMARK WITHOUT WHOSE MATURITY AND DEDICATION TO DEMOCRATIC FREEDOM THE FIRST INTERNATIONAL EXHIBITION OF EROTIC ART WOULD NOT HAVE BEEN POSSIBLE.

ACKNOWLEDGMENTS

Thanks and recognition for the success of The First International Exhibition of Erotic Art in Lund, Sweden, and Aarhus, Denmark, are due to a great number of individuals and institutions.

In the first place, we wish to express our gratitude to Mr. Folke Edwards, director of Lund's Konsthall (Museum of Art) for having had the courage to accept the idea of such a controversial exhibition and, even more so, for having stuck by it under the initial pressure of public criticism.

For the same reason we would like to thank Miss Minna Heimburger, director of the Kunstmuseum in Aarhus, Denmark. In this case, it was not so much any persistence in the face of opposition—as a matter of fact, there was no serious opposition—but her readiness to provide for sufficient space by taking down part of the museum's permanent collection to provide room for the exhibition and for her cooperation in many other respects.

Next in line, we owe thanks to Mr. Finn L. Falkersby of Copenhagen for having made valuable suggestions and frequently smoothed the way for us in the initial stages of organizing the exhibition, and in securing important contemporary and older works of art, both from his own collection and from other galleries.

Our gratitude is particularly great toward the numerous public institutions, museums, private collectors, and artists who graciously lent often priceless art treasures to the exhibition and who kindly granted us reproduction rights to include reproductions of some of these works in the present volume. Foremost among these, we wish to gratefully cite: the Ethnographical Museum of Leiden, Holland, the Institut Tessin, Paris, the Thorvaldsen Museum, Copenhagen, the Malmö Museum, Malmö, Göteborg's Konstmuseum, Göteborg, the National Museum, the Museum of Modern Art (Moderna Museet), and the Ethnographical Museum in Stockholm, and the Archive for Decorative Art, Lund.

The following private art galleries cooperated most unselfishly toward the same end: Galerie Alexandre Iolas, Paris, the Galleries Hartman and Ketterer, Munich, Gallery Brockstedt, Hamburg, the Gallery Pierre, and the Svensk-Franska Gallery, Stockholm, and the Gallery Nordquist, Malmö.

Many private collectors, too numerous to list every one of them, also helped with their magnanimity in completing the present exhibition, among them: F. T. Bayerthal, Munich; Jarl Borgen, Copenhagen; William Copley, New York; Mme. J. Crebs, Brussels; Jan Hannertz, Stockholm; C. O. Hulten, Malmö; Sam Kaner, Copenhagen; Ann-Margret Lindell, Stockholm; Sir Roland Penrose, London; Charles Ratton, Paris; Msr. Moreau-Gabard, Paris; Gunnar Rohde, Vassingeröd; Gunilla Samuelsson, Lund; Ulf Sjöberg, Göteborg; Lars Ungerth, Lerum; Patrick Waldberg, Paris; Peter Wagner, Stockholm; Kurt Jelenski, Paris; and Jack Hillier, London.

We also want to express our deep gratitude to those individuals without whom the documentation of the show and the preparation of this book would have been impossible, notably our two faithful photographers Janine Pradeau, Paris, and Mr. Centerwall, Lund. Photographers Ulf Simonsson, Paris, Knut Andreassen, Lund, and Peter Gullers, Stockholm, also contributed important photographs, especially action shots of the public in relation to the art work exhibited. Designer Michael Perpich was invaluable in the final preparation of the book.

Finally, we would like to express our appreciation to the entire staff of the museums in Lund and in Aarhus for their wonderful attitude, helpfulness, and devotion which kept the exhibition operational even when its extraordinary popularity put at times great stress on everybody concerned.

CONTENTS

THE FIRST INTERNATIONAL EXHIBITION OF EROTIC ART

"HOW NICE PEOPLE LIKE US GOT INVOLVED IN EROTIC ART"

Our interest in erotic art dates back to the period in which we were preparing the original edition of *Pornography and the Law* (Ballantine Books, New York, 1960). In that book we were trying to define the meaning of "obscenity" in terms of legal theory and practice in the United States. We confined ourselves to erotic literature, distinguishing between erotic realism and other forms of nonpornographic writing with erotic content on the one hand, and, on the other, "hard-core" pornography ("obscenity"), as defined by a narrower interpretation of the law.

It was clear to us even then that a strict distinction between pornographic and nonpornographic literature was impossible. Still, we felt that it was feasible to draw a line of demarcation between the two types of literature, if only for practical legal purposes and to protect at least those writings which did not clearly fall into the "hard-core" category—a special brand of low-brow erotica for which we were able to set up a number of distinguishing criteria.

While giving a great deal of thought to these matters concerning the censorship of erotic literature—a practice to which we have always been fundamentally opposed on philosophical and psychological grounds—our attention was naturally drawn to the parallel problems existing in the field of visual arts. Here the distinction between art and pornography ("obscenity") was even more difficult to make. For instance, is an intercourse scene by Rembrandt or Picasso "art," but "obscene" if from the hand of a lesser artist or photographer?

Certainly it could be argued that an intercourse scene or nude by a true artist would contain an interpretive, creative element which the amateur drawing or simple pornographic photograph might not contain at all, or at least not to the same exent. We had occasion, in fact, to watch the transformation of pornography into art before our own eyes when Hans Bellmer one day worked in our presence, making a complicated and highly erotic engraving from a series of common pornographic photographs.

In that sense one can perhaps distinguish between pornography and art. The criterion would be that the more a picture contains evidence of interpretive, creative elaboration, the closer it is to art (the test of "socially redeeming value" could be and often is applied in just this sense). But problems always arise in the so-called "borderline" cases where it could be argued whether a given picture does or does not contain such "redeeming" features.

In the case of a straightforward pornographic photograph or the most amateurish drawing, for example, *some* consideration may have been given to such artistic concerns as composition, lighting, angle, shading, proportions, movement, and expression. If so, where is the line between art and pornography to be drawn in these cases? Moreover, could not even primitive pictorial representations containing only minimal proportions of these factors have other "socially redeeming" features, such as educational or merely entertainment value?

Clearly the answers to these questions must become at one point or another matters of personal taste and individual point of view.

Furthermore, the whole concept of "socially redeeming value" presupposes universal agreement on one essential point—that erotic stimulation in and of itself does *not* constitute a socially positive value, but, on the contrary, is a personal threat and social danger. This supposition was spelled out some time ago by the American Law Institute; in presenting a stricter interpretation of "obscenity," it stated: "Everybody is subject to two conflicting forces: sexual drives, sexual curiosity on the one hand and universal social repression of that on the other hand. This creates a certain sense of shame, of embarrassment, or wrongness that sexual aspects of our life involve, and people who want to make a living by exacerbating that, by rubbing the sore, as one author put it, we say are out of bounds."

We need not here take issue with the consumer-society psychology expressed by treating the whole problem in terms of economic gain—"people who want to make a living by exacerbating that"—we merely wish to draw attention to it. More important is the Institute's assumption that there *is* general agreement on the "two conflicting forces" theory. The broad support of the anti-censorship movement, which in America includes such outstanding legal figures as the Supreme Court justices Hugo Black and W. O. Douglas and such groups as the Civil Liberties Union, makes it quite clear that cultural agreement on this premise does not in fact exist in our society, or, at least, that it no longer exists (as it might well have a generation or two ago). It follows, therefore,

that sexual censorship presently interferes with the constitutionally guaranteed freedoms of conscience, opinion, and expression, for a substantial and ever growing liberal minority in modern society holds to the view that the sexual drives are not at all in basic and necessary conflict with other constructive personal or social aims. On the contrary, this minority view holds, the candid recognition and freer expression of these sexual drives are essential to individual well-being, mental health, and social progress. It could therefore be argued that sexual stimulation—far from being disturbing to the individual and inimical to society—in itself is a positive social value. Writing or art that provides such stimulation consequently needs no other "socially redeeming" features to justify its existence. This, in fact, is our own position in the matter, and this is what we believe to be the underlying feeling or conviction of the liberal minority.

Having studied the literature on sexual censorship, as far as writing was concerned, we decided to go on to examine the censorship of pictorial representations. At the same time, we began to collect erotic art on our own—the only way to study it at close range and at leisure. To our surprise, there was more erotic art, both European and Oriental, available in America than one might have thought. We could have acquired a sizable collection of erotica without leaving the country, had we not been handicapped by our limited financial resources. Still, we purchased what we could, and from this early period of our collecting date some of the finest items in our collection: a Chinese painted scroll of the Ming dynasty; a rare piece of Peruvian pottery; an archeological ithyphallic sandstone figure from the Near East; a sixteenth-century drawing, possibly representing a Counter-Reformistic and unflattering portrait of Martin Luther, with two monks copulating on the top of his tonsure-trimmed head; and the Renaissance painting "Leda and Swan," a version of Veronese's painting which is either a product of his workshop and partly by his own hand or a contemporary copy by one of his students or followers.

At that time, Dr. Phyllis Kronhausen appeared twice on television interviews with the West Coast TV personality Paul Coates. On these programs, for the first time in America, some Oriental and Western erotic art was shown on that mass medium—to be sure, with some of the most "risqué" portions of the pictures blocked out by strips of paper.

It so happened that from 1960 on we came to spend more and more time in Europe, first on psychological consultation and later because we felt that we had both been spending too much time in the same cultural environment and needed a change for our own personal development.

In Europe we collected more erotic art, our most notable discoveries from the beginning of that period being the Dutch painter Melle in Amsterdam, the German painter Hans Bellmer, the Trieste-born artist Leonor Fini, and the French surrealist André Masson in Paris.

In 1964 we took the first of three often hectic and extremely exhausting working trips around the world. Nevertheless, they afforded us an unusual opportunity to study and collect during quieter moments the erotic art of various cultures, notably of Japan and India—the two countries, outside of China, which have undoubtedly produced by far the greatest part of erotica in the world. We were fortunate to find in both India and Japan scholarly friends and specialists who helped us collect, identify, and date the material we found. Once again, however, we had to restrain ourselves for financial reasons. But some very fine examples of erotic art from different periods and cultures did wind up in our small but growing collection.

It was important to make an immediate photographic record of every piece, for unique items could be lost in shipment or confiscated by customs, though we took every precaution to minimize these risks. Such documentary photography in distant places and often under somewhat less than ideal conditions had to be repeated later in Paris with better equipment, a task which again involved a considerable investment in time, labor, and money.

Originally we had merely hoped to study and eventually to publish this fascinating material, but gradually we formed the idea of exhibiting it in some place where public tolerance and acceptance of erotica and freedom from censorship would make this feasible. It was clear from the start that Denmark and Sweden were the only countries to be considered at all. There, the governments had over the past few years abolished one obscenity law after the other, until almost all obscenity legislation was gone. Still, there existed at the time, as there exists today, a certain minimum amount of censorship, and it was not at all certain if a public exhibition of frankly erotic art was possible on a large scale even in these liberal countries. A number of small exhibitions of erotic art had been held in private galleries, and while most of these had gone by without much official notice or interference, there had been occasional police actions, as in the case of an exhibition of David Rubello's paintings in a Copenhagen gallery, which involved, as a matter of fact, some of the pictures that we intended to show and actually did show in Sweden and Denmark.

Aside from such official censorship, there was also to be reckoned with the indirect censorship of conservative community pressure groups. These groups tend to intimidate fearful officials and frequently goad them into action against their own better judgment and intentions, wherever any kind of censorship laws or practices exist. And it was with this kind of intangible force that we ultimately came to grips.

We could have made things easier and financially much more rewarding for ourselves by accepting any one of the many offers from private galleries to present our collection, or at least part of it, privately. But we resisted their propositions, hoping to find a public museum to collaborate with us on a larger, more comprehensive exhibition which, by its official nature, would have a much greater social impact.

Consequently, we approached leading museums in Copenhagen and Stockholm with the view of organizing for them an international exhibition of erotic art. The core of the show was to be our own collection, supplemented by contemporary works from artists in Scandinavia, Europe, and America, as well as from the archives of other museums, many of which are known to contain important erotic works that have never been put on exhibit.

There was immediate interest in the idea on the part of the museum directors with whom we discussed it. But in every case, it turned out that after a period of time certain mysterious obstacles presented themselves which blocked all our efforts. Presumably, the directors themselves were in favor of the show, but the more conservative boards and committees they had to consult seemed less inclined to take the very possible risk of a critical press or negative public reaction which might result in loss of prestige and public funds.

We had almost given up hope when someone suggested we try the Lund Museum of Art (Lunds Konsthall). That idea had from the start much by which to commend itself: the museum had a good reputation for the quality of its shows; it had a new director, Mr. Folke Edwards, who was said to be a progressive-minded younger man; and the city of Lund featured one of the oldest and largest universities of northern Europe, with a student population of over eighteen thousand.

We thought it was worth trying. So we set out one fine day to see Mr. Edwards in Lund, making the same proposal to him we had made the others. He immediately showed a lively interest, but he, too, had a board to consult before a final commitment could be made.

As it happened, that board was to meet the day after our visit to Lund, and Mr. Edwards promised he would promptly call us in Copenhagen to let us know their reaction. It turned out that the decision of the board was positive; they were going to have the show—grounds for quiet but intensely happy celebration on our part, for we seemed close to realizing a dream that had begun as a dim vision over ten years ago, a dream, moreover, which we had almost given up.

All the greater was our disappointment and despair, therefore, when only two weeks later the same board threatened to go back on their original decision and call off the show. The reason for this change of heart seemed to be a few sensational headlines that had appeared in the two leading newspapers of southern Sweden upon the first official announcement of the proposed show. Not that these papers had meant any harm or that their intention had been to sabotage the project. Quite the contrary. The journalists who had come to interview us in Paris had been very friendly and sympathetic to the whole idea. But they had inadvertently used some rather unfortunate terminology, such as talking about "pornographic" instead of "erotic" art and publishing a photograph of ourselves and a Japanese phallus in black marble with the caption: "Japanese penis to be exhibited in Lund's museum." They had forgotten our explanation that this "Japanese penis" happened to be part of a seventeenth-century Shinto shrine and was not only a remarkable piece of sculpture but also an object of religious worship.

As soon as these articles appeared, some fanatical religious groups in the area began a propaganda and pressure campaign against the exhibition. This reaction had unnerved the board of the museum, all solid citizens and some of them officials of the city of Lund. They, understandably, did not wish to become known as the ones responsible for having sponsored a pornographic exhibit, nor did they wish their city to acquire the reputation of a kind of Swedish Sodom or center of pornography and licentiousness.

The way we first heard of the board's changed feelings was equally disturbing and helped to underscore our disappointment. The chairman of the board sent a telegram to Director Edwards, who was just then visiting with us in Paris so we could complete the initial preparations for the show. The laconic text of the telegram simply informed the director that the show was almost certainly going to be cancelled and that he had better start thinking about alternatives.

To Mr. Edward's credit, he did not accept this "almost certain" decision of the board, but returned to Lund, determined to fight for the show. A second board meeting was called. For the first time in the history of the museum, all twelve board members were in attendance. The mood was bad, and a heated discussion ensued in which the director and a liberal minority argued with the conservative majority, which was bent on blocking the exhibition. The liberal minority, however, felt that not only was the show a legitimate and worthwhile project, but that they had a moral obligation toward us for sticking by the original agreement, all the more so, since we had already made commitments to artists, accepting their works for the exhibition, and to others. Moreover, those in favor pointed out, it was by then too late to simply forget about the matter, since the liberal side of the press was certainly not going to let the issue go by without further comment.

Likewise, we on our part had made it known that we would publish a book on the exhibition, as either the one that was or wasn't. The museum was to be remembered in one way or the other.

After three hours of debate (which we, incidentally, did not witness ourselves), one member of the board remembered that he had to leave for a business appointment. He had been against the exhibition. Another member, a woman, decided to abstain from voting, since she was, in her own opinion, too prejudiced against the show to make an objective decision. By that time, we are told, the chairman of the board, who had first been for the exhibition and then against it, changed his mind once more—this time back in favor of the show. Two or three other members were swayed by his favorable reversal. So, when the final vote was taken, it was the lone ballot of Director Edwards that carried the day. He immediately dispatched a telegram to us, who were anxiously awaiting in Paris the result of the meeting; it read: THE SHOW IS ON. REGARDS. FOLKE EDWARDS.

We were too happy to taste the champagne we drank in celebration. It was almost too good to be true. For we knew, perhaps better than anyone, what this exhibition could mean in terms of long-range social implications: the blow it would deal to censorship, the victory for freedom of expression, the total cultural impact it could have.

Now the problem was to organize the exhibition in time for the opening in something less than a month's time. Loan pieces from artists and collectors had to be fetched; the catalog, poster, and invitations for the opening had to be prepared, and so on. In fact, we almost did not have a catalog, for the publisher who had agreed to produce and distribute it as a small picture book suddenly also had a change of heart. The news reached us in New York, where we were making arrangements for the loan of contemporary American pictures. We rushed back to Copenhagen, bought up the prepared photo-offset plates for the illustrations, and found a printer who was willing to put the catalog on the presses immediately. Then the binding took more time than the printing, and it was not until the night before the press opening, May 2, 1968, that a truck stopped in front of the museum and unloaded the first edition of our self-published catalog, which contained ninety-six illustrations and an Introduction in Swedish, English, German, and French. The museum had printed an additional alphabetical list of the artists represented in the show, with a numbered list of the art work, so that people could identify the exhibits more readily. Even with that, only a small fraction of all the items, numbering about one thousand pieces, were listed.

There were many other details that weren't quite perfect. On the day of the press conference and even prior to the official opening next day, we were still frantically helping to hang and mount the show. In fact, the hanging continued well into the second and third week afterward. But somehow it didn't seem to matter. The show, which lasted from May 3 to July 31, 1968, was a resounding success. It was especially gratifying to see that the exhibition was attended by a general cross-section of the population and not just special interest groups. People of all ages, from all social and educational backgrounds, were in evidence. Young couples came, often bringing their children along; baby carriages were casually parked anywhere on the ground floor and older children were taken by the hand to look at the exhibits.

Lovers strolled through the galleries hand in hand; single men and women of all ages were equally numerous. Groups of teen-agers, one would say equally divided according to sex, could be seen in the museum every day. Students from the university, who were taking off time from cramming for final semester exams, were perhaps the most numerous single group of visitors.

By accident, the exhibition coincided with the three-hundredth anniversary of the university. Lund therefore had an unusual number of visitors from out of town—including a sizable police force from all over Sweden that had been sent there in quite unnecessary fear of student riots.

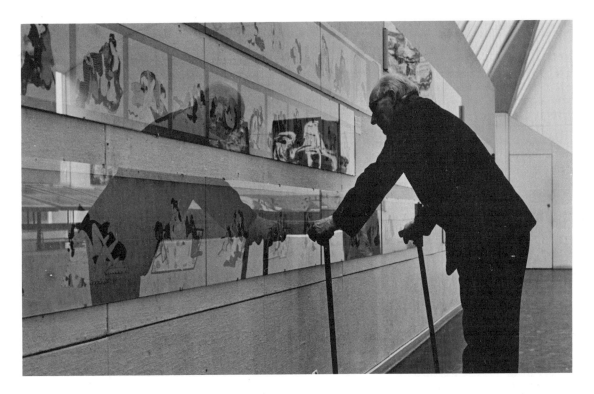

They were allowed to come in free, if in uniform, and a good number of them availed themselves of the opportunity.

One day, two American nuns somehow found their way to the exhibition. Another day, we spotted a beautiful young widow dressed in smartly tailored black mourning costume, complete with lace veil, studying in lost fascination some of the most outspoken pieces in the show. Another time, a man, obviously in his seventies, appeared, supporting himself on two canes. He studied all the exhibits with serious and undivided attention for at least a couple of hours, not revealing by the slightest facial hint whether he approved, disapproved, enjoyed, or suffered the whole thing.

Still another elderly man slowly moved through the galleries, dragging a chair along with him on which he sat down from time to time for a rest. He too got his full three crowns (about $.60) entrance fee out of the show, judging by the time he spent there.

On the whole, there were about as many younger as older people in the museum at any time, as well as quite a representational cross-section of nationalities. Thus, we were able to welcome to the museum one day a group of American Negro actors on guest performance in Sweden. They were ecstatic about the show, the women as well as the one man, and kept asking us when we were going to bring it all to America.

During the festivities of the university's tricentennial one could also see a number of order-bedecked academic dignitaries in the museum. Their old-fashioned cutaways, stiff white shirts, and mannerism of the 1900's gave the museum at those times an almost surrealistic cast.

Then a British cruiser put in at Malmö and uniforms of Her Majesty's Navy began to appear among the crowds. For them too, the museum waived the entrance fee.

The illustrated catalog, incidentally, which had found no publisher willing to take the financial risk, continued to sell exceedingly well, about every fourth or fifth visitor buying one at the price of ten Swedish crowns ($2.00). In addition, the museum received numerous daily mail orders from as far away as Bangkok, Hong Kong, Tokyo, and Formosa. Likewise, the colored postcards of Japanese and Indian pictures that we had belatedly printed upon popular request found an eager public, not only, as is the case with common pornography, among a certain group of middle-aged males, but equally among the women, as well as in older and younger age groups of all social and educational levels.

A special problem arose in connection with the poster of the exhibition, which featured a black and white woodblock print by the seventeenth-century Japanese master Sugimura Jihei. The subject matter, a frank intercourse scene with a highly decorative background design that made for a very beautiful ensemble, did arouse some controversy, due to the same small group of people who had tried to torpedo the show from the outset. They brought the matter to the attention of the local police, but the authorities in Stockholm who had the final say refused to take any action, and so the posters hung proudly all over town—outside the railway station, in advertising frames on lamp posts along some of the main streets, in shop windows, and even alongside the town's ancient cathedral (although this particular poster, after it had hung there unmolested for several weeks, was defaced and later altogether removed—along with the whole public notice board on which it had been mounted—by what was rumored to have been the order of the reverend Bishop of Lund himself).

The issue which had begun to arise over the poster ("invasion of privacy") briefly arose again in connection with the Swedish television network. It was feared by the TV authorities that some people might launch a protest on these grounds, if the network carried a report on the exhibition. In the end, they found a way out by producing a fairly lengthy reportage on the show and an interview with us and Director Folke Edwards in the context of a general survey on Swedish sex attitudes. This show, though it contained a few close-ups of some explicit paintings and statuary, apparently aroused no protest. Nor did a Danish TV program on the exhibition. A liberal Dutch television station also came to report on the show and filmed a forty-five minute program. In addition, several Scandinavian and foreign radio stations interviewed the museum's director and ourselves about the show.

As soon as word about the exhibition got abroad, requests came from several German and other foreign museums and organizations to bring the collection to their countries. The censorship situation outside of Sweden and Denmark being what it is, however, such plans clearly are more easily made than realized, though the day will undoubtedly come when all of this will be as readily possible elsewhere as it is today in these two Scandinavian countries.

Meanwhile, it was decided to transfer the show from Lund to Aarhus, Denmark, in the fall (September 7 to October 27, 1968). Directoress Minna Heimburger was anxious to have it as part of the city's general art festival, which included ballet performances, concerts, and theater.

What so far has been proven is that there exists—at least in Sweden and Denmark—a sufficiently large and mature public which can and does appreciate good erotic art, without being overwhelmed by the subject matter. And it is reasonable to expect that there exist similarly interested and emotionally prepared publics elsewhere.

But why, some critics of the whole concept may ask, have an exhibition of erotic art at all?

Briefly, we feel that erotic art, neglected, suppressed, and persecuted for centuries, has an important contribution to make to the understanding of art, the social history of mankind, and human happiness and progress.

It is our deep personal conviction that erotic art (as well as erotic literature) serves important social and therapeutic functions. In addition, it can be and often is a vehicle for social criticism or the expression of important philosophical, political, or religious ideas. By attempting to suppress erotic art, society not only deprives itself of a potential source for growth and insight, but cramps artistic production by blocking the free imagination of the artist and closes up a vital channel of communication.

Finally, erotic art expresses the demand for sexual freedom—a freedom vital to individual happiness and mental well-being. And sexual freedom, in turn, cannot exist without a high degree of political and economic freedom as well. In that sense, erotic art carries a truly revolutionary message: it demands no less than extension of freedom, not only in the sexual area, but in every sphere of social life. It was therefore the greatest compliment we could have received when, returning to Paris in the midst of the abortive spring revolution, André Masson, a life-long revolutionary by instinct himself, said to us, "The real revolution is not here in the streets. It has no direction and will lead nowhere. The real revolution today is taking place up there in that museum in Lund. The fire you have kindled with that exhibition will in time destroy the old order more effectively than anything else. I congratulate you, my friends."

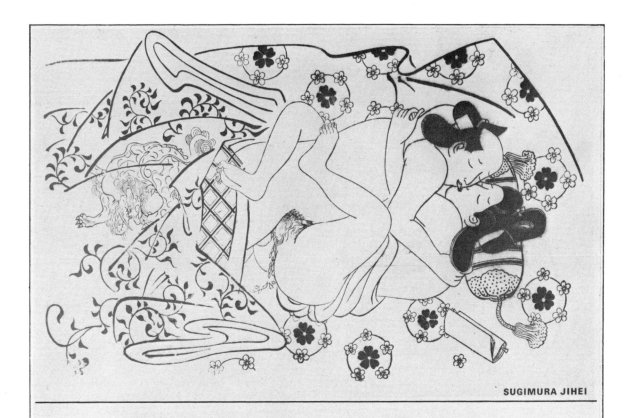

SUGIMURA JIHEI

The Drs. Kronhausen present

THE FIRST INTERNATIONAL EXHIBITION OF EROTIC ART

LUND'S KONSTHALL
MUSEUM OF ART
LUND·SWEDEN

3 MAY-31 JULY 1968·OPEN: 12-5 PM.

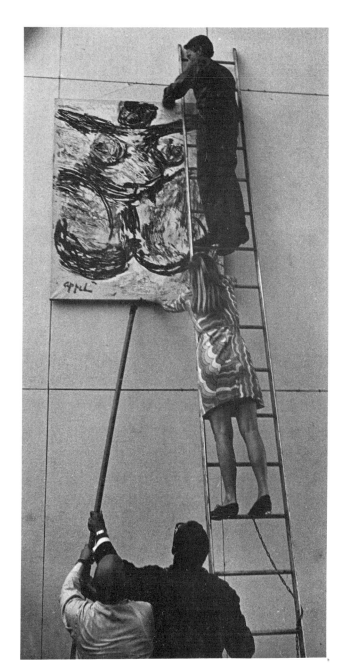

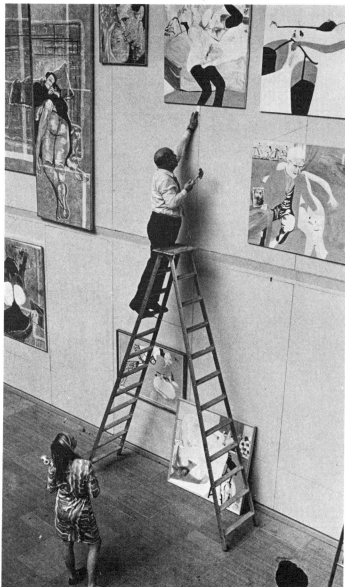

*The Kronhausens help mount the show
at the Lund Museum of Art.*

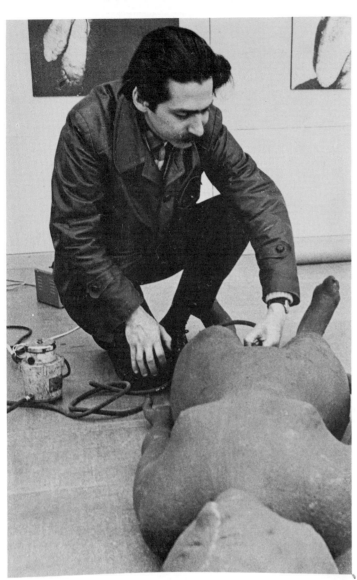

(Left) Painter Jacques Varnasky inflates the mechanized rubber dolls created by Gamarrá. (Below) The press conference held the day before the opening at Lund.

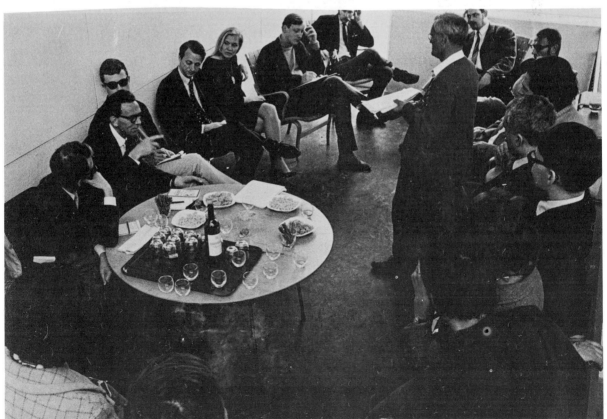

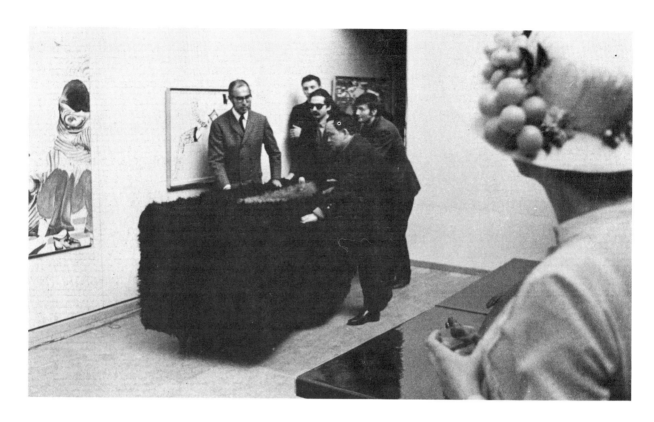

(Pages 12 and 13) The "Happening" on opening day at Lund. Phyllis Kronhausen emerges from Ferdi's "Womb Tomb."

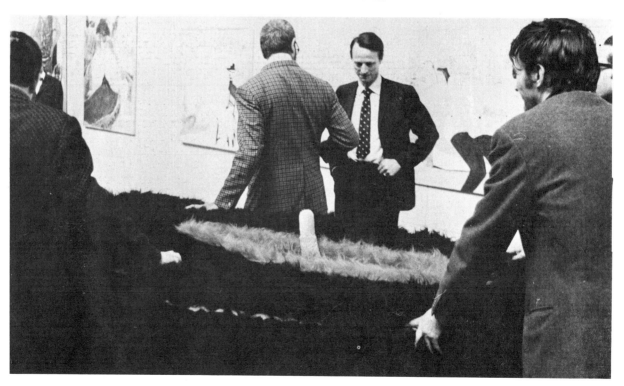

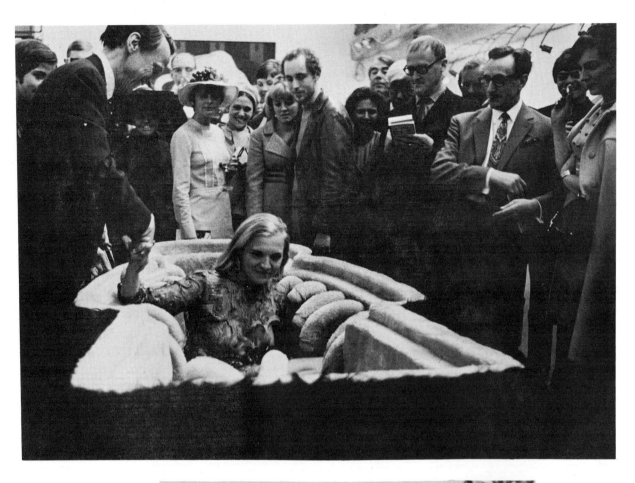

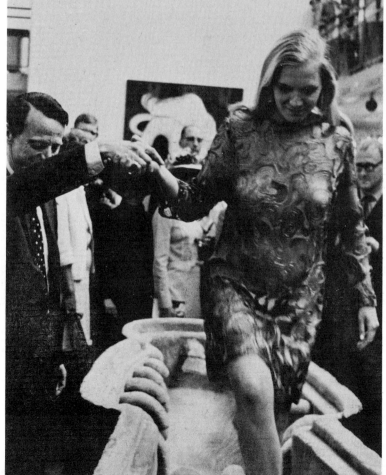

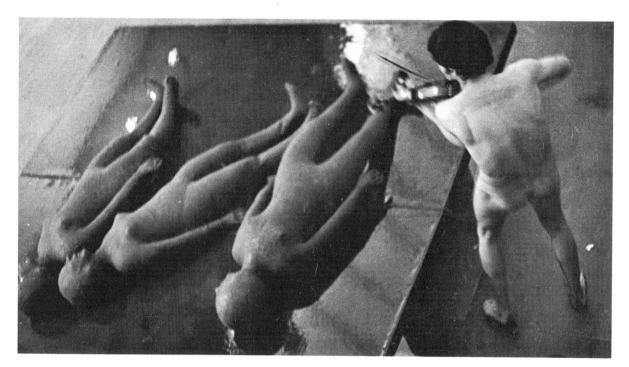

At the formal reception on opening day. Gamarrá's rubber dolls throb to the music of painter Tilo Keil (in the nude) while the guests make the most of the refreshments.

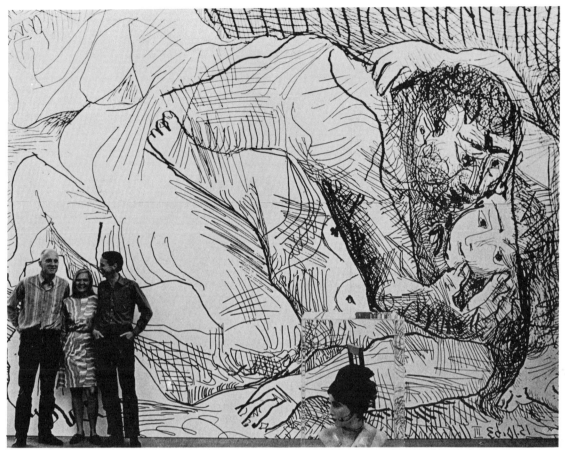

The Kronhausens with Director Folke Edwards.

EXTENSIONS OF FREEDOM

It had been clear almost from opening day that the show was a success. People had been coming to see it at the rate of one to two thousand a day, the Scandinavian press was issuing a steady stream of articles on it, almost all favorable, and the international press had begun to react to it in a surprisingly positive way.

After the show had been open for eight or nine days, we were ready to return to Paris. At that point Folke Edwards, the director of the museum, asked us for a tape-recorded interview to discuss our ideas about the nature and purpose of the exhibition. We agreed, all the more readily as it gave us an opportunity to interview Mr. Edwards in turn and to get his own reactions and ideas regarding the show.

Following is a transcript of that discussion, which took place in the inner court of the museum on a pleasant, sunny Swedish summer day, while, inside, people continued to arrive at the exhibition in large numbers, despite the unusually good weather which normally leaves the sleepy little town of Lund deserted at that time of year, most people preferring to enjoy themselves on the nearby beaches and in their summer homes.

EDWARDS—Some time ago you made a statement to me that, from your point of view, this exhibition is more important as a social event than as an artistic one. Would you try and explain that?

P.K.—What we mean is that the exhibition is an important historical event, especially from the viewpoint of censorship. All of this art has existed since almost the beginnings of mankind, but has never been publicly displayed, let alone shown in a museum—and you saw the reaction of the foreign press, for instance, in *The Guardian* [London], with the headline: EROTIC ART ON THE RATES—"rates" meaning taxes. So, what they were really saying was, "There in Sweden, a public museum, supported by taxes, is showing erotic art."

E.K.—In terms of the public reaction, as well as with regard to the effect of this show on the individual, I think that this show is perhaps more important sociologically and psychologically than in any other way, because I think that the over-all effect—if one may take a guess—on the average person would be primarily a psychological one which would affect his sex attitudes before it would affect his attitudes about art, or esthetics, or anything else, although I'm sure it will also do that.

EDWARDS—Can you be more specific about the possible esthetic effect of this show, as you think of it?

E.K.—Let's take a person who is fond of art and a museum-goer before, but who hasn't been exposed to erotic art as such. Now he comes to see this show. What is he going to think? What effect might it have on him? I think it is reasonable to assume that he might get a new esthetic perspective as an art lover, even as an art connoisseur, by seeing that important artists of all times and all countries have done erotic work and that some of their erotic works are the best they have done. But I do think that the most immediate as well as the most lasting effect on the average person would be a psychological one; the esthetic effect would be secondary. However, there is an important point: This show proves that sexual subject matter can be presented artistically and esthetically in a highly pleasing manner. That is perhaps the most important esthetic contribution the show can make. People will see that it is possible for good artists to use erotic or sexual subject matter and make something beautiful out of it, because some artists, even Leonardo da Vinci, have said that the genitals are so ugly that they aren't worth painting. But I think this might be a highly individual reaction on the part of those few painters like Leonardo who, as we know from Freud's analysis of one of his dreams, did have a few sex problems of his own.

EDWARDS—Do you think that the demand for eroticism in pictures will be higher in the future?

E.K.—Yes . . . but if I may back up a moment. This is the first time that the public can look at pictures about sex without—

EDWARDS— . . . looking at pornography.

E.K.—Yes, without shame or guilt and in the company of their fellow men, fellow citizens, maybe their own family, in a respectable public place instead of shuffling through a stack of pornographic photographs or magazines in some back-alley tobacco shop or sex shop. Now, we don't have anything against pornography, but there is, I think, a big psychological difference between the two situations. Because in the case of pornography, most people will feel that they are looking at something they shouldn't perhaps be looking at. But here in the museum they can look at erotic pictures that are beautiful and artistic and they can do so in an atmosphere of social acceptance, social approval. So that should remove a great deal of the *gêne,* the uncomfortable feeling that still accompanies, for many people, any overt interest in matters of a sexual nature.

EDWARDS—And you feel that this has a beneficial effect on the individual?

E.K.—Most of us suffer from an overdose of superego when it comes to sex. Any relief from the tyranny of guilt and shame is consequently a benediction to the individual. Applied to this show it means that this sort of superego relief might make it possible for a lot of people to look at erotic pictures in an entirely new way—it gives them a chance to take in and appreciate the esthetic, artistic aspects of these pictures without being overwhelmed by the subject matter and reacting only to the erotic content.

P.K.—This is especially true if people are spending an hour or two in the museum, as many of them do, or coming back several times, because of the quantity of the material on exhibit. It allows them to overcome the sexual excitement or any initial shock or anxiety reaction they might have had—that's what quite a few people here have told us. Another thing that has struck us is the way children have reacted to the show. As you know, many people have brought their children, including a fair number of pre-adolescents and teen-agers. And, as far as I could see and gather from interviews with some of the parents and children, their reactions have been completely natural. They are not upset by it, they just relate to the pieces they can understand and more or less ignore the rest. They've been relating especially to the mechanical things and this furry coffin [Ferdi's "Womb Tomb"] and the ethnographic items [see "Primitive" section]. It's what we expected: Children will take in what they are able to appreciate and pay no attention to the rest—which is just the opposite from what a lot of people have been saying, namely, that any child who's shown material like this will immediately become upset and disturbed and probably delinquent.

EDWARDS—Critics like that may now say: We'll have to wait and see what the long-range effects on the children are going to be . . .

E.K.—Sure, that will be the next line of defense for the apostles of censorship. But let me say this, there are already all kinds of strong indications that children are not harmed by seeing even the most fanciful depictions of sexuality . . . I'm thinking, for instance, of Nepal, where children can see the most fantastic sexual scenes in the form of colored wood carvings on many of the temples and palaces. And it didn't seem to us that they were in the least affected by them. Obviously, it all depends on the attitudes of the adults around them. If they show signs of alarm, shame, anxiety, and disapproval at these pictures, the children will automatically react to these attitudes. But if the reactions of the adults are neutral or positive, the children's reaction will be neutral or positive as well.

EDWARDS—I have noticed a good deal of hilarity at times on the part of the public. Do you consider that a normal reaction?

E.K.—Laughing can be a cover-up for embarrassment and anxiety. A certain percentage of the people react to sexual material and sexually toned life situations in this characteristic manner. But the vast majority of the people who have come to this exhibition have, in our opinion, shown a remarkably mature and healthy attitude. Sure, they have been laughing at some of the pieces in the show—and for good reason: some of these pictures are really very, very funny. In these cases, laughing is a perfectly appropriate, healthy response. And to only take sex seriously, without a sense of humor, could be a terrible bore, could it not?

P.K.—I think the important thing is that the people, for the most part, were not *snickering* at the pictures—they were *laughing*. There is a big difference. And they were laughing at the humorous pieces that are meant to bring out laughter, not at the other ones.

EDWARDS—One of the reasons why you put up a show like this, and put so much effort into it, is, as far as I can understand, to change social attitudes towards sex.

P.K.—Absolutely.

EDWARDS—How would you try to define the goal you are aiming at? Or what do you think is wrong about our sex attitudes, such as they now are?

P.K.—There is a great deal wrong with our present sex attitudes. Anybody who denies the reality and importance of sex, which is what a lot of people are still doing, including the governments of most countries, is on a very dangerous course, because sex is one of the most important driving forces in human relations.

EDWARDS—So, by getting together a show like this you want to make people aware of the role sexuality is playing in our lives, is that right?

E.K.—Yes, the important thing being brought out here is that all cultures and the most important artists have done a good deal of erotic art. When you see this, it becomes immediately clear how important sex is to humanity. You can't go through this show without seeing that there is and always has been a lot of interest in sex and that there are many aspects to it we didn't even know about.

P.K.—And when you stop to think that this is only a small percentage of the erotic art in the world . . . if one had the financial resources, one could expand this by a hundred times. . . . What we mean by sex is not just the narrow biological drive, but sex as a driving force in all the creative aspects of life. Here in this show we have limited it to direct sexual behavior. That is only because this is what has been censored the most. When you look at this show, it's ridiculous to think that these things have ever been censored. You see the insanity of censorship at a glance.

E.K.—Many contemporary artists have sent those pieces to the exhibition that they have not been able to exhibit before anywhere.

P.K.—I would say that ninety per cent of the show has never been exhibited before for reasons of censorship. Probably more. So these artists were delighted to finally have an opportunity to exhibit these things, sometimes after many years of obscurity after their original creation.

EDWARDS—What do you think will be the effect, if any, of this show on the art world?

E.K.—I think the collectors will be encouraged now to buy and hang up works of erotic art— not only in the bedroom but in the living room.

At this point, French artist Boris Vansier, who had been listening to our discussion, asked if he could contribute the following observation:

VANSIER—One thing that is important to me suddenly is that when I had a private show of the "Offrandes" [a series of female nudes and semi-nudes in provocative "offering" attitudes; *see* Figs. 117–19] in Paris at a private gallery, it looked like an obsessive painter showing his

obsessive work; it didn't look like an erotic show. It might have struck one as some kind of oddity in painting. The same paintings here are in context with other artists' works and suddenly they fall into place and simply come across as another contribution in another art medium. And seeing this gives me a great sense of satisfaction and vindication after the previous negative experience.

E.K.—No doubt, a show like this will inspire artists to do more erotic works. Some artists have even told us that the mere fact of our personal interest in their erotic work over the past years has encouraged them to produce other erotic pieces.

P.K.—As far as the art-buying public is concerned, we hope that this exhibition will also encourage them to include erotic pieces in their collections and to enjoy and display them in their homes rather than hide them away in some dark closet or at the bottom of some drawer. For if people can loosen up to the point of hanging a piece of erotic art in the living room, they're thereby acknowledging the role of sexuality in human life. By accepting erotic art in their homes openly, they are making a declaration that they are accepting sex, accepting eroticism, that they are not ashamed of it, that they are no longer trying to hide it, that they admit being sexual human beings and don't mind saying so.

EDWARDS—Can you think of any other effects of this show on the general public?

P.K.—As you noticed, the public press has not missed the opportunity of this show to publish a fair number of pieces from the exhibition. I think this is on the whole a good sign and a step forward toward greater public tolerance of frankly erotic representations, even if a certain degree of sensationalism is playing a role in it. The effect on the public can again only be one of greater frankness and less hypocrisy, and that's a very good thing from my point of view.

EDWARDS—I think one can talk of two main types of reaction against an exhibition of this kind. One is the rather traditional one that everything that has to do with sex is automatically associated with sin and guilt and dirtiness of some sort. We all know this sort of reaction and there's no need to discuss it any further. Then there are other people who might say that sex is something necessary and something that we accept, that we love and like, but it should be restricted to the private sphere of life and shouldn't be shown in public or discussed publicly; that it's something so very intimate and personal, that it concerns such deep individual reactions and feelings that it shouldn't be emphasized in this fashion. What would you say to that kind of argument?

E.K.—There are societies where eating is taboo and where people have the same attitude about taking in food in public as we have about sex in our Western civilization. . . . It's a question of cultural conditioning . . .

EDWARDS— . . . which you are trying to break down?

P.K.—We're not trying especially to break it down for everybody. We feel that people who want to keep it that way for themselves ought to be free to do so. But that does not mean they should be able to force their own point of view and, frequently, their own sexual misery on everybody else, because a lot of people feel the opposite way.

EDWARDS—The opposition I mentioned would cite the need and sacredness of privacy in sexual matters as an argument against any public display of sexuality like this show.

P.K.—I fail to see how a show like this would take away from the privacy and intimacy of sex. If anything, it should enhance it, because the privacy should come from the love part, not from the actual sexual act. Intimacy comes from the way you feel about your partner. We're not asking that people should make love in public. But we are saying that people have a right to read and a right to see.

EDWARDS—Some people feel that in a show like this you sort of stress the biological facts . . .

P.K.—Certainly, because there's no need to show romantic love pictures. That has been done before and there is no social problem in that respect. But showing the genitals and the act of intercourse has been taboo. That's why we are stressing it here: to show that this too is a legitimate and highly important subject in art, that it can be beautiful, and that it is of considerable social significance.

EDWARDS—Critics could nevertheless say, could they not, that this show deals with many aspects of sex or sexual experiences which are totally foreign to most people and which might therefore be upsetting to them, for instance, pictures of group sex, animal contacts, etc.

P.K.—It is true that most people would not have actually had these experiences, but a lot of them have probably had fantasies of this sort at one time or another. This is true for the artists

as well. They are presenting, more often than not, sexual fantasies rather than something they saw or experienced in reality.

EDWARDS—But how common are these fantasies in the average person's sex life?

P.K.—Extremely common. These fantasies you see in the show are, I would say, among the most common—and that is why this show is so therapeutic, because many a person who has had these unacceptable fantasies feels, when he sees these pictures, he's, after all, not the kind of "freak" he thought he was. As a result, he will feel less isolated and much more reassured.

E.K.—This fantasy factor is also one of the main reasons why this show proves to be so interesting and intellectually exciting, in spite of the fact that there are only so many ways of making love and depicting it and that people can in this country freely buy photographs, or even films, showing every known intercourse position. If they still come in numbers to see this show and find it "different," it is because the pictures here deal, to a large extent, with sexual fantasies, humor, satire, etc., and that they touch on social, political, and other issues, far beyond the obvious, erotic content.

P.K.—That is why this show is not boring. Remember, even you were worried that the show might be boring. We told you from the beginning it wouldn't be, because of the fantasy material, quite aside from the different artistic styles and media which also prevent any kind of monotony— a fact which quite a few of the journalists stressed in their discussions of the show.

EDWARDS—And as psychologists you felt that this taboo on sex, on the discussion of sex, even the taboo on having sex in groups, etc., has only resulted in giving people all sorts of psychological complexes and sexual problems, if I understood you correctly. And it is your policy to try and make all of this as open as possible because you feel that the more open we are about sex, the better for our mental health, is that right?

P.K.—The less sexual anxiety, the less guilt and false shame, the better, of course, for the individual. That doesn't mean you'll necessarily act on any or all of these sexual fantasies. So, a person seeing them might say to himself: Well, other people are having such ideas too, they don't seem all that bad, there's no harm in them. In short, emotional freedom is always on the side of mental health. The freer an individual, the healthier he is. Because when you have prejudices, when you are bound by taboos, it's going toward a constriction of the personality and a constriction of your outside world. The more you can open up life for yourself, whatever it might be, even the unpleasant aspects of it, it means going in a safer and healthier direction.

EDWARDS—Do you think that the taboo on extramarital relations is a taboo in Western society that we should get rid of?

P.K.—The basis of the taboo on extramarital sex is essentially economic. You see, women used to be regarded as man's property, so anybody trespassing on another's sexual territory was therefore no better than a common thief, according to that primitive way of thinking.

EDWARDS—Do you see any signs of a social change along these lines?

P.K.—Well, to change a whole economic and social system takes generations. But it is slowly changing—women are becoming more independent, the patriarchic system is breaking down gradually and perhaps will break down more rapidly in the next ten years than it ever has before. You will see, of course, a change. This enforced monogamy in Western civilization—also the double sex standard, which gives a degree of sexual freedom to the man but not to the woman—will certainly go by the boards in the next few years. My guess is it will be virtually a thing of the past inside of the next ten years or so.

E.K.—The social sciences have been far behind the physical sciences till now. But in the next generation or two, you'll see tremendous social changes. They are partly based on technological advance, partly on changing economic conditions. As a result, men and women will soon become truly equal economically, socially, politically, even sexually—that is something which has never been so throughout the history of our civilization. We are just now getting into this era. The fact that we'll have almost one hundred per cent sure and easy contraception, that eventually we'll wipe out venereal disease, which are two of the main inhibiting factors sexually, all this will speed up social change along these lines tremendously.

EDWARDS—What implications will that have for the sex life of society? Will the monogamous marriage and family life as we know it disappear completely?

P.K.—No, I think marriage is a very good solution for raising young children. I think the family situation is good as long as it's not bound, enforced in a negative way. First of all, it is a

good thing if two people who are compatible want to live together and that they want to have children. But when you stop to think that so many of the couples that are together do not really want to live together, and secondly, that so many people who have children don't really want them, it's quite a different matter. You see, many people are having children for the most incredibly irrational and neurotic reasons, when you start analyzing their real motives.

EDWARDS—What are, in your opinion, some of these neurotic reasons for having children?

E.K.—One reason is the fear of death and trying to immortalize oneself through one's off-spring. Another is to live vicariously through one's children, to have them live out and redeem one's own frustrations, or to prove one's masculinity or womanhood, etc. Besides, it's still a matter of guilt for many people to accept sexuality or eroticism by itself, so they have to unconsciously justify it somehow by producing children.

P.K.—That's another point we wanted to make in the show—that sex is pleasurable, it doesn't have to be for procreation. With overpopulation today, we have to cut down on this. We've got to learn to enjoy sex for its own sake.

E.K.—That's another important point about this show—it doesn't deal so much with the biological sex urge, which is simply on an animal level, a reproductive level, but it deals with the fantasy level, which concerns itself with the erotic aspects of sex. In that respect the show is making an important statement, that eroticism even by itself, without procreative overtones or intentions, completely separated from procreation, is a good thing in and for itself.

EDWARDS—You separate eroticism from procreation. Do you also separate it from what is conventionally called love?

E.K.—Certainly. Love has little to do with eroticism. The love of a mother or father for the child, or just of one human being for another, is normally not a sexual, erotic one; it's based on other things, even though it may have erotic overtones.

EDWARDS—Can you think of eroticism without love? You can think of love without eroticism, that I can see clearly, but can you think of it the other way around too?

P.K.—Yes, surely.

EDWARDS—This I think is an idea which might shock a number of people. We commonly see eroticism, the sexual act, as the summit of love, do we not?

E.K.—But that's just looking for another excuse, like producing children. Either you have the biological excuse, that here you're in bed together and—maybe not tonight, but surely another time—you'll produce a child. Now the most sophisticated excuse today is—though it's not exactly a new kind of rationalization either—that we're in bed here because we love each other. It all sounds very high and noble, but it's really just another way of justifying sexual relations.

P.K.—Of course, you can have eroticism and love together, and that is very fine and good. But we think it to be a mistake to make romantic love the prerequisite for sexual contacts, which can be perfectly satisfying and healthy in and by themselves. It's always wrong to go into any rigid pattern. The healthier an individual is mentally, the more flexible he is. You cannot expect to respond exactly the same way every day. It doesn't make sense. One day you might react to one kind of stimuli, another day to something else entirely, that's only normal.

E.K.—If you can only respond sexually to a narrow range of stimuli, say, to only one particular person or type of person, or only under certain rigidly proscribed conditions, it automatically limits a person's potential for full sexual enjoyment. Obviously, the healthier individual is able to respond to a greater number of stimuli than the more constricted one, sexually or otherwise. . . . Mind you, we are not advocating unlimited and irresponsible promiscuity—whatever that term means. But we do believe in flexibility and variety, depending on the person's psychological needs and make-up.

P.K.—Also, when we say eroticism is quite possible without romantic love, we are not saying that eroticism should be without regard for the other human being, without mutual respect, without affection, without tenderness, without tact and sensitivity and consideration. To the contrary, our requirements might be higher in these respects than what is taken as the norm for even married couples. In fact, we feel that a frighteningly high percentage of legal marriages which are devoid of these basic human feelings are utterly immoral and obscene in the true sense of the word . . . whereas a casual and temporary sexual relationship which includes some of these attributes may be highly dignified and benign in comparison. It all depends on the nature of these relationships and the attitudes involved. If the attitudes are bad, marriage won't make them any better. And

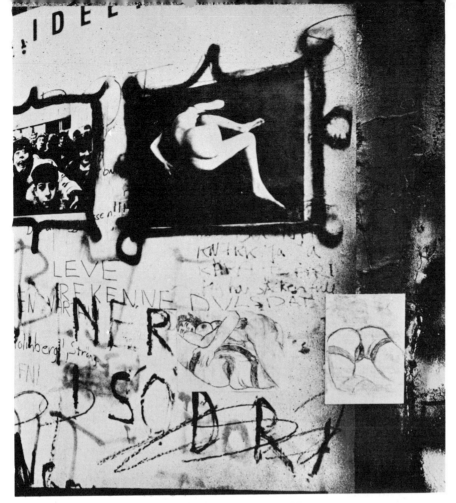

*Examples from the Lund Exhibition were mounted by
a photographer on a public billboard in Stockholm,
where they attracted much attention.*

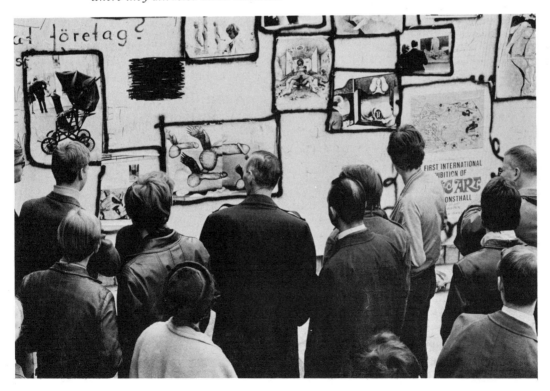

if they are good, there is no need to rationalize and justify these relations on any other grounds, be it marriage, love, or anything else.

EDWARDS—I have been asked about the absence of pictures showing homosexuality and certain perversions in this show. Since you were largely responsible for its composition, let me pass that question on to you.

P.K.—First of all, there are a few pictures of this sort in the exhibition, though I must admit there are relatively few of them. We didn't purposely eliminate them, but we didn't want to stress these aspects in this show, which deals with sexuality in a broader, more general sense. Still, we did include a few examples of this kind, for instance, of sado-masochism, because we thought it important to have a few such representations against the background of a majority of healthy, normal depictions of sexual relations.

E.K.—Some of the art work exhibited here also brings out the intrinsic bisexuality of the human sex drive, that is, the capacity of the individual to respond to stimuli from members of his own as well as of the opposite sex.

EDWARDS—As I understand you, you are for complete individual freedom in a person's sexual choices and behavior. Does that, in your opinion, also include public intercourse?

P.K.—That's a slightly different matter, because there you impose on other people's privacy. But with regard to books, pictures, films, etc., we believe in complete freedom from any kind of censorship. And the same with private sexual behavior, entered into voluntarily and without coercion and in the absence of any clear indication that there is physical or mental harm to the individuals concerned or that society is harmed by their behavior. In that sense, we believe in utter and complete sexual freedom, without interference from any source and without hypocrisy.

EDWARDS—In other words, these are things you choose for yourself.

P.K.—Exactly. If somebody is making love on the street, he's forcing everybody into the role of a spectator, and perhaps an unwilling spectator.

EDWARDS—This is an argument that the head of the Swedish television used too, for not making a reportage of this show.

P.K.—Yes, but it is not applicable, because you can turn off your set.

EDWARDS—Yes, you can, but before you reach the button . . .

P.K.—Looking at a show on TV is still a voluntary act.

E.K.—This kind of argument would be just so much hypocrisy on the part of the television people, because why is this not true of other programs, for instance, those showing violence, which is very offensive to a lot of people . . .

P.K.—In fact, I would say that a high percentage of television programs would be obnoxious to me personally. That's why we don't have a set. But that doesn't mean we are going to set ourselves up to censor programs for other people.

EDWARDS—The argument goes this way: These are things—meaning matters dealing with sex —that upset us so deeply that we have to be careful.

P.K.—All kinds of topics can be upsetting.

EDWARDS—You are sort of making sex less important than others think it is.

E. K.—I think that by having shows like this and radio and TV programs on it as we have already had in Denmark, Holland, and as we are, I am sure, going to have in Sweden as well, and talking about it in the newspapers, publishing pictures even, will all help to break down this artificial distinction of sex over other human concerns. After all, sex is only one of the basic human drives and an important one. That's what we've been saying all along. But certainly there are other human affairs of equal importance. It is only by surrounding sex with all kinds of taboos and prohibitions that we have managed to make it the kind of universal fixation that it has become. Once you remove some of these taboos, it simply starts to take its normal, rightful place in life, and that is all. Like in this exhibition: people are taking it in their strides; they come to see the show, they have their laughs, they hopefully learn a few things, they may have some esthetic enjoyment, they may even get a sense of relief—and bless their hearts if they get some kind of erotic charge from it as well—and that's all there is to it.

EDWARDS—Do you think people will have more sex on account of having seen this show?

P.K.—I think you might get a temporary increase in sexual interest with some people, but in a few hours or days it will certainly drop back to their normal rate.

E.K.—We're not trying to change behavior.

P.K.—But we do hope this show will change attitudes.

EDWARDS—This, in the long run, may change behavior, don't you think?

E.K.—Over time, yes.

EDWARDS—I'd like to take up one more argument against an exhibition of this type—a political argument. You've stated in the catalog that the strongest suppression of sexuality and the most severe censorship comes from either a reactionary or a revolutionary kind of society. Would you try to explain this apparent paradox and give your reasons for it?

P.K.—First of all, the reactionaries and revolutionaries are for the suppression of sexuality from different motives and from different points of view. Though the result is, of course, the same. The reactionaries are imposing sexual censorship to preserve not only the sexual, but also the political and economic status quo. They understand very well that sexual freedom is incompatible with a politically repressive regime and a patriarchal kind of society. That's why they associate sexual freedom with political subversion and react against it with such violence.

E.K.—It's quite a different matter with the newly emerged socialist or communist societies. They still feel insecure in having achieved their socio-economic structure and they might, over the long run, loosen up on censorship. But when they begin, they feel they want to do so much in such a short time—China, Cuba, and even Russia—that they feel that any degree of freedom they give, not only in the sexual area, but in general, will threaten them in achieving their social goals. To them, social goals come before freedom of expression.

EDWARDS—How would it threaten their social goals, then?

P.K.—Because, if they abolish censorship, it would mean tolerating criticism of their own communist or socialist system. And they feel that if they accept this kind of criticism, the system will not survive or, at best, that it will retard progress in the attainment of their social goals.

EDWARDS—Excuse me, but I can't really see this. If you're criticizing the government, this doesn't imply that it will have to put heavy censorship on sex.

P.K.—Of course, because once you allow freedom of expression in sex, it spreads; you can't just have freedom of expression in sex alone. When you tolerate freedom in any area, it has a tendency to spread. That is why today Russia is concerned with what is happening in Czechoslovakia . . . criticism and revolt are very contagious.

E.K.—In Sweden and Denmark, freedom of expression has spread from the political and other areas to the sexual. The abolition of the so-called obscenity laws, of sexual censorship, was only the logical extension of the principle of freedom of expression in a democratic society. The same holds true for behavior. Laws discriminating against sexual minorities are as intolerable in a true democracy as are laws or practices aimed against any other kind of minority, religious, racial, or whatever.

P.K.—Realizing this connection and interrelation between sexual and political or even religious ideas, one need not be surprised that it finds expression in erotic art and literature as well. There are quite a few pieces in this exhibition which demonstrate this kind of relationship, especially in the area of sexual humor and satire, but also with regard to the Indian pieces, some of which express very definite religious and philosophical ideas in the context of overtly erotic subject matter.

E.K.—Another reason why some of the more radical or totalitarian regimes suppress sexuality is the fear that there may be an inherent competition and incompatibility between an individual's sexual interests and the comprehensive claims of these groups on his time, loyalty, and physical energy.

P.K.—Eroticism takes leisure, first of all; you have to have time. These countries want almost all of their people's time spent on the achievement of socio-economic goals. Secondly, satisfactory sex does require a little basic comfort; you generally have to have more or less pleasant surroundings and some privacy. Now, in these new socialist countries, especially China, a lot of people live in dormitories, or two and three or more people to a room; you have no privacy, so it cuts down on the opportunity for sexual activity. You see, if you indulge in eroticism, you indulge to a certain extent in luxury . . .

E.K.—This show is a very democratic event in another sense too: For the first time, the average person, even the poor person, can see these works of art which up to now have only been accessible to the wealthiest classes in every part of the world.

P.K.—All the pieces we brought back from the Orient were formerly owned by wealthy people.

E.K.—You see, these Japanese scrolls which are hanging here on the wall are not just expensive today because of their age and rarity—they have always been expensive. It's been an eye-opener for us when we sometimes complained about the high prices we had to pay for some of them, and were told by our friends in Japan, "Don't forget, these scrolls were already that expensive three hundred years ago when they were first painted!"

P.K.—*The Guardian* commented on this democratic aspect of the show too. Here anybody can come and see the show, while in England the attitude still is to a certain extent that these things are only for the upper classes who "know how to handle them," but not for the average person. What is happening today in Sweden and Denmark, as far as the abolition of censorship is concerned, is bound to spread to other countries. That is why the international press is so interested in this show—they realize that it has implications for their own countries. Sooner or later, their people will demand the same freedom, the same privileges for themselves.

E.K.—One might say, the international press has been waiting for an opportunity of this sort . . .

P.K.— . . . to fight censorship in their own countries. For up to now there has not been too much opposition to sexual censorship in these countries, the public has not even been quite aware of it.

E.K.—So what we hope will happen is that the liberal minorities in other countries will be able to impress upon their governments that if this is possible in Sweden, without people starting to copulate in the streets, without women being raped, without the family falling apart, then it should be possible elsewhere as well.

P.K.—The press has commented especially that this has been possible in probably one of the oldest and most conservative towns in Sweden and one with a large population of young adults from the university here, which is, of course, the more liberal element in this town, but not necessarily the one that determines public sentiment and policy.

EDWARDS—There's an American Marxist, Herbert Marcuse, who has the theory that, well, censorship is in the hands of the Establishment. The reason why the Establishment now, in Western society, is loosening up on censorship, giving people more and more freedom in sex, is that by doing so they can direct the revolutionary interests of the classes toward these individual pleasures, instead of accomplishing the social revolution which is necessary to make society better than it is. So this is really an extremely reactionary tendency to try to fool the people by giving them more sexual freedom. So, these Marxists feel that this sort of exhibition, instead of promoting a healthy social development, is, in reality, preventing it.

P.K.—First of all, governments—outside of Sweden and Denmark—haven't loosened up that much on censorship till now. Secondly, I think Marcuse is using an overly simple-minded and one-sided approach to the problems of censorship. And lastly, to assume some kind of sinister personalized scheme on the part of modern governments as complex and impersonal as those of the industrialized nations is a paranoid type of reasoning which can be very dangerous and misleading. The trouble is that people like Marcuse are interested in only one particular kind of social development—their own brand of politics and economics. They want freedom for themselves, yes. But they deny freedom to opinions and points of view other than their own. They are not interested in the extension of freedom into other areas than those of their own concerns. Freedom as such is not important to them. That's where we differ fundamentally. Because we feel very strongly that freedom is the most important factor in all social progress. If you are really free, you are tolerant and liberal in everything—not just in one particular way or sphere of life. That's a contradiction in itself; you can't be free in one department and unfree in another. Now, Marcuse and many of the young revolutionaries today who are taking their cues from him, want to establish some sort of uniform Marxist-Leninist-Trotskyist or whatever socialist society that's all red, or all gray, or all black, depending on the particular brand of revolution these groups happen to subscribe to. But we don't believe in any rigid systems of this sort. We live in a complex, modern society that demands a much more flexible and comprehensive approach to social problems than the rather narrow and by now slightly old-fashioned Marxist-Leninist theories. Instead of going back to these antiquated ideologies—that were developed and meant for much more primitive societies than our own—we must go forward and find new ways of solving our problems that are more in keeping with the realities of human nature and the functioning of groups as we know them today.

EDWARDS—It seems you feel that sexual freedom is more compatible with some form of capitalism than socialism.

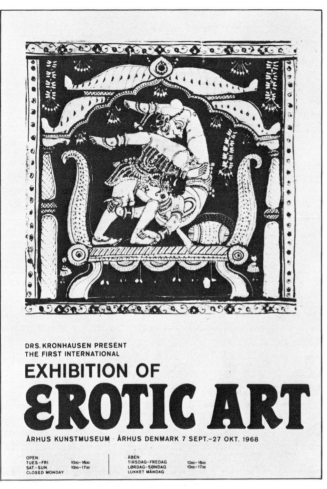

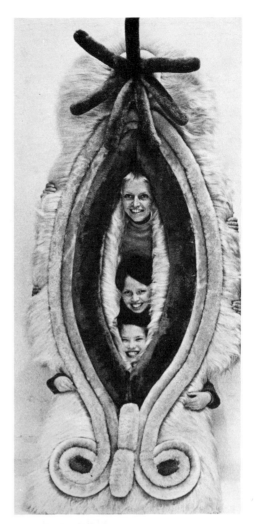

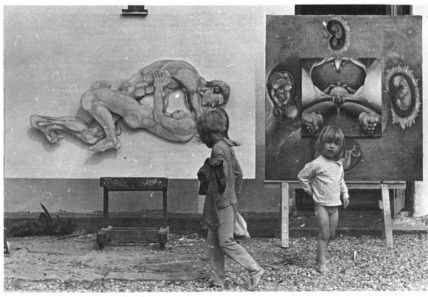

(Above left) Poster for the show while it was at the Aarhus Kunstmuseum, Denmark. (Above right) Ferdi and her children peek through the cover of her "Womb Tomb." (Below) Ulf Rahmberg's children before his construction "Couples."

E.K.—We feel that sexual freedom is not incompatible with some form of enlightened capitalism, nor with enlightened socialism, nor, for that matter, with tolerant and enlightened religion. I'm saying "enlightened" and "tolerant," because the more orthodox and doctrinaire one gets, the less room there is for anything else. And we don't think there is an inherent contradiction between sexual freedom or happiness and the essence of religion—all religions. Indeed, it would be a sad state of affairs if you had to be anti-religious or irreligious to enjoy sexual happiness.

EDWARDS—Will you become apolitical if you really start enjoying sex in the sense you are speaking of?

P.K.—I'm very interested in politics and so is my husband, and I like to think that we are enjoying ourselves sexually.

E.K.—I think the emphasis on sex as recreation, apart from any procreative function, is the most political and revolutionary aspect of this show. Because it's not the atom bomb that's going to do us in, but simply babies—babies which we are creating ourselves, babies which we are breeding to such an extent that we are crowding ourselves out of living space, of breathable air, or drinkable water, out of everything.

FOLKE EDWARDS

P.K.—Let us ask you a few questions now in turn, if we may. When we first approached you about this exhibition and talked to you about erotic art and so on, I don't remember, did we show you any photos or original pieces at that time?

EDWARDS—You had a few scrolls and a few small Indian things with you.

E.K.—Were you able at that time—it's hardly fair to ask—to visualize what would happen, in terms of the variety, the content of the show as it turned out in the end?

EDWARDS—No, I wouldn't say I was able to do that. We were discussing then how you intended to organize it and I thought that the idea was quite good. You had your own collection, which was mainly Japanese and Indian material, and we'd try to expand from there and go into the contemporary field and cover that as much as possible. So this was pretty clear, theoretically, from the beginning.

E.K.—It was just the extent of it, then, that was not clear at the moment, where it would go? You had a general idea where we were going, but it was almost impossible—

EDWARDS—Yes, to visualize. I can tell you that when we started organizing this show and you showed me these objects, I got the impression, since you couldn't carry with you the heavy things, that this would be an exhibition of minor things, of small things—minor from the point of view of size. So, I could feel that perhaps a gallery of this size would be too large somehow. I thought at first that this show you wanted to present might require a more intimate atmosphere, more intimate rooms than we have. But now . . .

E.K.—Maybe you were a little worried whether . . .

EDWARDS— . . . we could fill as large a place as this museum; that's true.

E.K.—And, as it turned out, we have more things now than we can hang.

P.K.—Did you foresee some of the difficulties that we encountered? To what extent, for instance, did you appreciate beforehand the social and political pressures that were to be put upon you, I mean, pressures from your own board or committee at the museum and some of the more conservative segments of the public?

EDWARDS—I knew from the beginning that this would be a controversial show, that there would even be some pretty severe criticism—we've had to have two meetings of the board to get this thing through; they wanted to withdraw it at the second meeting . . .

P.K.—This you didn't anticipate?

EDWARDS—No, I thought this was against the rules, and I'm very much for the rules. Once the board had said they would go for the show, I felt they should stand by it. The reason why they wanted to go back on their original decision to have the show was that there had been certain sensational headlines in the press as soon as the show had been announced, and I guess they just got scared or got the wrong impression from it.

E.K.—So, this is an extremely un-Swedish attitude, to go back on an official decision or commitment, once made?

EDWARDS—I would say so, yes. But the argument was that when this thing was first decided upon, not all the members of the committee had been present. Later they said that this was such an important thing that we should have the full board there to decide. So we must have another meeting and see if we should have the show after all—that was the meeting when they almost did manage to stop it.

E.K.—Didn't they try and stop the show even before that second meeting? I remember a telegram being sent to you when you were with us in Paris, saying something to the effect that the show was most likely off . . .

EDWARDS—They wouldn't act quite as much against the rules as all that. The telegram did say that most likely, or even more strongly, that almost certainly they would cancel the show, so I had better start thinking of something else.

E.K.—Wasn't that foregoing the conclusion before the meeting had been held?

EDWARDS—You see, that telegram was sent by the chairman of the board. He felt that he had been in touch with the members of the board and he knew that if we had a meeting then, they would turn it down. So I shouldn't waste my time in Paris. He had then switched from being for the show to being against it. Later, during the second meeting here, he switched once more.

P.K.—How did he feel about the show when he actually saw it?

EDWARDS—All right, I think. He has no hard feelings. He thinks it's all right.

P.K.—What do you think the majority of the committee feels at this time? Have they all seen the show by now?

EDWARDS—Not as far as I know; not all. The majority has seen it, I'd say, and they seem to think it's all right.

P.K.—Have you been at all criticized for the show since then, either by the press, the committee, or anybody else?

EDWARDS—I haven't received any criticism so far. That's after more than a week that the show has been on. This is one thing that's really interesting: all the criticism came *before* the show opened. Since then, I haven't seen any criticism at all.

E.K.—Was there any reaction about the posters? [*See* p. 9.] After all, the posters are hanging right next to the church, outside the railroad station, along the highways, and so on. Was there any reaction to that?

EDWARDS—Well, there was a group, called the Group for Sharpening Film Censorship, which wrote to the legal authorities of the city of Lund—this was before the poster was published, but they had somehow managed to see the poster—and said that this thing should be stopped; it cannot be shown, this is against the Swedish law to publicly show a piece of this kind. They made quite some fuss in the papers and so forth, but the legal authorities haven't done anything so far; they've accepted it. They won't do anything either, because they would have acted rather quickly if they felt like doing it.

P.K.—Have you talked to any of the police in Lund?

EDWARDS—The police have been here and they've taken two posters to have a close look at them, to send them off to the authorities in Stockholm who are supposed to decide on such things.

P.K.—And have they seen the show, the police?

EDWARDS—Yes, they've seen it and they haven't said anything so far. I called the Department of Justice in Stockholm—this was before the show—because I thought that it would be silly to put up this show if they closed it immediately. But they said that their policy was that they are against a public showing of things if people can't decide themselves whether they want to see it or not. When you call it an exhibition of erotic art, they come here, pay their entrance fee, and they know what they're going to see, so you don't fool them.

E.K.—It's voluntary.

EDWARDS—Exactly. Then they said that there would have to be extremely strong pieces before they would do anything. I don't know what that means . . . but apparently they felt that this here was O.K.

E.K.—We've been talking about the possible psychological effects of a show like this—making sex appear much more normal, as just another part of life, removing taboos . . . have you had personally such a reaction or heard about this sort of effect on people you know or talked to?

EDWARDS—Oh yes, I would say so. Before I started to work with the material for this show, I was much more hesitant about talking about these things and using the normal, Swedish expressions for these facts of life than I am today. This I've also noticed among friends and the people I know; somehow I've gotten the impression that we are definitely more . . .

E.K.— . . . loosened up?

EDWARDS—Yes, definitely.

P.K.—In social situations that you've experienced since the show opened, have you noticed reactions that would indicate any change in attitudes? Do the people come up freely and talk about the show?

EDWARDS—Oh yes, and some of them even discussing personal sex problems . . .

P.K.—Which they've probably never done before?

EDWARDS—Well, we did it, but I have the feeling that we do it more freely now.

E.K.—It's easier?

EDWARDS—It's easier, yes. Because it's not only in here, in ourselves, but it's also out there in the museum, so we can always refer to something objective.

P.K.—I know you received a certain number of nasty letters, "nut mail," we call it in America, and your wife has received some obscene phone calls. Does any of this upset you at all?

EDWARDS—No, I wouldn't say so. I feel rather comfortable myself, I mean I have no serious doubts about what I'm doing in this case.

E.K.—Do you feel more relaxed about the show now than you might have felt at the outset?

EDWARDS—Well, I might have expected more violent reactions from the public—I wouldn't have been surprised if someone had tried to damage certain things, and this, of course, is always a responsibility. But it hasn't happened. So, in that respect I feel more comfortable. When we started here we had three or four extra guards. Now I feel almost as though we can get rid of them all.

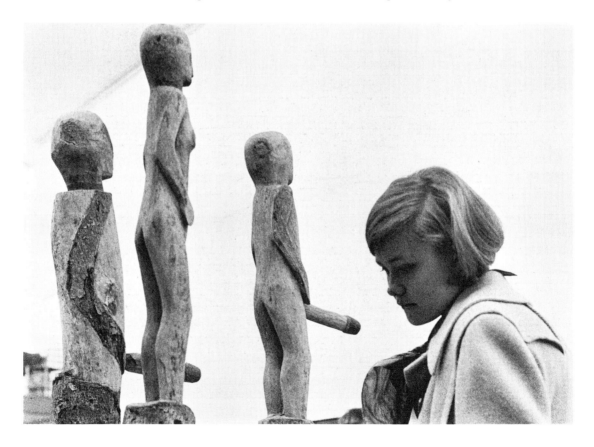

THE PUBLIC SPEAKS

REACTIONS OF FOREIGN VISITORS

The city of Lund, an old university town and famous center of learning, is frequently host to international scientific congresses, just as its industrial neighbor Malmö is the natural choice for numerous business conventions, both Swedish and international.

We therefore had a large number of visitors from these meetings and conventions at the museum. This included groups from the European continent, South America, the United States, Australia, Japan, as well as from Eastern Europe—Czechoslovakia, Poland, Yugoslavia, and Romania.

Perhaps one of the most interesting groups of foreign visitors was a contingent of American college professors who were attending an educational congress in Lund. After they had seen the exhibition, we asked a group of them to sit down with us around a table and give us some of their impressions. This they readily agreed to do, and following is the transcript of our conversation with them.

AMERICAN PROFESSORS

PROF. A.—It's overwhelming. This is the sort of show we never see. Some of it is pretty stark and real, some of it is fantasy. Very unusual colors, quite interesting, I think.

P.K.—Do you go a lot to art exhibitions in America?

PROF. A.—We have a fairly active group of artists in the area where I teach [California] and we do have a lot of shows, made up in part by our own local people, and then we get the traveling exhibits too. So there is some kind of an art show on almost all the time—students, faculty or artists in residence, artists in the general area, or artists elsewhere.

P.K.—Was there any section that you liked best?

PROF. A.—No, I guess I would just have to come back several times. I think I enjoyed the old Japanese and Chinese pieces because of the color . . .

P.K.—And the Indians?

PROF. A.—I didn't react to them as much.

P.K.—Do you think it's possible to have this show in America, say, in New York or California?

PROF. A.—Well, a lot of people in America still live by the old Victorian and puritan standards. . . . On the other hand, I'm sure there are a sizable number of people in our country who would like to see the show and study it . . .

P.K. (to another professor)—What is your reaction to the show?

PROF. B.—It's extremely difficult to absorb in a relatively short period of time. The common element of man is certainly identified here in a sense, whether you're talking about the modern European comic strips or some of the old Japanese paintings. Essentially it's the same thing—human problems, human fantasy, presumably human hang-ups are the same down through the centuries. . . . When it comes to this animal aspect of man, called sex, we are used to playing it down, even though the drives that are represented in these pictures are those which have made

specimens able to reproduce and maintain themselves. If you add to that kind of drive man's abstract-thinking capacity and fantasy to play on it, you get what may appear to many people as weird . . . though personally I think it is perfectly understandable. But one must remember that we've been so careful about trying to hide and inhibit any overt expression of this that an exhibition of this kind which brings it out into the open will certainly be highly controversial . . .

E.K.—Do you think that the Americans are less ready to accept a show like this, which emphasizes the realities and the fantasies surrounding human sexuality, than the Scandinavians? As you see, the people here, young and old, seem to be able to take it in their stride and enjoy it.

PROF. B.—I think you would actually find the same thing in the United States if the exhibit were actually on.

PROF. C.—Well, a lot depends on how the press reacts to a thing like that. If they try and play up the most sensational aspects of it, as they often do, they, of course, prejudice the public against it beforehand and in that case you're bound to have some problems . . .

P.K.—A correspondent from *Time* magazine was up here for two days and he was very positive about it. [Note: So was the report of the show which appeared after this interview; see *Time*, May 17, 1968.]

(Phyllis Kronhausen then pointed out Rahmberg's "Couple" [Fig. 172] and asked):

P.K.—Did you see this piece? What would you think of using something like this in sex education?

PROF. A.—I don't think I've seen anything like this before. I'd have to think of that in terms of the whole context, so I guess I'd just better not say anything.

P.K. (*turning to Prof. B.*)—What do *you* think?

PROF. B.—Well, I suppose that there would be advantages to this. Sex education in the United States is becoming more advanced all the time and I think it's a matter of how and where a piece like this is used. I don't think it would be possible in the public schools at this time, but I would think that in, say, marriage counseling it would be extremely valuable.

E.K.—Do you think it's important for sociologists, psychologists, social scientists, to see this show?

PROF. B.—I would think so, in many ways. Certainly anyone involved in marriage counseling, social work, and so on. As for the general public, I think it's a question of how it's going to be presented and how it could be interpreted. In other words, I can see where you two could take a group of people around here and this would become a completely different kind of exhibit in terms of real functional utility . . .

PROF. A.—Well, the point is, if there's a possibility of it being useful, then people should see it.

A BUSINESSMAN FROM STOCKHOLM

One day, a visitor at the exhibition spotted Phyllis Kronhausen at the museum and came over to express his thanks that we had brought the collection to Lund. In the course of conversation, he volunteered some reactions to the show which Phyllis Kronhausen thought to be of sufficient interest to tape-record with his permission.

VISITOR—One of my first reactions when I came into this exhibition was to watch how other people reacted. Why do they come to this exhibition? As for myself, I read about it in the papers and got curious.

P.K.—You said, your first reaction when you came here was being upset?

VISITOR—Yes, I walked around in the exhibition and on the first round I got more and more upset. Then, after half an hour, three-quarters of an hour, I began to feel much more calm. I wondered: Why do I feel like this? I watched the people around me to try to find out how they felt and how they reacted to the other visitors. I found that they sometimes watched each other and I was doing the same. But slowly I began to study each picture more and more carefully—especially the Chinese and Japanese ones.

P.K.—You said you had been here three times?

VISITOR—No, but I've been walking around the exhibition three times today. I've been here for one and a half hours.

P.K.—This is the first time you have come here?

VISITOR—Yes, I'm in Lund for only today. I'm from Stockholm; I'm here on business.

P.K.—You said that each time round, you became calmer and calmer and you could appreciate the art more for what it is—is that right?

VISITOR—Yes, at last I had to go and thank you for arranging this. Of course, I think that what I'm saying is only what most people here will feel about this exhibition.

P.K.—And you really feel that it was what we call a therapeutic experience, it really seemed to help you emotionally?

VISITOR—Yes. I think that this exhibition should go to as many towns in Sweden as possible to show people that this is a fine thing, because it's what happens every day between man and woman. And that is nothing to be ashamed of.

P.K.—You mentioned the Chinese and Japanese pictures and said that people of other cultures, for instance, Scandinavia had also done erotic work . . .

VISITOR—Yes, we are people in one world and I think we react in the same way, whether we happen to be living in Sweden or China or Japan.

E.K.—Do you have children yourself?

VISITOR—Yes, I have three boys. My youngest is three years old, one is seven, and another, eight years.

E.K.—If the seven- or eight-year-old wanted to come to this exhibition, would you bring them?

VISITOR—I would like to have them here, if I could, because in our family we talk openly together about everything and we are not afraid of showing ourselves nude in front of one another.

P.K.—Do you think that your wife would like to see the show?

VISITOR—Yes, I have bought the catalog to show her. Maybe she is a bit more traditional than I am, but I think she will react after a while as I did.

CHILDREN AT THE EXHIBITION

It was the museum's policy for this show not to admit children under fifteen unless accompanied by an adult. Still, a surprisingly large number of children attended the exhibition, mostly in the company of their parents.

What struck one immediately was the natural and mature reaction on the part of these youngsters, most of them from eight to fourteen years old. They seriously studied the exhibits, commenting matter-of-factly on this or that aspect of a picture (as one could see by their gesturing); they showed signs of lively amusement and merriment at some of the humorous and more bizarre pieces; they identified by means of the catalog pieces of special interest to them—in short, they behaved in all respects as one might expect a reasonably well brought-up member of that age group to behave in any kind of art exhibition. Above all, they did not respond to the erotic content of the exhibition with visible signs of embarrassment or anxiety. In fact, the children and even the teen-agers we observed in the show seemed the least affected and most natural of all visitors.

We spoke to one couple from Denmark, the father a medical doctor, who attended with their two daughters, aged nine and twelve. We asked them how the children liked the show. The mother said that she was pleased to see they had taken it so naturally, which was to her proof that the children's sex attitudes were healthy. She commented, however, that there was a difference between the younger and the older girl's attitude, a fact which we ourselves had also observed by watching the girls studying the various exhibits.

The mother told us that when she had been discussing sexual intercourse with them, using for illustration Rahmberg's construction entitled "Couple," which shows a couple in intercourse, the older one had said, "Mother, you shouldn't be telling us these things, because we're too young."

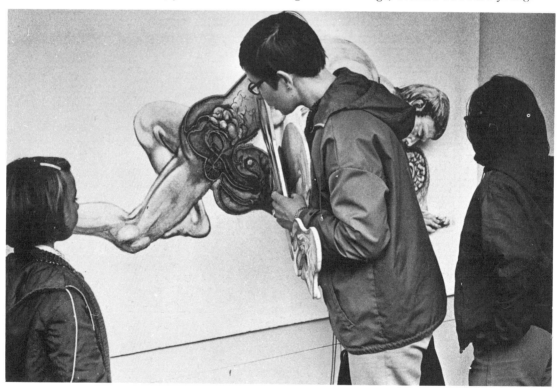

The father associated this incident with an earlier one which occurred when the girls had been about four and seven. The four-year-old had followed her father without his knowledge into a house where he was assisting with a difficult birth. Back at home, she had excitedly told her older sister that she had seen the baby's head come out of the woman. The older sister had not wanted to believe her and had insisted that the little girl had only been "imagining" these things.

It seems that the older girl had picked up more of the inhibiting attitudes of other children from her peer group, who did not come from as liberal homes as her own. The younger one, in contrast, was simply reflecting the parents' natural and matter-of-fact attitudes about sex and apparently had not absorbed the differing peer-group attitudes that had had a definite effect on the older girl.

These differences in basic attitudes and temperament between the two girls were expressed in other ways. The younger one openly enjoyed some of the "funnier" pieces of art, while the older one tried to keep a straight face. The younger one freely pointed at the objects and liked to touch them, if allowed to, while the other kept a certain physical distance from them, though she too looked at everything with great interest. The younger girl, for instance, pointed laughingly at the penis on the *female* figure of Sachi Hiraga's dolls, observing correctly that it was "on the wrong doll!"

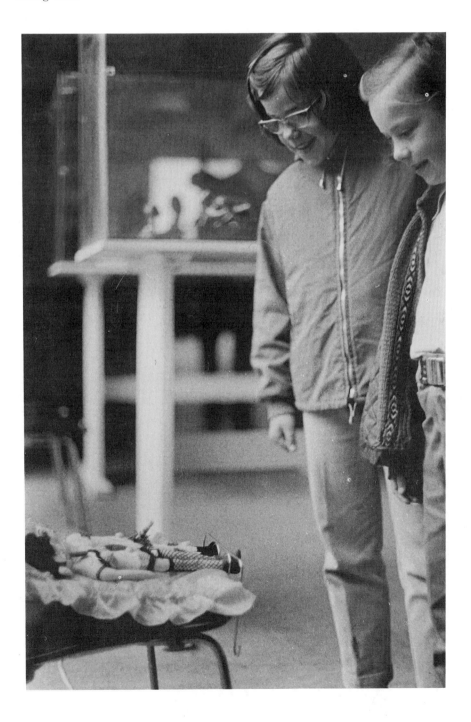

These differences in attitude between the two Danish girls reminded us of an experience in Katmandu, Nepal. While we were photographing and filming some of the erotic wood carvings which proliferate on many temples and public buildings of that Himalayan city, an older boy who had been watching us came over and said, "Those are dirty pictures." He said this without much conviction, but apparently felt it necessary to make some such remark to us foreigners, since by his knowledge of English he was trying to identify himself with Western attitudes which he might have imbued from his English lessons and from contact with other tourists.

One day we noticed the parents of a four-year-old boy showing the child the already mentioned painting of an intercourse scene by Ulf Rahmberg. We walked over and asked the father, first of all, whether he spoke English and, upon hearing that he did, whether he would mind translating for us what the boy was saying about the construction.

The first thing the little fellow remarked about was that they used the same word for the man's and the woman's genitals, even though "they don't really look like each other." The father explained that in Sweden it was customary in talking to children to use the word *kiss* for both the male and female genitals. On seeing in the construction how different the organs actually were, the boy was struck by the illogic of this.

At one point, father and son started to talk about nudity:

FATHER—So I asked him if he could be on the beach without clothes, and he said, Yes, he can. But when I asked him if his mother and father could be naked on the beach too, he said, No. He can't understand why we must have clothes on and he can be naked.

E.K.—What does he think of the couple in the picture—how does he interpret the situation?

FATHER—He can't understand it, because he thinks the man is letting water, but he seems to be doing it inside the woman and that puzzles him.

The little boy next went over to examine Rahmberg's "Phallic Chair." He bent over to look underneath and then took hold of the erect phallus which sticks out of the seat. He told his father that his penis sometimes got hard like that too. We had already noticed that the children, especially the young boys, liked to handle the phallic sculptures that were within their reach and not protected by glass enclosures. One little boy not only repeatedly touched the phallic bronze by Tajiri, but also tried to kiss or lick it.

This boy also picked up, one after the other, the Tahitian wood carvings which represent a group of men and women with prominent genitals, and played with them as if they were dolls. He turned to ask his mother what they were and when she did not know what to answer, Phyllis Kronhausen told her to say that they were "men and women," which she did and which seemed to satisfy the child.

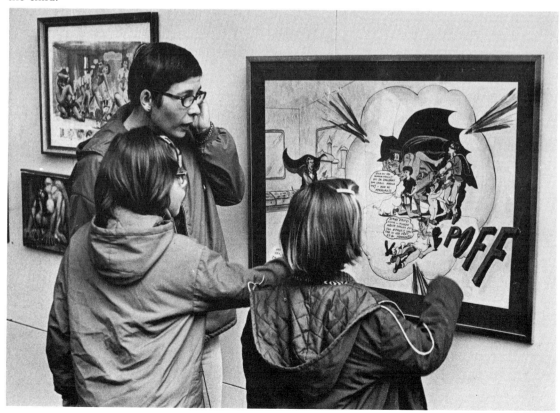

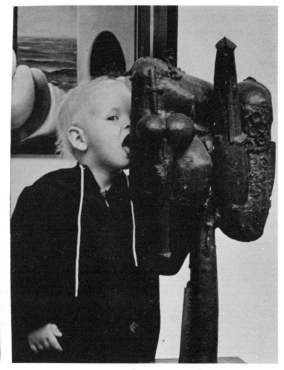

A few days later we noticed a twelve-year-old boy in company with another boy about the same age. We introduced ourselves and on hearing that he spoke very good English, asked how it had been possible for him to get in without being accompanied by an adult. He said he was a regular museum-goer and that the guards at the entrance had recognized him and let him in for that reason. He added that his parents, who were unable to see the show that day, had told him they would take him in later if he had any trouble gaining admittance. He said that this was actually the second time he was seeing the show, both times on his own.

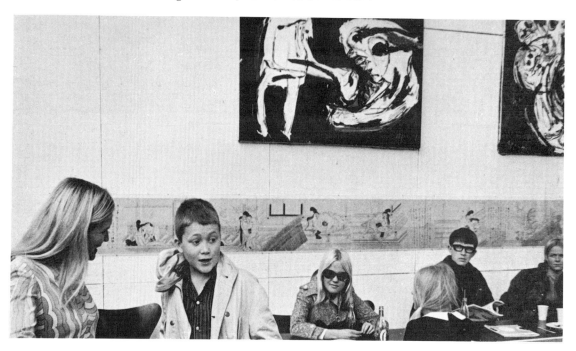

Standing with the boy in the section with the paintings by Boris Vansier, we asked which one he liked best. He pointed out the middle section of three large panels, showing a young woman with her legs quite open and exposing her genitals (Fig. 118). But he changed his mind:

Boy—Oh, now that I see it closer, I think that one up there is better . . . *(pointing to a large nude portrait of ourselves on a bed, also by Vansier).*

P.K.—You saw the object with the rubber figures of the women moving down there when it was working, didn't you? [*See* p. 49.] What did you think of that?

Boy—I thought it was fun.

P.K.—*(showing him the series of large photomontages by Tilo Keil; Figs. 68 and 70)*—Which one of these do you like best?

Boy—I like all of them.

P.K.—Isn't there one you like better than the rest? If you could choose one to have, which one would you choose?

Boy—I wouldn't say no to any of them.

E.K.*(pointing to a photomontage by Tilo Keil, Fig. 68)*—What do you think this represents? What do you see there?

Boy—Fingers, and then . . . have you seen the Swedish film . . . in which some children are playing a game . . . one runs after the other, and when he catches him, he's supposed to shout, "Oodle, doodle, duck!"

P.K.—And what makes you think of that?

Boy—In the film a boy made a woman's thing with his fingers like this.

(Phyllis Kronhausen asked him how he liked Ferdi's "Womb Tomb.")

P.K.—You said it was very interesting?

Boy—I don't know how to say, but I think it would be fun to be inside and sleep; it is a bed, you know, to sleep in.

P.K.—(*invites him to get inside*)—Do you like it?

Boy—Yes, it's nice.

P.K.—It makes you feel good?

Boy—Yes.

P.K. (*pointing out Rahmberg's "Couple"*)—And what do you think of the idea there; do you think it's an original unusual idea?

Boy—It's an unusual idea, but it should be more concentrated . . . not so many things that don't belong.

P.K.—You want it to look still more like the actual anatomical details?

Boy—Yes. The idea is anatomical and I think the artist should have gotten more out of it that way, instead of . . . [He feels it's anatomically not precise enough.]

(We learned in the course of conversation that his father and mother were both medical doctors.)

E.K.—Have you seen such pictures in your parents' library?

Boy—No, they don't have such pictures . . . they have more pictures of cells.

E.K.—Did you know that people's tongues could meet like that when they are kissing?

Boy—Yes.

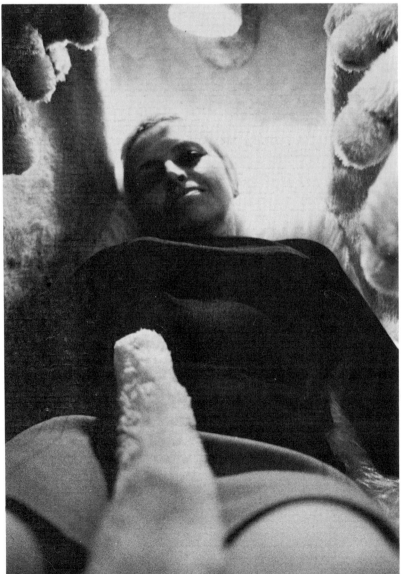

Ferdi in her "Womb Tomb."

E.K.—Did you learn anything at all from this picture?

Boy—Yes, it did teach me a little about the anatomical parts, and I think he [the artist] should stay more on teaching . . .

E.K.—Perhaps other boys don't know as much about these things as you do; do you think this kind of picture could be helpful to them?

Boy—Yes, this kind of picture, only more concentrated.

Boy *(in front of a Japanese "phallic contest" scroll, Fig. 332)*—I think I like this one, but I don't know . . . the positions are a little strange.

P.K.—Like gymnastics?

Boy—Yes.

E.K. *(pointing out the showcase with black and white woodblock prints by Moronobu, Figs. 365–68)*—Do you like these?

Boy—A little funny positions, but I like all the Japanese pictures . . . I like the poetry in them . . . but it's not too much poetry; it's with a balance.

E.K.—Did you know before you saw these pictures that people could make love in so many different ways?

Boy—Yes, I knew that.

E.K.—How did you know that; did you see pictures of people making love before?

Boy—Well, I read . . .

P.K.—You've read about it?

Boy—Yes.

P.K.—But you had never seen it before?

Boy—Well, I haven't seen so many positions.

P.K.—But you had seen some before . . . in photographs or magazines?

Boy—No, I've read about it. I've maybe seen some too, I don't know. But I knew about it.

P.K.—But mainly through reading and not through pictures?

Boy—Yes, I think so.

(Asked how he liked the Indian pictures, he said he liked them too, but not those that had little color, because he was very fond of color. Of the Indian wood panels, he liked best those that were least deteriorated, commenting that he did not like the ones that were "too old.")

P.K.—Have your parents been to the exhibition yet?

Boy—No, not yet.

E.K.—Do you think they will come?

Boy—Yes, I think so.

P.K.—What do you think about the rule we have here not to let children under fifteen in without some adult being along?

Boy—I don't think it's a good idea!

P.K.—You think that everybody should be able to come in, no matter what age?

Boy—If they want to, they should be allowed to see it.

P.K.—Do you have any brothers and sisters?

Boy—Two sisters, nine and four.

P.K.—Do you think that they will come to the exhibition too?

Boy—Yes, I think so.

P.K.—Do you do any art work yourself?

Boy—I draw and paint a little, but not well. I'm not good with my hands. I like to write . . .

P.K.—You could be a writer, you think?

Boy—Yes.

P.K.—What do you want to be when you grow up?

Boy—I will work on the world situation, but I don't know yet how. . . . And then I want to do a little what you do . . . work against people's conservative . . .

P.K.— . . . ideas?

Boy—I think so.

P.K.—You want to make them freer?

Boy—Yes, freer in every way; not only on the sex level.

Is it too much to hope that a boy like this should someday be an outstanding leader in his country? But whatever may become of him in later life, he certainly cheered us up and electrified us by his remarks—remarks that should provide food for thought to those who simply take it for granted that children are unprepared to assimilate erotic subject matter.

True, this boy was an exceptional case. But while less intelligent and less educated twelve-year-olds may not have come up with the same sort of—almost overly—adult comments, we think that most of those who came to the show did learn something from it.

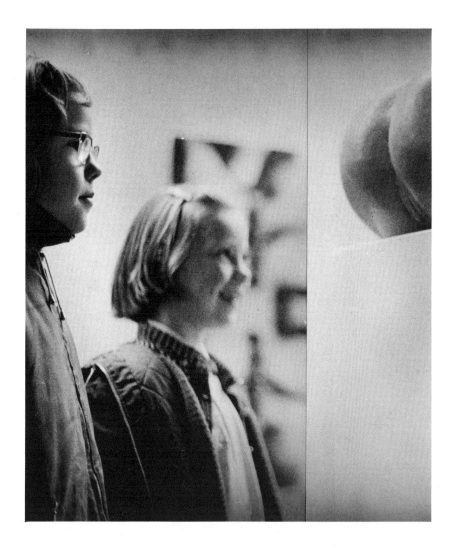

THE ARTISTS SPEAK

LARRY RIVERS

E.K.—What is your concept of erotic art?

RIVERS—There's an art you can show to the public and there is an art that is supposed to be something you don't show to the general public. So then that gets to have a name. But, as a matter of fact, every year now there are more erotic shows and you begin to wonder what the heck "erotic art" means. I think of it as a subject matter. Even though the word can be interpreted many ways. At the end of the show at Janis [Erotic Art '66, Sidney Janis Gallery, New York], somebody came over to me, much younger than I, and said to me, "That's a rather conventional interpretation of erotic you're presenting there, Rivers—you know, a piece of velvet can be erotic too." So we just had different ideas about what was conventional. Like it's not a very new idea that velvet can be erotic and perhaps screwing as an idea of eroticism has been around a little longer. I don't know, I think it probably was the same. But since I was asked to do something that would be in a show called Erotic Art, I thought I would take a very central issue and then I thought it would be funny to kind of display in the most ludicrous way the myth of the black male screwing the white girl, which is supposed to be such a fantastic thing . . . you know those black cats are supposed to be such terrific lays . . . and it turns out the more you read—black women having been interviewed more and white woman as well who have actually lived with black men—and it turns out that there have been a lot of sexual problems in these cases too . . . whatever "a lot of problems" means. I'm certain that one of the problems it includes is, "no hard-on." So I took that as the theme. It's very funny, because this man who was the male model or inspiration for this work is not even interested in women.

P.K.—Is he homosexual?

RIVERS—He's not queer, nor is he really anything else; I guess he's just not interested in sex. And he now is known as Lampman, because he's a real genius when it comes to anything electric.

E.K.—So this fellow who's in the construction you did for the Sidney Janis show [the original scale model of which appeared in the Lund exhibition, Fig. 141] is a real person?

RIVERS—A real person who's dreaming of going on TV.

P.K.—What's he going to do on TV?

RIVERS—Hm . . . let me see . . . what's Lampman going to do on TV? I suppose he's going to pray for everybody . . . I don't know. He's getting so far out . . . when he was with me, I had to sort of keep most of these fantasies of his in check, but now there's no hope. He walks around with a tape cross on his forehead.

E.K.—Oh, I think we actually met Lampman at a reception of Salvador Dali's at the St. Regis the other day.

P.K.—How did you come to think of using him for an erotic object?

RIVERS—Well, that's a bit complicated. As I said, the idea of using this guy who's so asexual as the symbol of the black super-male appealed to me, because it concretizes the silliness of this whole concept or myth that people insist on perpetuating. Besides, it had perhaps more to do with the idea of lamps and electricity than with sex, since, as you know, this particular object was to be some sort of a lamp.

E.K.—Isn't the other . . . the female figure in this object the same you did for *Playboy* magazine?

RIVERS—Sure, I'd done this Playmate for the magazine, so when Janis asked me to do something for the erotic art show, I thought, perfect—I'll put Lampman and the Playmate together.

P.K.—I understand that some people objected at first to your object when it was exhibited.

RIVERS—Well, the objections really came before the show, because some people thought the show would be closed, because this black male lamp had something which at one point went out into a pink female plexiglass shape. Besides, my lawyer said I couldn't use the original girl's face, because she really existed and the photograph of her is only with her bare ass sticking out. So, if I put anything up her in this new picture or object, I'd be in trouble. That's why I changed the thing around, so it could be any kind of white girl and not anyone in particular.

E.K.—Was there any trouble with your piece during the exhibition in New York?

RIVERS—Of course not. But that was perhaps because they kept the blinking light off that's supposed to go on and off in Lampman's head and where the two connect below.

P.K.—You mean to say, your Lampman was shown all the time with the lights off?

RIVERS—Well, they kept turning it off, so friends of mine would call me up and say, "Whatsa matter with your lamp, Rivers, like it died." I finally gave up. I once withdrew the thing and they called me up and I said, "Look, I don't want to be tough, but what the hell are you guys doing?"

P.K.—How long was the show on there?

RIVERS—I don't know. A month or so.

E.K.—To come back to your idea of the erotic in art; would you care to say something more about that?

RIVERS—Well, we use the word "erotic" in the sense of something that will get some sex response or in the sense that the subject matter is sexy. Now, perhaps a guy could find a dozen eggs sexy. . . . I think that one can make a case of the fact that if the individual is aroused by something, it's erotic. Or, let's say, some guy in an erotic show presents a tin can or some sliced peaches. Now, there could be something there that he wants you to think about. I mean, it may be another way of approaching the subject . . . just as it could be a convenient sort of cop-out.

P.K.—Do you feel that the subject matter of sex in art is of concern?

RIVERS—Sure . . . it could be. Why not? As far as my own work is concerned, I find that from time to time it's more or less an accident. I'd say it isn't terribly important to me personally. I think the subject in a sense is related to the material and some nutty way I seem to want to put it together. When you really look at Lampman, I mean there's a certain physical idea of construction, but I always move in relation to some sort of idea that I've given myself that precedes the material.

E.K.—You wouldn't mind if someone got a sexual charge from that Lampman object?

RIVERS—Not at all. I'd love it.

E.K.—Why do you say that?

RIVERS—Because I'd be giving someone pleasure, I guess, and I'd be happy that I'm responsible for it.

P.K.—Let me ask you a rather personal question. Have you ever felt that sex was at the expense of your creative work?

RIVERS—No, not at all.

P.K.—Do you think it helps your creative work?

RIVERS—I don't know. If I'm happy, I suppose I do more . . . I really don't know. I do things all the time anyway. . . .

E.K.—But you've never noticed that when you're sexually more active than other times your creativity goes down?

RIVERS—Oh, sex is quite a strong activity, I mean, if you get interested in it. I seem to have made some sort of choice somewhere along the line. I decided like, well, I wouldn't hunt around until I had accomplished something. I don't know . . . I remember when I was younger and it was a fantastic day, I'd look down and see boys and girls together, but I'd stay in and work. So, maybe the way I operate is I build up my energy by feeling sorry for myself . . .

P.K.—So, it's a sort of voluntary self-deprivation you've imposed on yourself?

RIVERS—I don't think of it that way, because then that sounds like you're giving yourself a martyr's role. I'd prefer to simply think that it was more important for me to have a certain image of myself, I suppose, than to actually enjoy myself.

E.K.—What do you think about homosexuality?

RIVERS—In what sense?

E.K.—I mean, do you think that homosexuals are more neurotic than heterosexuals or that it is an anti-social kind of sexuality?

RIVERS—No, as a matter of fact, it strikes me that the world is going that way. The whole thing of monogamous relations and the notion of being consistent in your lovemaking and things like that is becoming something of the past. I don't think that people consider homosexuality as being abnormal or anti-social anymore.

ANDRE MASSON

E.K.—What has been your experience as an artist with regard to censorship?

MASSON—Well, I am no longer so young, and during my lifetime I have seen a constant back and forth in that respect: at one period there is less censorship and then, all of a sudden, the state clamps down again and one has to be very careful.

As you know, I am or have been primarily a surrealist painter. Now, the surrealists have always been very interested in eroticism. Consequently, their big problem has always been that of censorship. To get around this, we have devised different systems of expressing this erotic interest by indirect means. Still, my art dealer has had a number of my paintings returned by clients who had bought them without realizing that they were at all erotic. For instance, there was the case of a painting by me which all the critics were highly enthusiastic about and which they described as an abstraction of a flower still life. It had a sort of neutral title which could have meant anything. To make a long story short, a collector bought it, but brought it back a short time later, saying he had not realized its true nature—which happened to be a representation of the female sex.

You see here (*points to a beautiful watercolor of a couple making love, apparently under water and surrounded by fish*) . . . it's another example of what I am talking about. Obviously, this is a couple in the sexual act. But I had to make it an underwater scene, put fishes all around them, and call it "Encounter in a Fish Store," to be able to exhibit it. So you see, censorship enforces a sort of involuntary hypocrisy on the artist.

I have suffered all my life as an artist from this sort of insidious self-censorship. As you know, I have done a great many erotic drawings and paintings, but most of them have remained in my own possession because they couldn't be shown in the gallery. I would have liked to do much more in that genre, but I do catch myself saying: What's the use doing this, if you can't exhibit the painting anyway? So, I would say it has crippled my own creativity a lot, even though I have done perhaps more erotic pictures than many other painters.

E.K.—What do you think about the effect and significance of an erotic art show like the one we are planning for Sweden this year?

MASSON—I think an exhibition like this is of the utmost importance. The whole world is looking to Scandinavia as the pace-setter in these respects. To my knowledge, this is the first time a public museum and not just a private gallery has put on an exhibition of erotic art. Hopefully, other museums in other countries will take courage from the example and say: If they can do it in Sweden, why can't we?

BORIS VANSIER

E.K.—What do you think the effect on the public will be from this exhibition of erotic art?

VANSIER—I think it will have an extremely healthy effect. First the public will have the unavoidable and very necessary shock you always get when confronted with something completely new and unexpected. The public will find out that throughout the ages there has been a constant, though officially suppressed, interest in erotic subject matter on the part of the artists. I am not saying that eroticism is the *only* subject and object of art, but it is an important one which should not be left out. I think you and the museum are very courageous to call the exhibition an exhibi-

tion of erotic art. It would have been easier, no doubt, to make an exhibition, like it has often been done before, which includes, among other things, erotic art. But it would have been dishonest. I think it is time that the public face the fact that erotic art has always existed—you can go back to the Greeks and the Egyptians, you don't have to stop at the seventeenth century; erotic art started since man expressed himself in art.

E.K.—One more thing. We've called it an exhibition of erotic art, but some journalists have been calling it a pornographic exhibition. Would you care to state what you feel is the main difference between an erotic picture and a pornographic picture, if any?

VANSIER—The only difference is in the mind of the people. It's what *they* make it to be, depending on their own background. It's not one thing or another in itself. So, I would say there is no specific difference between pornography and erotic art because you can call anything pornographic, if you like.

FREDERIC PARDO

It was Jean Jacques Lebel who first introduced us to the work of this talented young French artist. If he has been relatively unknown until now, this is largely due to the fact that Pardo refuses to be exploited by the commercial art circuits and is content to work for his own satisfaction and the small group of devoted friends and collectors who immediately absorb whatever portion of his small output is for sale.

In the following interview, Frédéric Pardo explains his concept of eroticism in art.

E.K.—What would you say about the erotic element in your work?

PARDO—Everything I do in art has certain erotic tendencies.

E.K.—You mean that there is an erotic element in every picture you paint?

PARDO—Yes, absolutely. In some of my pictures the erotic element is more predominant than in others, but it's always there . . .

E.K.—Is this something conscious, deliberate on your part?

PARDO—If you mean whether I paint with a definite, conscious goal in mind, no. My work is always a little dream-like; it doesn't concern concrete ideas or things like that.

E.K.—Has this always been the case with your work?

PARDO—Yes, always. . . . The first picture I ever painted was a landscape with a large phallus . . .

E.K.—Could we see it?

PARDO—Unfortunately not, it was sold . . .

E.K.—Could one say that your work is surrealistic in character?

PARDO—That is what some critics have been saying . . . though I don't think in those terms.

E.K.—In the picture [Fig. 73], there is a strange detail, showing a woman with a little boy riding on her thigh.

PARDO—Yes, it could be a mother and her child . . .

E.K.—It seems the little boy is having an ejaculation . . .

PARDO—That is correct.

E.K.—And the lady or mother is sticking her tongue out, as if she also were under the influence of strong erotic excitement . . .

PARDO—Yes, it definitely seems to be an incestuous scene, though, again, it just happened like that, without my thinking of anything in particular.

E.K.—Do you think that it represents a childhood memory, perhaps an unconscious memory on your part?

PARDO—I don't have any such recollection, but I wouldn't rule it out, because I remember that I experienced considerable erotic excitement during the painting of that picture.

E.K.—What about the frogs in that picture?

PARDO—The frogs, that's another problem . . . I've frequently drawn frogs, but I couldn't tell you what it means. In this picture, they could be a fantasy of the woman [the frogs have human-like erections], or they could be real frogs . . .

E.K.—In the other picture, there is a woman, seen from the back, and near her a pill or capsule floating in space. Can you tell us anything about that?

PARDO—Well, it could be that the woman is producing some kind of drug with her own body. I remember getting the idea for her from a magazine called *Paris-Hollywood,* a magazine that specializes in a sort of erotic pop-art and which has frequently inspired me in my work.

E.K.—Since your work is so highly personal and since you have been avoiding the commercialization of your work, how do you feel about your paintings going to be shown at the exhibition in Lund?

PARDO—I am very happy to know that people should see these paintings because, after all, that's why I have been doing them.

JEAN JACQUES LEBEL

Noted for having organized some of the most exciting "happenings" in France, Jean Jacques Lebel is an important painter and writer of the young Paris avant-garde. During the popular revolt in the spring of 1968 which shook France out of ten years of cultural lethargy, it was he who was largely responsible for the student occupation of the Théâtre de France (Place de l'Odéon, Paris) and who led many of the spirited debates on the cultural revolution in the arts.

We decided to exhibit a series of cartoons by Lebel (Figs. 147–48) which concern human communication via sexual symbols in a technological society such as ours and the interrelation of eroticism with political, economic, and philosophical ideas.

Following is an interview we conducted with Lebel in which he expresses more fully his point of view on the role of erotic art and the artist in modern society.

E.K.—Jean Jacques, what do you feel is the significance of the erotic element in art?

LEBEL—I think it's the central problem of not only art, but culture in general. I think that all cultures in highly developed civilizations, such as ours, are simply the codifications of prohibitions—moral, political, sexual, social, etc. And what interests me as an artist is not only culture, but even more so what's behind culture, what is suppressed by culture—I think that behind all sculpture, all painting, all drawing, all poetry, all movies, lies a basic sexual language. And especially behind "happenings," which are, as you know, a form of art that has sprung out from action painting and has gotten into a thing they call "games of art," where collective participation is very important, just like in an orgy. I think that art should express much more of that than it actually does. I think that the trouble with art and the culture-industry—because it *has* become an industry—is that it has desexualized art completely. The job of the artist, I mean, the function of the artist, if he is going to be at all lucid about his work, is to express the unexpressible and bring out the things that culture is trying to hide, in other words, the instincts of the human being, and the instincts are basically sexual, of course. It's as simple as that. Any artist who's going to be honest about it understands that that's a central part not only of his life but of his work.

E.K.—What do you think about an exhibition of erotic art like the one we are planning?

LEBEL—Since I think that all art is more or less covertly or overtly erotic, all art exhibitions are more or less erotic to me. But when an exhibition is overtly and honestly erotic, that is of historical importance. And I think you are doing a very important job. I think you're breaking through in an area.

E.K.—Do you think that erotic art will become, at one point or another, recognized, respectable, acknowledged . . . by the public?

LEBEL—Art cannot escape the contradictions and alienations of the society which produces it, and ours is a very alienated and conflicted sort of society. The only possibility therefore for erotic art to become fully accepted and integrated into public life would be a tremendous revolution in social structure toward a much more liberal, democratic, non-authoritarian kind of society.

E.K.—How far along do you think we are toward this sort of radical change in the social structure of our society?

LEBEL—It is certainly coming, but slowly because of people's fear of their instincts, especially their sexual instincts. And, as you know, human beings tend to resist change. They defend themselves against all political, sexual, intellectual, or artistic forces that try and change them. A sexual revolution would be something that would change the authoritarian type of repressive society that

we have, be it in America or here in Europe, it's the same idea, really—just local changes. It would transform these structures into a so-called "open" revolution of the total human being, in which people could find a much greater fulfillment of all their instincts. And they would not go into aggressive, destructive mass murder things like they're doing today . . . the way people release their instincts by fighting and killing one another. . . .

E.K.—In other words, the *real* reason for the suppression of eroticism in life, in art and in literature is to maintain a certain social status quo . . .

Lebel— . . . and to keep people in a kind of slavery. They're told: You may go to the movies once a week or go to an exhibition once in a while, but don't *practice* what you see there. You can *see* it on the wall if they let you see it at all!—but if you try and *do* it—No! They—and by "they" I mean the Establishment—if they can't any longer prevent you from reading or seeing things like erotic literature or art, mean to keep you at least a passive spectator, like in the theater. They don't want you to participate in your own life.

E.K.—What you are saying is that there are two stages of censorship: the first is trying to suppress even the production of erotic art and literature . . .

Lebel—Yes, definitely. Any artist who does erotic art could cite many examples of that. But worse than that is the kind of self-censorship that society is forcing upon everyone. I mean, in order to survive socially, you hold things back. And you hold them back and hold them back and hold them back till finally you get to a point where you're holding so many things back that you're not yourself anymore. Talk about "depersonalization"—that's how it happens. So, I think the job of the artist is to counteract all that depersonalization and re-personalize and re-sexualize the individual.

E.K.—And yet you seem to feel that people having greater sexual freedom would result in some sort of larger social change . . .

Lebel—Definitely. That's what we're trying to do with our happenings. It would make people understand that the robot lives they live every day really amount to a kind of slavery.

E.K.—But you don't mean to say, if we understand you correctly, that people would just want to make love or smoke pot all day long, if there was more freedom?

Lebel—Of course not! They would like to understand a little bit more about themselves, they would like to have deeper and more meaningful contact with other human beings—that's what sex is all about, isn't it? It's communication. And the more people communicate, the more they want to change their environment.

E.K.—But, as an artist, how do you feel about the fact that some of your colleagues, past and present, have felt that more direct sexual expression had led to decreased creativity in their own lives?

Lebel—Well, I know, Mondrian, for instance, used to say that every time he had an orgasm, that meant one painting less than he would have done. Balzac said the same thing about writing. But I think that's again a little too simple-minded. Because if you've got a groovy sex thing going— some people have a sex thing going with one person, and some have it with several persons—but whatever the particular thing is, I think that, on the contrary, it brings out a level of cosmic awareness that helps your work.

ANDY WARHOL

Our interview with Andy Warhol might best be described as a group effort. Present during the taping were Andy, his associate Billy Name, our editor Arnold Leo, and ourselves. It should be noted that for some time now Andy has worked exclusively in films. His most recent silk screen (Fig. 176) is reproduced in this book by photographic means, because no prints have ever been pulled from the screen. *Fuck,* the film discussed below, was his first project after recovering from the near fatal gun wounds he received in June, 1968.

E.K.—Andy, do you consider your work erotic?

Andy Warhol—No, I don't think it's erotic because we show everything and the way we show it, it doesn't look really that sexy.

BILLY NAME—Yeah, to us it may be not so erotic, but I think to most people it is.

A.W.—What, really?

E.K.—I think that in a sense anything unknown is exciting . . .

B.N.—It's definitely experiencing a situation which people don't commonly experience.

A.W.—It's so funny, somebody came up and said they saw *The Loves of Ondine* and I said well was it a good movie, and he said ah it doesn't matter, he'd never seen people like that before.

P.K.—Do you feel that if more were shown both in the art work and the films that it would be more erotic, is that what you were saying?

A.W.—No, we show so much of it in the movies that I always thought it wasn't that dirty; others lead you up to it and it really seems dirty somehow.

ARNOLD LEO—Andy, if the unknown is titillating just because it's unfamiliar, do you think that in some sense in your art and films what appeals erotically to people is the fantasy that may be revealed to them by looking at things they weren't aware of before?

B.N.—Whether suggestion *towards* an erotic experience is actually eroticism, I don't think it is. I think that what they get out of your films *is* the erotic experience rather than a leading up to it or a suggestion of it. It happens to people sometimes from other towns when they come to New York and pick someone up and they just behave as indulgently as they really want to—they have an erotic experience which most people just don't have usually, and it's the actual erotic experience which they find in the film.

A.W.—It's very funny because the people who used to do girlie movies copy our movies now and they're really good, they're so good you really just can't believe it—they go all the way, with good sound and lighting, but they're so dirty, there's one we saw—it was the Art of Teaching Love— there's these three girls and one says drop your clothes and then the girl says put your hand on the right tit of the other girl and your left hand underneath it and it's so terrific. And then all of a sudden there're scenes with the guys really completely naked and she's going down on him but you don't see the cocks so I guess it's not dirty. Her whole head is in the leg, or the other way around, the guy's head is down there. Oh, it's real dirty, I mean I've never seen anything so dirty. They copy our technique, they do four reels . . . they do them simply and just cut the four reels up.

E.K.—Have you done fully explicit sexual scenes?

A.W.—We just finished our *Fuck* movie with Viva. It's a two-hour movie.

A.L.—Does *Fuck* have explicit fucking scenes in it?

A.W.—Yes, one whole thirty-five minutes.

A.L.—A thirty-five-minute fuck? Is it shot in such a way that you see the genitals?

A.W.—Oh, yeah . . . I used outdoor film for indoors—it's really pretty, it makes it like arty, so it could be an art movie—it really is so beautiful. There's only one time Lou really opens his legs up so you see his cock so many times, but then Viva gets on top of him—the only comedy in it— she takes the cock and she sits on it—it's really comedy, it's really funny. But that's a dirty part. What I want to do is, if they [the distributors] don't want to show it, maybe we could make it blue over those spots, you know, just really dark blue. It's really so pretty.

P.K.—In the explicit sex act do you find something artistic?

A.W.—Well, we used the wrong outdoor film, so it looks really beautiful.

P.K.—But I mean, it wasn't the act, or was it? Was it the act itself or the way you were conceiving it with the outdoor film?

A.W.—Well, no, it just worked all right, it started like . . . then they made a cross because they were lying right to the camera and then they turned and made a cross, I don't know what happened but it just seemed to work all right. It worked out just perfect, I don't know why . . .

A.L.—Andy, then you do see the erotic as an element in your work?

A.W.—No.

A.L.—Even when it's like the *Fuck* scene?

A.W.—No.

A.L.—Either it works or it doesn't work and the sexual part of the film simply comes about through circumstance?

B.N. (*to Andy*)—Are you attempting to glorify erotica, or are you just using erotica as the

means of presentation? Because I know most underground artists are sincere in their philosophic stance. [They use] eroticism for the point of glorifying it as beautiful, as a thing that human beings do that's beautiful and they present it because they think it's the most beautiful thing to present.

A.W.—No, we don't do that.

A.L.—People find your work erotic, titillating.

B.N.—It's not pretentious. It's not an attempt to glorify anything, it's not pretentious, which is what really gets people and which is why it's really erotic. I think that it should be noted that in Andy's case, you might say, Andy's sort of beyond sophistication.

P.K.—That people do find your work erotic, does that mean anything to you?

A.W.—No.

P.K.—But if people get erotic pleasure from it . . .

B.N.—That's incidental.

A.W.—Well, I don't find it erotic.

B.N.—And particularly knowing the people that are in the films . . .

A.W.—But I do find those 42nd Street ones have gone really far, they're really kind of dirty.

E.K.—Have you had censorship problems?

B.N.—People take strong stances in regard to Andy sometimes. Like the *Daily News* refused to allow the word *"nude"* in our ad for *The Nude Restaurant,* so it appeared as *The Restaurant,* with a blank space. And once we wanted to call a film *Super Stud* but had to change it to *Bike Boy* because *Cue* magazine wouldn't carry a blurb about a super stud. We shouldn't have made that change—it wasn't necessary. But individual people here and there get very upset by Andy's work.

A.W.—Oh, but you know the FBI is still calling us about . . . they think Viva was really raped in the cowboy movie.

B.N.—That FBI man said, you know, you know what it was, he told me that someone had complained that guys were going down on her and she was going down on the guys. That's the thing that upset . . . that got some people to get the FBI on us. It's not the rape thing, it's that supposedly people saw her going down on the guys.

A.W.—We don't have that in the movie, do we?

B.N.—No, she didn't do it.

A.W.—Oh . . .

B.N.—But the FBI wants to see the, uh . . .

A.W.—They just called again. He came here but he said he doesn't care . . . but people just keep complaining.

B.N.—He's a perfect FBI man, you know. He is *so* agreeable.

A.W.—Oh I know he's very nice to Paul.

B.N.—I've never known a nicer person in the world . . .

A.W.—but . . . he got mad at George when he was here because he got . . .

B.N.—Sure, because George is a little fairy and all the FBI men are closet queens.

A.W.—Oh . . .

B.N.—But he's really a good guy.

A.W.—Yes, I know he was really nice to Paul.

B.N.—I can talk to him for a half-hour.

A.W.—Oh yeah, he talked to Paul for a half an hour too, he asked about how he was feeling . . .

B.N.—He really knows how to get you on the perfect train of thought.

A.W.—He said, there's no rush, or anything, he really was so nice.

A.L.—He should do this interview.

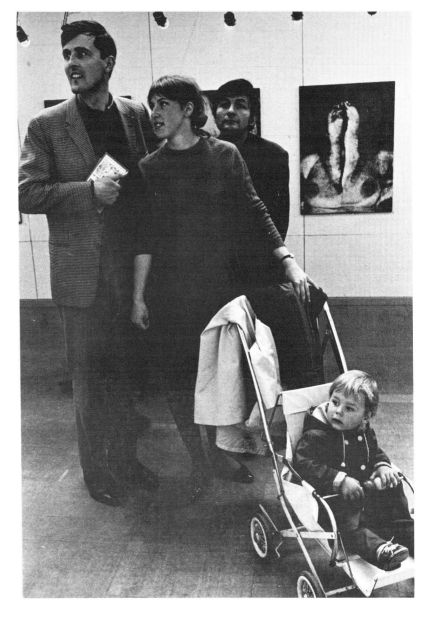

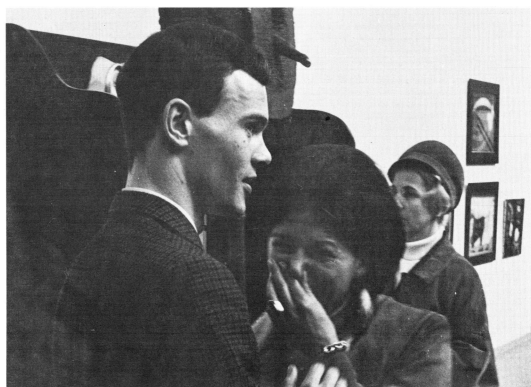

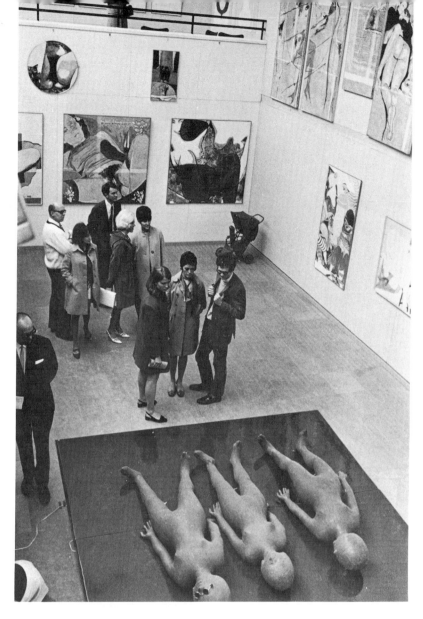

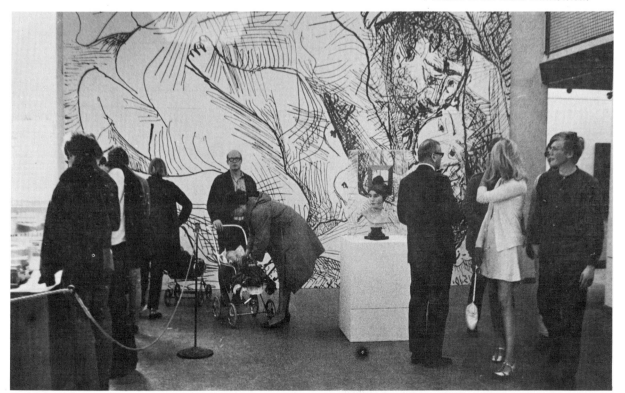

Visitors to the Lund Exhibition.

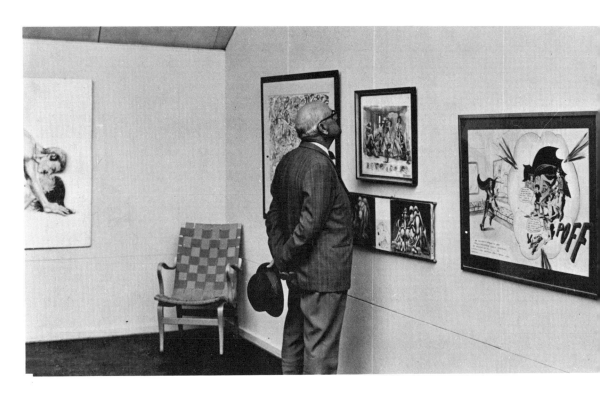

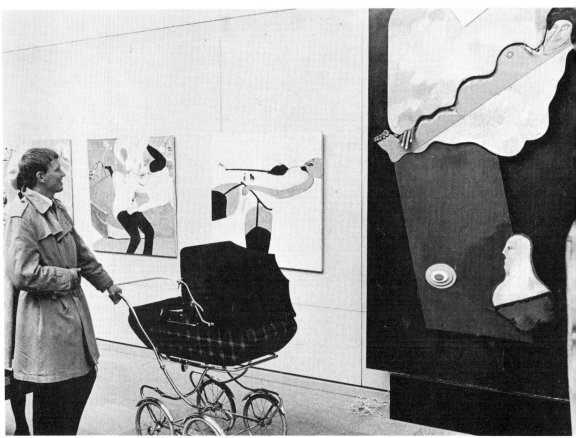

Visitors to the Lund Exhibition.

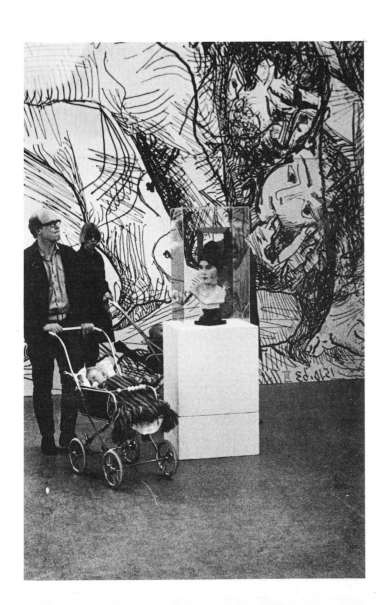

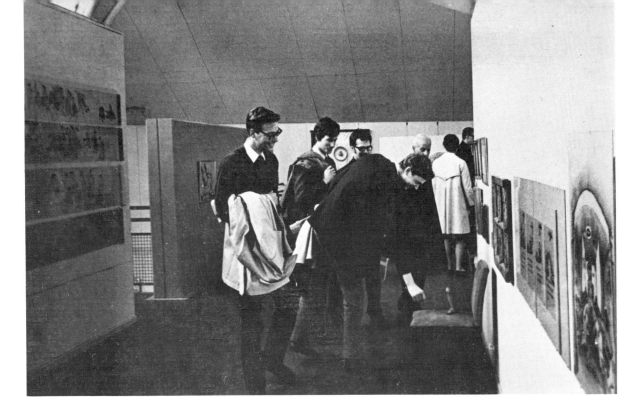

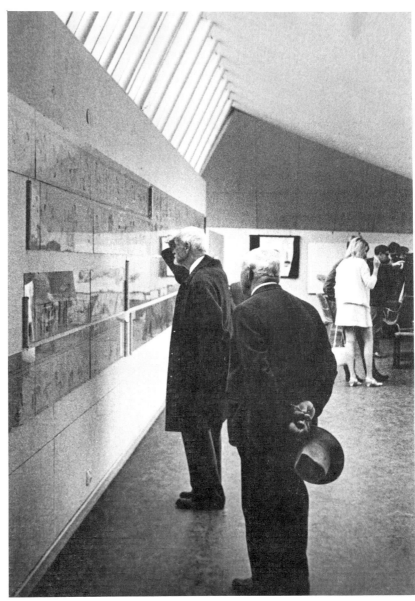

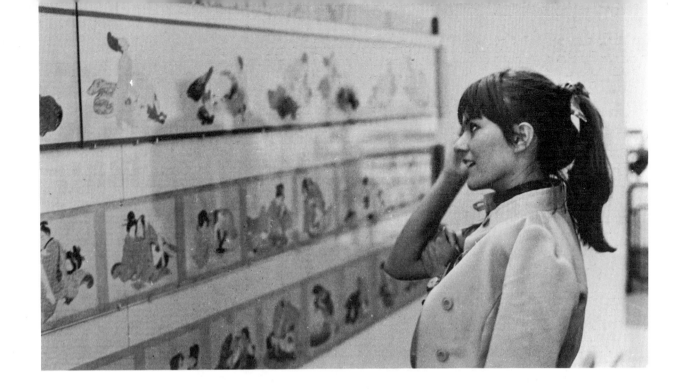

Visitors to the Lund Exhibition.

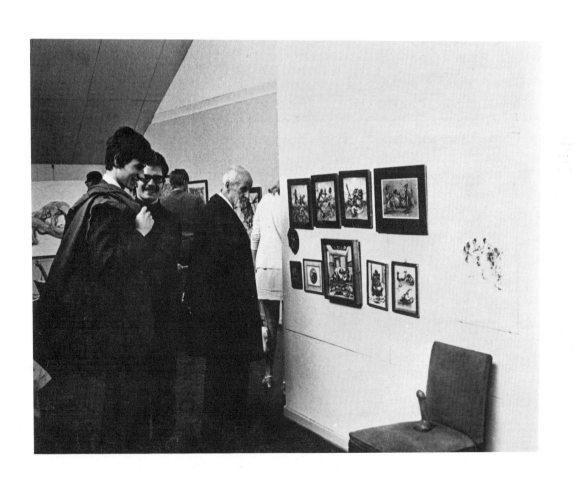

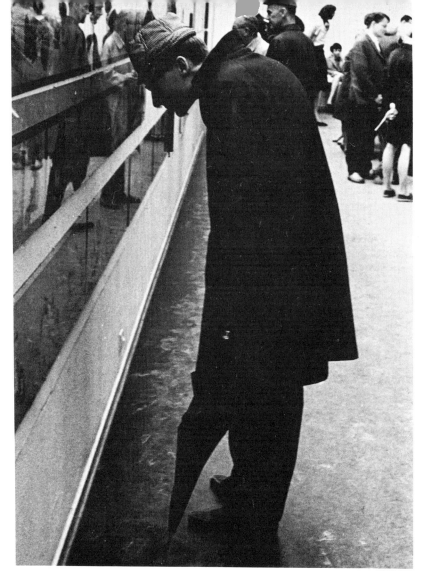

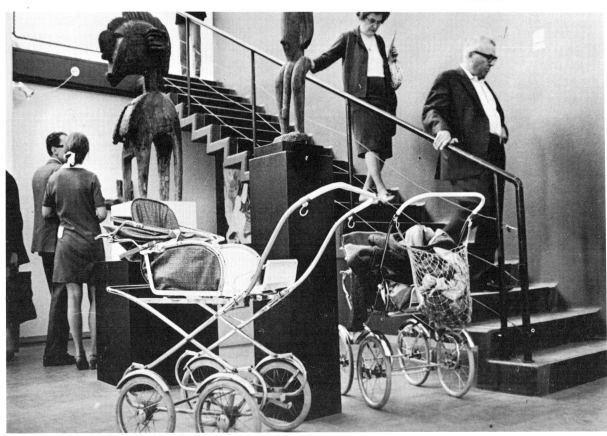

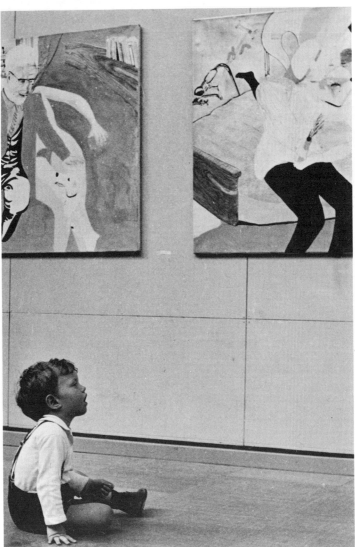

Visitors to the Lund Exhibition.

The primitive, almost animalistic couple by Karel Appel (above) contrasts sharply with the sophistication and refinement of even the early Japanese ukiyo-e ("floating world") pictures, such as the scene from a painted scroll by the 17th-century master Sugimura Jihei (below).

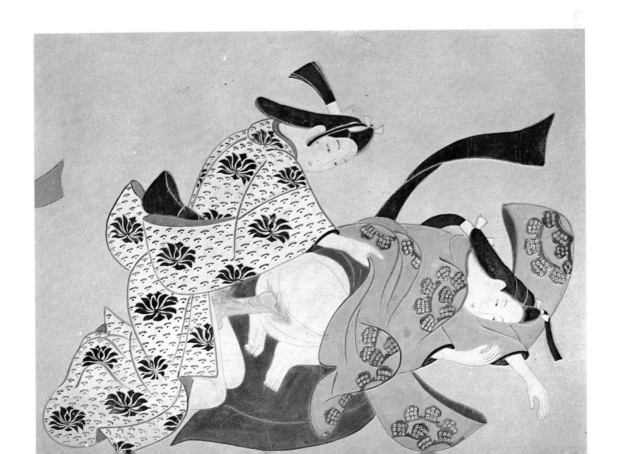

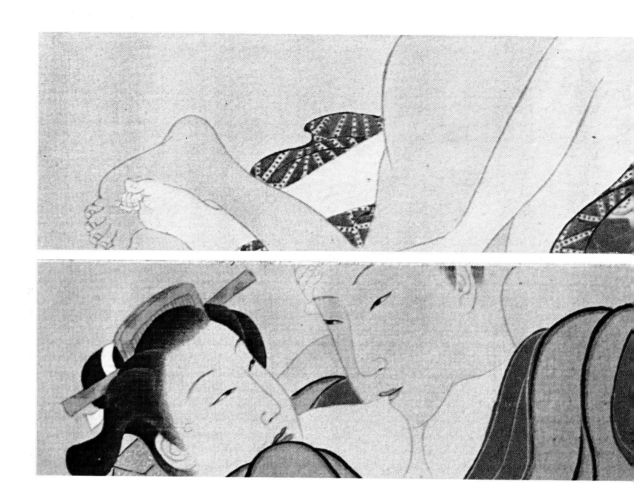

Invitation to voyeurism: The two narrow painted scrolls (above), by Okyo, the 18th-century master of Kyoto Naturalism, are making us look in on the amorous couples as through the slots of a bamboo screen.

By contrast, Sukenobu affords us an unimpeded view of two lovers by the light of a paper lantern (lower right). In this early 18th-century scroll, the bodies are shown almost totally nude, though the patterns and colors of the garments strewn on the floor are skillfully used in the over-all design, giving the illusion that the figures were clothed. Later shunga pictures usually depict the subjects draped in rich garments, even if the lively action would seem to call for nudity.

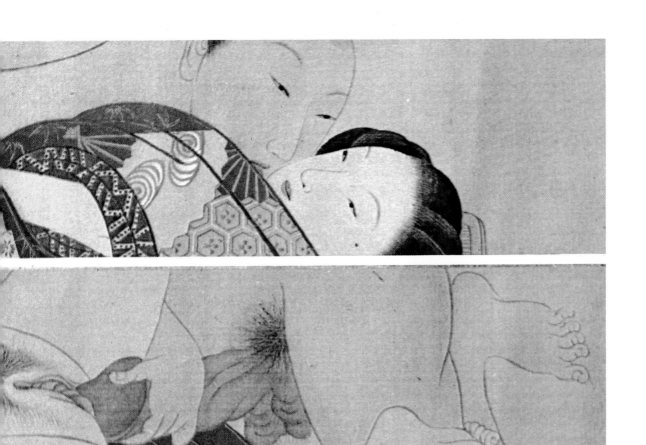

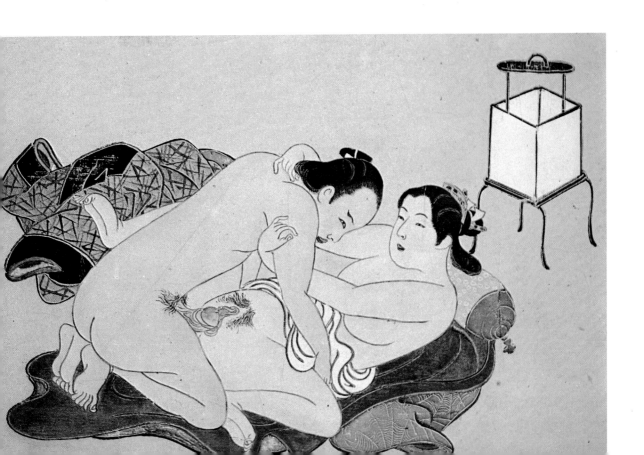

شکل بیست و چهارم مرد زن را بر مان خود نشانده مجامعت کند

در آن وقت شیرفای نمودار شد از تیر و کمان شکار شیر کند

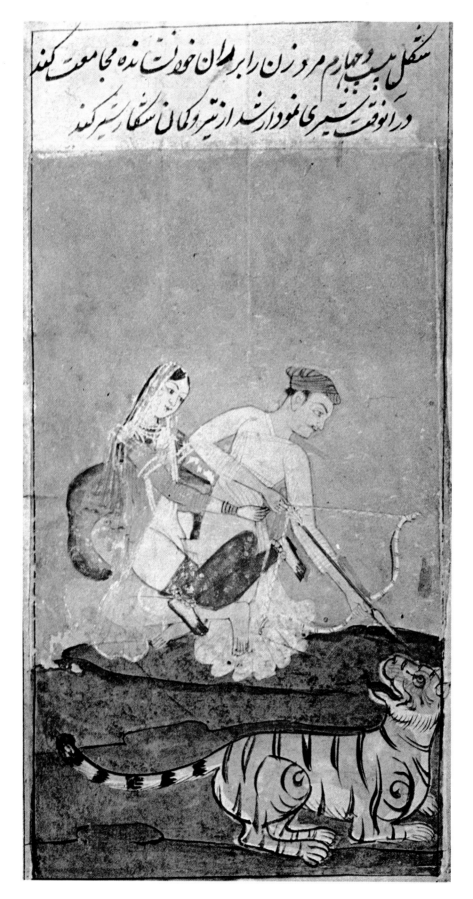

60

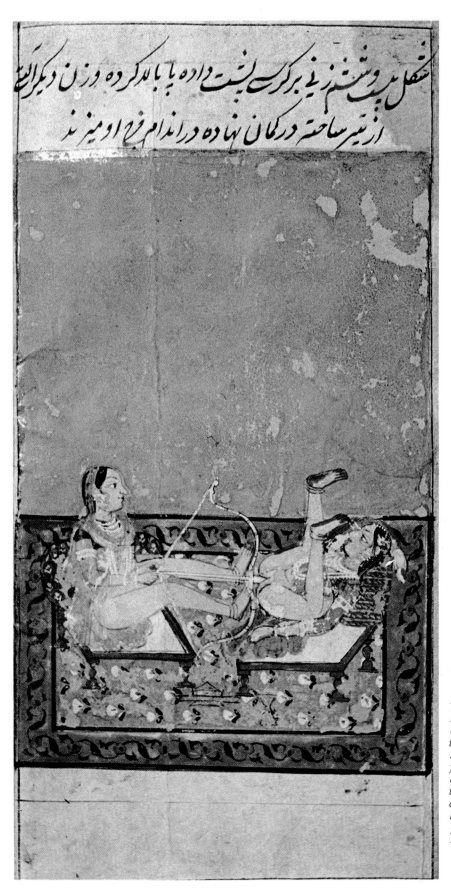

نشغل ميدوشتم زني بركرس يشت داده بابالدكرده وزن ديكرآثيّه

ازتير ساخته دركمان نهاده دراندام فرح اوميزنند

Two 17th-century Rajput miniatures. (Left) The erotic tension of the love scene derives mainly from the added danger and excitement of the tiger hunt. (Right) Not a sadistic treatment of a lesbian theme, but a playful use of sexual symbolism.

شکل پنجم و دوم زن را سر بالین نهاده دراز کون خفته و آهو ار پس
آمده مجامعت کند

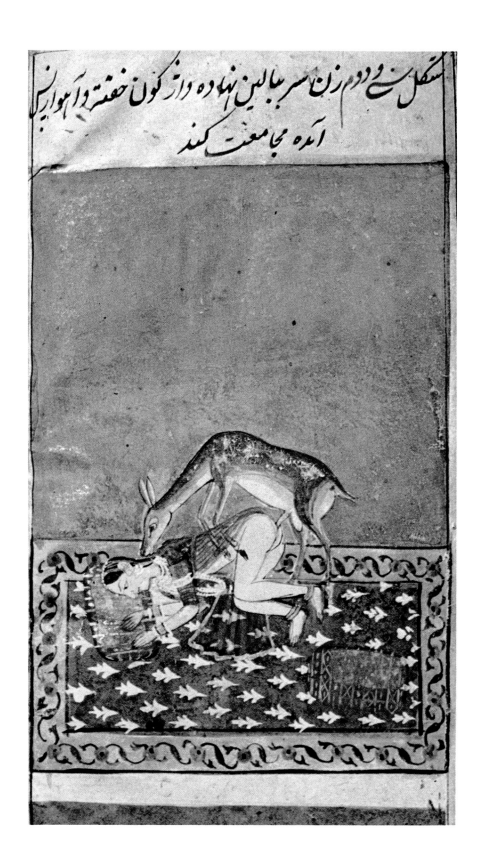

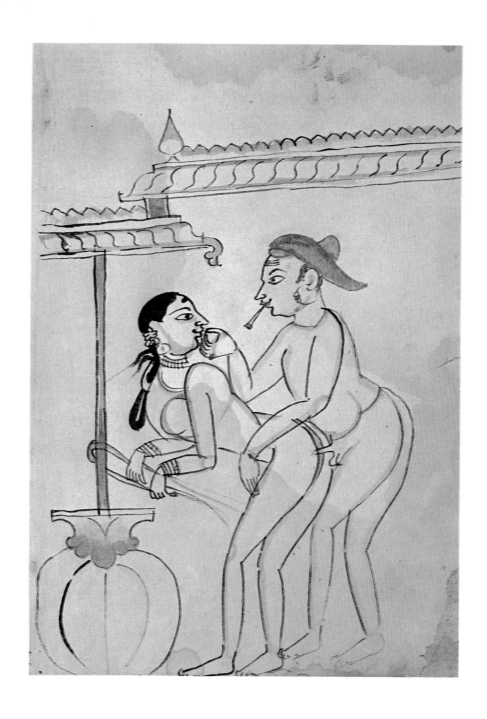

(Left) A fanciful notion rendered not only inoffensive but almost plausible by the delicate treatment of the 17th-century Indian miniaturist.

(Above) Airy water colors in this 18th-century Bengal-style picture help give the impression that sex is a joyful part of the uncomplicated life.

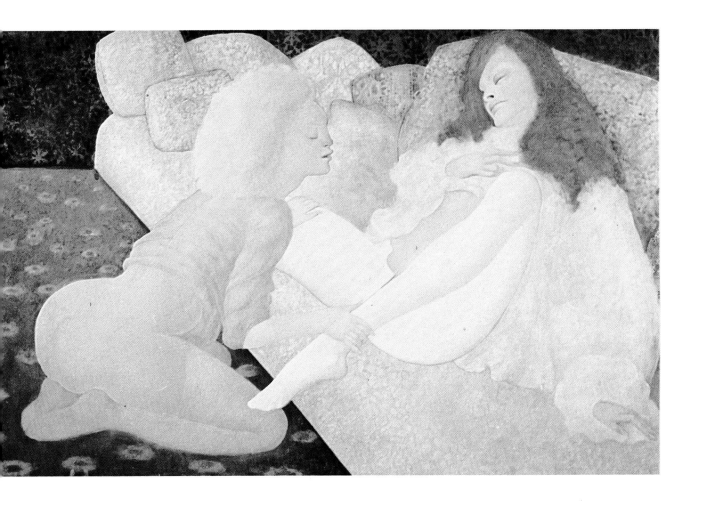

(Above) Leonor Fini uses suggestion and elegance of décor to create an atmosphere of sensuality and expectation. (Right) André Masson's dancing girl reflects abandon and joie de vivre.

(Above) A sail flutters unperturbed in the breeze as the supposedly unexposable is exposed. Oil by Boris Vansier from his "Offrandes" series. (Right) Lithograph by the Norwegian Edvard Munch, with a border of floating spermatozoa.

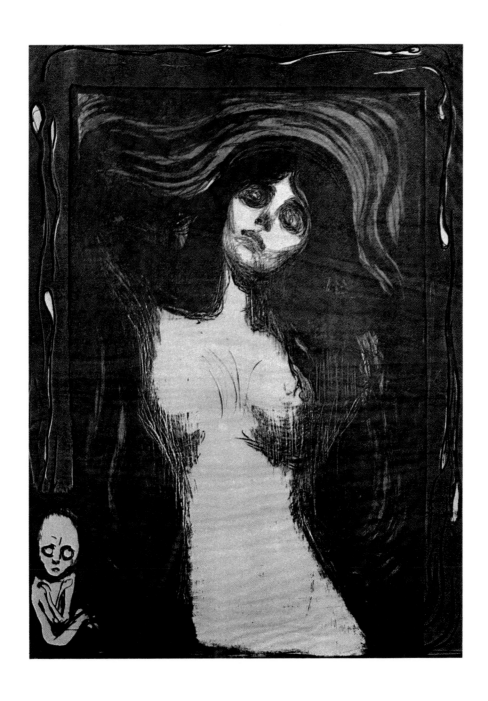

(*Above right*) *The "Brushwood-Fence Scroll" (Koshibagaki-Zoshi), earliest truly erotic scroll known in Japan, tells the story of a princess's seduction and progressive introduction to the variety of sexual pleasure. (The 12th-century original is lost, but this is an excellent copy of the year 1800.)*

(*Below and below right*) *Painted scroll; ca. 1640's. Two scenes from one of the few complete shunga scrolls known to exist from this period.*

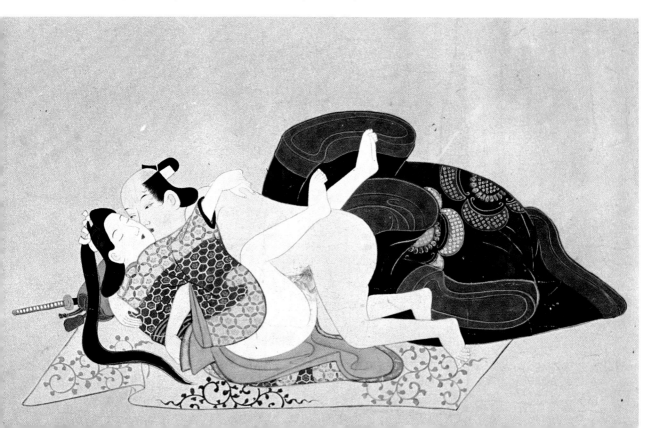

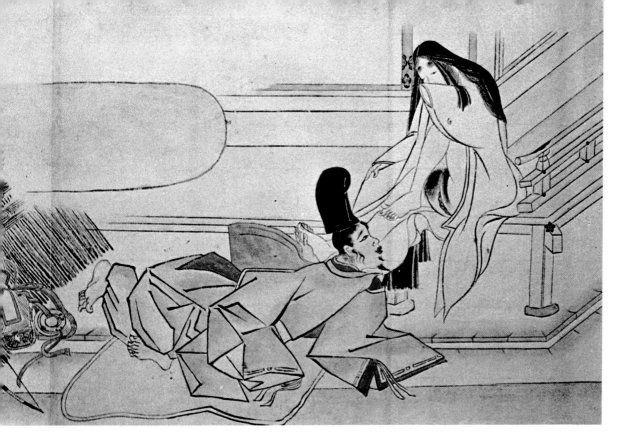

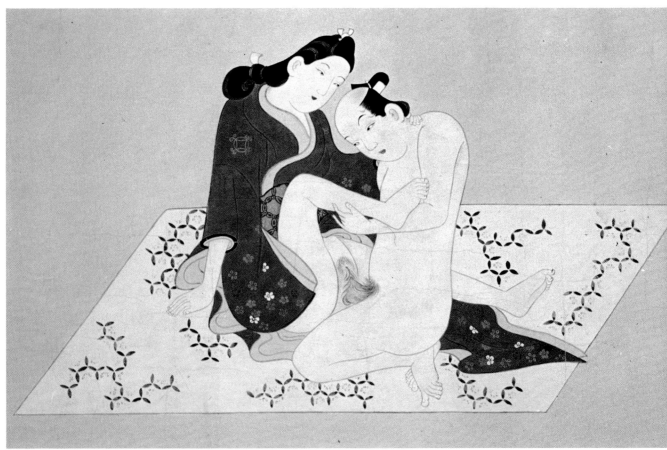

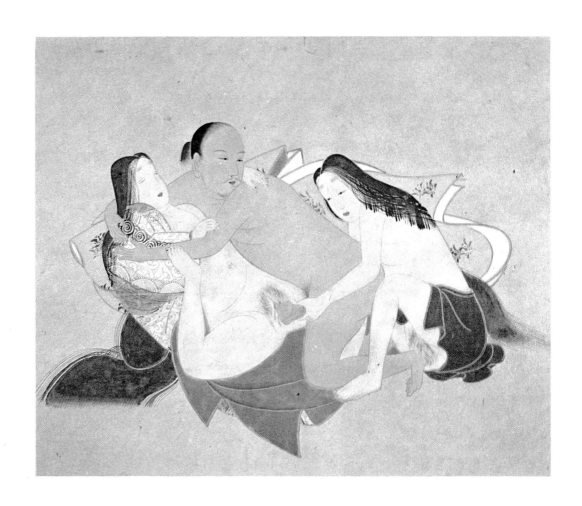

(Above) Jealousy has no place in this group scene from a 17th-century Japanese scroll. It depicts a courtesan and her lover, assisted by the former's helper-in-training, as used to be the custom.

(Above right) The gigantic, corseted ladies in Corbusier's bordello scene strike one as more grotesque than erotic. (Bottom right) Kyosai deliberately uses the bizarre in the service of erotic humor in this detail from his "phallic-contest" scroll.

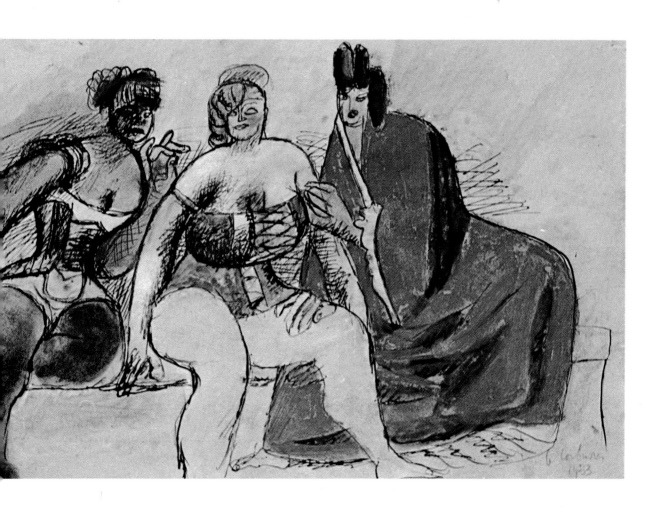

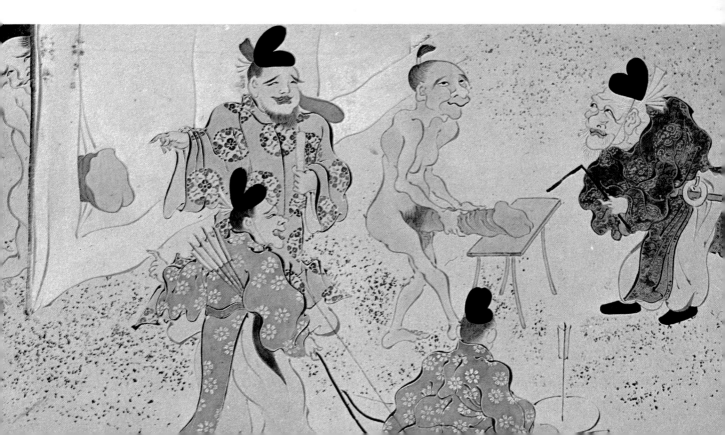

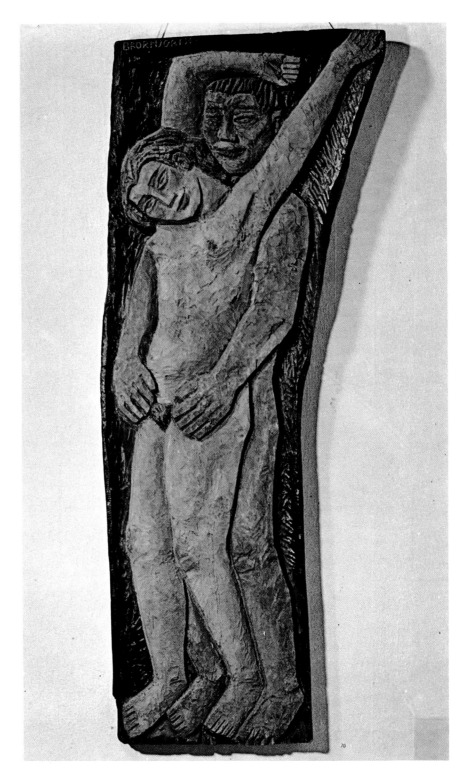

Warmth, tenderness, and innocence radiate from the wood relief of a loving couple by the Nordic "primitive" B. Hjorth.

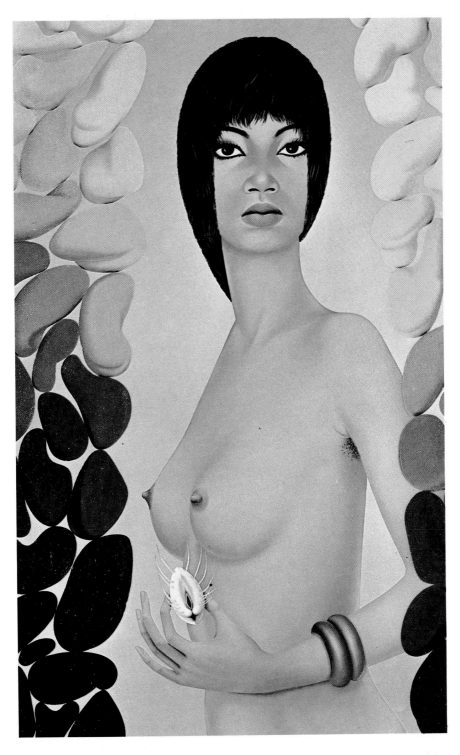

A harsher note is struck by the blue sex goddess of Felix Labisse. She is knowing, and doesn't mind letting one know as well.

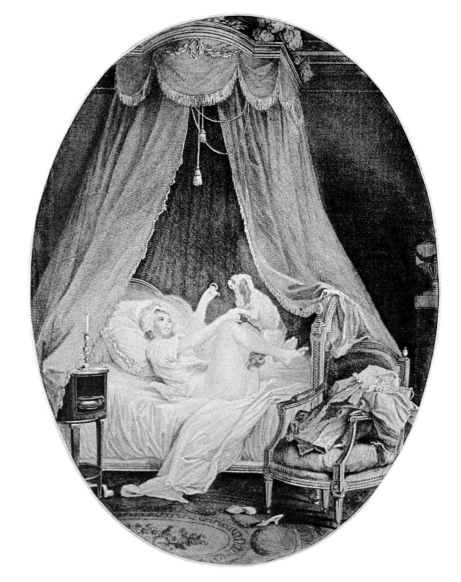

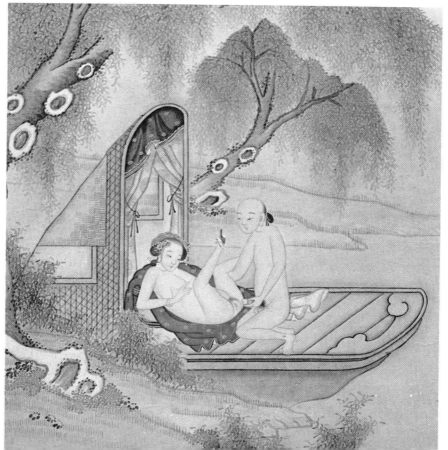

Delicacy and refinement dominate in these three totally different examples of erotica from as many cultures. Languor and auto-erotic play are the mood of the 18th-century boudoir scene by Lafrensen (above left); sensitivity and harmony with nature characterize the romantic detail from the Chinese Ming scroll (bottom left); while a small screen blocks from our view that which the Japanese couple is watching in Sukenobu's 18th-century painted scroll (below).

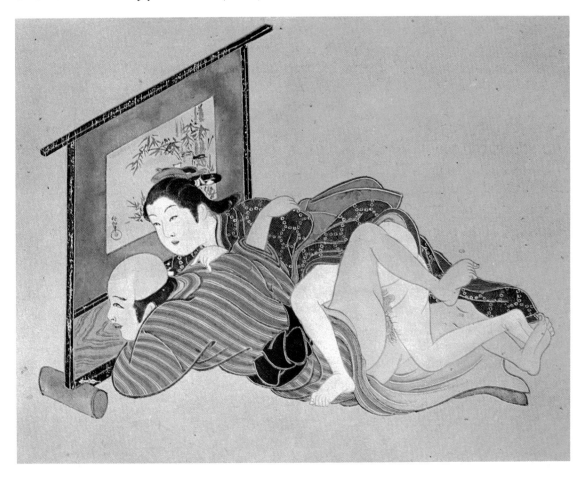

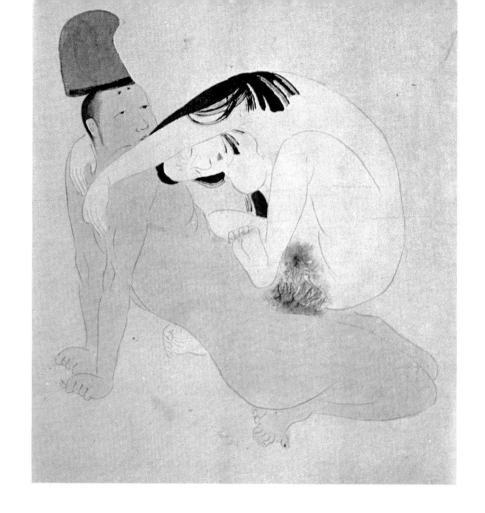

(Above) The female's greater passion is probably a means of depicting the male virtue of self-control (late 18th century, after a 16th-century Yamato-e original).

(Below) Two friends enjoying the favors of the same lady (late 18th century, after a 16th-century Yamato-e original).

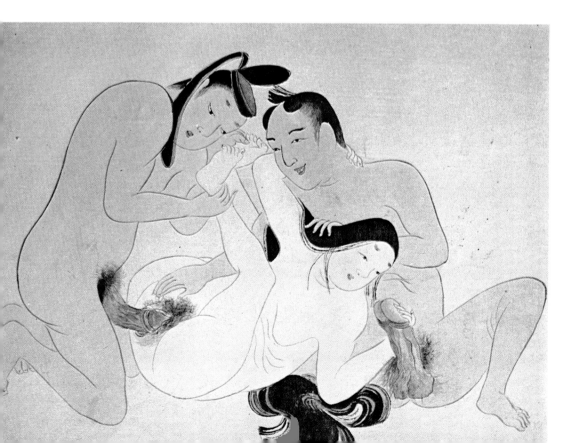

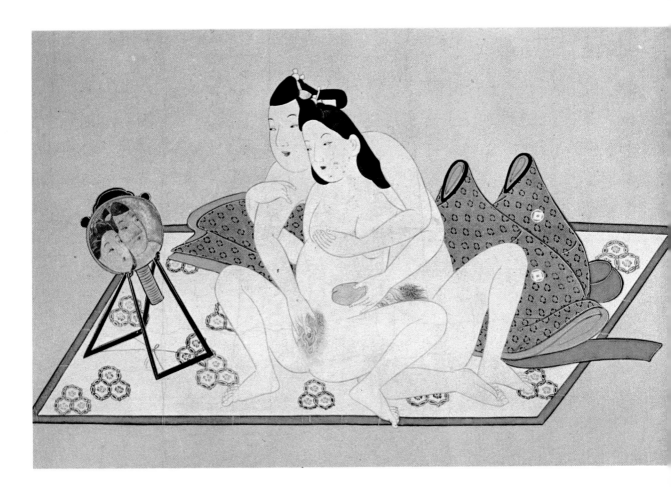

(Above) A couple watching their own mounting excitement in a round mirror which reflects their facial expressions only (Moroshige; late 17th century).

(Below) Painted scroll from early Momoyama period (late 16th century).

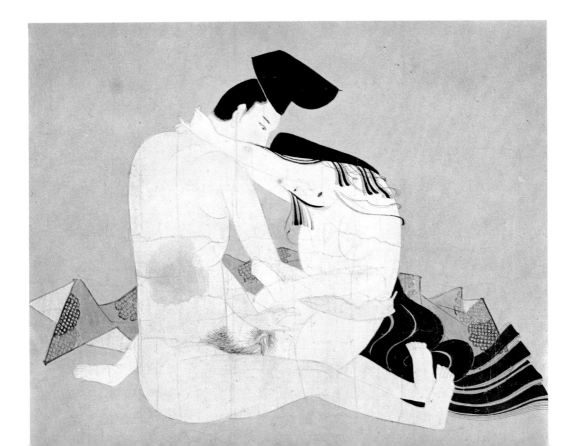

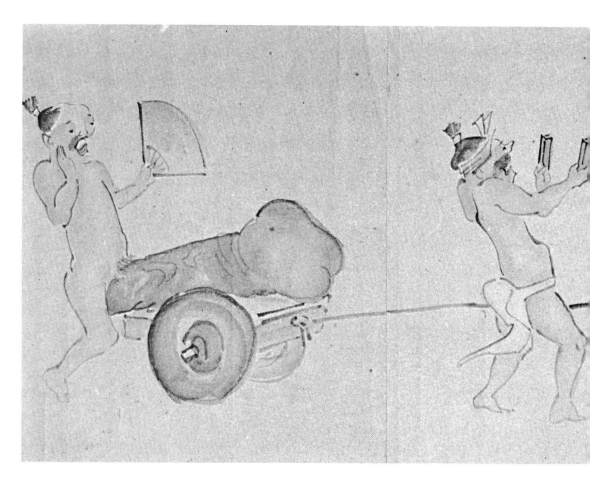

A pace-maker is clapping wooden blocks to cheer on the crew pulling a cart on which rests the giant member of an entrant in this "phallic contest," by the 18th-century Japanese painter Jichosai.

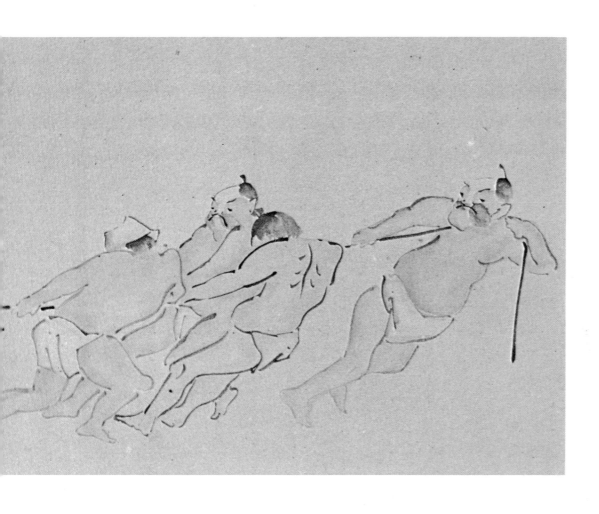

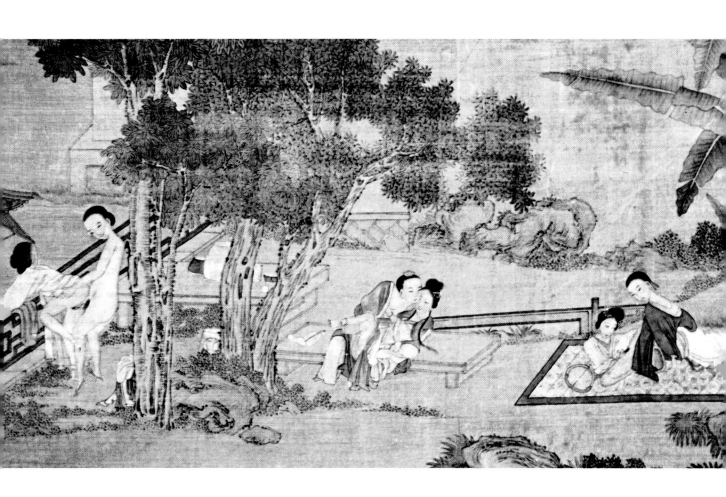

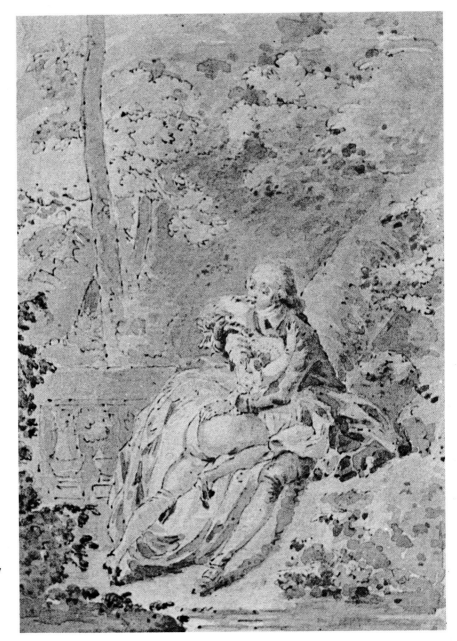

(Left) Three love scenes in a garden setting from an 18th-century Chinese painted scroll on silk.

(Right) A similarly romantic mood is expressed in the outdoor scene by the 18th-century Swedish painter Niclas Lafrensen.

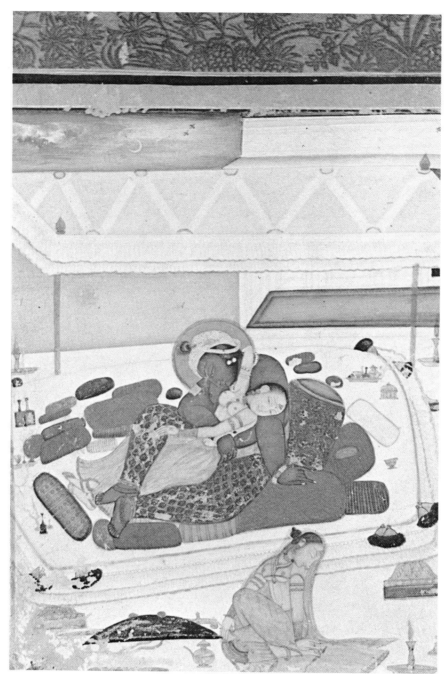

Lord Krishna (always depicted in blue), in amorous encounter with a human female, while her sleepy attendant sits by unawares of the divine visitation (Indian miniature, Mogul style, late 17th century).

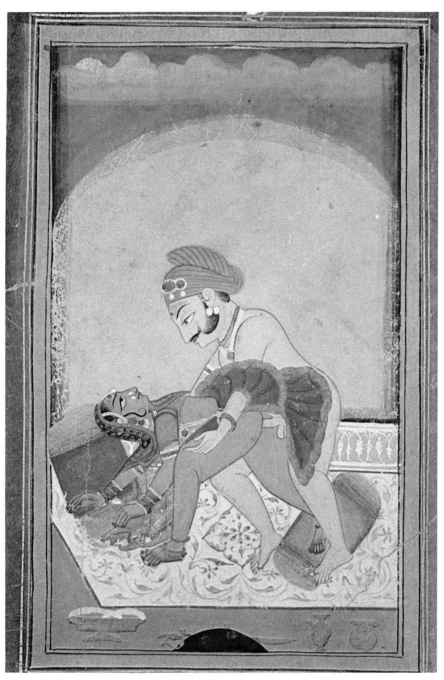

The woman turns her head to gaze into the eyes of her fair-skinned lover—an important aspect in Indian romantic love (Rajput style, late 18th century).

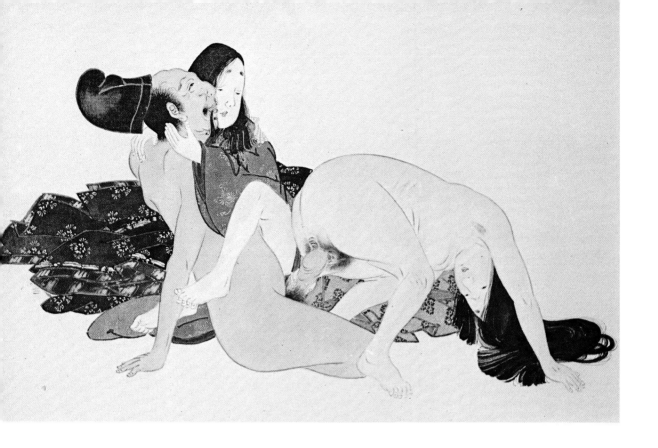

(Above) A noble or "daimyo" receives the tender attention of two women (Kangyo; late 19th century).

(Below) The lovers are supporting themselves with the help of a sling in this unusual scene from an early 17th-century Japanese painted scroll.

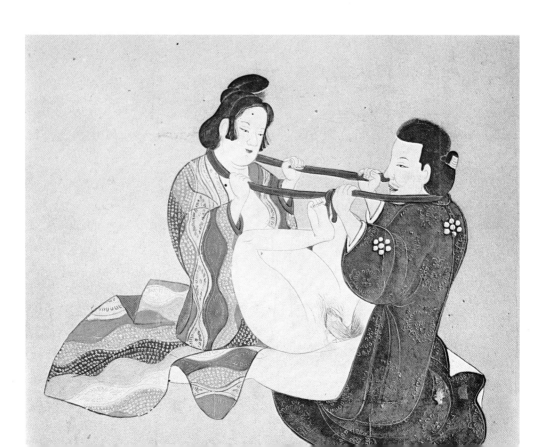

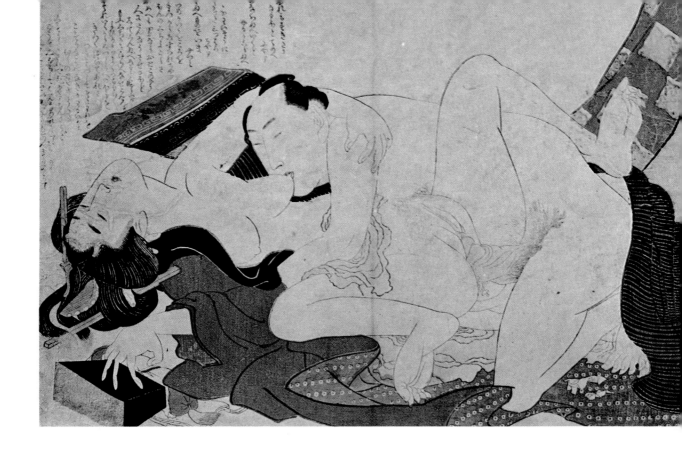

(Above) The ecstatic moment (woodblock print by Hokusai, 1760-1849).

(Below) The lover approaches the lady just as she is combing her hair before a round mirror (woodblock print by Utamaro, late 18th century).

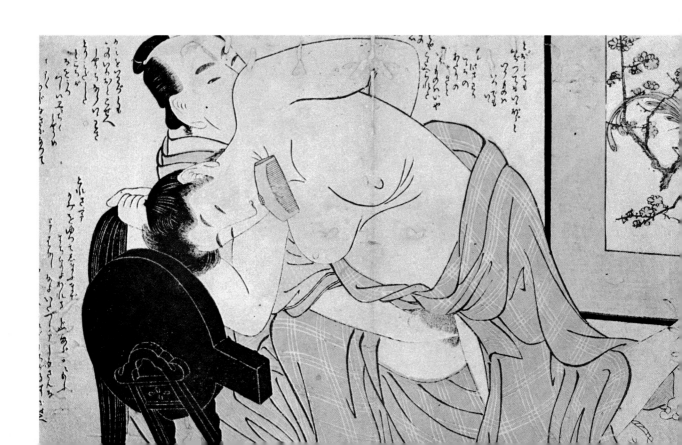

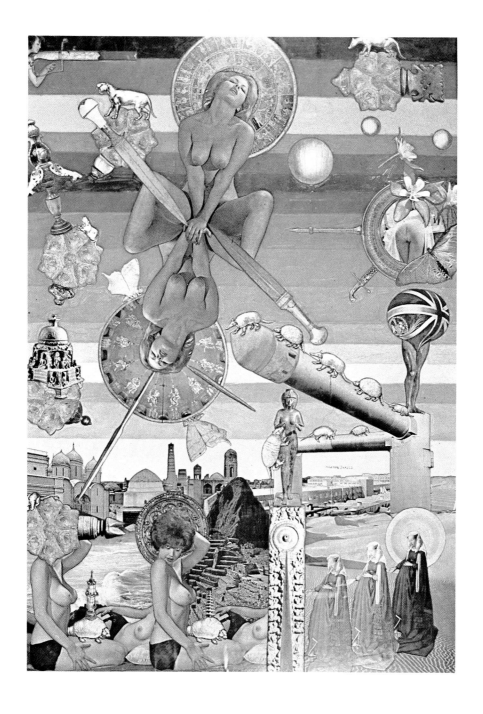

(Above) Surrealism and pop art are combined in this collage by Max Walter Svanberg to create an almost tactile erotic tension. (Above right) A piano is making love to a woman in a surrealistic vision by André Masson, while the erotic daydream of the young man in Jacqueline de Jong's painting (bottom right) includes a cow and vague amorphous shapes.

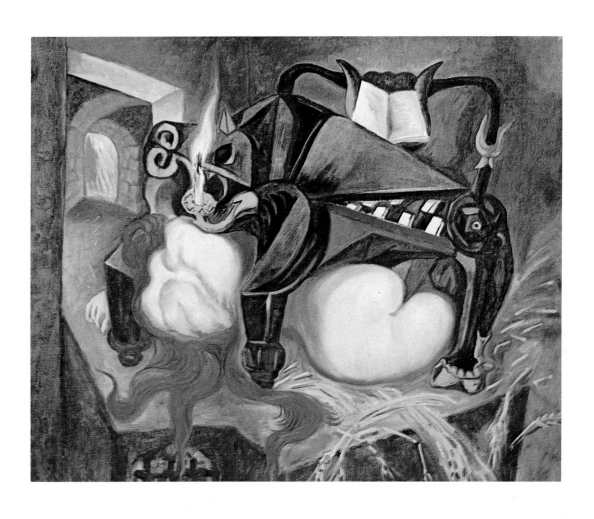

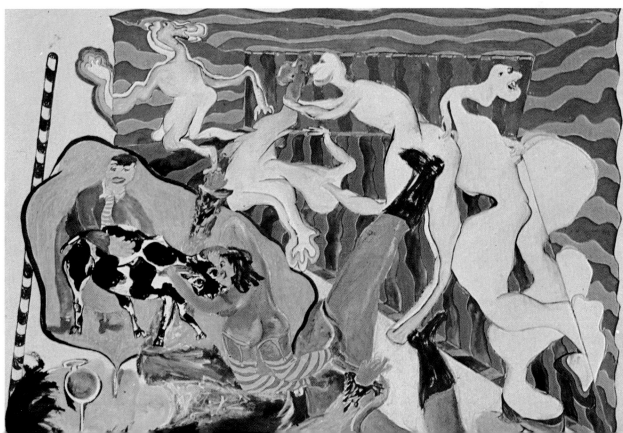

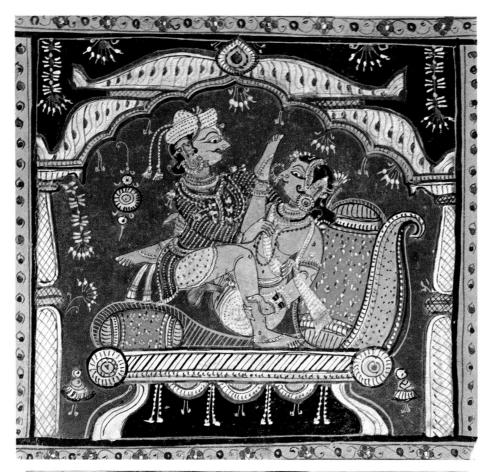

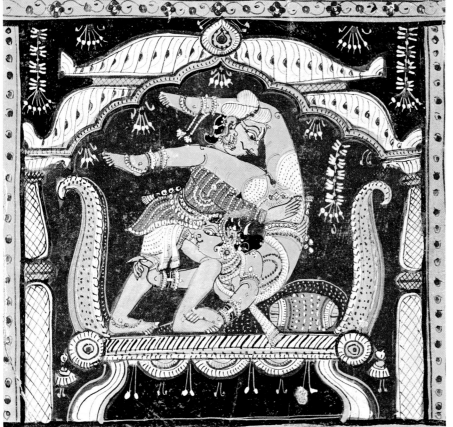

The highly decorative style and playful mood of these two Orissa paintings divest the erotic subject matter of any sense of taboo or secretiveness (oil on cloth, ca. 1830's).

WESTERN ART

The first sexual representations in Western culture were the highly erotic designs on Greek ceramics, mostly from the fourth and fifth centuries B.C. They depict homosexual and heterosexual scenes of definitely phallic character, even in the heterosexual context.

Also in ample evidence were phallic amulets in all sizes and materials, from stone, ceramic, and glass to iron, silver, and gold. They were worn around the neck by the Greek and later the Roman ladies as good-luck charms.

From excavations we also know that erotic murals and mosaics were not uncommon as decorations in the homes of upper-class townsmen and high-class courtesans, and in bordellos. Numerous phallic bronzes from the Greek and Roman period have been found, but while intercourse scenes abound in painting, we have seen none in Greek sculpture.

Most curious of all erotic art in classical antiquity was that of the Etruscans. They constituted a subculture of the Greek and Roman civilizations, but much freer than either of these. The Etruscans, for example, wore a loose garment with the hemline just below the navel. They produced erotic art in quantity and, for the most part, of extraordinarily high quality. As in ancient Peru, their erotic art was closely related to their beliefs and practices with regard to the burial of the dead. Their culture, like that of ancient Egypt, was obsessed with the idea and nature of life after death, an obsession which led them to construct the most extensive and elaborate necropolises, cities of the dead, such as the one near Tarquinia. And they frequently decorated their subterranean tombs with the wildest erotic murals and artifacts.

The Romans continued the Greek-Etruscan tradition of erotic art, adding little of their own. Still, what they produced was mostly of high quality, judging from the archeological finds in Pompeii and elsewhere.

When the Roman Empire crumbled under the onslaught of the Germanic tribes, classical civilization gradually disappeared. The semi-barbarian tribes from the North had no erotic art of their own, though they were expert at wood carving, weaving, jewelry making, and the like. But aside from a few phallic bronzes and some male figures with enormous erections, scratched into rune stones, they were apparently uninterested in erotica.

Thus when the first Christian missionaries appeared not long afterwards, there was no erotic art to destroy in the North. But the new religion, which had taken on Paul's negative view of women and sex, hardly favored a rebirth of erotic art. The Middle Ages therefore produced almost no erotic art as such, aside from some fairly erotic Madonnas and languishing female saints, some-

times shown in the thralls of orgasm-like religious ecstasy. There were also some rather charming Bible illustrations which depicted such scenes as Lot frolicking with his daughters. Susanna in the bath being spied upon by the group of lascivious, voyeuristic elders, and so on. Sado-masochism also found a niche in portrayals of the torture and martyrdom of saints, preferably female ones.

With the Renaissance, however, a change took place: the arts were freed of religion, with artists no longer taking their themes exclusively from the Bible, but more often from classical mythology. The nudes became nuder and the subjects more and more daring. One of the favorite Renaissance themes in painting was the legend of Leda and the Swan, the amorous bird being, of course, the old god Zeus, seducing Leda.

What made Leda pictures so popular, not only in the Renaissance but well into recent times, was their striking symbolism—the swan between Leda's thighs in a similitude of human intercourse and his beak in her mouth in obvious analogy to another sexual practice. By such allusions, representations of these subjects became possible, whereas their direct depiction would have been beyond the tolerance level of the culture.

Medieval art prior to the Renaissance had been primarily anal, with scatological representations much more in evidence than genital-erotic ones. There were, however, a few notable exceptions. The Swiss painter Urs Graf, for instance, did some extremely curious semi-erotic drawings and woodblock prints, such as the picture of a young woman passing unconcernedly under a tree from the branches of which hangs a dead man, or a woman riding on the back of an elderly bearded man, flagellating him with a bunch of large keys on a ring.

Even more directly erotic and quite modern in feeling were the equally curious drawings of witches and their goings-on by the German painter Hans Baldung (Hans Grien). With these exceptions, there was very little erotic art in Europe until the seventeenth century, when the Dutch school of painting flourished. It produced a number of earthy semi-erotic pictures, such as those of Jan Steen, as well as the famous Rembrandt etchings, "The Fourposter," said to be a self-portrait of the master with his wife (Fig. 1), and "The Monk in the Cornfield" (Fig. 2).

But it was not until the eighteenth century that Western erotic art really came of age. At that time, particularly in France, artists like Fragonard and Boucher received royal commissions for erotic paintings, and a large class of sophisticated, wealthy aristocrats constituted a ready market for high-class erotica. Especially popular were copper engravings, either as single prints or as book illustrations (Figs. 5–6).

An outstanding example of eighteenth-century erotic art that may be cited from the exhibition is the sepia drawing by Niclas Lafrensen, a Swedish painter who worked in France (pp. 74 and 81). The French influence, as well as that of the Renaissance tradition, is also noticeable in the erotic work of Carl August Ehrensvärd, another Swedish painter of that period (Figs. 7, 8, and 14), and Johan Tobias Sergel (Figs. 9–13), both calling forth memories of such Renaissance artists as Annibale Carracci and Giulio Romano, the latter being best known for his series of intercourse pictures which were meant as illustrations for Aretino's *Sonnets*.

With the French Revolution, the market for expensive erotica virtually disappeared, the bourgeoisie and the proletariat having neither the means nor the understanding for it. The nineteenth century was consequently rather unproductive along this line, with but few notable exceptions. In England there appeared on the otherwise dull art horizon the witty and ribald watercolors of Rowlandson. In France, there was Daumier, who did at least four erotic caricatures in watercolor, two of which we had an opportunity of examining in a private collection in America and which are outstanding in wit and sophistication, quite up to the artist's highest level. In the second half of the century, we find artists like Monnier and Deveria, who brought new approaches to the subject; there were also a number of less important figures.

Toward the end of the century, Aubrey Beardsley's black and white illustrations to *Lysystrata* appeared, as well as a few fantastic drawings by Füssli, some semi-erotic pictures by Toulouse-Lautrec, and shortly afterwards, the extensive and important erotic work of the Belgian engraver Félicien Rops (Figs. 15–16), who is only now beginning to be appreciated for the extraordinary craftsman he was.

Of the impressionist painters in France there was perhaps only Courbet, who did at least one very daring nude with the pubic region and hair fully delineated and who is said to have done even a few intercourse scenes.

Of pre-World War I painters dealing with erotic subject matter, there was especially the Austrian von Bayros (Fig. 19) who did nothing but erotic book illustrations and who was strongly influenced by Beardsley. In a more naturalistic vein we have the Hungarian Zichy, who did a series of pictures showing different techniques of intercourse in a variety of situations and often with a fine touch of humor.

While we had a few examples of eighteenth-, nineteenth-, and early twentieth-century erotic art in the exhibition, the accent was definitely on Oriental art on the one hand and contemporary Western art on the other. However, we were most happy to be able to show works by Otto Dix (Fig. 25), and Rudolf Schoff (Figs. 23–24), as well as some examples of the early erotic work of George Grosz (Figs. 27–28) and of Lovis Corinth (Fig. 32).

If erotic art lay dormant during World War I and the immediate period of political upheaval afterward, it found a new form of expression in the surrealist movement from the 1920's to the outbreak of World War II. The surrealist movement was essentially a French cultural phenomenon, though it affected the art world everywhere. As far as erotic subject matter was concerned, surrealism provided a means of presenting it—as with classical mythology during the Renaissance—in a form that was acceptable to the art-buying public and at the same time too sophisticated for the police to understand and interfere with.

We had several outstanding surrealist painters represented in the show: André Masson, Max Walter Svanberg, Max Ernst, and one might include Melle and Friedrich Schroeder-Sonnenstern in this category. But we think that the latter two belong more properly, like Frédéric Pardo and even Salvador Dali, to what we would call "painting of the unconscious." For we are dealing here not so much, as in surrealism, with universal symbols and a deliberate mixing of the "real" and the "unreal," as with highly personal symbolisms and largely unconscious or "automatic" projections of an inner, independent world.

Of pure surrealism, André Masson's painting "Le Pianotaur" (*see* p. 87) was the most outstanding example. Masson's "Pianotaur" shows a piano making love to a woman, but so subtle was the point that few people in the exhibition seemed to get it. Still, it is a magnificent painting which had never been exhibited before.

More in the naturalistic style was Masson's ink drawing meant as an illustration for the classical story of *The Golden Ass* by Apuleius (Fig. 33). In a sense, the drawing carries on the Renaissance tradition of such themes, but surpasses the representations of that period in frankness, while expressing it in a totally modern style that gives it much more immediacy and power.

Of Picasso, we had a number of graphic pieces showing various intercourse scenes, but no oils. The artist is said to have done a large number of explicit sexual subjects in oil, but has apparently kept them in his private collection, out of public sight and off the market. He is also known to have treasured for many years a small collection of Japanese shunga (erotic pictures) which have obviously had an influence on his own erotic work.

Of Dali, there was an ink drawing in the show (Fig. 39), done as a dedication to us in his book *The Angelus of Millet,* the sketch being an obvious parody on Millet's "Thanksgiving" scene in the fields.

Unlike Picasso, Dali does not own much of his own work, erotic or otherwise. But we saw in a private collection in America a group of four very interesting colored ink drawings, one of them representing a variation on the theme of St. George and the Dragon, the dragon being in this case a giant octopus whose tentacles ended in so many phalli, one of them fertilizing a nude woman below, with poor little St. George unable to do anything against the monster.

Still another important erotic work by Dali we had occasion to examine at close range was an old Spanish metal advertisement, showing all kinds of phallic-shaped firecrackers whose outlines had been pressed into the metal so that they stood out in relief. This advertising sign Dali had decorated, or "improved," by painting wild erotic designs on it (Figs. 37–38).

Another very important Paris-based artist in the exhibition was Hans Bellmer, who is, in our opinion, along with Ernst Fuchs, one of the greatest graphic artists of our time. But while Bellmer's output is almost entirely of an erotic nature, Fuchs is known to have done very few erotic pieces, of which two (possibly the only two?) were exhibited in Lund (Figs. 65 and 67).

Leonor Fini, who was born in Trieste, is another artist whose work, like that of Dali and

Bellmer, is "erotic" in the wider, extended sense of the term. But even her most deliberately erotic pictures never show the slightest trace of any kind of obsession with the subject matter.

In addition to some of her ink drawings (*see* Fig. 63), we exhibited two large oils by her which, at a recent exhibition of hers in a private gallery in Italy, had been secretly shown only to specially trusted clients in a separate room. Both pictures show two girls in erotic but ambiguous relation to each other and are outstanding in subtle tones of coloration and the creation of a mood appropriate to the subject matter (Fig. 62 and p. 64).

Leonor Fini's work frequently features as central figures beautiful young girls, and even when they are shown in sexual situations with men, the focus somehow rests on them, the males being merely in the role of supporting characters. There is a marked emphasis on costuming and decor in her oil paintings, where the medium allows full expression in that direction. Today she is one of the leading theatrical and costume designers in France.

Like Bellmer, Leonor Fini has done numerous erotic book illustrations, among them a set of drawings for the works of Sade and a series of beautiful gouaches for *The Story of O.*

It is not surprising that such a strong personality and creative intelligence as that of Leonor Fini's should have influenced a number of other painters, among them Colomboto Rosso and Stanislav Lepri. The latter, however, has developed a more independent style, marked by the skillful use of light and the creation of an almost mystical, other-worldly mood in which the sexual act depicted takes on the meaning of a sacrament or ritual (Figs. 103–4).

It would be quite impossible to mention every contemporary artist who participated in the exhibitions at Lund and Aarhus. At best one can touch on a few of the highlights from different schools or tendencies in the visual arts.

One outstanding discovery of our earlier years of collecting in Europe was the Dutch painter Melle. One is tempted to label him as a surrealist, but it is almost certain that Melle would scorn any such classification of himself. In fact, one cannot really compare his style to that of any other living artist, though it does bear comparison both in excellence of technique as in choice of subject matter to another outstanding and equally enigmatic Dutch painter, Hieronymus Bosch.

If for all this imagination and competence Melle is not better known outside his own country, it is to a large extent his own choice. More than once he has turned down offers for one-man shows in various European capitals, if for no other reason than that he did not want to leave his native Holland. But there he has a large enough following to absorb his limited output (he sometimes takes as long as a year or two to complete a single painting).

Melle is frequently preoccupied with "monsters" or "monstrosities," freaks and mutations in nature, such as are seen in the upper part of the picture "Noah," (Fig. 77). Equally dominant or part of the same central theme in his work is the idea of nature's continuous procreative but blind process, mindlessly replenishing the earth with geniuses and cretins alike.

In an entirely different genre, style, and technique, but also highly imaginative and technically resourceful, is the work of the Polish painter Jan Lebenstein. He is a superb draftsman and has in his oils a wonderful feeling for texture, the colors tending to be on the somber, subdued side of the spectrum. The two large oils in the exhibition (*see* Fig. 126) did not fail to attract a great deal of attention, as did the bitter-sweet humor of his drawings (Figs. 127–28).

The Italian painter Arturo Carmassi, represented by two large oils (*see* Fig. 87) and a few drawings, was another surprise to us. We had never heard of him until the French writer Patrick Waldberg called our attention to him. As soon as we had seen some reproductions of his work in catalogs, we invited him to participate in the exhibition.

In a class by himself in style and competence is the painter Matta. Born in Chile, married to an American and living in Paris when not in Cuba, the United States, or Russia, Matta is a truly international artist. His erotic pencil and crayon drawings (Figs. 94–97) give evidence of his long-standing preoccupation with spatial relations and what he calls "the space of the species." In that space he may include in human sexual scenes a horse, an elephant, angels, or machines and still achieve the effect of a perfectly "sensible" and "integrated" ensemble.

We were fortunate enough to have from Matta's personal collection an exquisite small erotic oil painting by Max Ernst (Fig. 41).

Max Ernst's wife, Dorothea Tanning, has done a number of imaginative and sensuous erotic paintings of pubescent girls. Mr. and Mrs. Patrick Waldberg helped us out by lending us some of her work from their collection (*see* Fig. 55).

A discovery of our own was Boris Vansier. We had seen his work first in a Paris gallery where it had become an object of contention after some of his provocative paintings of females had been shown on French television. Everybody who had had anything to do with that program had been fired from the state-owned network, but the show at the gallery had not been closed.

Vansier works in series of pictures or themes employing a technique of reproducing pictures, say, from magazines or newspapers, directly onto impregnated paper which is later fastened onto canvas to serve as the base for his paintings (which he calls *collages imprégnés*). He had done a series of portraits of de Gaulle which had already attracted much comment. Then he completed a large group of "Faux tableux," which were parodies on pictures by famous artists, such as Picasso, Matisse, and Van Gogh, executed exactly in their style, though with some technical innovations and new interpretations of their favorite subject matter. Other Vansier themes include a "Kindergarten" series in which he has integrated actual children's drawings into his paintings.

In the same vein is his series of paintings of women, nude or semi-nude, who are exposed or exposing themselves in a quite unusual manner. This is the series of "Offrandes," or "Offerings," in which he wanted, as he explained to us, "to paint exactly those parts of women from which other painters have shied away." His technique of the *collage imprégné* lent itself very well to this task, so that his forty or fifty "Offrandes" constitute one of the most remarkable achievements in the field of modern erotic art (Figs. 117–19 and p. 66).

Another surprise was the Israeli artist Y. Neiman, now working in Paris. Our attention had been drawn to him by a catalog from one of his exhibitions in which the French art critic Pierre Restany had discussed his work. Like so many other artists, Neiman had previously been able to show only his milder erotic work. He, too, was therefore eager to exhibit some of his more daring compositions, photomontages, and sculptures. Like many artists who have produced strikingly erotic works, he does not consider himself an erotic painter at all. He is, as an artist, interested only in the combination of forms and spatial relations. If he uses, to this end, photomontages of the sexual organs or impressions of a woman's behind and genitals to form a sculpture (Fig. 86), the actual physical subject matter for these shapes and patterns is quite incidental to him—or, at least, to his conscious mind.

The paintings and drawings of Robert Jon, on the other hand, are deliberately erotic, as, for example, his oils which show undisguised positions of intercourse (Fig. 108). He also did a series of dynamic erotic drawings, sketched from life, which depict couples and groups in various sexual situations.

The Dutch action painter Karel Appel has had better luck than some of his colleagues in selling and exhibiting his erotic works, perhaps because pictures done in his characteristic style frequently emphasize color and movement to such an extent that the subject, no matter how sexual, recedes into the background or is entirely overlooked (*see* p. 57).

Appel had sold, for example, a picture entitled "Fucking Dogs" to a public gallery in Holland, where it still hangs, and had already exhibited other pictures with sexual subject matter, including a series of nudes. In that series, however, he had done a nude portrait of Phyllis Kronhausen in which he had painted the genitals by squeezing whole tubes of paint onto the canvas in quick, sweeping movements. The technique proved extremely effective (Fig. 90), but nobody had dared to show it prior to the Lund exhibition.

The public was fascinated by Tilo Keil's macabre photomontages in which he combines close-ups of anatomical parts, sexual and otherwise, to form shocking combinations of bisexual shapes (Figs. 68 and 70).

We had a long interview with Keil, who is German, in which he told us frankly of the deep and lasting impression that the bombings and killings of World War II had made on him as a child. It was this kind of trauma which he tried to externalize through these pictures which combine violence and fear with intense sexual feeling. Having done so and discussed his feelings about these matters with us, he felt he was now ready to go on to happier, more positive subjects and a new type of erotic imagery, no longer associated with death and violence.

On the lighter side, cartoons, an art form characteristic of our own times, were represented by several artists, among them Ulf Rahmberg, Tomi Ungerer, Jean Jacques Lebel, and Barbara Nessim. In one of his most successful pictures of this type, Rahmberg used familiar cartoon characters, such as Superman, Blondie, and Little Orphan Annie with her dog, to create a kind of cartoon of cartoons (Fig. 163). Tomi Ungerer's fellatio machine (Fig. 166) proved to be so disarmingly

naïve and straightforward that it seemed to disarm even the most defensive viewers, and again and again caused peels of uninhibited laughter.

Barbara Nessim's humorous watercolors are not, of course, cartoons in the stricter sense of the term. Still, like Ungerer's line drawings of erotic machines or Lebenstein's erotic fantasies, they seem to fit, broadly speaking, into that category (Fig. 174).

We were pleased to exhibit the drawing "Home Movies" by the young American artist David Wilton (Fig. 161), and the cartoon-like drawings of Cuban-born Ramon Alejandro (Figs. 153 and 156), since they reveal a rich fantasy world of homosexual hue about which so little is known either from an artistic or scientific point of view. Also in the style of cartoons were perhaps a series of "primitive" sketches by Dubuffet (Figs. 149–50). Meant as a child's version of human intercourse, they deliberately ignore the difference between the skin surface and what goes on inside.

Jean Jacques Lebel's cartoons of "Sexual Communication" are an example in point of how erotic representations can and often do include important social criticism, even though their imagery and ideas may be as intensely personal as in this case (Figs. 147–48).

Among the new media of the exhibition were the mechanical objects of Gamarrá and Varnasky, both of Argentina. Gamarrá's life-sized supine rubber girls moved languidly like sunbathers on a beach or like young women awakening and stretching in bed (*see* p. 49).

Jack Varnasky's near life-sized female nude with a male hand running up and down her body (which could be stopped and reversed by pushing a button to heighten the humorous illusion of a real caress) was another much admired and widely publicized piece.

Ferdi's "Womb Tomb" was used in the "happening" of the opening day and remained throughout the exhibition a piece which attracted wide attention. With its female sex symbolism in the context of a coffin with sensuous, fur-like lining, it not only expressed the same universal birth-death symbolism one encounters so frequently in primitive art, but seemed to be an almost conscious mockery of death (*see* pp. 12–13).

If erotic art by women is always somewhat of a surprise because it reflects fascinating differences in male-female sex psychology, that of American Betty Dodson is doubly so. It is not only frankly erotic (the work of several other female artists is equally candid), but it represents a celebration of pure physical love, without romantic apologies or decorative excuse (Fig. 102).

In a style strangely resembling that of Klimt and Schiele is the work of Charles Stark. However, Stark is possibly less violent than Schiele and not as languid as one might be tempted to say of Klimt. He, too, is making an important statement in modern erotic art, at once robust and sensuous, tender and passionate (Figs. 92, 180, and 182).

In the category of unusual media one might also mention Larry River's original scale model for his object "Lampman" (Fig. 141). Like the larger "Lamp" that followed, this smaller prototype could also be lit up by pressing a button, which illuminated the heads and the genital region of the couple represented.

One may also count as an object Ulf Rahmberg's picture of an intercourse scene painted in oil on plywood, in which the legs and heads are attached by hinges to the trunk of the body (Fig. 173). This construction allows the picture to be opened up at these points, revealing another painting on the underside which shows the same parts in anatomical cross-section. As an idea, this is nothing new; already, Leonardo da Vinci had done a cross-section drawing of the genitals during intercourse. But as a full-sized intercourse model, Rahmberg's construction is a definite innovation and rightly attracted a great deal of attention and publicity during the exhibition. It was especially a favorite with teen-agers who often studied it intensely and, no doubt, to good advantage, since it presents anatomical information in a libidinal context, a feature which is deliberately lacking in Western sex-educational material, though the Japanese and Chinese used to include it with equal deliberation in their erotic "bride's" pictures.

Of contemporary painters working in new styles and creating new effects with erotic subject matter, we would also like to mention, among others, the German painter Prem (Figs. 109–10, 124), the American David Rubello with his pop-artish, utterly realistic style (Figs. 120–21, 123), Lothar Fischer in ceramics and bronzes (Fig. 184), Jacqueline de Jong with her "free association" paintings (p. 87), and the painted erotic ceramics of Swedish Britt-Ingrid Persson (Fig. 189).

It is clear that we may in the future expect still other modern techniques including kinetic, optical, electric, pictorial representation of sound, and other effects, to add further refreshing and fascinating dimensions to the inexhaustible and ever new subject matter of the sexual side of life.

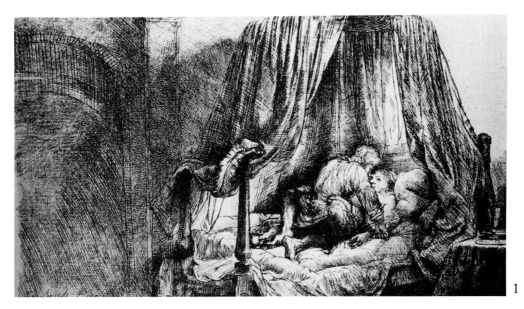

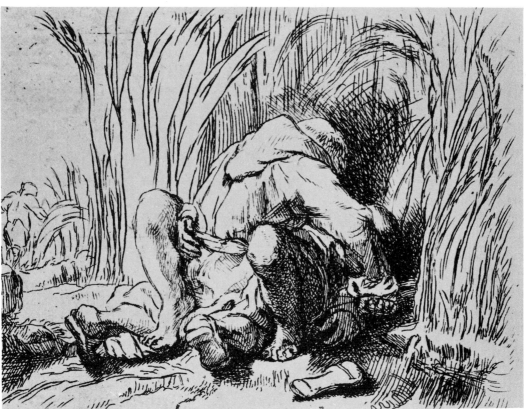

1—Rembrandt (1606–69), "The Fourposter," etching; supposed to be the artist and wife. 2—Rembrandt, "The Monk in the Cornfield," etching.

3 4

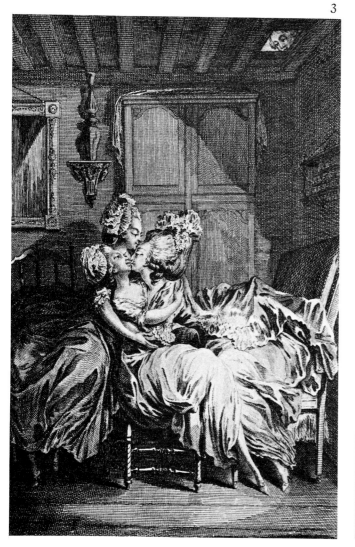 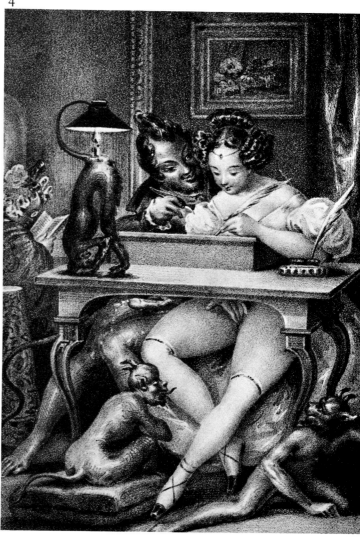

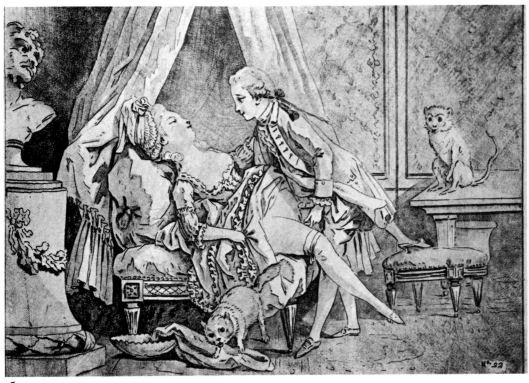

5

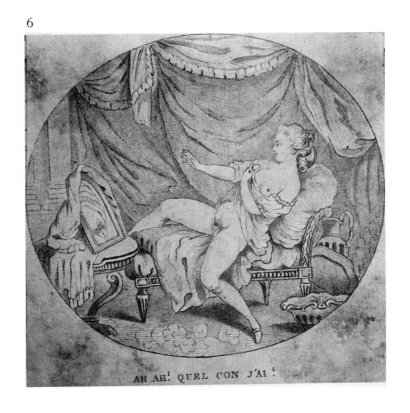

6

AH AH! QUEL CON J'AI!

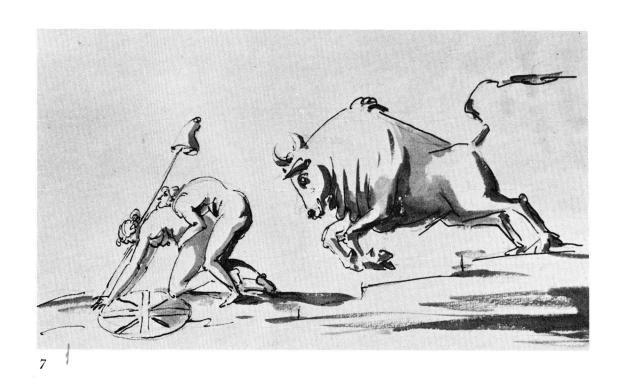

7

8

9

7–8—*Carl August Ehrensvärd (1745–1800; Sweden), ink drawings.*
9—*Johan Tobias Sergel (1740–1814; Sweden), sepia drawing.*

10

11

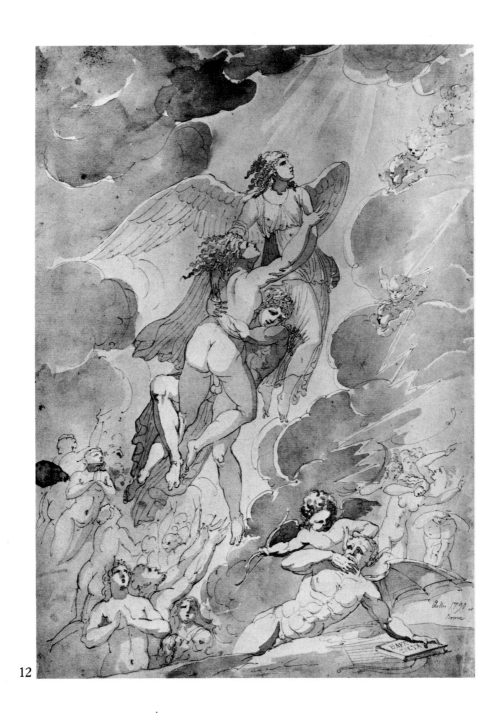

12

10–12—Johan Tobias Sergel, sepia drawings.

Och om jag dölier mitt Ras
så skier av fallet måg doch föga

13

Och vii att du ej giör som Andra.

No 8.

*13—Johan Tobias Sergel, sepia drawing.
14—Carl August Ehrensvärd, ink draw-
ing. 15—Félicien Rops (1833–98; Bel-
gium). 16—Félicien Rops, "Serre Fesse,"
extremely rare engraving on copper plate.*

15

16

17—Bordello scene by Viset (France), ca. 1840. 18—Orgy scene by James Ensor (France), pastel. 19—Franz von Bayros (Austria), engraving, ca. 1910. 20—Julius Klinger (Germany), ca. 1909; printed illustration from a limited edition of the Earl of Rochester's erotic play Sodom.

17

18

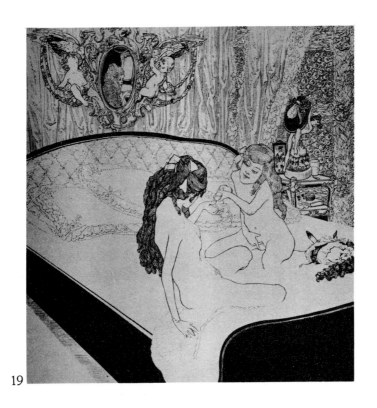

19

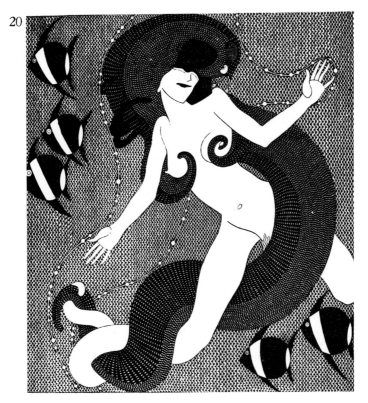

20

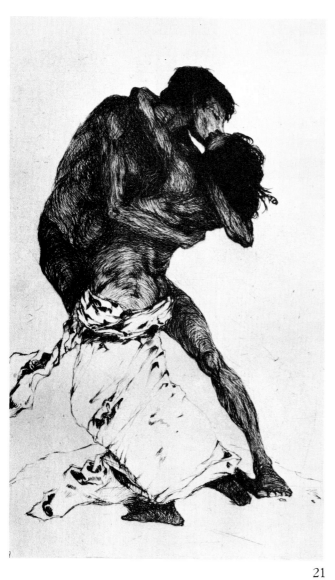 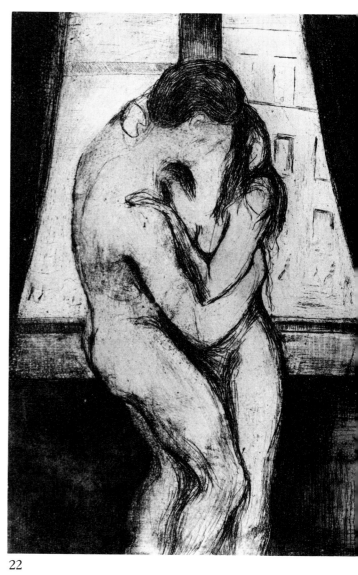

21 22

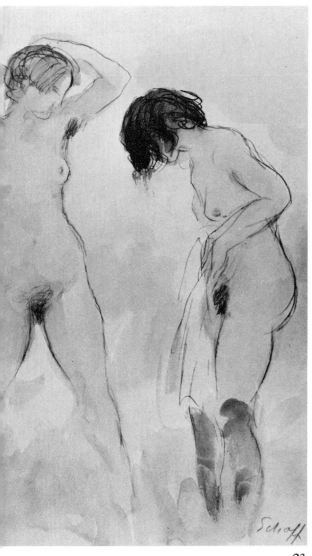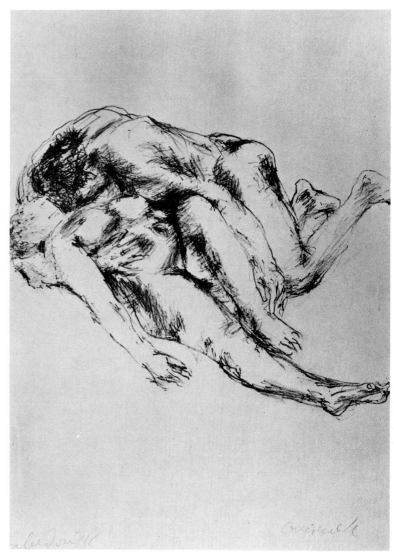

23 24

21—Willi Geiger (Germany), "Passionate Couple." 22—Edvard Munch (Norway), "The Kiss." 23—Rudolf Schoff (Germany), pencil and water-color. 24—Rudolf Schoff, pencil.

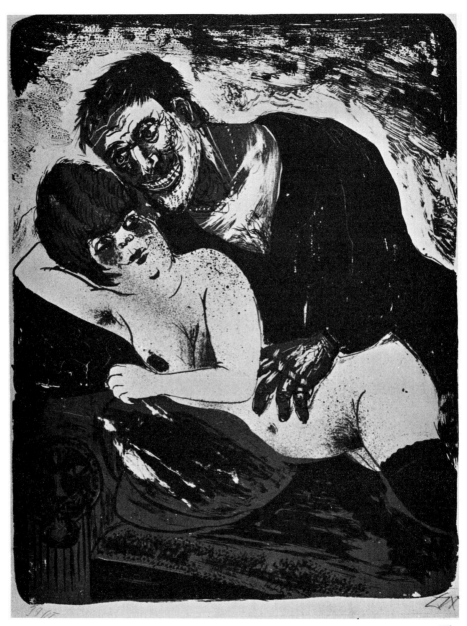

25

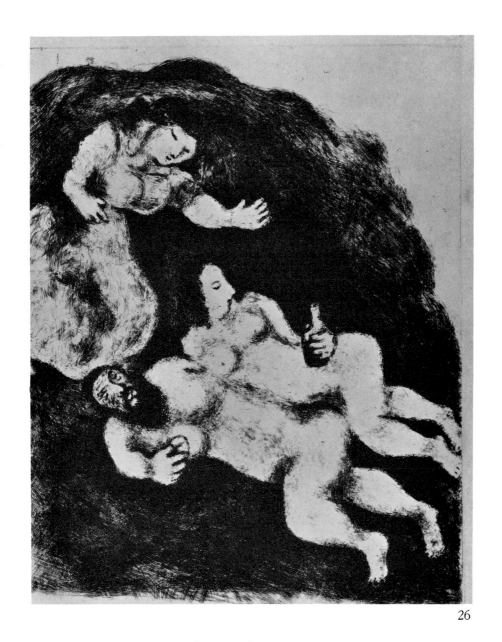

26

25—Otto Dix (Germany), "Gypsy and Girl," lithograph, 1922. 26—Marc Chagall (France, of Russian origin), "Lot and His Daughters," etching.

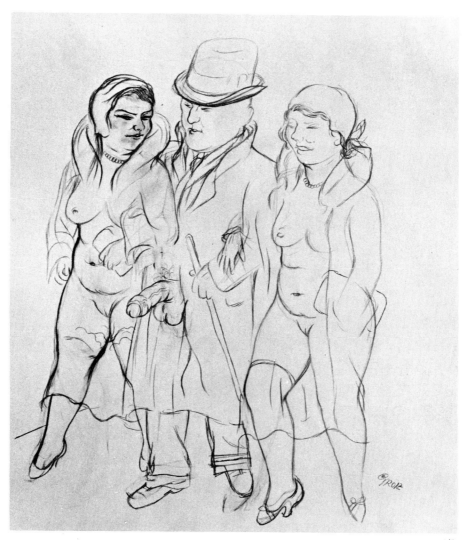

27

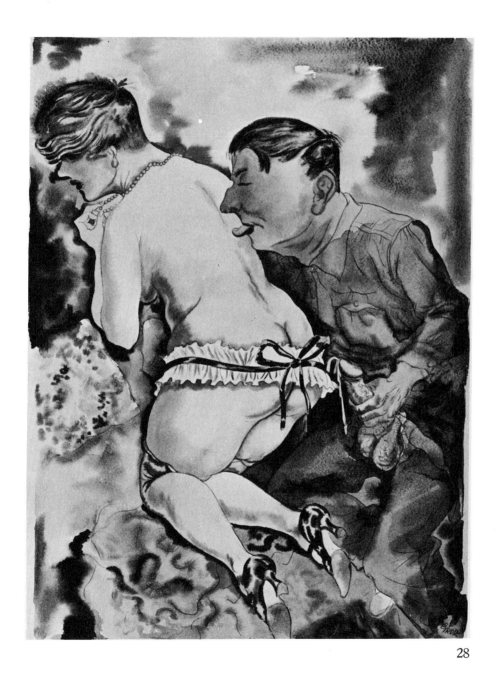

28

George Grosz (Germany). 27 — "Mann mit Zwei Dirnen" (Man with Two Whores), pencil drawing, ca. 1920. 28— "Die Anbetung" (Worship), one in a rare set of watercolors, ca. 1920.

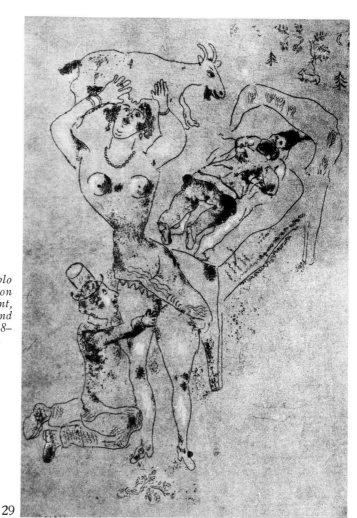

29—Marc Chagall, etching. 30–31—Pablo Picasso (Spain), lithographs (the date on Fig. 31 is reversed in the original print, since the artist dated the litho plate and not the print). 32—Lovis Corinth (1858–1925; Germany), "Position 2," pencil.

29

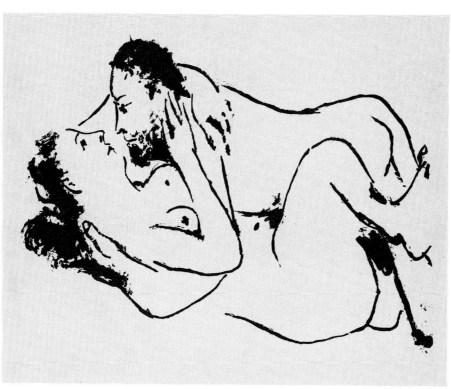

30

31

32

33

34

35

André Masson (France). 33—Ink drawing; illustration to The Golden Ass *by Apuleius. 34—Ink drawing. 35—Lithograph. 36—Ink drawing.*

36

37–38—Salvador Dali (Spain), details from a metal advertisement for fire-crackers, painted over by the artist. Collection Sir R. Penrose, London. 39—Salvador Dali, ink drawing inscribed in the Drs. Kronhausen's copy of the artist's book The Angelus of Millet.

38

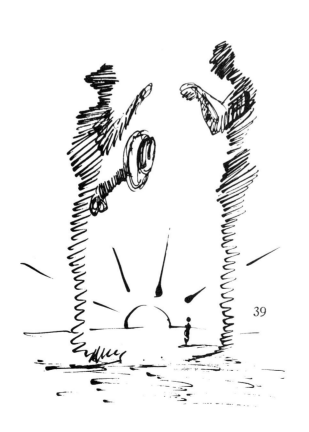

39

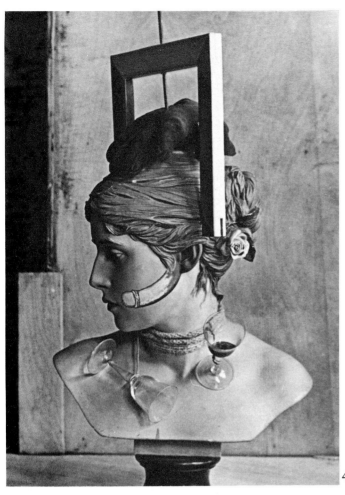

40—*Wilhelm Freddie (Denmark), "Sex-paralys-appeal," object, 1937. 41 — Max Ernst (U.S. and France; of German origin), oil. Collection Matta, Paris.*

40

41

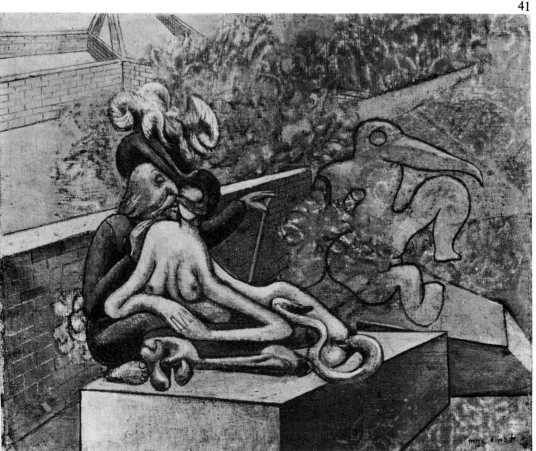

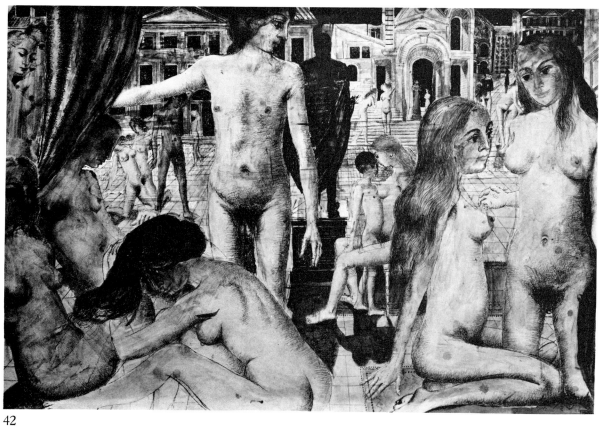

42

43

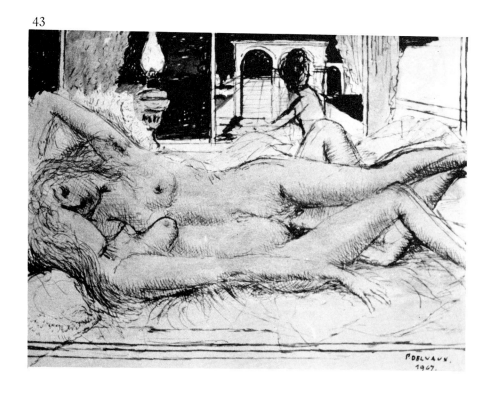

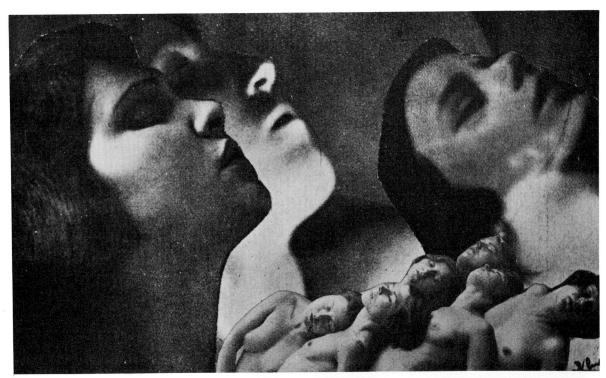

44

45

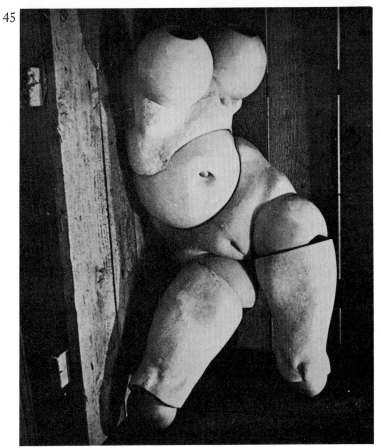

42—Paul Delvaux (Belgium), "Bac-
chanale ou la Statue," watercolor,
1967. Collection Mme. J. Krebs,
Brussels. 43—Paul Delvaux, water-
color and ink, 1967. 44—A photo-
montage by the late French poet
Paul Eluard. Collection Matta,
Paris. 45—Hans Bellmer (Germany
and France), "Les Jeux de la Pou-
pée," hand-colored photograph.

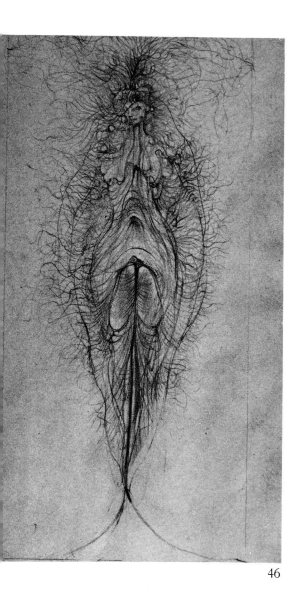

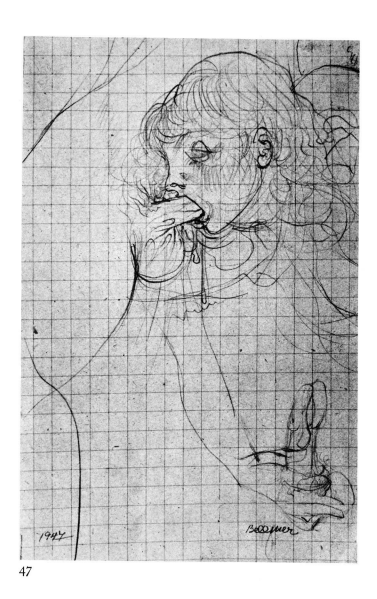

46

47

46–49—Hans Bellmer, pencil drawings.

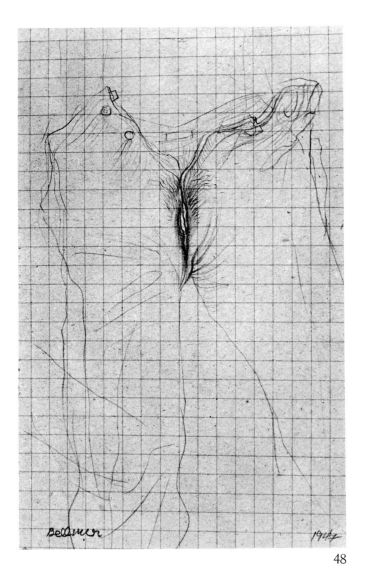

48

49

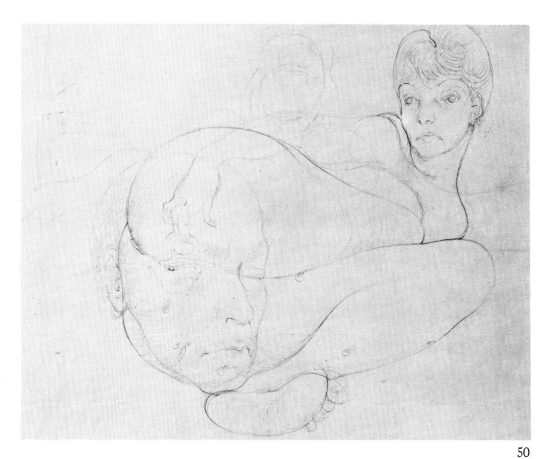

50

51

52

*Hans Bellmer. 50—Pencil drawing; double portrait of the artist
and model. 51—Pencil drawing. 52—Hand-colored engraving.*

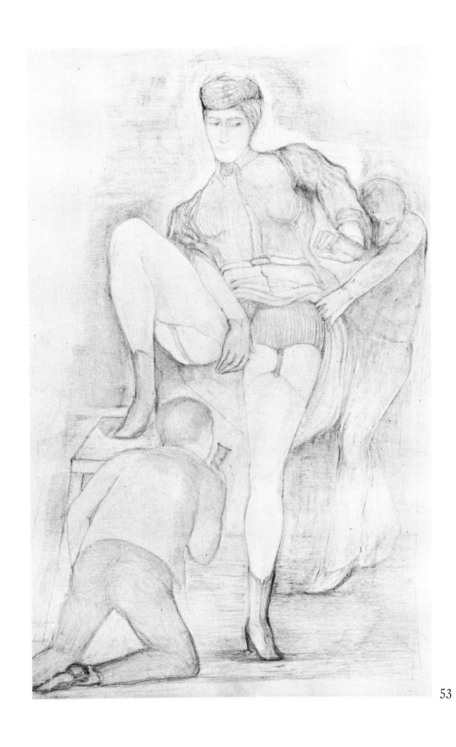

53

53—*Pierre Klossowski (France), pencil. 54—Pierre Klossowski, "Diana and Actaeon," pencil. 55—Dorothea Tanning (U.S.), ink. Collection Mr. and Mrs. Patrick Waldberg, Paris.*

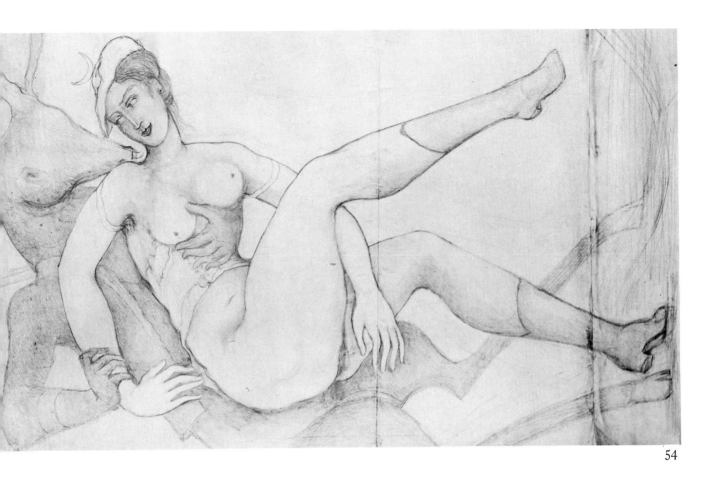

54

55

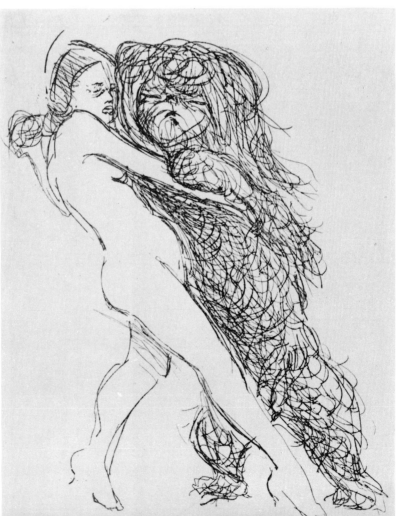

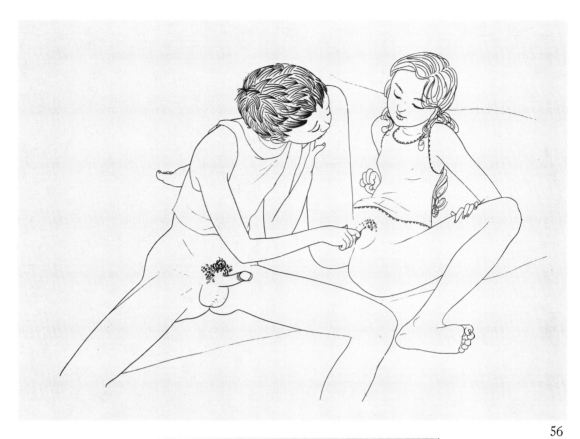

56

57

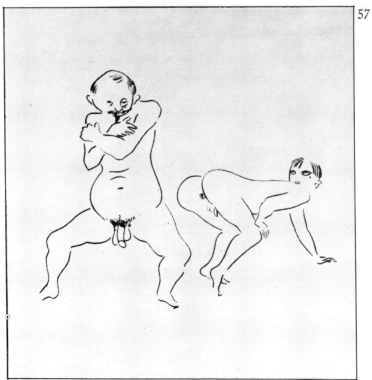

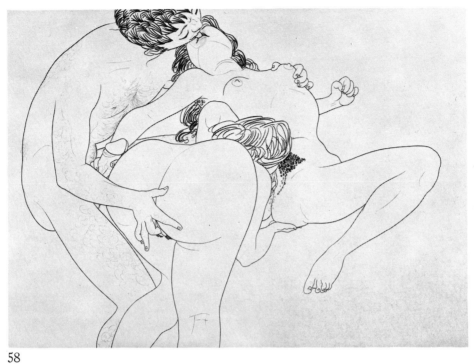

58

56 and 58—Mario Tauzin (France), offset prints from copper plate; from an extremely rare portfolio, published ca. 1943. 57 and 59—Fujita (Japan and France); original lithographs from a series of book illustrations.

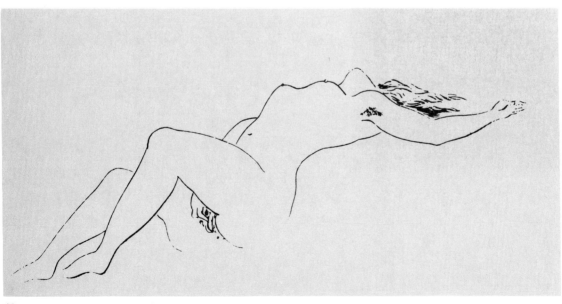

59

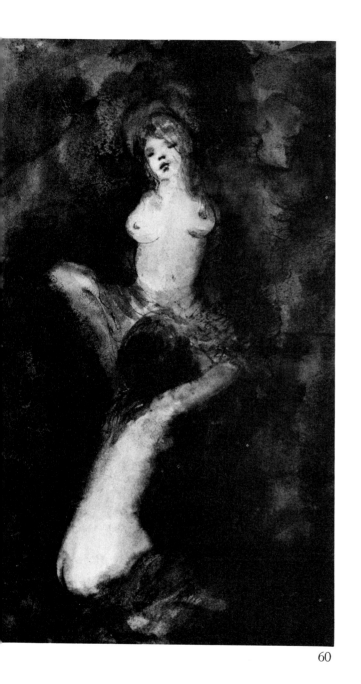
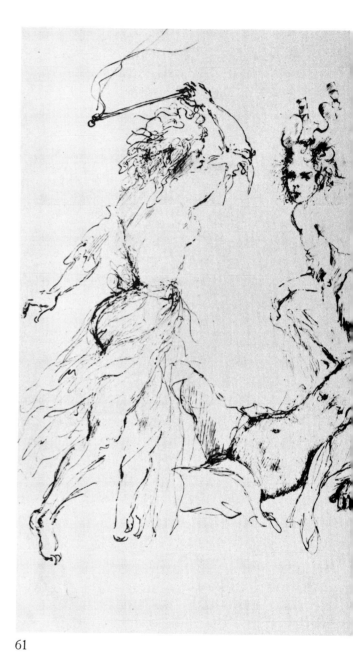

60 61

*Leonor Fini (Trieste and France). 60—Lithograph; illustration for a
luxury edition of L'Histoire d'O. 61—Lithograph; illustration for a lux-
ury edition of Sade. 62—"Le Long du Chemin," oil. 63—Ink drawing.*

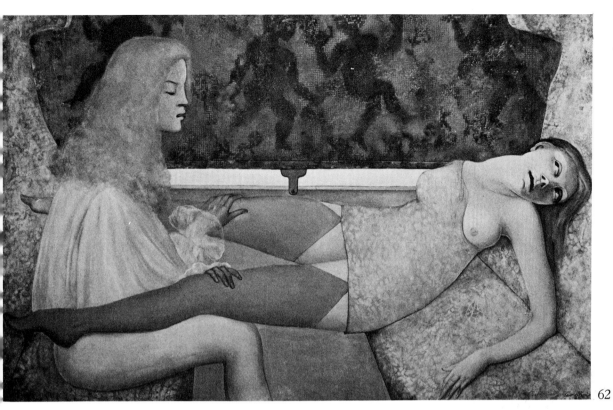

62

63

64

65

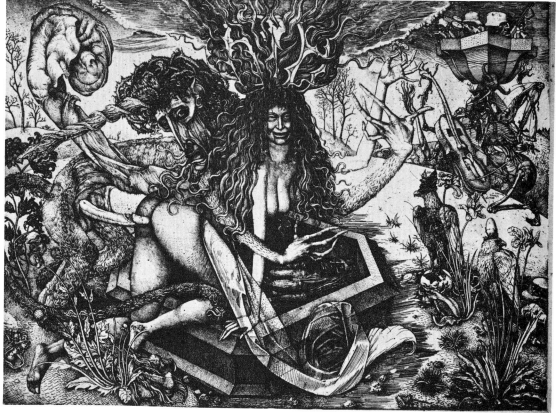

66

67

64 and 66—Marcus Behmer (Germany), engravings from the portfolio "Kalos," 1928. 65 and 67—Ernst Fuchs (Austria), engravings (Fig. 67 is entitled "Marriage of the Sun and Moon").

68

69

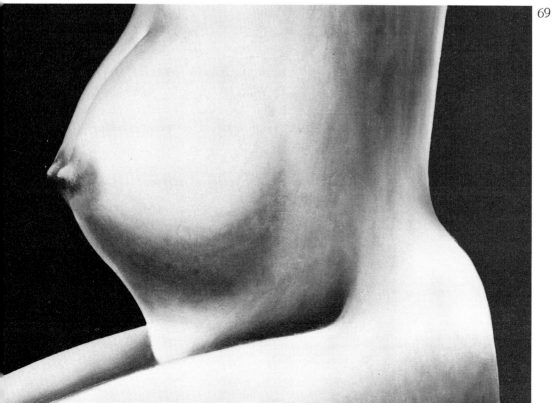

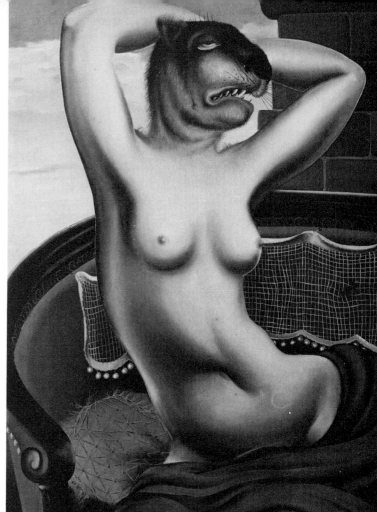

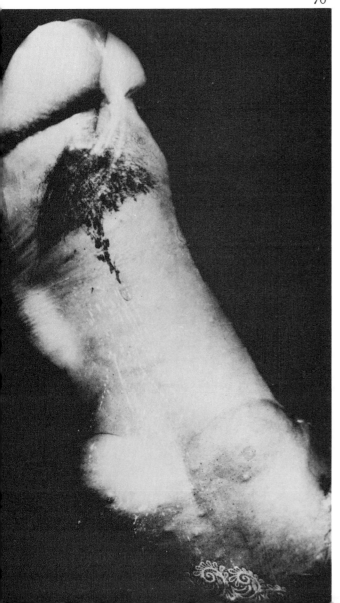

71

68 and 70—Tilo Keil (Germany), photomontages. 69 and 71—Felix La- bisse (France), oil on canvas (Fig. 71 is entitled "Le Bonheur d'être aimé").

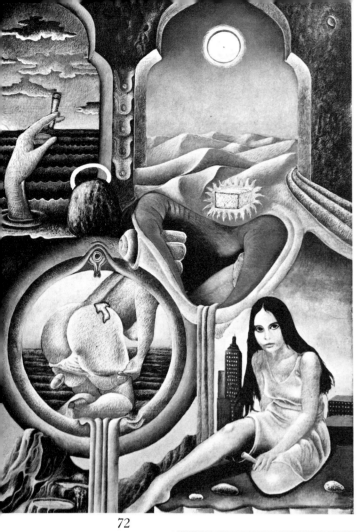

72

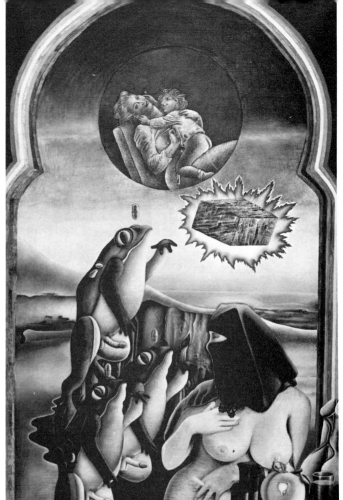

73

74

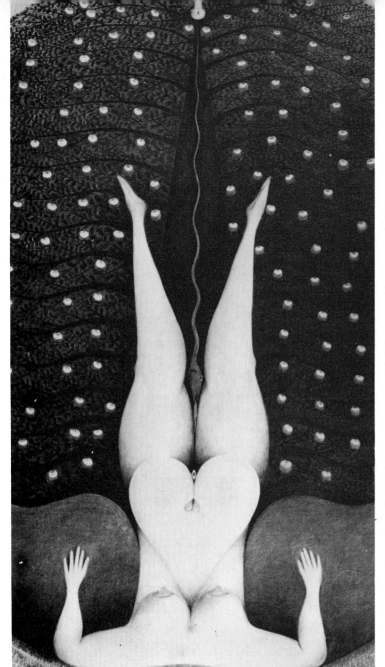

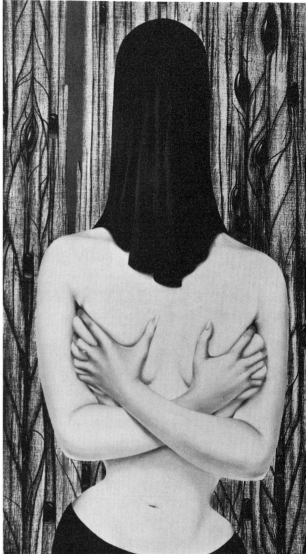

75 76

72—Frédéric Pardo (France), oil on wood. 73—Frédéric Pardo,
"Oedipal Trip," oil on wood. 74—Frédéric Pardo, "The Woman-
Eating Monster," oil on wood. 75—Friedrich Schroeder-Sonnen-
stern (Germany), "Fertilization," watercolor. 76—Felix Labisse,
"Le Deuil de Salomé," oil on canvas.

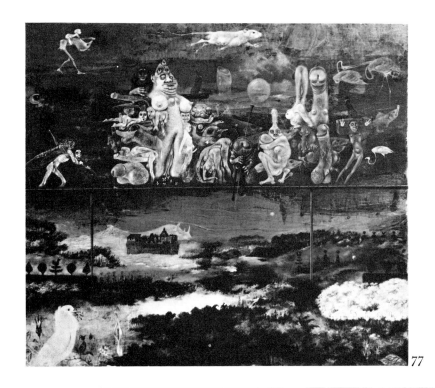

77

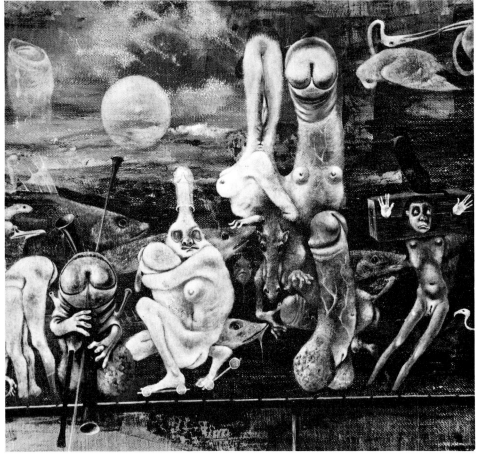

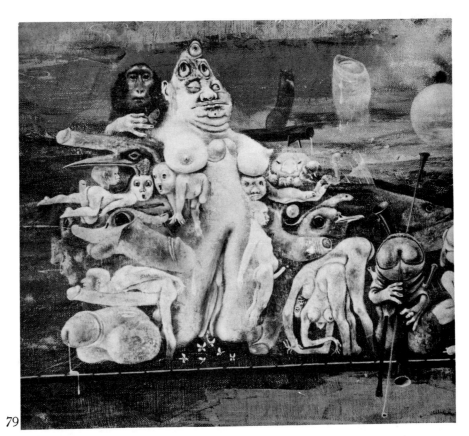

79

80

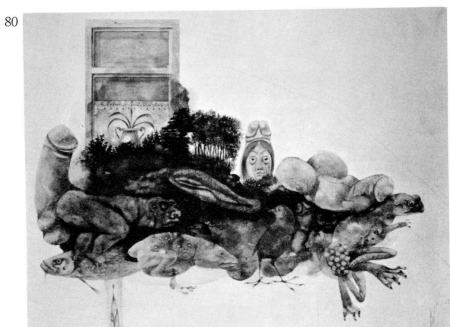

Melle (Holland). 77—"Noah," oil on canvas.
78–79—Details from "Noah." 80—Watercolor.

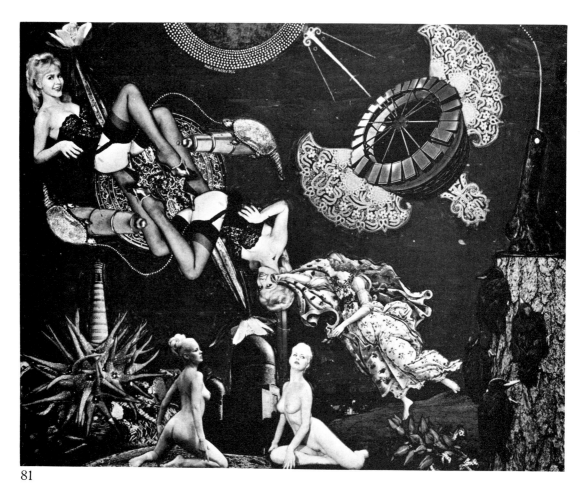

81

82

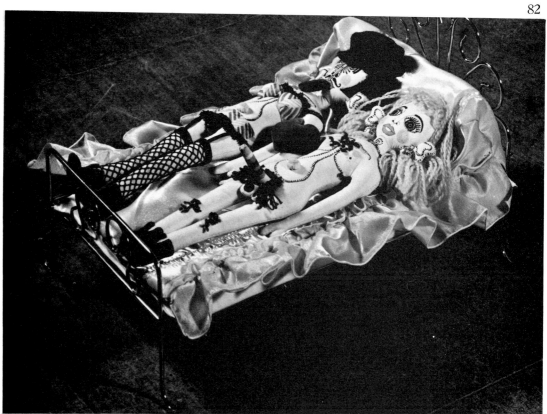

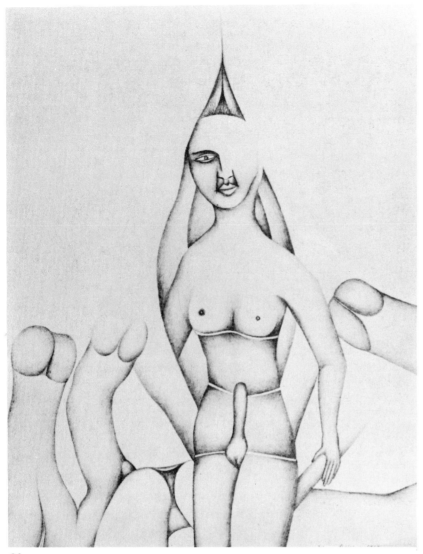

81 — Max Walter Svanberg
(Sweden), collage. 82—Dolls
by Mrs. Sachi Hiraga painted
by her husband, Key Hiraga
(both of Japan). 83—Werner
Hilsing (Germany), pencil
drawing. 84—Sam Mercer
(U.S.), watercolor.

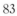83

84
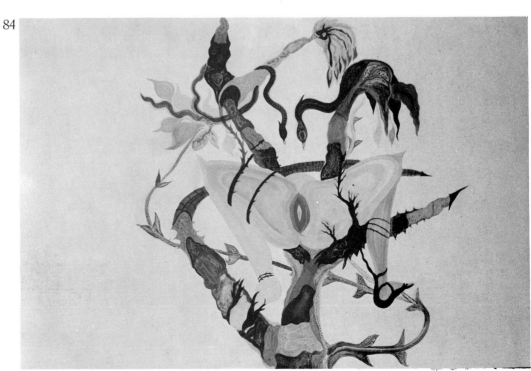

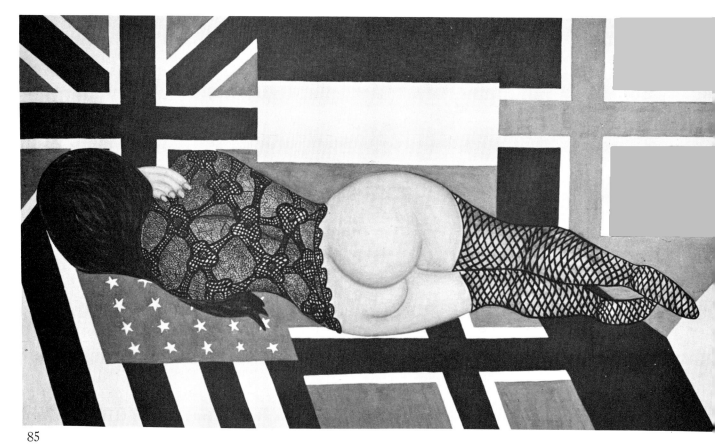

85

85—William Copley (U.S.), "Some Things We Have in Common," oil on canvas.
86—Y. Neiman (Israel and France), aluminum and oil paint. 87—Arturo Carmassi,
oil on canvas. 88—David Rubello (U.S. and Denmark), "When You Pass Copen-
hagen," oil on canvas.

86

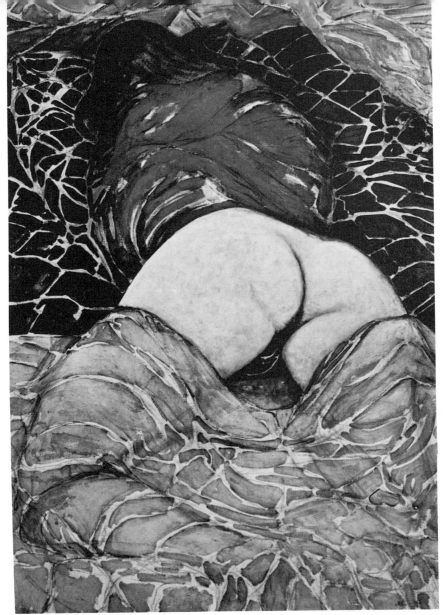

87

88 When YOU pass COPENHAGEN visit

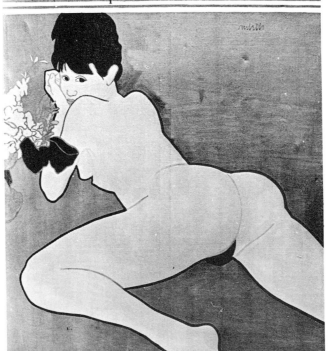

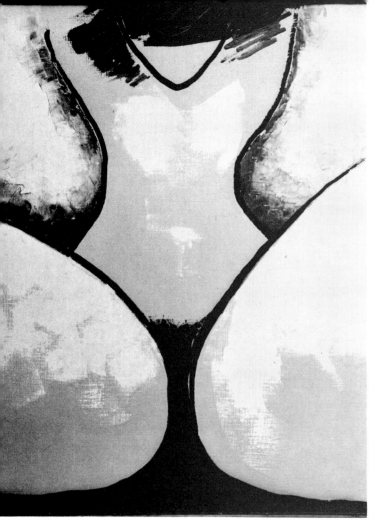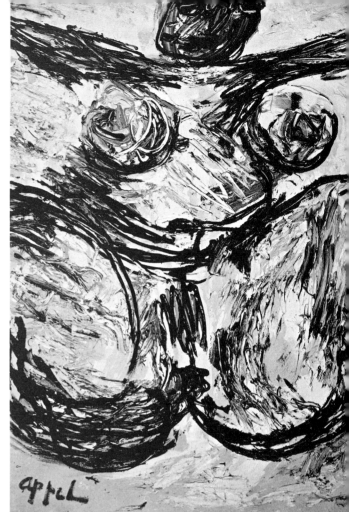

89 90

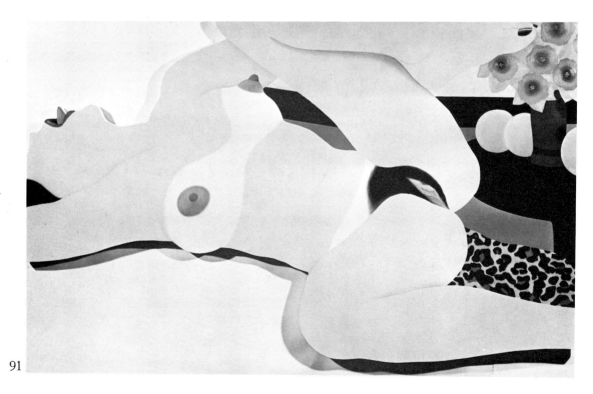

91

89—Man Ray (U.S.), oil on canvas. 90—
Karel Appel (Holland), oil on canvas.
91—Tom Wesselmann (U.S.), "Great
American Nude #91," 1967. Collection
Richard Wenninger, Frankfurt, Ger-
many; courtesy Sidney Janis Gallery;
photo: Geoffrey Clements. 92—Charles
Stark (U.S.), pastel. 93—Cesare Peverelli
(Italy and France), tempera on crepe
paper.

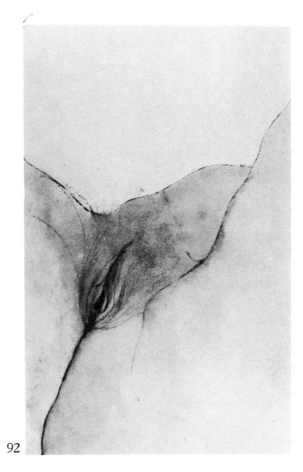

92

93

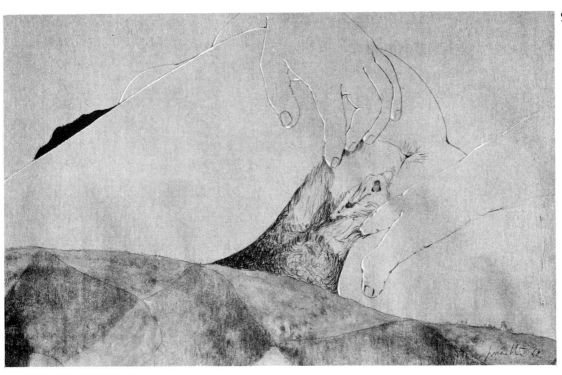

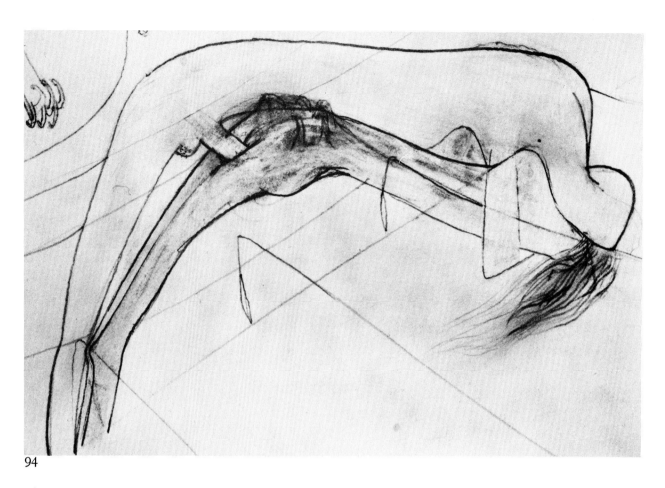

94

95

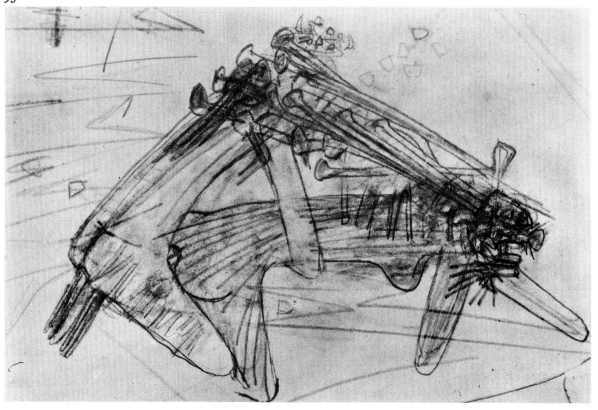

96

94–97—Matta (Chile and France), pencil and colored crayon.

97

98

99

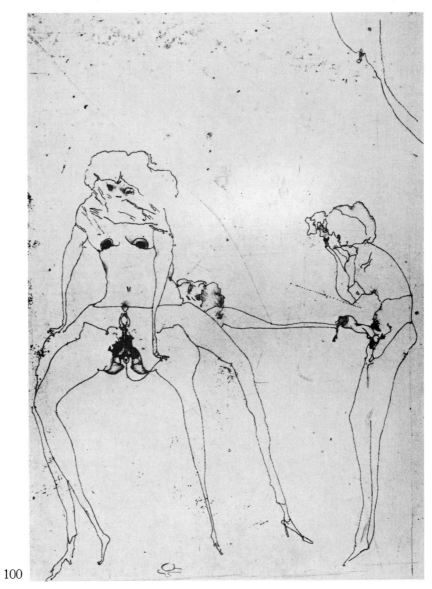

100

98 and 100—Horst Janssen (Germany), etchings. 99 and 101—Else Maj Johansson (Sweden), pencil drawings.

101

103

102—*Betty Dodson (U.S.), pencil. 103–104—Stanislav Lepri
(Italy), oil on canvas.*

104

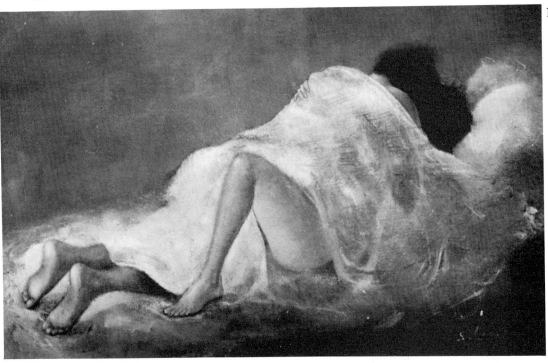

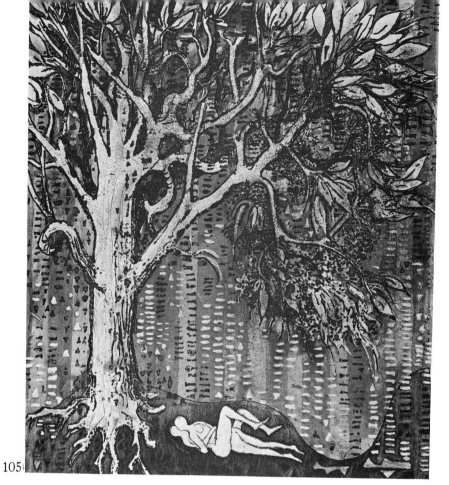

105

105—Lars Bo (Denmark), colored engraving. 106—
Michel Henricot (France), oil on paper. 107—Else
Maj Johansson (Sweden), pencil. 108—Robert Jon
(U.S., of Chinese origin), oil on canvas.

106

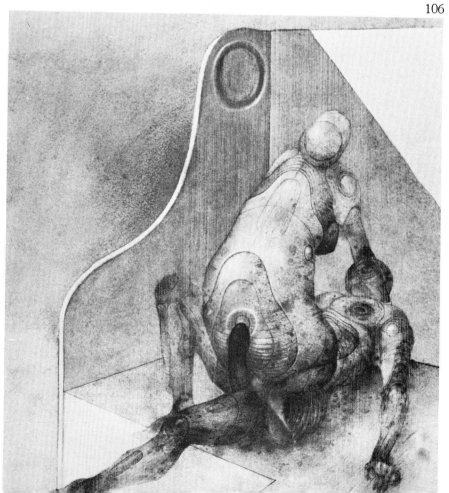

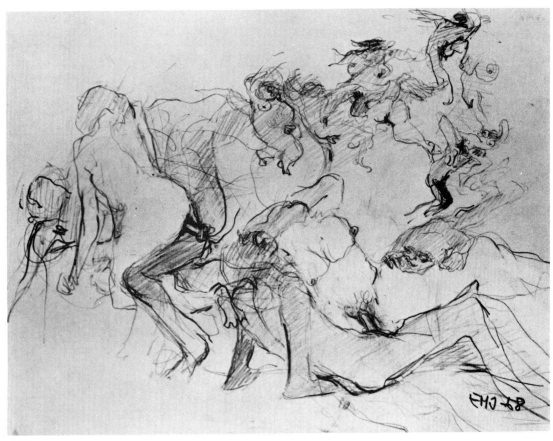

107

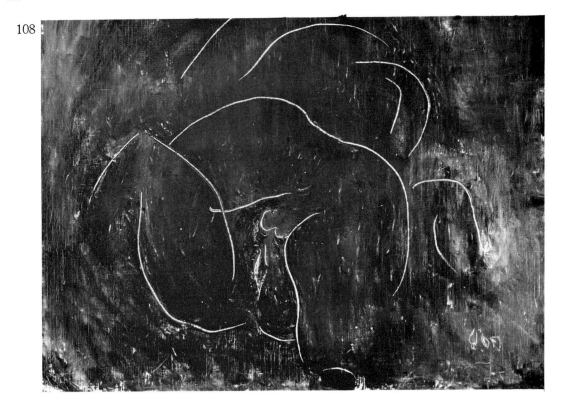

108

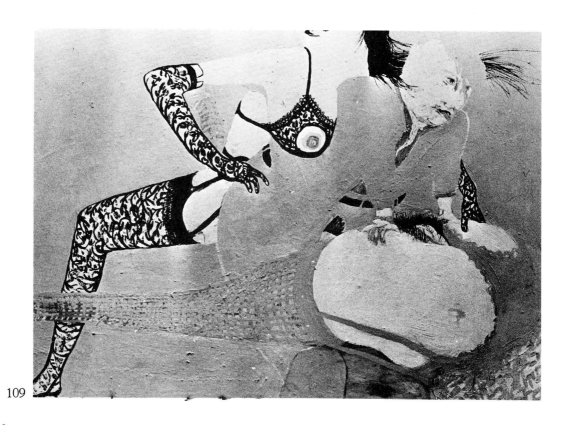

109

110

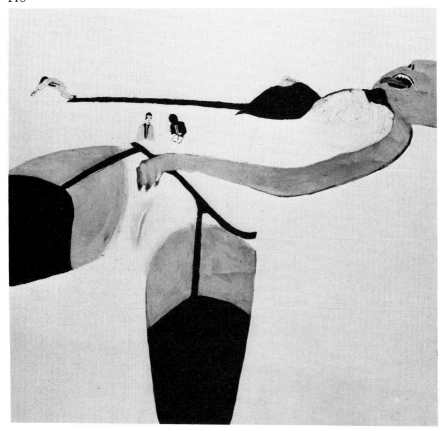

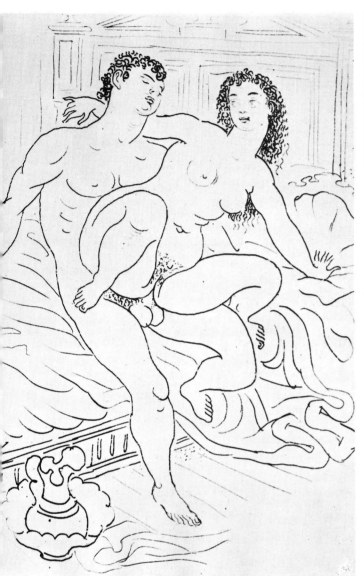 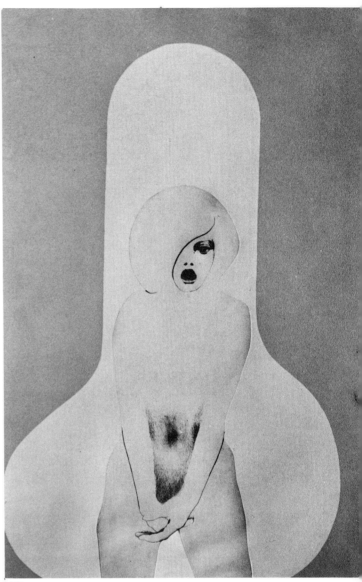

111 112

109–110—Heimrad Prem (Germany), oil on canvas. 111—Galanis (France), engraving. 112—Tom Rose (U.S.), watercolor.

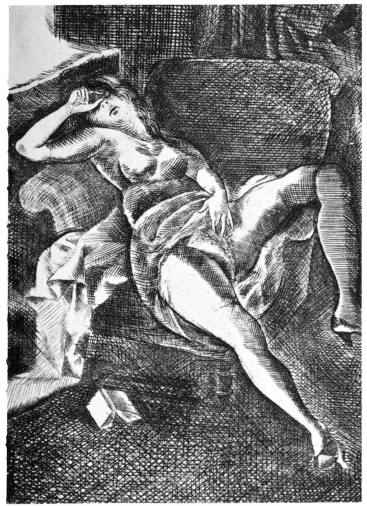

113—Galanis (France), engraving. 114—Anne Grete (Sweden), pencil. 115—F. Souza (India and England), ink. 116—Ernst Schlotter (Germany), "The Web," pencil and ink.

113

114

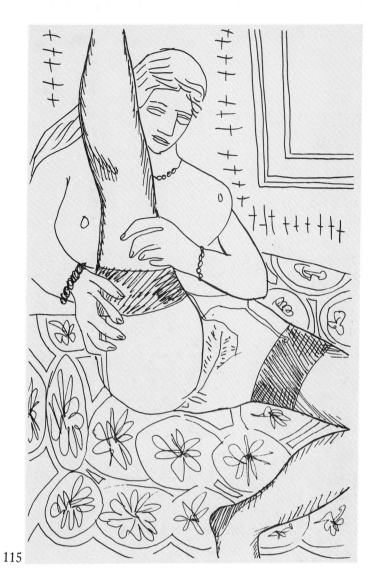

115

116

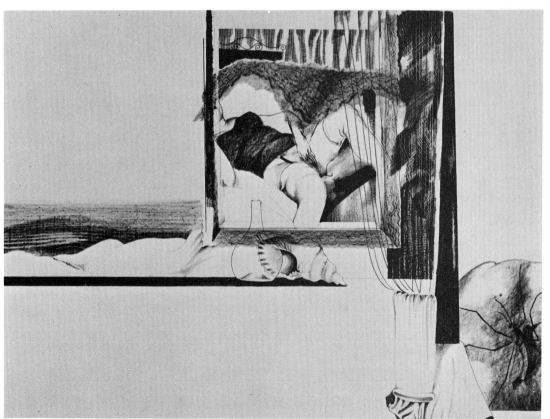

*Boris Vansier (Switzerland, of Russian origin), three works
from the series "Les Offrandes." 117—"La Montagne St. Gen-
eviève," collage imprégné. 118—"Plein Soleil," collage im-
prégné. 119—Collage imprégné.*

117

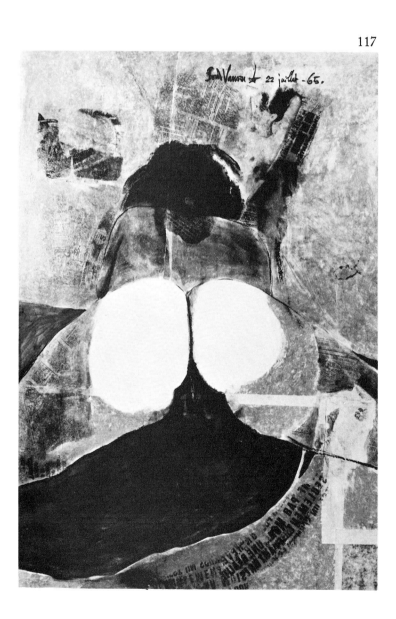

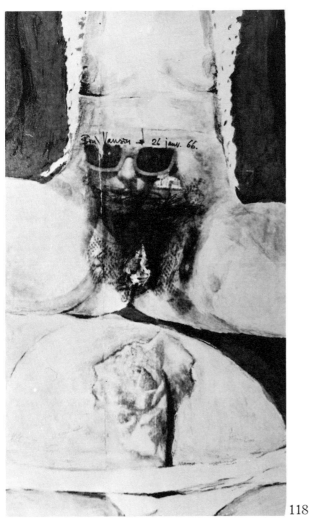

118

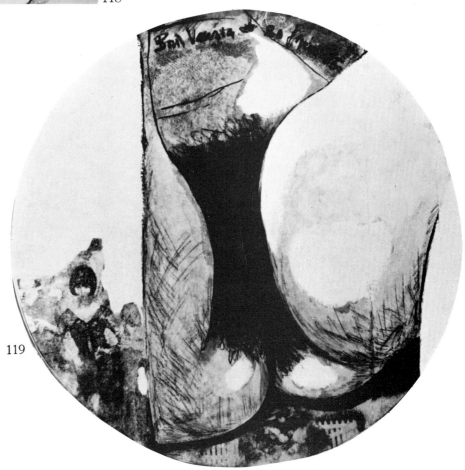

119

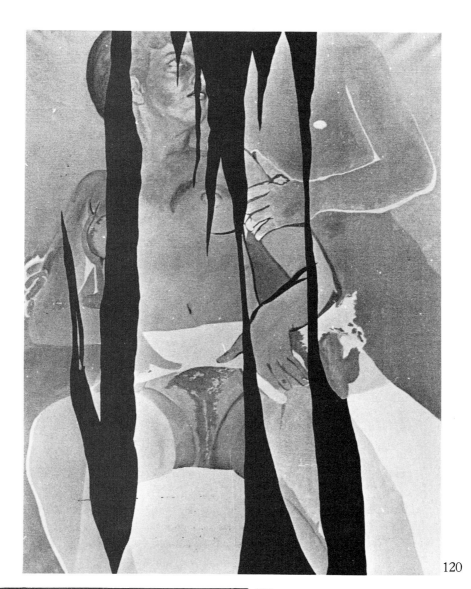

120

121

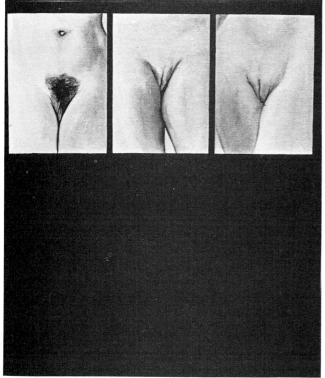

122

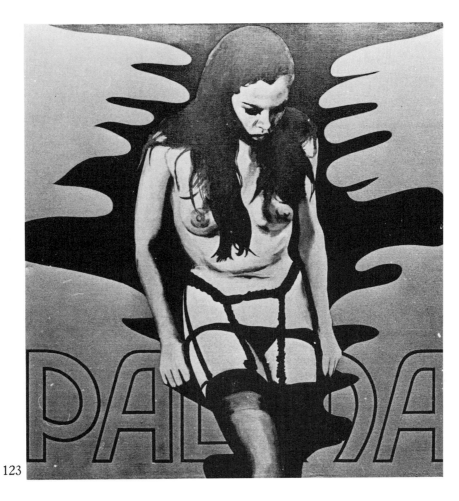

123

120–121—David Rubello (U.S. and Denmark), oil on canvas. 122—Arthur Köpcke
(Germany), oil and collage on cardboard. 123—David Rubello, oil on canvas. 124—
Heimrad Prem (Germany), oil on canvas.

124

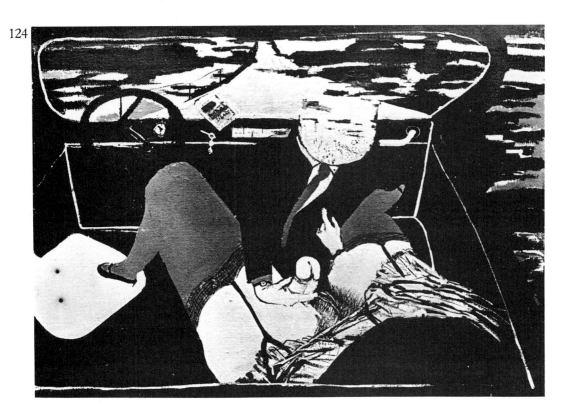

125

125—Harold Stevenson (U.S.), oil on canvas. Courtesy Gallery Iris Clert, Paris. 126—Jan Lebenstein (Poland and France), oil on canvas. 127–128—Jan Lebenstein, ink drawings.

126

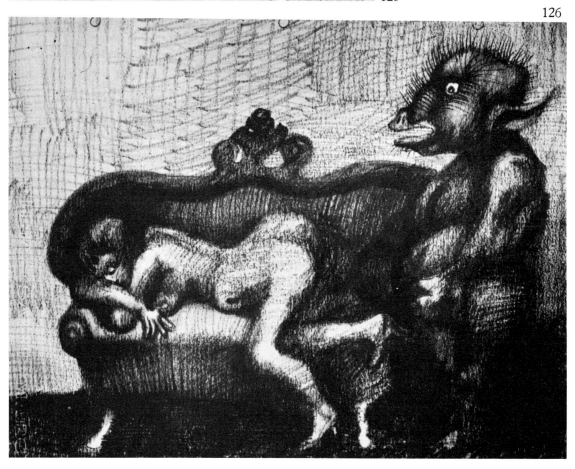

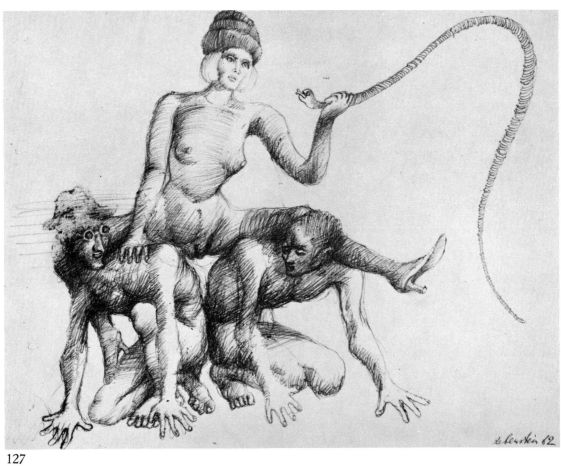

127

128

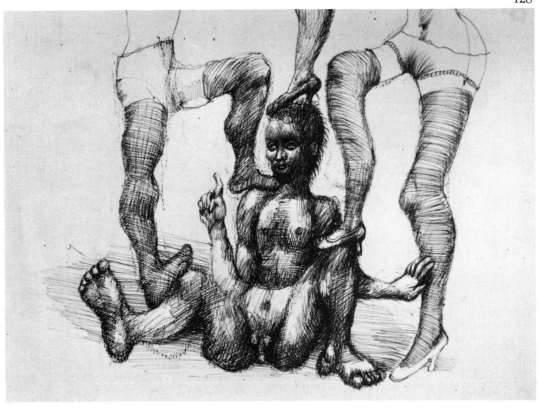

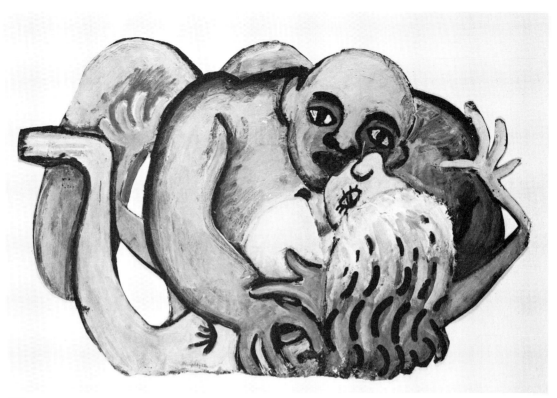

129

130

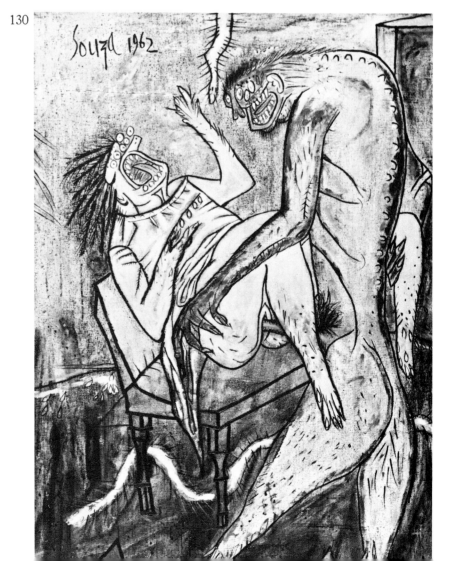

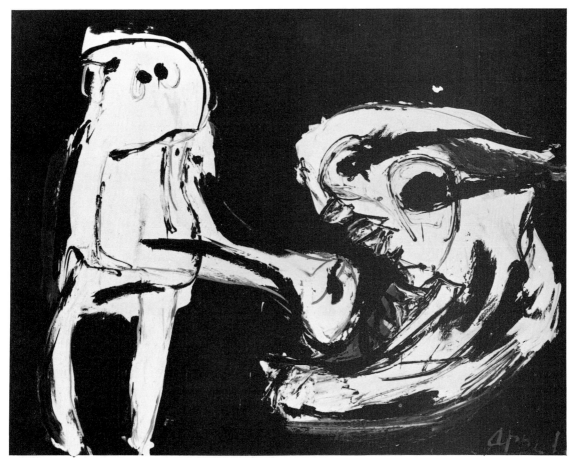

131

132

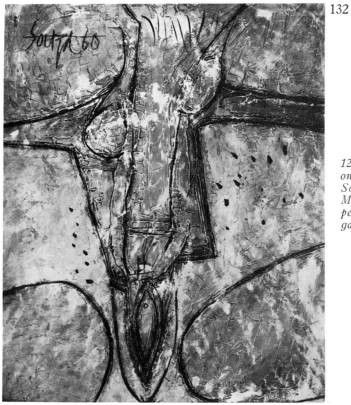

129—Phyllis Yampolsky (U.S.), acrylic on paper; photo: Peter Moore. 130—F. Souza (India and England), "Fall-out Mutation," oil on canvas. 131—Karel Appel (Holland), ink. 132—F. Souza, "Lingam and Yoni," oil on composition board.

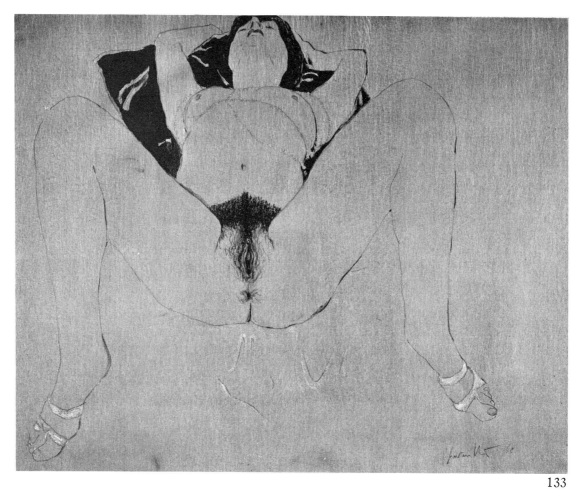

133

134

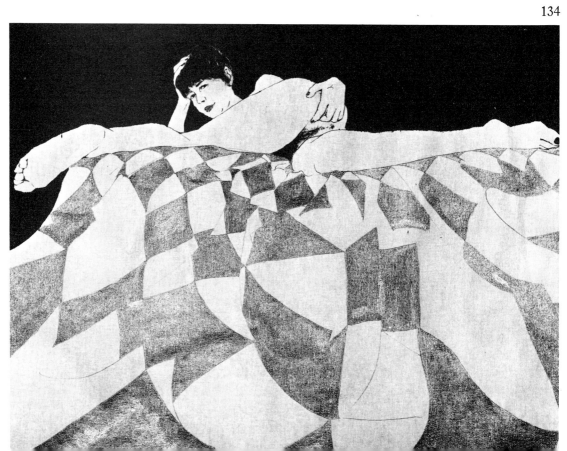

135

133–135—*Cesare Peverelli (Italy and France), tempera on crepe paper.*
136—*Ron Ronarong (Thailand), oil on canvas.*

136

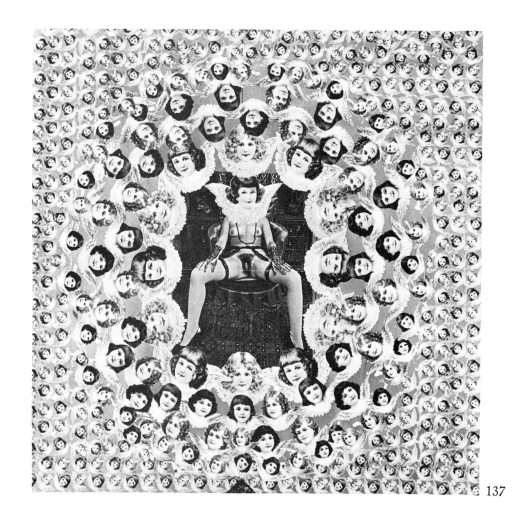

137

138

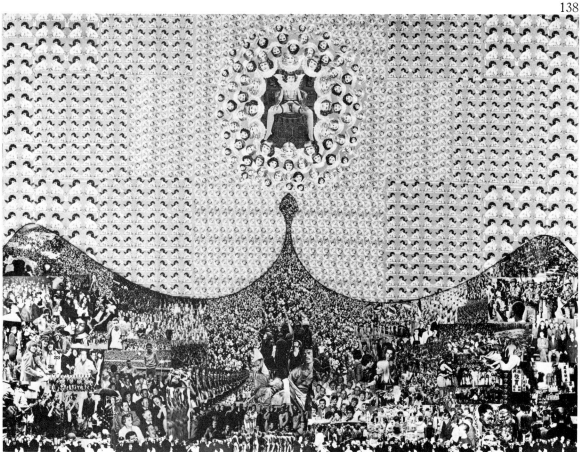

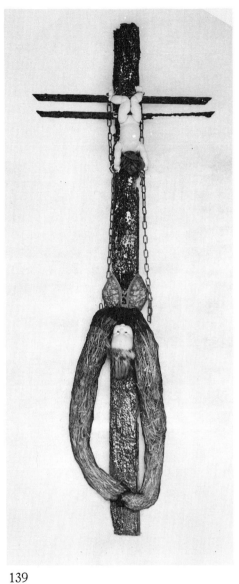

139

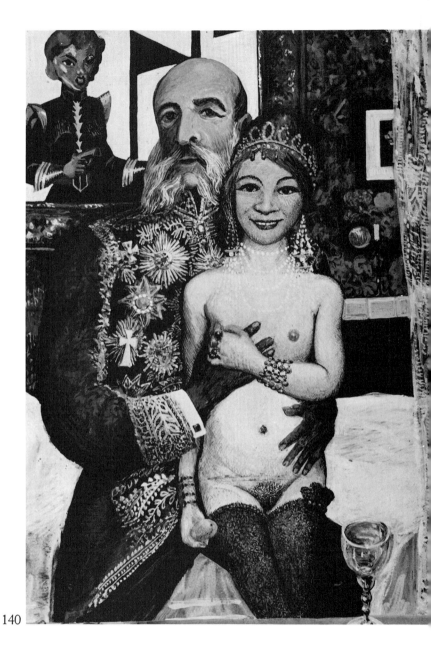

140

137—*Leif Norman (Sweden), detail from "Good Heavens!" 138—Leif Norman, "Good Heavens!" collage. 139—Carmen (U.S.), "Crucifixion of Woman," construction; childbirth seen as the crucifixion of woman, who gives up her personal life for her child. 140—Norman Rubington (U.S.), self-portrait, watercolor.*

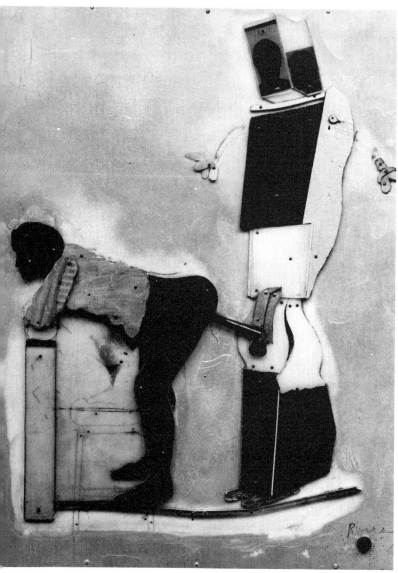
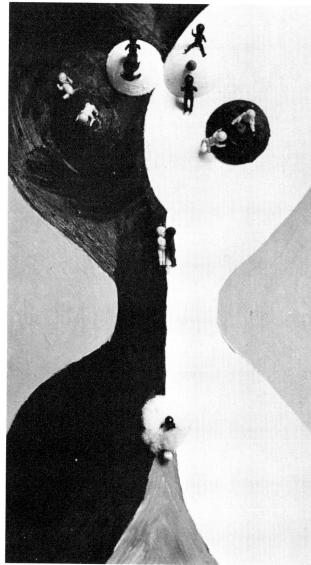

141 142

141—Larry Rivers (U.S.), "Lampman Loves It," construction; heads and genital area light up by depressing button. 142—Carmen (U.S.), "Integration," oil on wood. 143—Carmen, "The Obscenity of War," construction. 144—Peter Alvermann (Germany), "Rolling into the Future Without Love or Sorrow," object.

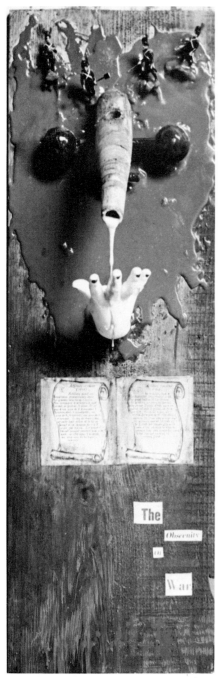

143

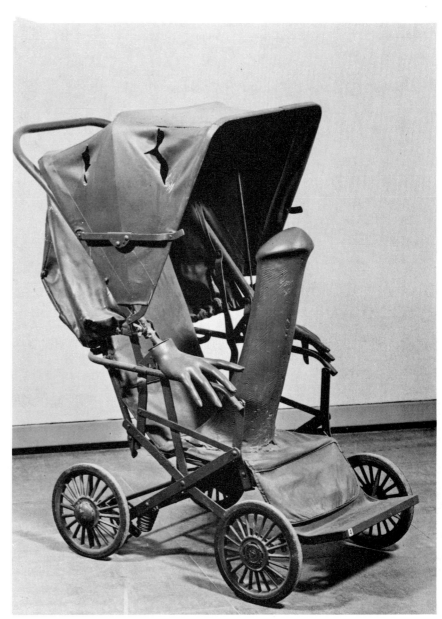

144

145

146

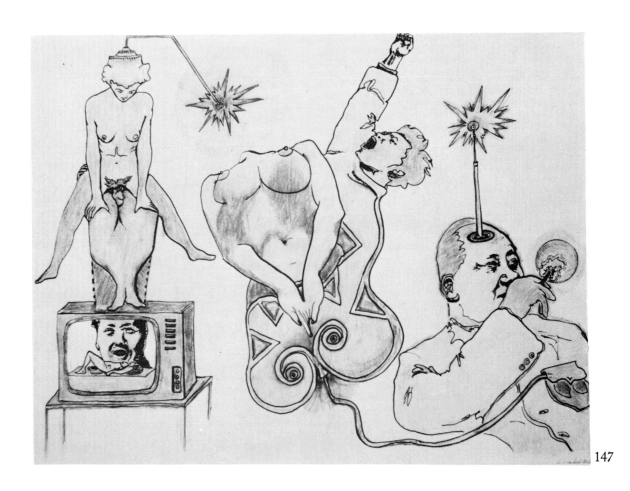

147

145—Jacques Varnasky (Argentina), Fascist salute, ink. 146—Coudenhove Kalergi (Germany), "Geheime Reichssache" (Secret Affair of State), ink. 147—Jean Jacques Lebel (France), "How Mao Controls the World," colored drawing. 148— Jean Jacques Lebel, international sex network, colored drawing.

148

149 150

149–150—J. Dubuffet (France), lithographs, illustrations from his book La Bonne
Femme à Beber. *151—Max Walter Svanberg (Sweden), painting.152—Phrabashar
Barwe (India), ink.*

172

151

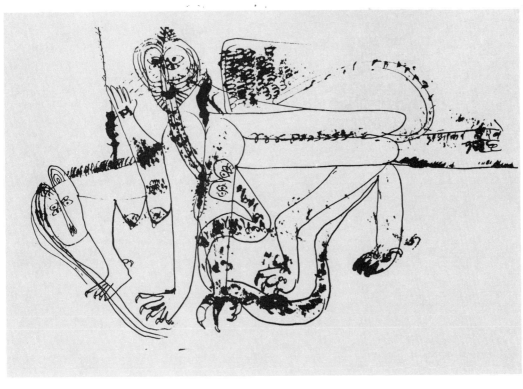

152

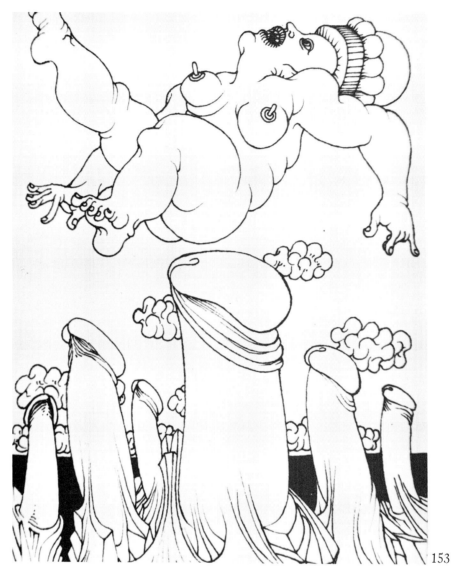

153

154

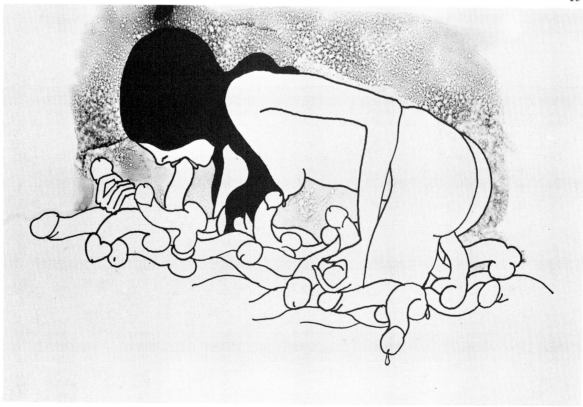

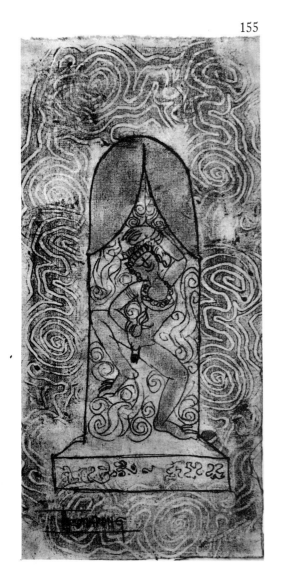

155

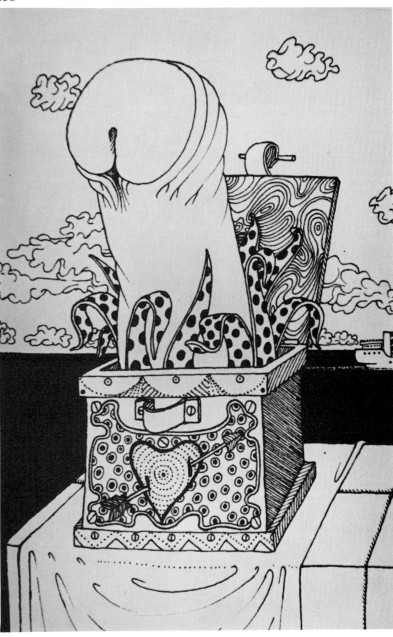

153—Ramon Alejandro (Cuba), "Phallic Island," ink. 154—Tomi Ungerer (France and U.S.), ink. 155—Ron Ronarong (Thailand), "Sivaling" (Siva dancing on lingam), oil on cloth. 156—Ramon Alejandro, "Jack-in-the-Box," ink.

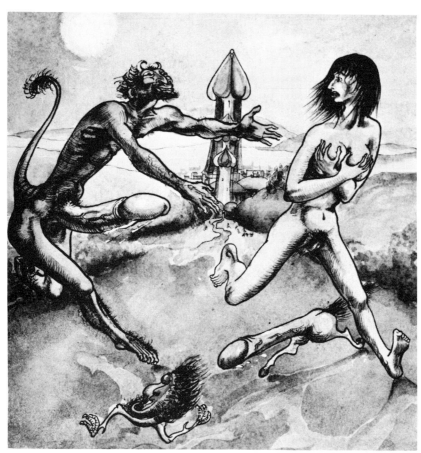

157

158

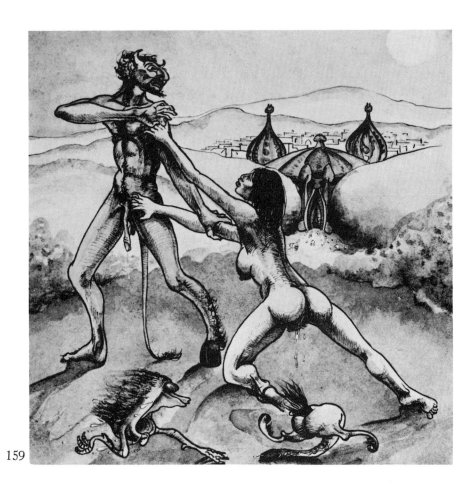

159

157–160—Ulf Rahmberg (Sweden), watercolors.

160

Home Movie: Afternoon / 8mm Brassaï 161

162

178

163

161—*David Wilton (U.S.), "Home Movies," ink. 162—J. Wesley (U.S.), "Legitimate Intercourse," liquitex on paper. 163—Ulf Rahmberg (Sweden), colored ink. 164—Mateos (Portugal), political commentary, drawing.*

164

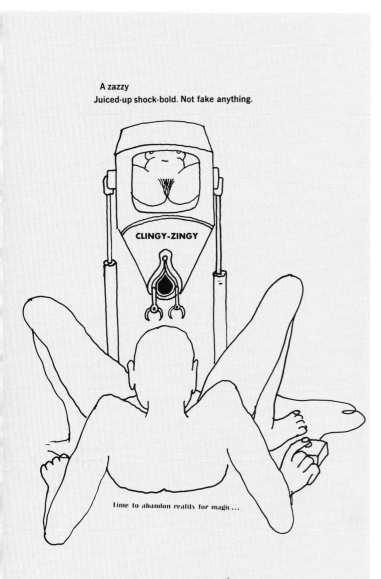

A zazzy
Juiced-up shock-bold. Not fake anything.

CLINGY-ZINGY

Time to abandon reality for magic...

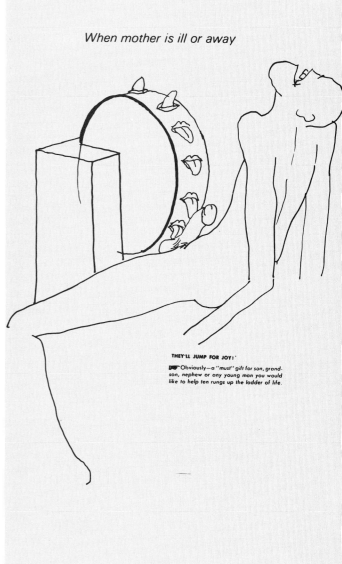

When mother is ill or away

THEY'LL JUMP FOR JOY!
☞ Obviously—a "must" gift for son, grand-
son, nephew or any young man you would
like to help ten rungs up the ladder of life.

165 166

165–167—Tomi Ungerer (U.S. and France), prints.
168—Carl Magnus (Sweden), ink.

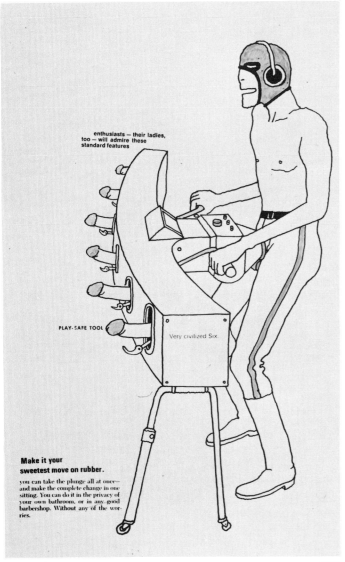

enthusiasts — their ladies,
too — will admire these
standard features

PLAY-SAFE TOOL

Very civilized Six.

**Make it your
sweetest move on rubber.**

you can take the plunge all at once—
and make the complete change in one
sitting. You can do it in the privacy of
your own bathroom, or in any good
barbershop. Without any of the wor-
ries.

167

168

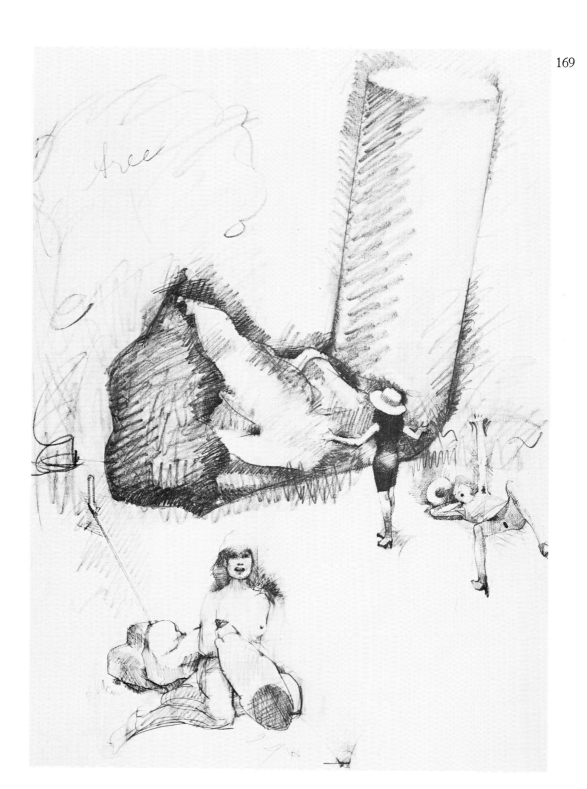

169—Claes Oldenburg (Sweden and U.S.), "Colossal Fagend, Dream State," 1967, pencil. Collection Alfred Ordover; courtesy Sidney Janis Gallery; photo Geoffrey Clements. 170—Claes Oldenburg, "Clinical Study, towards a heroic-erotic monument in the academic/comics style," 1965, pen; photo: Nathan Rabin. 171—Jan Lebenstein (Poland and France), ink and tempera.

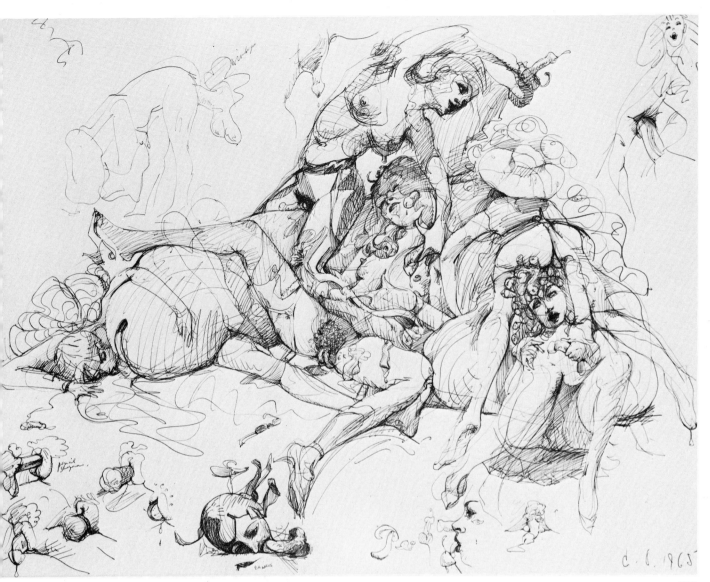

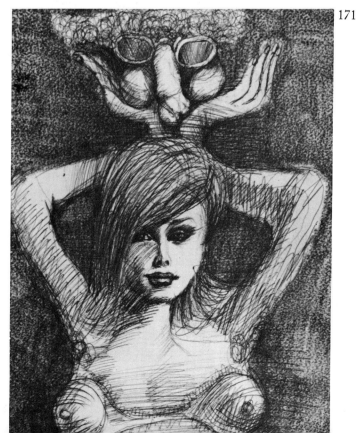

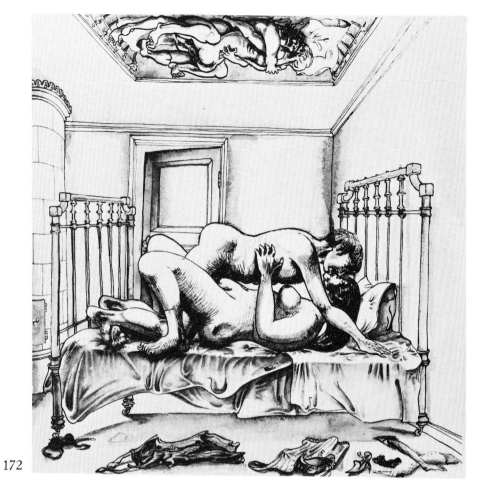

172

172—Ulf Rahmberg (Sweden), ink and watercolor. 173—Ulf Rahmberg, oil on plywood; sections open on hinges to show inside of anatomy. 174—Barbara Nessim (U.S.), watercolor. 175—Enno Hallek (Sweden), "Gagarin's Orbit," oil on canvas.

173

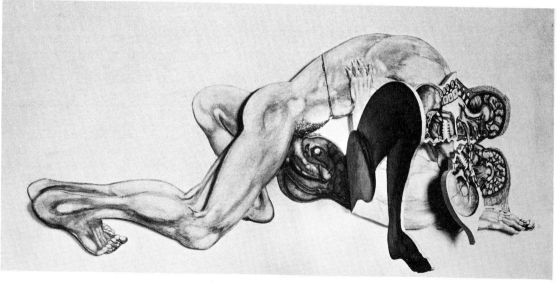

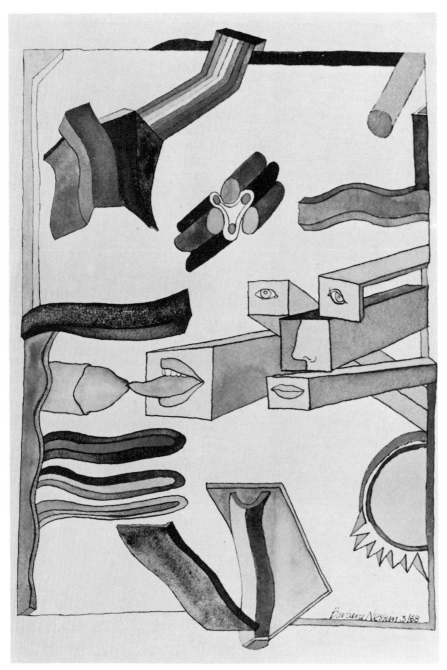

176

177

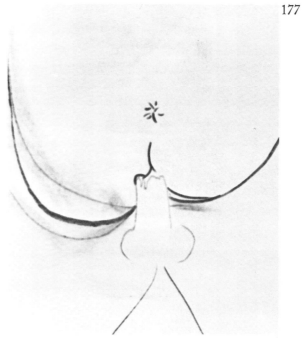

178

176—Andy Warhol (U.S.), "Rape in ★★★★," silk screen. 177—Miles Forst (U.S.),
"Birthday Cake," pencil. 178—Miles Forst, ink and colored crayon. 179—Robert
Stanley (U.S.), silk screen.

179

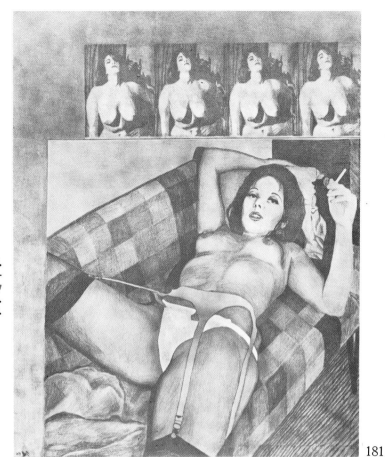

180—Charles Stark (U.S.), pastels.
181—James Gill (U.S.), "Candy-
Apple Chicks," painting. Courtesy
Landau-Allan Gallery, New York.
182—Charles Stark, oil on paper.

181

182

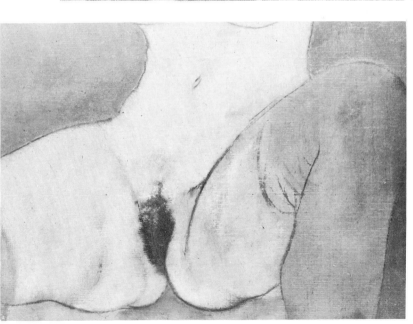

189

183—J. Wesley (U.S.), "Honeypot," ink. 184—Lothar Fisher (Germany), painted ceramic. 185—Otto Dressler (Germany), "Sitzbild No. 1," foam rubber pillow. 186—Otto Dressler, "Sitzbild No. 2."

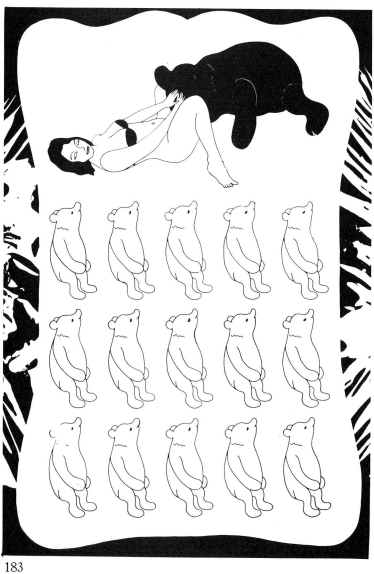

183

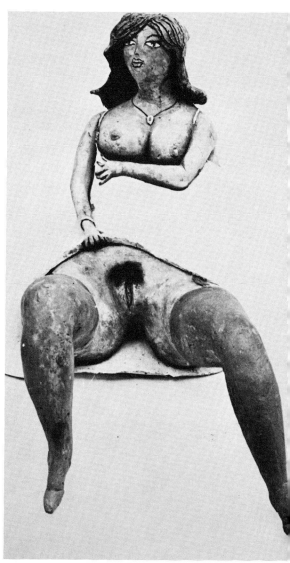

184

185

186

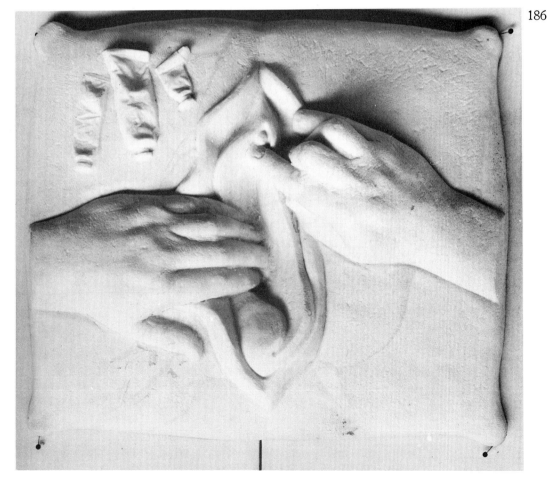

187

188

187—Man Ray (U.S.), "Paperweight for Priapus," silver object on marble base. Collection Mme. J. Krebs, Brussels. 188—Andy Warhol, silver balloon; photo: Billy Name. 189—Britt-Ingrid Persson (Sweden), painted ceramic. 190—Tajiri (U.S., of Japanese origin), bronze.

189

190

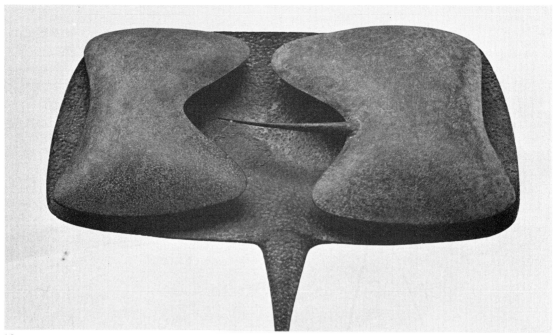

191

192

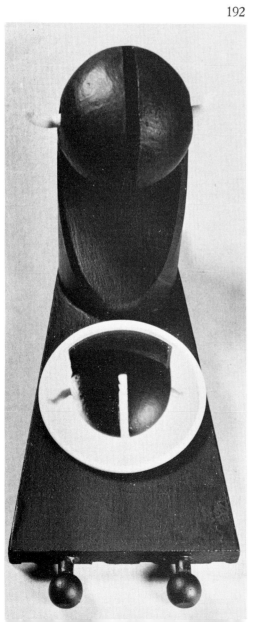

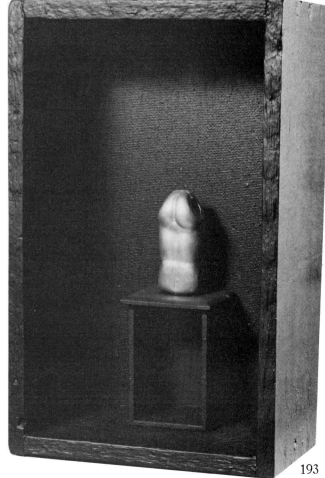

193

191—*Hiquely (France), mobile bronze; the two upper sections are made to vibrate in unison when manually set in motion. 192—Marek Piasecki (Poland), construction. 193—Marek Piasecki, construction, 1935. 194—Lothar Fisher, bronze. 195—Tajiri, bronze.*

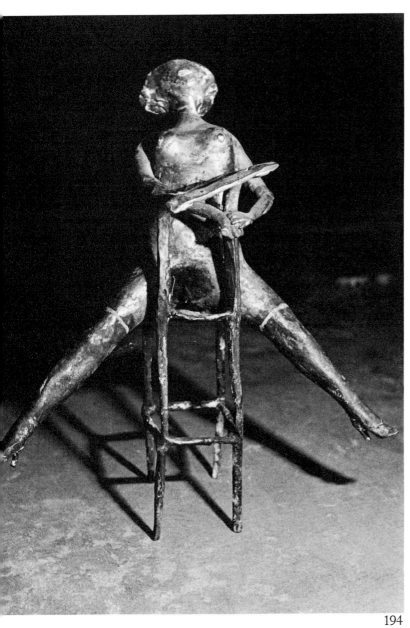

194

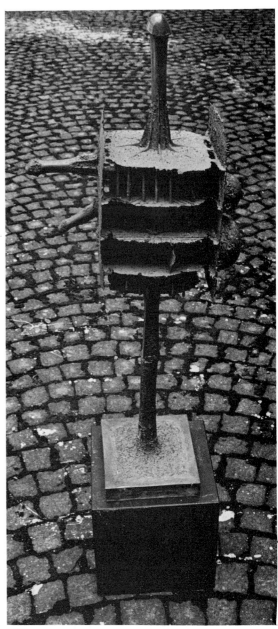

195

196

197

196—Liss Erikson (Sweden), "The Swinging Couple," bronze. 197—Alfred Aschaur (Germany), "Paar," bronze, 1966. 198—George Segal (U.S.), "The Legend of Lot," sculpture; courtesy Dwan Gallery, Los Angeles, Calif. 199—Lothar Fisher, bronze.

198

199

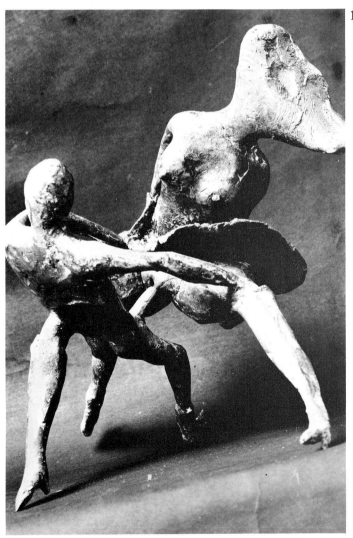

200—Borge Sornum (Denmark), "Memoirs of a Mannequin," construction and oil paint. 201—Bror Hjorth (Sweden), wood sculpture. 202—Bror Hjorth, wood sculpture, 1935. 203—Christina Martínez (Argentina), papier-mâché.

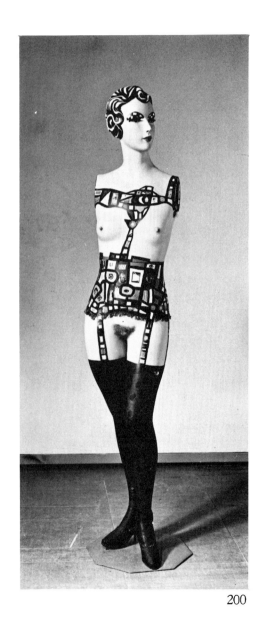

200

201

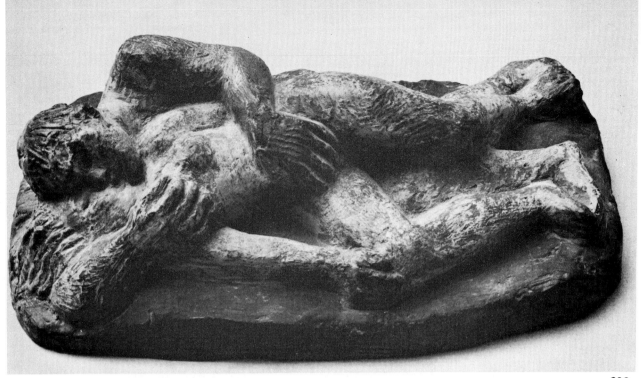

202

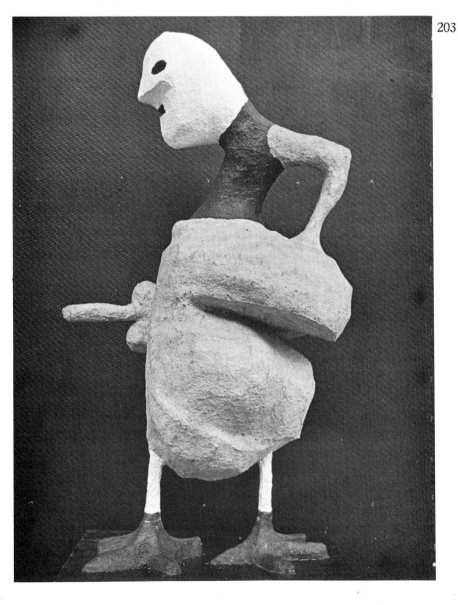

203

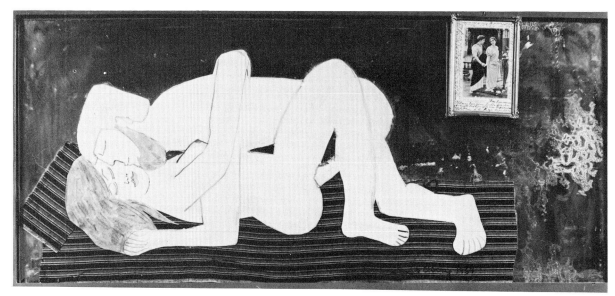

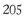

204—Kerstin Apelman Öberg (Sweden), collage on mirror. 205—Carl Fredrik Hill (1849–1911; Sweden), colored crayon. 206—Bror Hjorth, oil on canvas, 1952. 207—Carl Fredrik Hill, colored crayon.

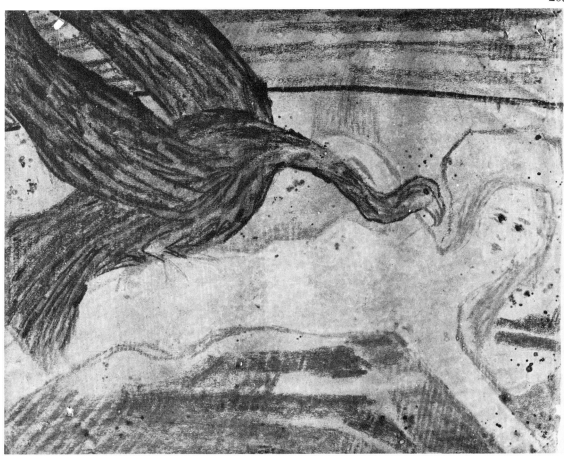

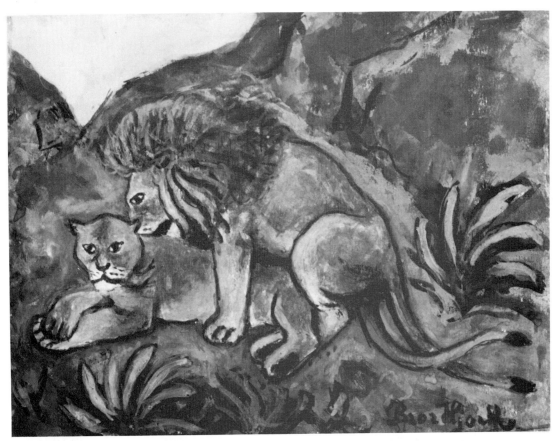

206

207

208—Guy Harloff (Holland), female symbol, gouache, Paris, 1960. Collection Philippe Heinich. 209–210—Watercolors on paper by a prisoner in an institution for the criminally insane. (U.S.)

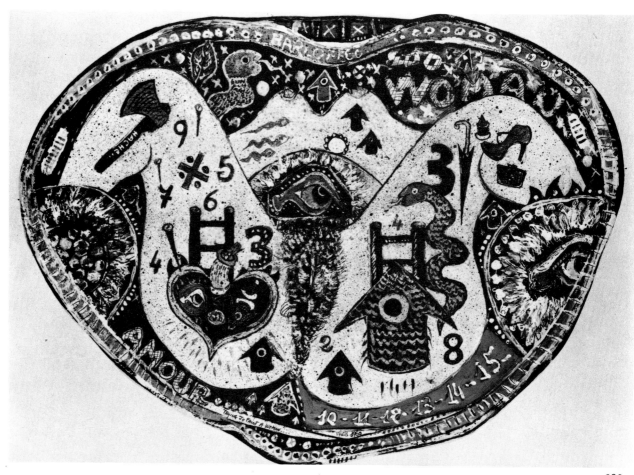

208

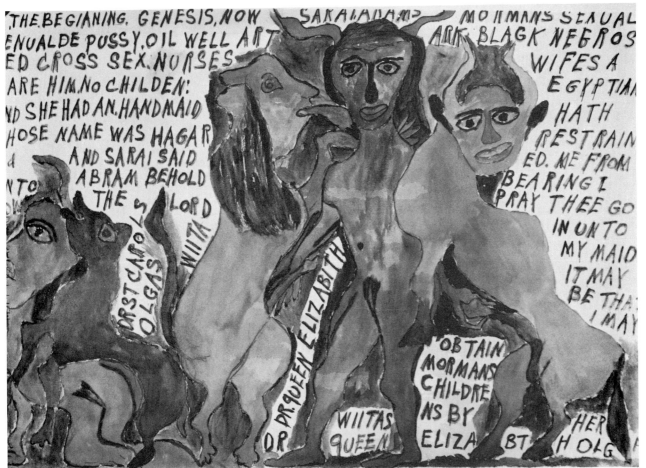

PRIMITIVE ART

Representations of sexual subject matter are not infrequent in primitive art. For the most part, however, they are not intended to be mental aphrodisiacs or sex images as such, but, rather, are made as fertility symbols or for fertility magic. This does not mean that some of these pieces do not have a definite libidinal or erotic appeal, but if so, it is purely incidental.

All of this applies to a much lesser extent to the erotic ceramics of the ancient Chimú and Mochica cultures of Peru, dating mostly from the third century B.C. Their artistic specialty was sculptural ceramics, more often than not of a utilitarian function, a craft in which they achieved a degree of perfection unequaled by any other culture.

These early inhabitants of the fertile Chicama and Mohi valleys of Peru seemed to have a truly natural and uncomplex attitude toward sexuality. This is reflected in the extraordinary clay objects which they either shaped or decorated with a wide variety of sexual motifs, ranging from representations of the human genitals to a Kinseyian list of sexual activities, both human and animal, including masturbation, exhibitionism, oral-genital contacts, and every possible (and impossible!) form of intercourse.

We had in the exhibition two or three fine examples of Mochica ceramics, one a water or tea pot, depicting a fellatio scene (Fig. 229), and a smaller, perhaps less utilitarian vessel in the form of two copulating animals (Fig. 227).

The "erotic" art of Africa consists mainly of two types of objects: the large wooden fertility figures, either male or female, with prominent, exaggerated genitals (see Fig. 216), and the many small wooden sculptures and bronzes of couples in intercourse positions (Fig. 232).

Curiously enough, the latter are frequently fashioned of thinly rolled metal (iron or bronze) with the figures giving the impression of being stick-men and -women—abstractions rather than real flesh-and-blood humans (Figs. 232–33). For the same reason, they strike one, as is true for so much of primitive art, as strangely modern in concept and execution.

What these little African intercourse figures were originally meant for is still another question. The later ones are undoubtedly influenced by the West and perhaps even manufactured with an eye to the tourist trade. But similar figures were known to exist long before the new commercialism became a factor in Africa. It is therefore safe to say that they used to serve (and to a certain extent still serve) other, more genuine aims, such as protective and good-luck idols for the home.

We were fortunate enough to be able to present an unusual group of erotic wood carvings from Tahiti which, though contemporary, are quite representative of the South Pacific area in style and general feeling (Figs. 221–22). They very closely resemble the often life-sized, carved *Tikis* which are characteristic for many of the island cultures, including Hawaii, and which undoubtedly once featured the human genitals, until Western influence brought about their gradual de-sexualization.

It is also certain that in both the Pacific area and Africa, artifacts with sexual symbolism and even naturalistic sexual representations played an important role in initiation ceremonies and in the ritual of the many secret societies. In that sense, they probably also served sex-educational functions, similar to the erotic dances of natives which are frequently more or less direct re-enactments of human sexual activities.

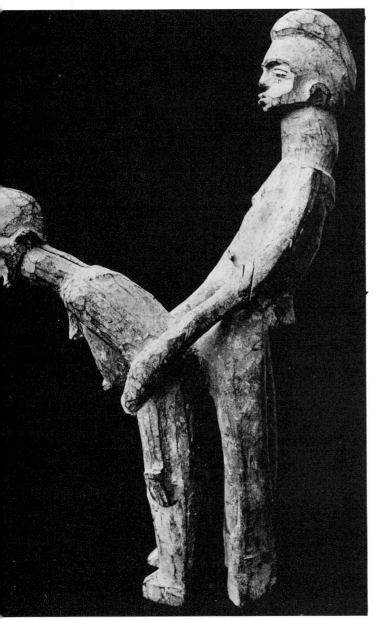

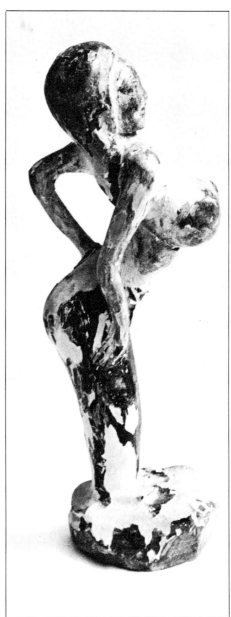

211 212

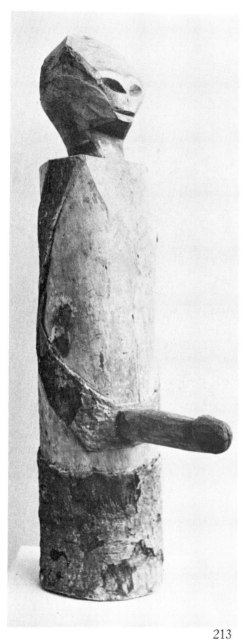

213

214

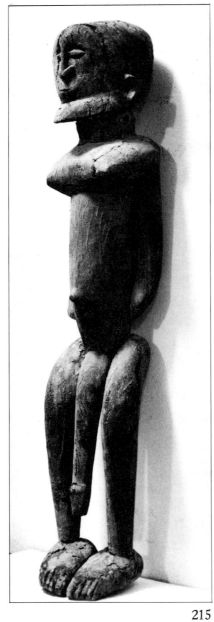

215

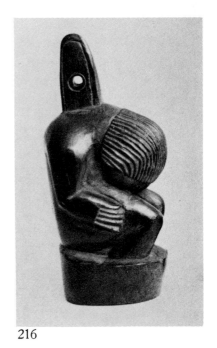

216

213—*Wooden grave figure; Madagascar.* 214—*So-called "Double Cocoanut," found in Indian Ocean area; frequently used as fertility cult object because of its natural resemblance to the female genitalia.* 215—*Wood statue; Ivory Coast; note the elongated phallus and hermaphroditic breasts. Collection Charles Ratton, Paris.* 216—*Wood sculpture; Bali.*

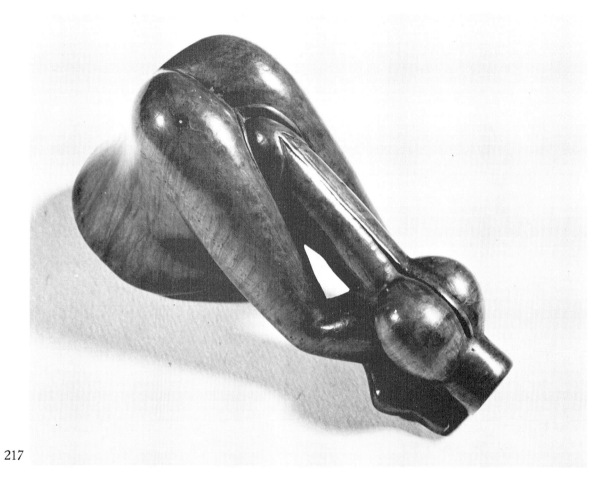

217

218

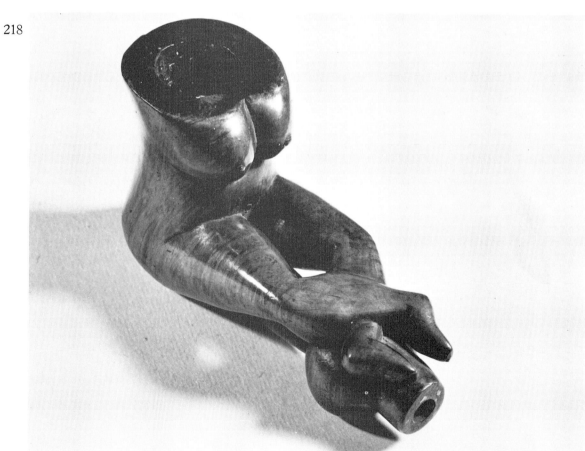

217–218—Wooden pipe (two views); probably of European origin; ca. 1900. 219—Fertility figure of pregnant woman; Bali. 220—Humorous phallic figure from the Philippines; contemporary.

219 220

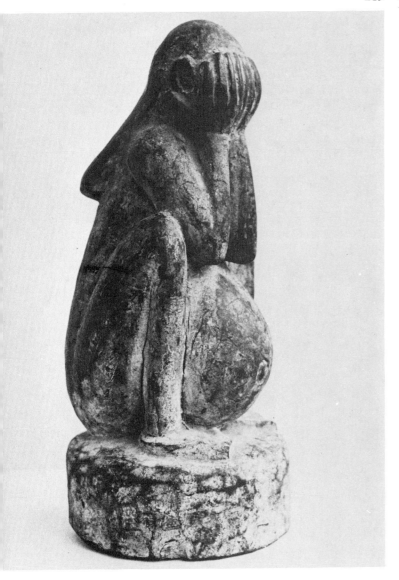 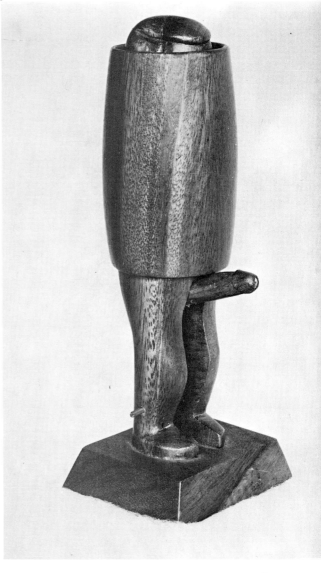

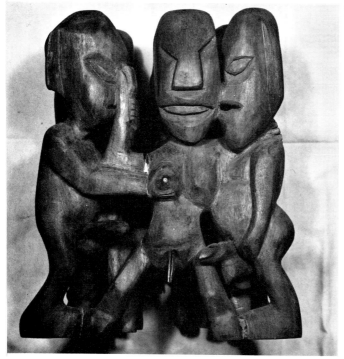

221

223

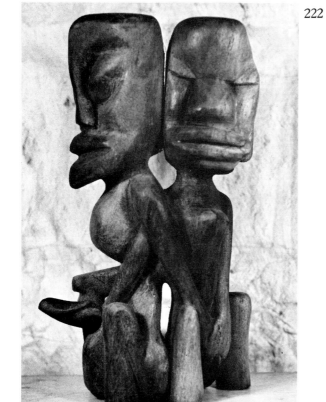

222

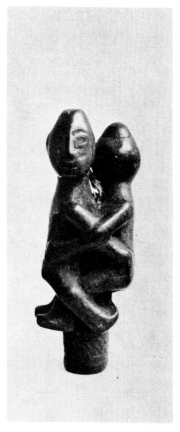

224

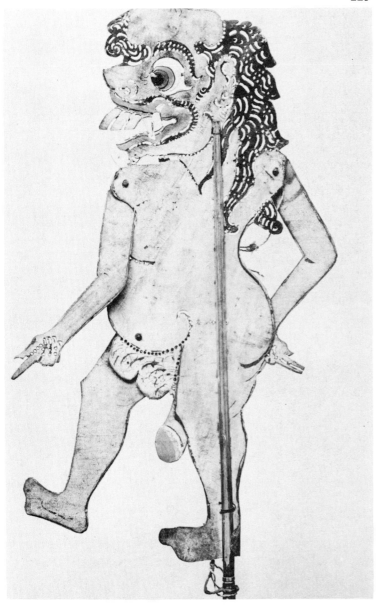

*221–222—Wood carvings; Tahiti; contemporary. 223—Wedding pipe; Kentucky.
224—Wood sculpture; Congo. 225—Humorous phallic demon; animated puppet for
shadow plays, made of rawhide; Bali. 226—Silver figures (male and female);
Peru; contemporary, based on an ancient design which allows the figures to be
united in various positions.*

227

228

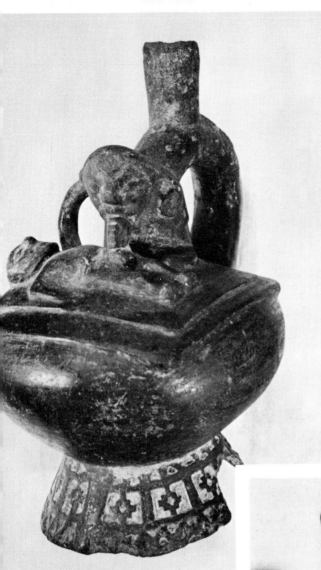

227—*Peruvian (Mochica) pottery, ca. 300 B.C. 228—Phallic terra cotta, probably Roman period from Near East region. 229—Peruvian (Mochica) pottery; ca. 300 B.C. 230—Mexican terra cotta figure; third or fourth century B.C.*

229

230

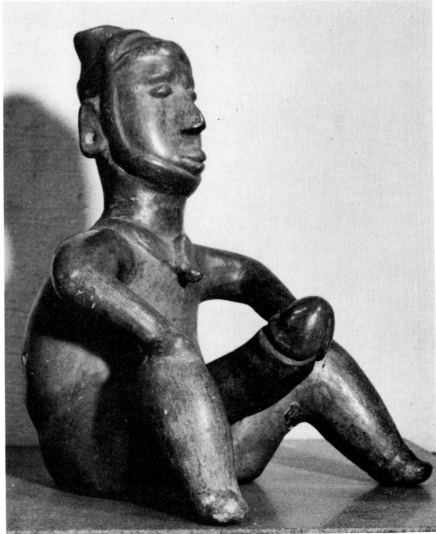

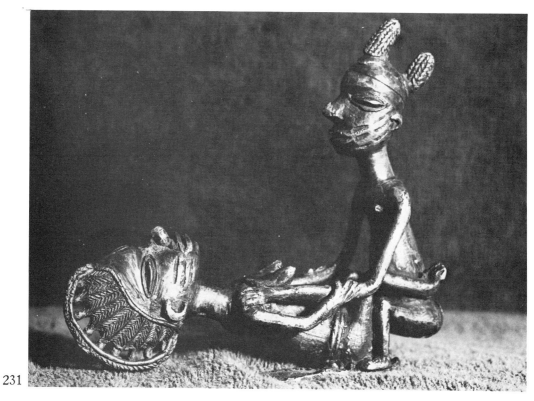

231

231—Bronze; Central Africa; note tribal scarification on the cheeks and the characteristic hairdress of the region. 232—Two bronze figures which can be fit together in intercourse position; Ivory Coast. 233—Bronze figure; Ivory Coast.

233

232

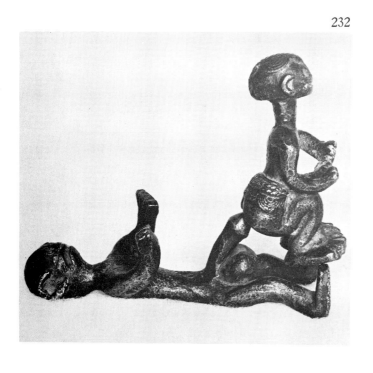

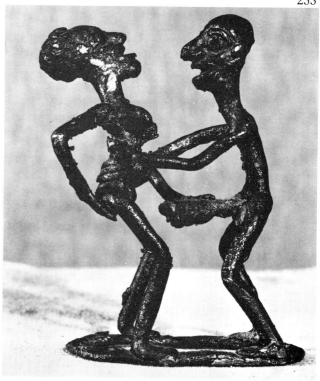

INDIA

"Inserting his organ into the mother's womb, pressing his sister's breasts, placing his foot upon his guru's head, he will be reborn no more."

Irreverent and sacrilegious as this quotation may seem, it is a sacred passage from tantric Hindu scripture and essential to the understanding of Indian erotic art. To decode it, we have to analyze each of its constituent parts: the "organ" represents the contemplating mind; the "mother's womb" is the base center of the yoga body; the "sister's breasts" are the heart and the throat center, respectively; and the "guru's head" is the brain center. Thus, the hidden meaning of the tantric text emerges as something like: He practices mental penetration through the successive centers, and when he reaches the uppermost center, he will not be reborn, as he has thereby attained nirvana.*

In tantric tradition, the sexual symbolism stands for certain cosmological and philosophical principles. The same holds true for representations in Indian, Nepalese, and Tibetan art of the god Siva with his consort or shakti in the act of sexual intercourse: the physical act of copulation is used to represent the principle of polarity between the static and the dynamic aspects of life. In Tibetan and Nepalese religious thought, it is the male who is thought of as embodying the dynamic principle, whereas the Hindu pundit considers the dynamic element or power and energy as essentially feminine in nature.

Looking at the typical representation of the gods in the sexual act—with the male divinity seated in the lotus position with legs crossed beneath him and his shakti astride him on his lap— one gets indeed the impression that they represent more the Hindu than the Buddhist (Tibetan) point of view. At any rate, it is hard to imagine the male being very active in that position, while his female consort, on the contrary, has every possibility for vigorous movement. However, one could perhaps say that the fierce expression of the male on many of these images reflects the Tibetan-Buddhist point of view in conveying an intense dynamism which is beyond mere physical movement.

Hindu erotic tradition never fails to include descriptions of sexual intercourse in which the female partner takes the active part, that is, *maithuna viparita,* or obverse intercourse. Likewise, the phrase "dancing upon the [male] lover" occurs already in very early Indian literature and refers to intercourse with the woman atop the man, her feet planted upon his chest.

The active male sex dynamism has been well expressed by a Buddhist writer: "Soon after he has embraced his female partner, inserted his organ into her vulva, drinks from her lips sprinkled with milk, makes her speak cooingly, enjoys rich delight, and makes her thighs quiver, man's true nature will become manifest." The Hindu notion, on the other hand, of the male being identified with the inert, passive principle, is brought out in the oft repeated theme of Siva being the goddess's mattress, or her footstool. However, one must not forget that in Hindu art and writing one frequently finds hermaphroditic representations of Siva/shakti, that is, "the Lord who is half woman."

Thus, the Siva/shakti figure represents to the initiated both the cosmos and the process of its evolution, as another tantric verse beautifully expresses: "You [shakti] are the body of Siva with the sun and moon as your pair of breasts, your self I take to be the flawless self of Siva, O Blessed Lady; hence as you reciprocally realize each other as complement and essence, this union exists of you two experiencing supreme bliss with equal savor." Here the feminine principle, or shakti (power), personified as the goddess Devi, is the first and supreme principle of the universe. It includes both the spiritual and the material world and comprises therefore both the soul and the physical body of man.

*For our source on tantric symbolism we are following Agehananda Bharati's learned discussion, *The Tantric Tradition* (London: Rider & Co., 1965).

We have gone into these matters at some length, because it is impossible to understand Indian erotic art—and even Chinese and Japanese erotic art, which has been influenced by tantric thought—without being aware of these things. The erotic temple sculpture of India represents to our minds an acceptance of physical sexuality, or, one may say, the erotic temple sculpture of India parallels tantric philosophy and expresses it as physically acted-out sexuality.

We take this to be the reason why Indian erotic temple sculpture is so incredibly pure and innocent even in its most outrageous representations. It never works on the principle of taboo or the forbidden and is therefore the only kind of erotic art which is totally beyond any hint at prurience. In fact, these very frank erotic representations were to show the worshiper that true inner peace and sainthood could not be achieved by denial and rejection of the physical, but by its transcendence. To transcend the purely physical, one must first fully accept and embrace it; to go beyond the world of the senses, one first has to be able to exercise them to one's utmost capacity.

Likewise, by worshiping the invisible through the visible, and the spiritual through the physical, the Hindu devotee could abandon himself to sexual pleasure in the same sense that the modern hippie aims to expand consciousness through hallucinogenic drugs and other means. Using sex as a means of transcendence, he would "go out," in the same sense as one may speak of "going out" on drugs, and through sexual union find union with something greater than himself.

Somehow the Hindu artists have managed to convey this ultimate oneness of the spiritual and the carnal in the erotic temple sculpture of Khajuraho and Konarak. In Khajuraho (about an hour's flight from Delhi), the temple sculpture dates from the ninth to the thirteenth century and exceeds in our opinion, in artistic quality and impressiveness that of the slightly later (thirteenth century and on) sculpture of Konarak, south of Calcutta.

Indian erotic temple sculpture is unique in its pervasive sensuousness. It combines the most languorous sensuality with the most intense sexual passion, without ever losing a strong sense of tenderness. This is true even for those scenes which show the kind of sexual behavior which is perhaps most foreign and least acceptable to the Western mind, such as sexual contacts between humans and animals, homosexuality, and various combinations of sexual contacts, involving a number of participants simultaneously. The Indian artists have, however, succeeded in expressing even these aspects of sexuality in the same spirit of uninhibited openness and natural acceptance as just so many aspects of possible human sex experience, and therefore they never are shocking or strike one as in the least offensive.

With regard to sexual group activities depicted in these temple sculptures, the following has to be kept in mind: in the first place, plural wives offered an opportunity for such activities; secondly, they represent not just so many orgy scenes, but like the Dionysian mysteries, point beyond the mere physical union to a spiritual oneness of the participants through sexual ecstasy.

There is a similar double meaning to other representations of sexual acts: human contacts with animals, for instance, do not merely portray the physically possible and what we would today call "a slice of reality," but constitute also in this religious setting a silent plea for tolerance and a reminder that all living things are part of one another and that there is a "human" aspect to animals, just as there is an "animal" part to humans. In Hindu mythology, the elephant-god Ganasha is part human, part animal, and part divine. We must also remember that in some Hindu belief, it is possible for humans to be reincarnated as animals and vice versa. This may explain the relative frequency of human/animal contacts in Indian erotic art—a rather rare occurrence in Western as well as Japanese and Chinese art.

This, then, is essentially the message which the silent and yet so eloquent temple sculptures at Khajuraho and Konarak are to convey.

Aside from these temple sculptures, India has produced a wealth of pictorial erotic art. Unlike the erotic art of China and Japan, these Indian erotic paintings are seldom mounted in albums or presented in the form of scrolls that can be rolled up. Rather, they are done as single pieces or groups of pictures, with perhaps the only exception being the narrow palm-leaf books from Orissa, which feature small, cartoon-like illustrations within the hand-painted text.

There is great variety of styles in Indian erotic art, just as there is in Indian art in general, thanks to the extremely heterogeneous nature of its culture. Life is very different along the sun-baked coasts of southern India than in the cool foothills of the Himalayas or in the central plains. So are the customs and traditions of the many ethnographic groups which constitute the human

melting-pot of that vast continent. No wonder, therefore, that in India we find the primitive erotic art of indigenous tribes together with the most refined miniatures of the Mogul style, the gaily decorative and vivacious oil paintings of the south, the airy, single-brush or -pen-stroke drawings of Bengal, and the watercolors of Rajput, etc.

What strikes one perhaps as the most outstanding feature in Indian erotic art is its emphasis on unusual acrobatic positions. The earliest temple sculptures show individuals literally standing on their heads in certain sexual combinations, and this artistic convention prevails throughout the centuries.

Undoubtedly, the reason for this strange emphasis on the unusual or even impossible in Indian erotic art is to be sought in its connection with certain Yoga practices and religious teachings in which these positions assume symbolic significance.

At the same time, the variety of sexual activities depicted was probably meant to assure marital happiness and not infrequently refers to intercourse positions advocated in such Indian sex manuals as the *Kama Sutra* and *Ananga Ranga*.

Different also is the Indian sense of humor. Western erotic humor is often crude and brutal, the laugh being at the expense of someone else. Chinese erotic humor is rare and where it does occur in pictorial form it strikes the Western observer as rather bizarre—a man sticking his penis through a hole in a fence to exhibit himself to a reposing beauty on the other side; a couple facing each other, seated in swings, which are moved back and forth by a female attendant on either side so that their genitals should connect in the middle (or, as a variation on the same theme, a fat bonze, seated in a sling, being pulled back and forth so he can have intercourse with a girl, seated opposite); a reclining nude with a long-stemmed lotus flower stuck in her genitals, and so on. Japanese erotic humor is often a subtle sub-theme in otherwise "serious" shunga, or it is slap-stick as in the famous "phallic contest" and "wind-breaking contest" scrolls.

In contrast, Indian erotic humor is predominantly playful and definitely closer to Chinese than to Japanese sex psychology, as is their erotic art in general. For example, the incident of the couple in the swings is a favorite subject in both cultures. (For the Oriental observer, such scenes are not nearly as "fantastic" as they may seem to the Western mind.)

In Indian erotic art we also find such playful scenes as the woman delicately balancing a bird on her upraised hand or shooting it with bow and arrow (symbolic, of course, of the male ejaculation, "shooting," as of the detumescence, "death," of the penis, "bird," after the act); the man imperturbedly smoking his water pipe during intercourse; a couple perched on top of an elephant, apparently on a tiger hunt, the man shooting at the animal without ever disengaging himself from the girl; the wife, squatting on the floor, combing her fierce warrior-husband's long hair, while enjoying penetration from below by her lover who is lying on his back beneath the floor, taking advantage of a hole in the boards to reach the woman above with his long, erect penis; and many similar subjects.

Still another aspect of Indian erotic art which is extremely rare in other cultures is that it extends not infrequently to the decoration of entire pieces of furniture, doors, and even ceilings with erotic motifs. This may be achieved either through wood carvings or by painting directly on the house furnishings and interiors. Still another specifically Indian feature in erotic art is the wood carving on the sides of ceremonial temple and wedding carts. It is fragments from these carts which one sees most frequently on the antiquarian market, though most of them are recently "antiqued" imitations.

Finally, there exists in India a rich erotic folk art which has no equal in any other culture. It consists mainly of small and medium-sized watercolors, showing couples in various intercourse positions, but with a freshness of concept, a daring in coloration, and inventiveness of style which puts these little gems in a class all by themselves.

All Indian erotic art, however, has one common denominator which makes it entirely unique in the world: its total absence of a sense of "sin," of the forbidden, or the taboo. There is no catering to fetishism, specialties, or deviations. Yet everything is shown, but with a naïveté, innocence, and purity that puts to shame every thought of prurience. This is especially true for the erotic temple sculpture, but permeates to a lesser extent all later Indian erotic art as well. This, to our way of thinking, represents an ideal which will hopefully be re-created and reinterpreted in new forms and new media by the artists of a new generation who will no longer have to appeal to a public that needs the "forbidden" for maximum erotic appeal.

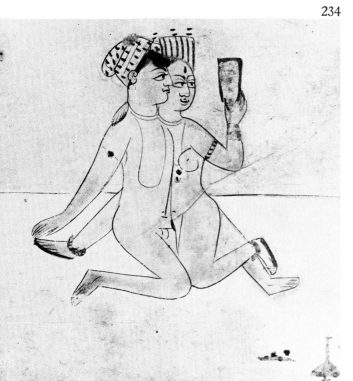

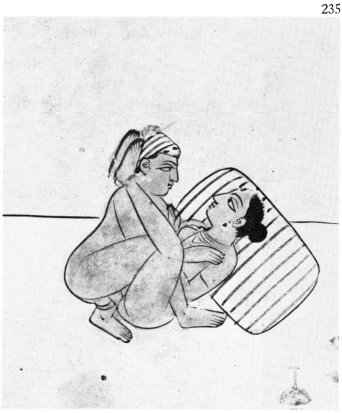

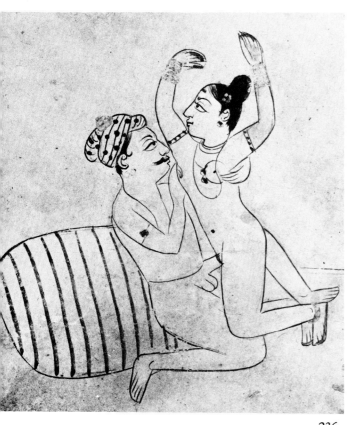

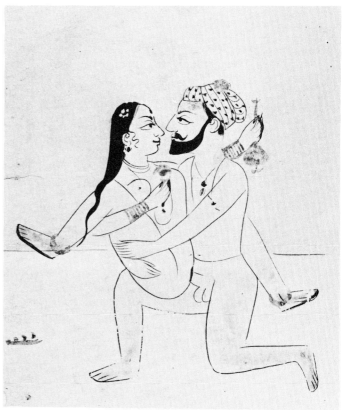

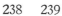

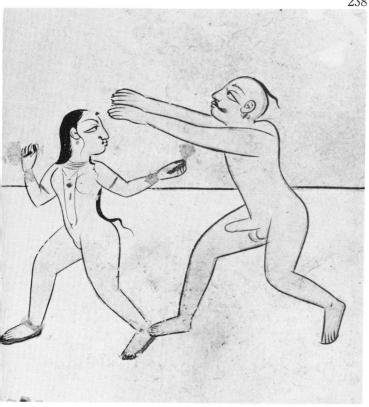

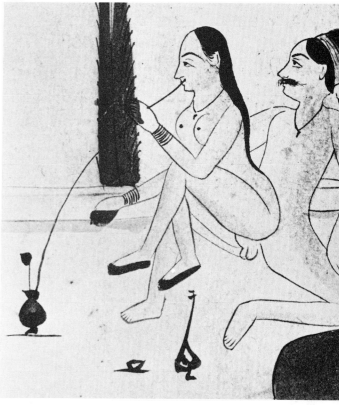

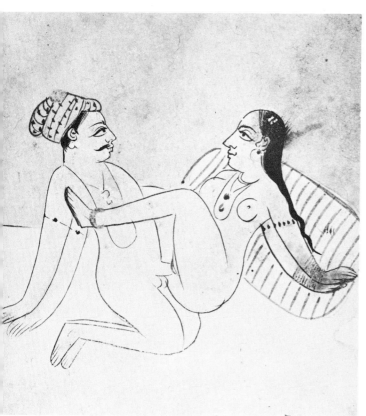

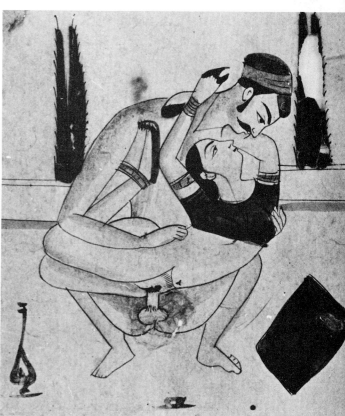

234–241—Miniatures in delicate watercolors on paper; the originals are about one half the size shown here; Central India, mid-19th century.

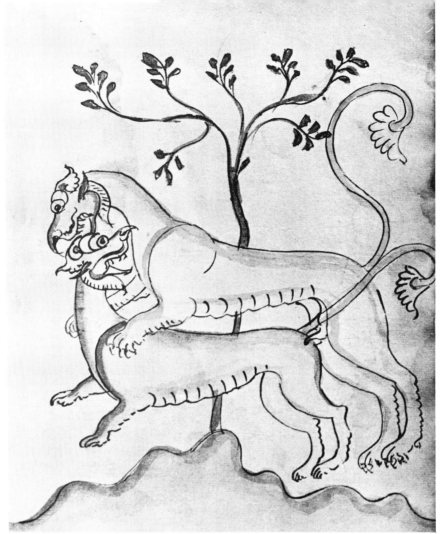

242

243

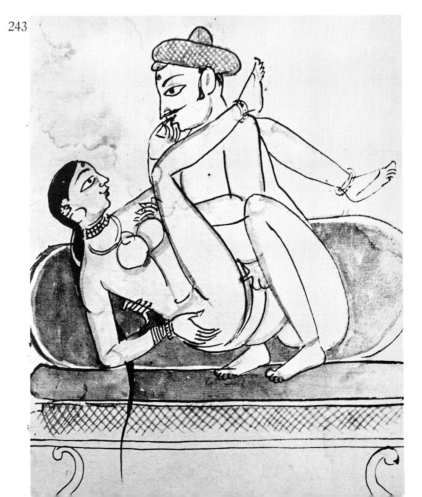

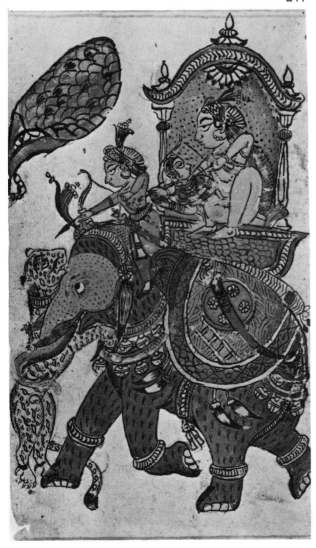 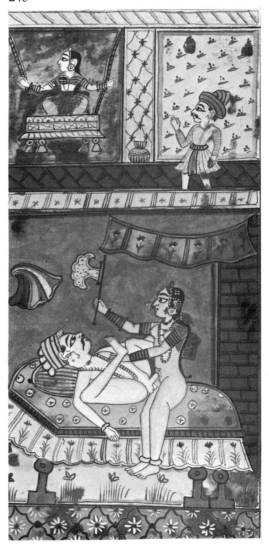

242—*Watercolor, Bengal style, 18th century.* 243—*Ink and watercolor, Central India, 18th century.* 244—*Central India. ca. 1830.* 245—*In this miniature, the woman is fanning her lover during intercourse, a custom which still obtains in certain parts of the East; watercolor, mid-19th century.*

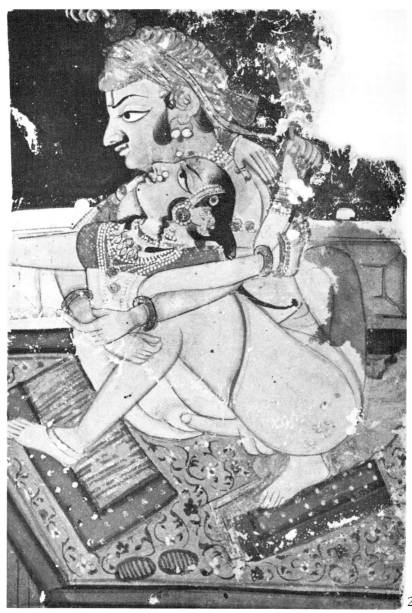

246

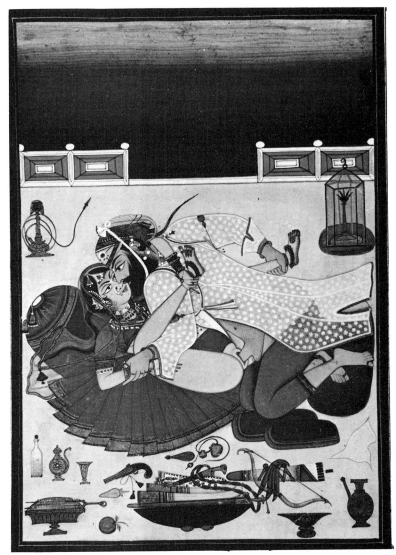

247

246–247—Miniatures, Mogul style, 18th century.

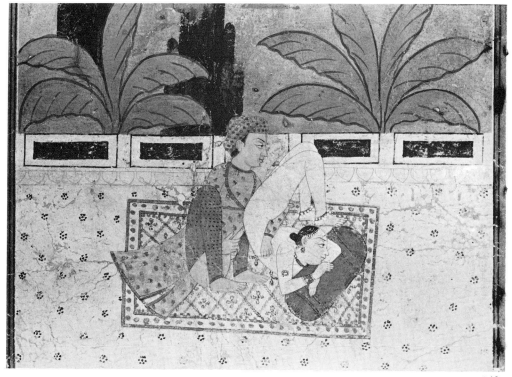

248

249

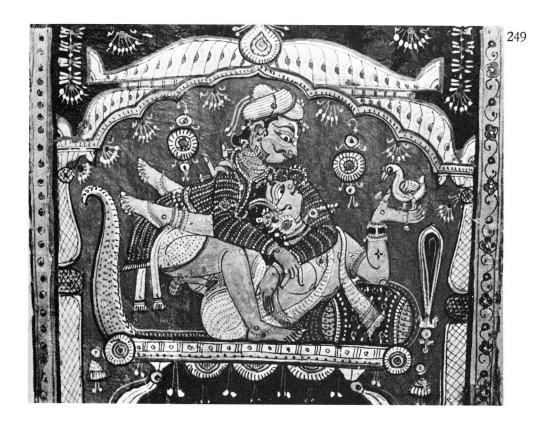

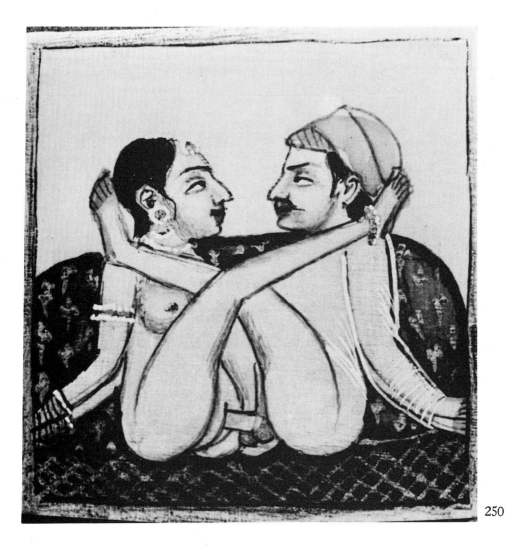

248—Miniature, depicting one of the many acrobatic intercourse positions char-
acteristic of Indian erotic art, making clear the connection between such sex tech-
niques and certain Yoga practices; mid-19th century. 249—Oil on cloth, Orissa
style, ca. 1830. 250–251—Miniatures on ivory, contemporary.

250

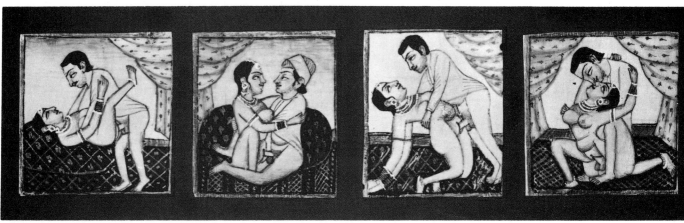

251

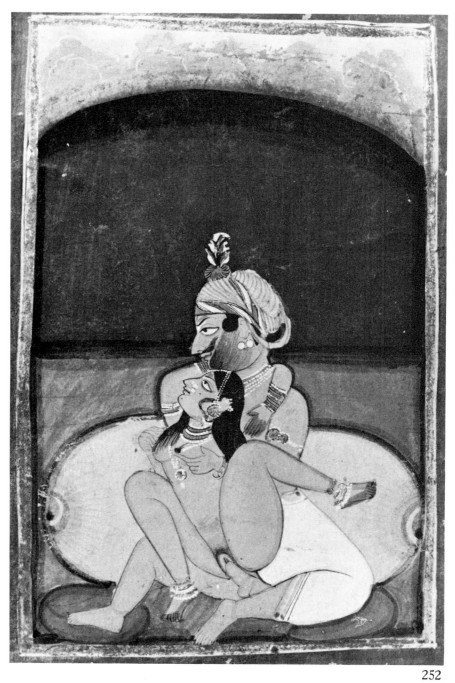

252

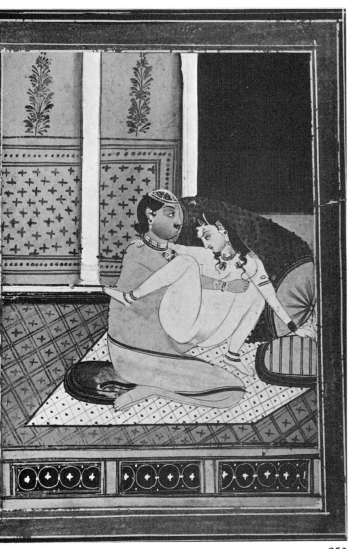

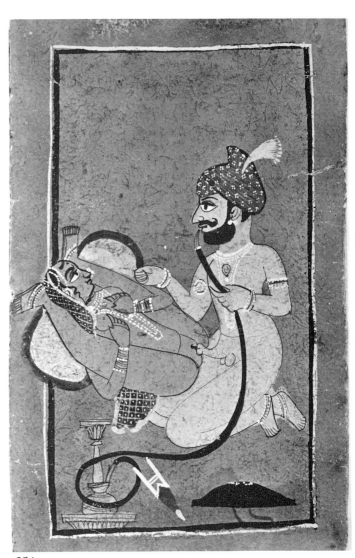

253 254

252—Miniature, Mogul style, 18th century. 253—Miniature, depicting a favorite Oriental intercourse position; mid-19th century. 254—Miniature, Mogul style, ca. 1850; an example of the playful aspects of Indian erotic art.

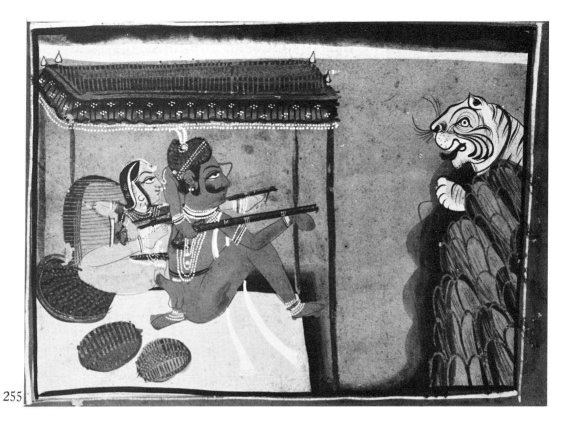

255

256

257

259

260

255–256—Watercolors, mid-19th century; the tiger hunt was a popular subject in Indian erotic art. 257—Miniature, Mogul style, mid-19th century; couple with water pipe. 258—Miniature, Mogul style, mid-19th century; "shooting the bird." 259—Animal contacts are frequently depicted in Indian erotic art, perhaps because some forms of Hinduism allow for the reincarnation of animals into humans, and vice versa, thus blurring the boundaries between the species; ca. mid-19th century. 260—Miniature, Mogul style, mid-19th century.

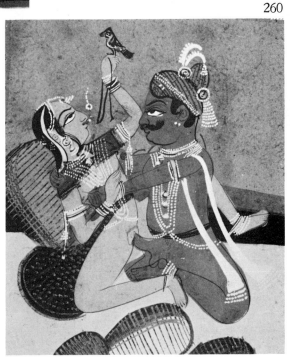

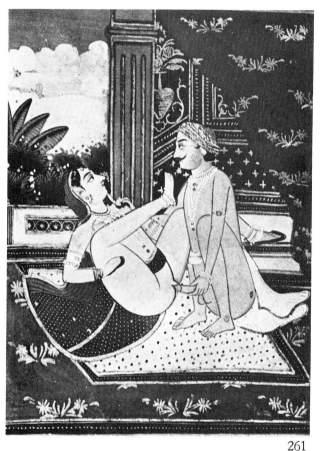

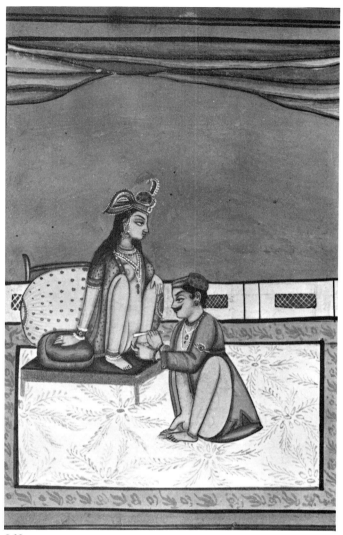

261 262

261—*Miniature, mid-19th century.* 262—*Removal of a woman's pubic hair by shaving (in parts of the Orient, the depilated vulva is considered particularly attractive); mid-19th century.* 263—*Wood carving of a woman exposing her vulva above a small phallic creature which can be seen as both a personified male sex organ and an embryo or baby; 19th century.* 264—*Wood carving of the story-telling type, this one depicting a situation in which the wife is combing the hair of her warrior husband, while surreptitiously engaging in sexual intercourse with her lover who is lying beneath the wooden flooring; 18th–19th century.*

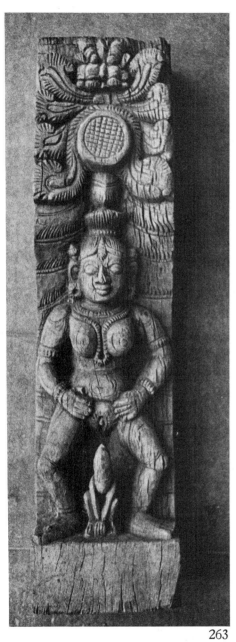

263

264

265

266

265–266—Trick pictures; erotic motifs are incorporated into the design of an animal form, usually a horse or elephant; Central India, 18th century.

267

267—*Trick picture, in the shape of a horse; Central India, 18th century.*
268–269—Painted metal figure (two views); probably of Nepalese origin,
18th century.

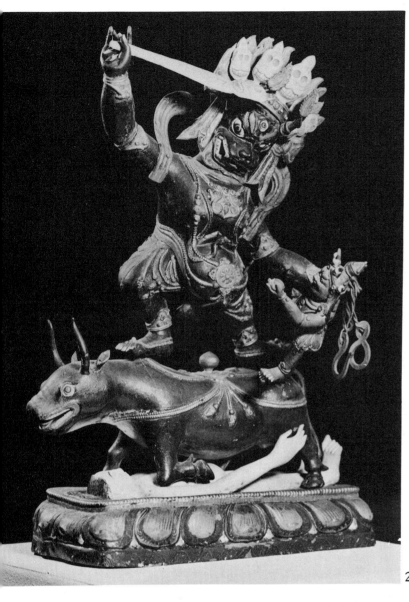

268

269

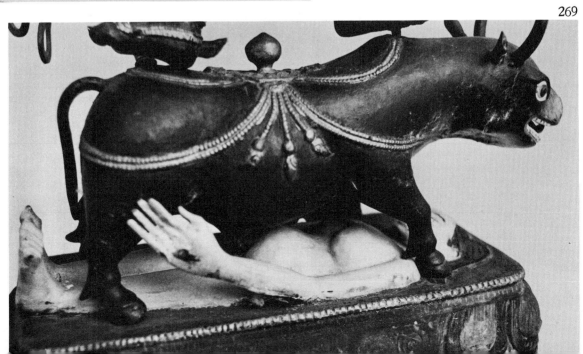

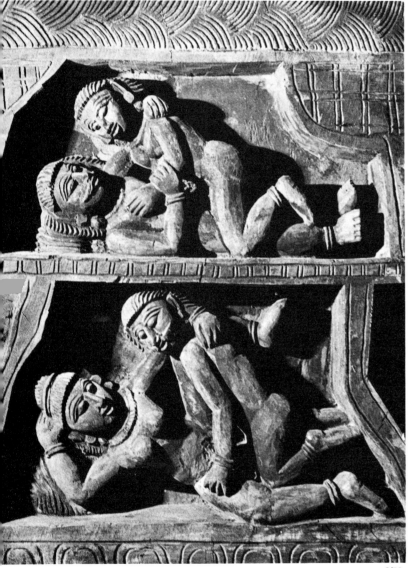 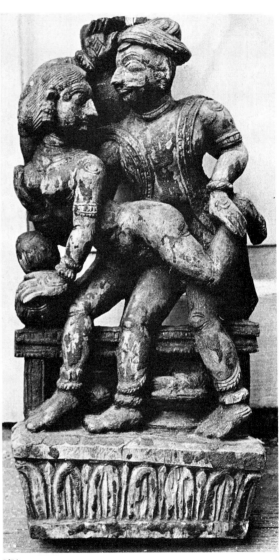

270 271

270—*Wood carving, 19th century.* 271–272—*Wood carvings of different inter-course positions; such carvings are usually cut out from larger ornamental panels, frequently from temple chariots used in ceremonial processions; 18th–19th century. 273—Tantric bronze, probably of Nepalese provenance, showing the god (Siva) and his consort or* shakti *in the classical Yin-Yang position (the female astride the male), above a lovemaking scene involving the elephant-god Ganasha.*

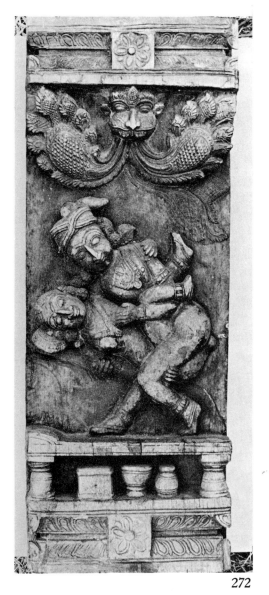

272

273

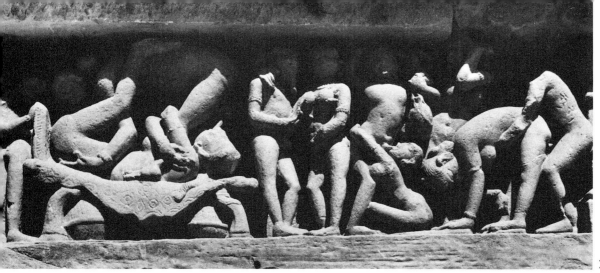

274

275

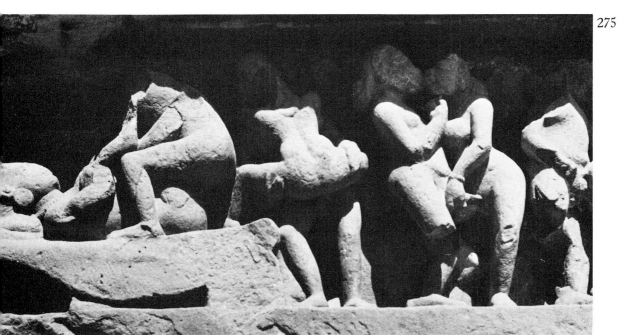

276

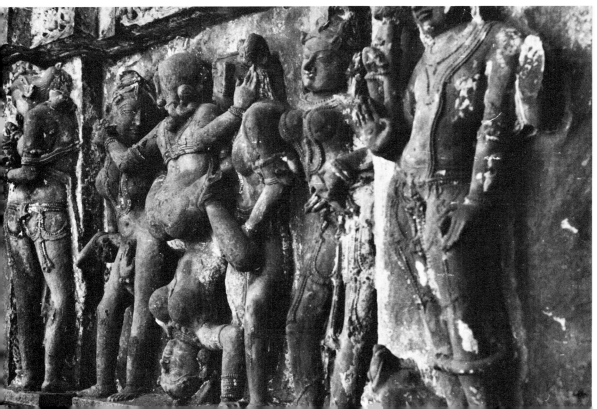

277 278

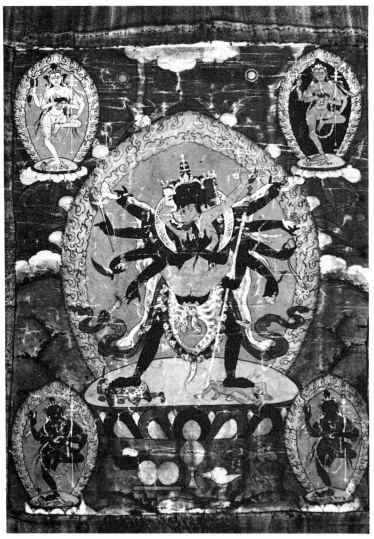

274–276—Details from temple frieze at Khajuraho (Northern India), showing various sexual group activities; 9th–11th century. 277—Nepalese Tanka, oil on cloth, 18th century; the gods are in the Yin-Yang position. 278—Temple sculpture in gray sandstone; Northern India (Mount Abu area), 11th century.

239

CHINA

The most ancient Chinese representations of sexual subject matter date from the Han dynasty (*ca.* 206 B.C.–A.D. 24). Excavations from that period have unearthed bricks from tombs and gifts buried with the dead which show definite sexual motifs.

The first Chinese handbooks on sex were not far behind. Likewise, the first reference to erotic pictures used for the guidance of bride and groom occurs in a poem from about A.D. 100. This is the *T'ung-sheng-ko,* a treatise in verse, written by the famous poet Chang Heng, who lived A.D. 78–139.* In this poem, the bride, preparing for sexual intercourse, says:

> *Let us now lock the double door with its golden lock,*
> *And light the lamp to fill our room with its brilliance,*
> *I shed my robes and remove my paint and powder,*
> *And* roll out the picture scroll *by the side of the pillow,*
> *The plain girl I shall take as my instructress,*
> *So that we can practice all the variegated postures,*
> *Those that an ordinary husband has but rarely seen,*
> *Such as taught by T'ien-lao to the Yellow Emperor.*
> *No joy shall equal the delights of this first night,*
> *These shall never be forgotten, however old we may grow.*

[Emphasis ours.]

This classical poem sets the tone for all Chinese writings on the matter. Sex is happily accepted as one of the greatest pleasures and blessings in life: "For, of all the joys mankind has, there is none that surpasses this [sexual union], hence I name this essay 'Poetical Essay of Supreme Joy' [*Ta-lo-fu*]."

With this philosophy of life went naturally a great emphasis on sexual adequacy and sexual skill on the part of both man and woman. It was clearly understood that man's skill in the sexual act means more to most women than her partner's youth or handsomeness. Furthermore, according to Chinese tradition, a man was supposed to be able to engage in sexual intercourse and prolong the act at least sufficiently to bring the woman to orgasm, while himself refraining from ejaculation.

An old Chinese text, *Lieh-hsien-chuan* (ascribed to the Han scholar Liu Hiana, 77–6 B.C.), says the following on this point: "Master Jung-ch'eng was adept at nurturing and controlling his own physical function. He absorbed new semen in the mysterious vagina. The main point of this art is to prevent the spirit of the male [i.e., man's potency] from dying by preserving man's vital power and nurturing the male essence. Then man's gray hairs will turn black again and new teeth will replace those that have fallen out. This art of sexual intercourse with a woman consists of restraining oneself so as not to ejaculate, making one's semen return and strengthen one's brain."

*In this and other respects we are following the scholarly research of the late Robert van Gulik: "Erotic Color Prints of the Ming Period with an Essay on Chinese Sex Life from the Han to the Ch'ing Dynasty, B.C. 206 to A.D. 1644" (Manuscript, Tokyo, 1951).

This emphasis on the necessity for the retention of male semen goes back to the erroneous notion in Chinese sexual philosophy that while man's semen is strictly limited in quantity, woman is an inexhaustible receptacle of Yin (i.e., sex) essence. According to this belief, sexual intercourse was considered to have a twofold aim. The first purpose was to make the woman conceive so as to produce sons for the continuation of the family line. Only thus could a man fulfill his assigned role in the order of the universe, but it was also his sacred duty to his ancestors. The peace of the dead in the hereafter could be ensured only by regular sacrifices made by their descendants on earth (family worship). Secondly, the sexual act was to strengthen the man's Yang essence, while at the same time the woman would derive physical benefit from the stirring of her latent Yin nature.

These two aims of the sexual relation were closely interwoven. In order to obtain healthy male children, the man's Yang essence was to be at its very apex when he ejaculated. In order to develop his Yang essence to its peak, he should engage frequently in sexual intercourse with women without emitting semen. In this way he was thought to be able to supplement and nourish his Yang essence with woman's Yin essence. It followed, then, that the longer the man's penis remained inside the vagina, the more Yin essence he would be able to absorb, thereby augmenting and strengthening his vital force.

This whole complicated system can be briefly expressed by these two postulates which are stressed by every ancient Chinese treatise on sex:

1. Man's semen is his most precious possession, the source not only of his health, but of his very life; every emission of semen will diminish this vital force, unless compensated by the acquiring of a suitable amount of Yin essence through sexual intercourse.

2. Man should give the woman complete satisfaction every time he engages in sexual intercourse with her, but he should allow himself to ejaculate only on certain specified occasions.

In keeping with these principles, Chinese erotic literature and erotic art are replete with discussions and pictorial representations of various intercourse positions. But among the many hundreds of Chinese erotic pictures that we examined, not a single one included an act of male masturbation, for masturbation in the male would result in a deplorable and noncompensated loss of male essence. There are, however, examples of female masturbation in Chinese erotic art, since this would not result in any such loss.

There are relatively few representations of fellatio; though a legitimate part of foreplay, it entailed the danger of man's ejaculation outside the vagina. Cunnilingus, however, is much more frequently represented, since it was traditionally considered an approved means of obtaining precious Yin essence from the woman.

Representations of male homosexual acts are scarce, though some older sources hint that intimate contact between men can never lead to a complete loss of Yang essence. Still, the idea of some such loss was apparently sufficient to discourage, if not the practice, at least its pictorial representation. Pictures of women engaging in sexual acts with each other, though rare, do exist, for no similar loss could possibly result between women.

In calling attention to these peculiarities of Chinese erotic art, we do not mean to imply that the Chinese artist, especially of later periods, was always consciously aware of these philosophical speculations. Nevertheless, they tended to establish certain artistic conventions and avoidances which have their basis in the Yin-Yang system of thought.

Sexual intercourse was considered in China not only a fact of life to be accepted and enjoyed, but essential for human physical and mental well-being. The emphasis on varied sex techniques and a multitude of positions was therefore held necessary in order to keep people interested in copulation, and this was one of the main functions of Chinese erotic art.

We have to turn to Chinese erotic literature to appreciate how erotic picture albums were used. In one of the best erotic novels of the Ming dynasty, *Jou-p'u-t'uan* ("Human Coverlets"), we find, for instance, the description of the amorous adventures of a young and gifted scholar, Wei-yang-sheng. He marries a well-educated and beautiful girl, Yu-hsiang ("Jade Perfume"), whose only fault lies in the sad fact that she is excessively prudish: she only agrees to sexual intercourse in the dark and refuses every sexual technique that deviates from the routine. To his further dismay,

the bridegroom also notices that Jade Perfume never reaches orgasm during their marital love-making.

To remedy this situation, the young husband decides to purchase a costly album of erotic pictures with which he hopes to educate his wife and change her attitude. Jade Perfume, as might be expected, at first refuses to even look at the pictures, much less to let herself be influenced by them. However, in the end she agrees to study them under her husband's guidance, "her passion becomes greatly aroused" by them, and she gradually turns into the warm, sensuous, and fully responsive woman that her name implies.

We owe to this same erotic novel a detailed description of the pictures contained in the mentioned album. At first we are told that this album differed from the usual ones in so far as the right half of every double page showed the picture itself, while the left half was taken up by an accompanying text, explaining each particular position.

Each position was usually given a very poetic title, such as "Posture of the Butterfly Exploring a Flower"; "Posture of the Bee Stirring the Honey"; "Picture of the Erring Bird Returning to the Forest"; "Posture of the Hungry Steed Rushing to the Trough."

The explanations which followed these titles were equally imaginative. In one scroll, "Position Number Eight," or "The Posture of the Gobbling Fishes," is described as follows: "One has two women lie down embracing each other in the position of the sexual union, one lying on her back and the other atop her, in such a way that their sexual organs touch. They should rub their vulvas together until the labia open of their own account, resembling the mouths of fish gobbling water-plants while swiming about. The man kneels between their thighs and waits until the two women are about to reach orgasm. Then he separates their genitalia with his hand and inserts his member in between. Thus the two women will profit at the same time, experiencing great pleasure when the man moves his member in and out. This method will greatly strengthen the sinews and bones and double man's potency, at the same time curing the five troubles and the nine afflictions."

As in Japan, there are basically two kinds of erotic pictorial representations to be found in Chinese art: (1) painted scrolls and albums, and (2) woodblock prints. However, in contrast to the situation with Japanese shunga, the vast majority of erotic Chinese pictures extant today are paintings and not prints.

In addition, the Chinese have produced a unique type of ceramics, such as perfume and snuff bottles, rice bowls, and wine cups, decorated with a variety of erotic motifs.

Typical also are erotic ivory, soapstone, and even jade carvings. Sometimes, Chinese artists have composed entire erotic scenes with a variety of these different-colored cut stones, mounted on lacquered wooden panels, similar to the artificial flowers and trees they once made in the same manner. Several such panels may be housed in a wooden box to form the equivalent of a story-telling or posture scroll (shunga).

Individual erotic carvings in ivory and other materials are frequently so executed that the subject matter appears completely innocuous at first glance. Usually small, these carved objects may represent a seated lady or couple fully clothed and in conventional attitudes. However, if turned upside down, they suddenly reveal the bare genitals or show the couple joined in intercourse. Similarly, a carved box with neutral design may contain erotic figures or feature erotic paintings inside, similar to some of the European snuff and tobacco boxes of the eighteenth and nineteenth century. Again, a rice bowl or wine cup may show traditional motifs for outside decoration and erotic ones on the inside, and so on. We have also come across a number of Chinese trick paintings which, if viewed normally, show only vague figures of an almost abstract nature. To be properly seen as the erotic pictures they were intended to be, a polished metal cylinder must be placed in the center to correct the deliberate distortions. In short, the elements of surprise and of secrecy are of the utmost importance to Chinese erotica.

In the history of Chinese erotic art, it is generally considered that the picture album *Hua-ying-chin-chan* ("Variegated Positions of the Flowery Battle"), from the end of the Ming period, is probably the finest known example of Chinese color printing. It was during that era that Chinese erotic art and writing truly flourished and achieved their highest artistic development. However, the bulk of Ming erotic literature and art has been preserved, not in China, but in Japan. It so happened at the beginning of the 1700's, when Ming erotic prints and paintings were still plentiful in China, a new prosperous middle class of merchants was coming into its own in neighboring Japan. The new wealth created a steady demand for erotica that could not at first be met by the

production of native Japanese artists alone. Moreover, the Japanese writers and artists of that period naturally looked for inspiration not only to the history of their own erotica, but to Chinese erotic novels and pictures as well. Nor was there any serious obstacle to the importation of Chinese erotica, since Japanese censorship was at that time more interested in suppressing books on military science and Christianity, while concerning itself little with questions of public morality.

In China, a considerable amount of erotic art continued to be produced until rather recent times. In fact, there were centers such as the village Yang-liu-ch'ing where erotic paintings used to be turned out almost on a factory basis and which enjoyed considerable prosperity on that account, until the Communist government put an end to it. Nowadays, the same "factories" in Hong Kong and Formosa which produce most of the imitations of "very old" Chinese paintings, also furnish a certain number of erotic scrolls and ceramics for the tourist trade, but their quality leaves much to be desired. We have, however, discovered one source in Macao which produces very fine erotic paintings on silk in the traditional style which are quite up to par and in some respects perhaps even superior to the average Ch'ing or even Ming paintings of this type.

While Chinese erotic prints and paintings of the Ming period were largely the inspiration for the Japanese ukiyo-e pictures of the eighteenth century, Chinese erotic art differs in many respects from that of Japan. The first and most obvious difference lies in the fact that Chinese erotic art does not exaggerate the size of the genitals; if anything, it minimizes or miniaturizes them in those cases which do not depict them in their natural proportions. Secondly, Chinese erotic pictures are "sweeter" and more romantic in mood than their Japanese counterparts, which often display an aggressive kind of sexuality. Third, Chinese erotic pictures seem to be anatomically less accurate with regard to the drawing and proportions of the human body. The upper parts of the body are often disproportionately large and differences in body build between male and female figures are frequently negligible, so that the male figures in Chinese erotica often seem feminized. As a result, the Western observer sometimes finds it difficult to distinguish between the sexes. Perhaps this deficiency in Chinese erotic art is due to the fact that the Chinese artist had less chance than his Japanese colleague to draw the human figure from direct observation. Instead, he had to content himself with the so-called ti-pen or miniature models of the human figure in wood or ivory which themselves were not very accurate. (If Westerners occasionally have similar difficulties with regard to Japanese erotic pictures, it is due primarily to the confusing similarity in classical Japanese hair styles for men and women, but hardly ever because the bodies show no definite sex differences.)

While both Japanese and Chinese erotic art frequently show scenes of sexual intercourse between one man and two, three, or even more women, there is an essential difference in the concept underlying these pictures. In the case of the Japanese, the women are courtesans and their assistants, while in Chinese erotica they represent the idea (or, perhaps, wishful fantasy) of the husband having simultaneous intercourse with his plural wives or concubines.

Another interesting difference we noted in Chinese as compared with Japanese erotic pictures, which sheds a great deal of light on the differing sex attitudes that underlie these pictorial representations, concerns the fact that in Chinese erotic art one finds not infrequently the man entreating the woman to have sexual intercourse with him. In contrast to this, female reticence or resistance is overcome in Japanese erotic art by male aggressiveness, sometimes to the point of forceful intercourse and rape—a very rare subject matter in Chinese erotica.

Still another revealing difference is that Chinese art reveals shyness, whereas the Japanese stress the idea of modesty. One could perhaps say that shyness is a more natural reaction, while modesty is "learned." Thus, each art form, the Chinese and the Japanese, though often confused by the unaccustomed Western observer, has very distinct characteristics, advantages, and disadvantages.

Above all, we owe to Chinese erotic art a tender, sensitive, and highly imaginative interpretation of human sex relations. It is therefore especially sad that the recent political events in China—as necessary as radical social reform in that country may well have been—have brought about the destruction not only of much fine erotic art, but of traditional art in general, which was held irrelevant or inimical to the aims of the cultural revolution. To us, this constitutes a fundamental misunderstanding as to the ultimate goal of all social reform, which should never be suppression, but rather greater freedom not only in the political and economic domain, but in all areas of life, including the sexual. One can therefore only hope that in the future a more relaxed and secure Chinese society will no longer see in eroticism the danger of subversion and in erotic art a symbol of "capitalist decadence," but will come to appreciate once more its own erotic tradition as the important contribution to civilized, gracious, happy living that it truly represents.

279

280

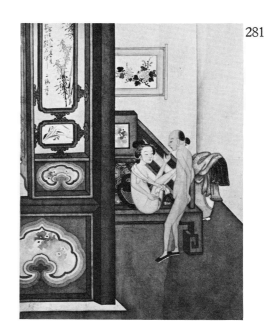

281

*279–281—Three scenes from a painted scroll in brilliant ground pigment colors;
late Ming dynasty. 282–283—Scenes from a painted scroll on silk; late-Ming–
early-Ch'ing dynasty.*

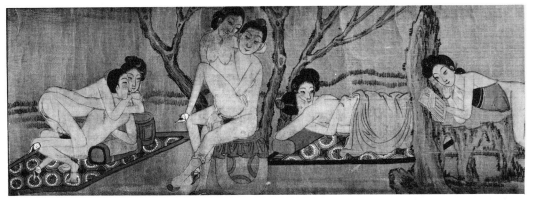

282

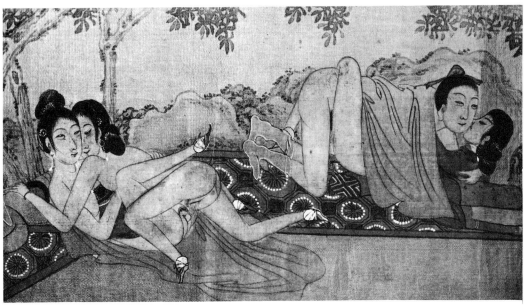

283

284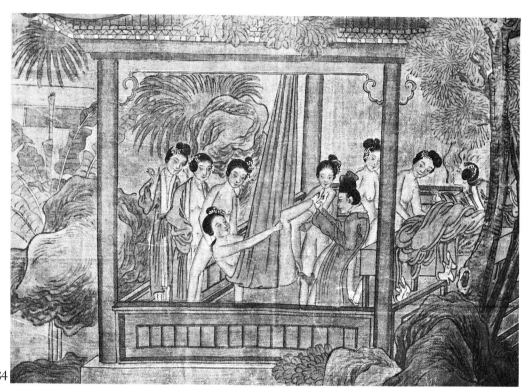

285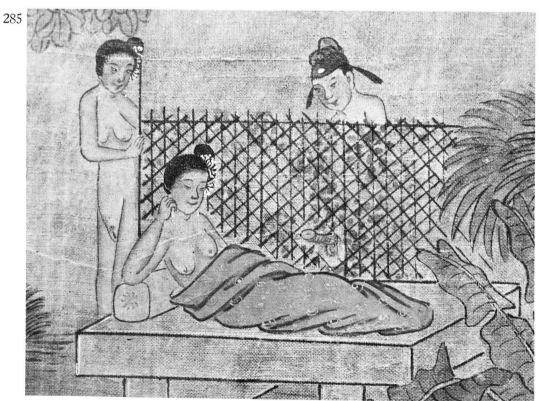

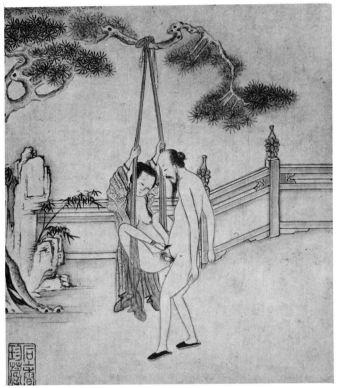

286

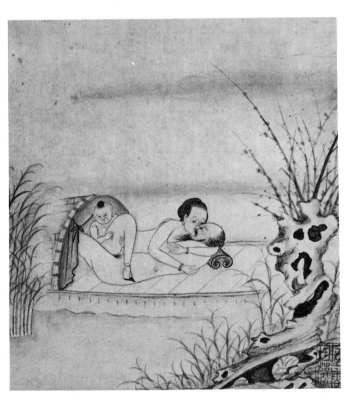

284–285—Two scenes from an unusually wide painted scroll on silk, revealing rich erotic fantasy and a sharp sense of humor; late-Ming–early-Ch'ing dynasty. 286–287—Two scenes from a painted album with erotic colophon text on opposite pages (not shown here); late-Ming–early-Ch'ing dynasty.

287

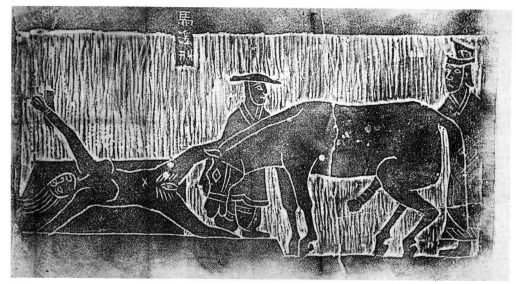

288

289

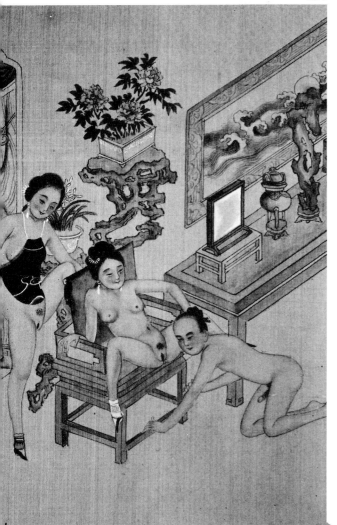 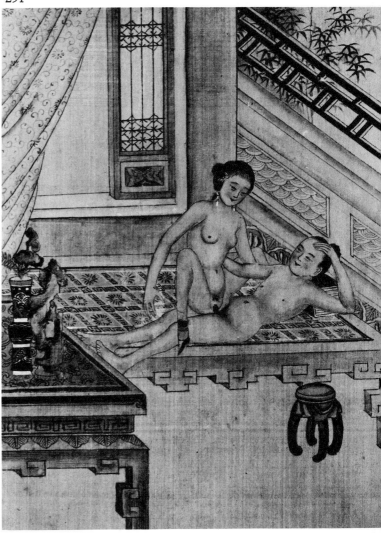

288—Stone rubbing depicting "Punishment by Horse Cock," a notorious type of punishment for females in Old China. Dates and provenance of the original engraving unknown; a rare item (originally mounted on wall panel). 289–291—Paintings on silk from erotic albums. The pictures in this series are of recent origin, but of high artistic quality. Western influence is evident in the free style and the large variety of activities shown.

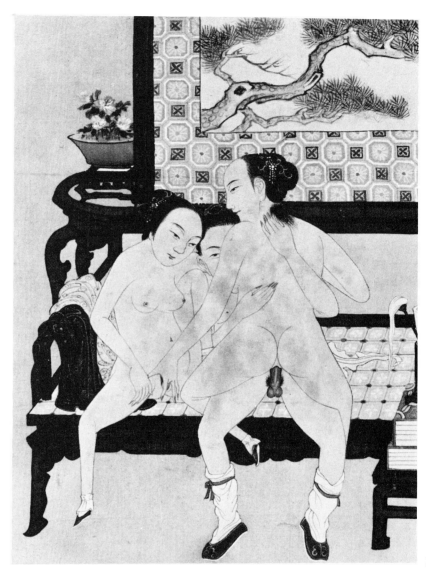

292

292–293—See caption to Figs. 289–291.

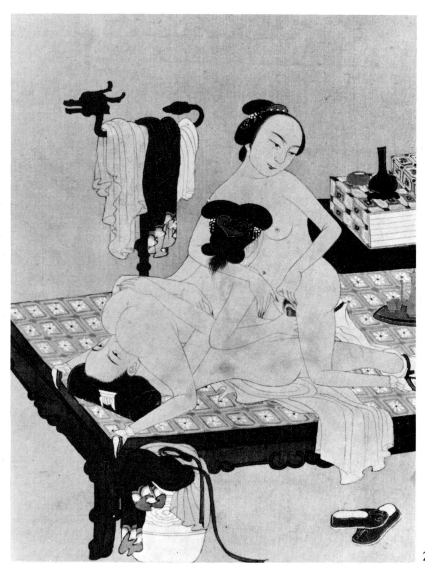

293

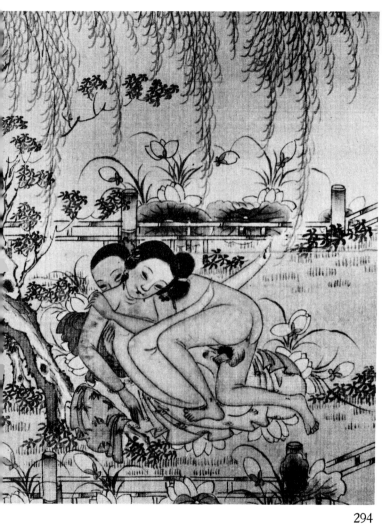

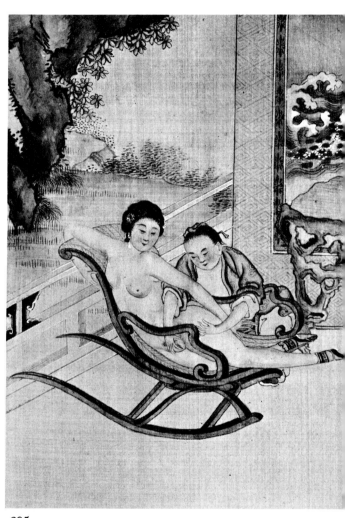

294 295

294–297—See caption to Figs. 289–291.

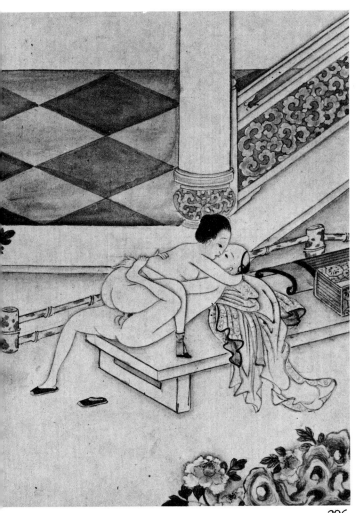 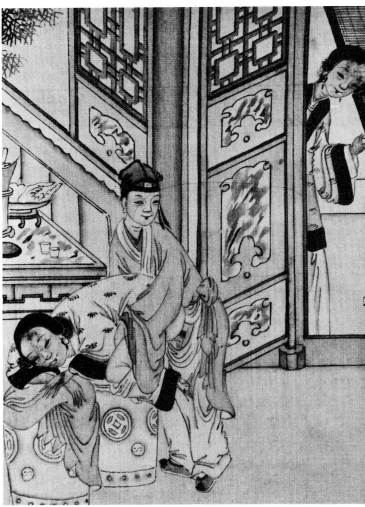

296 297

253

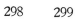

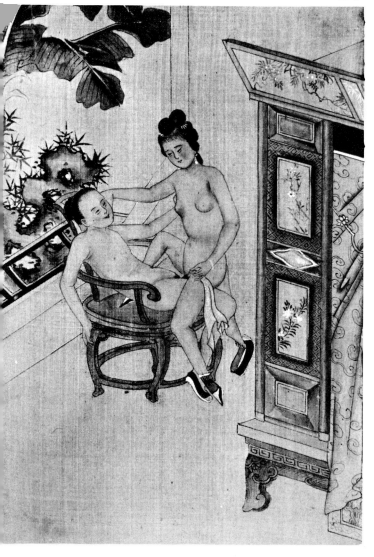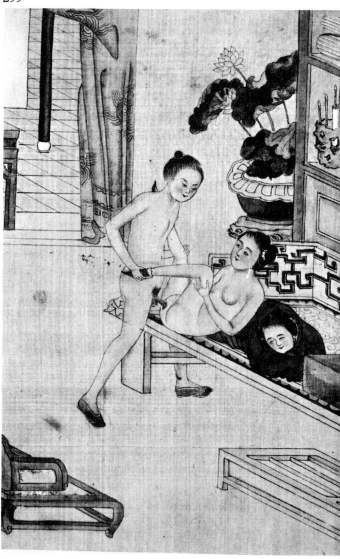

298–301—See caption to Figs. 289–291.

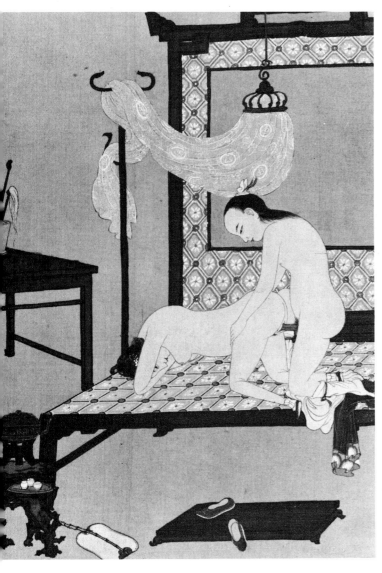 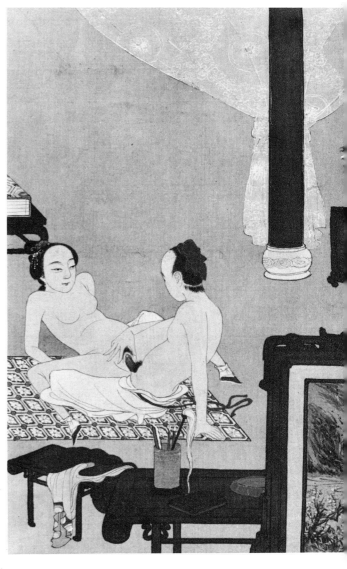

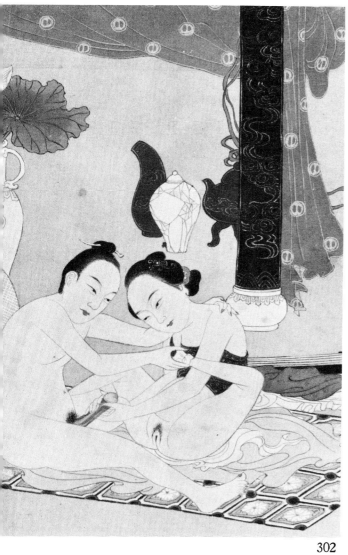
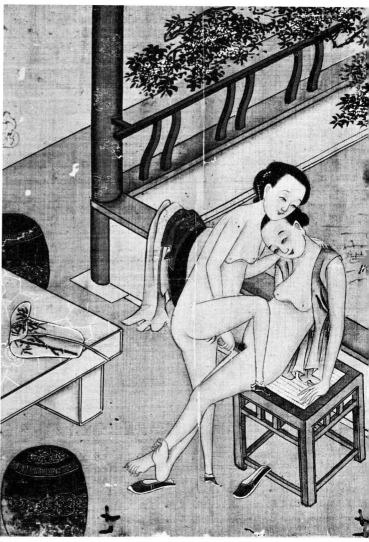

302 303

302–304—See caption to Figs. 289–291.

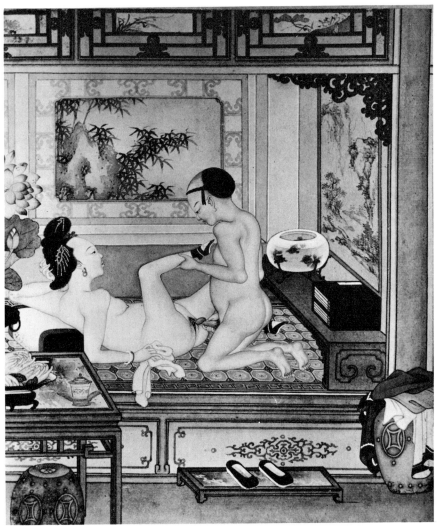

304

305

306

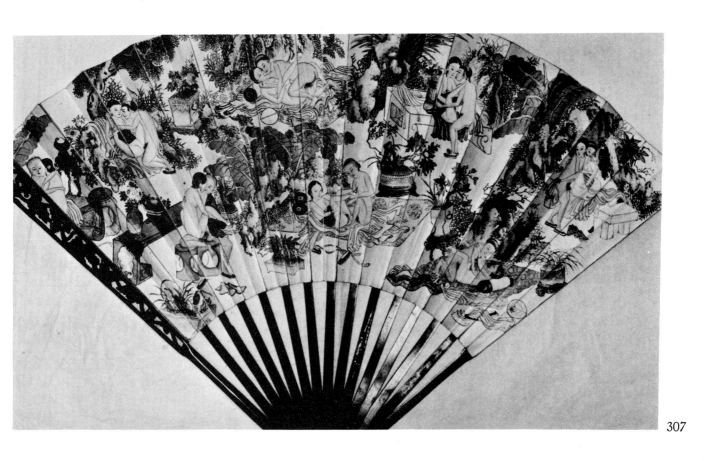

307

305–307—Folding paper fan, with painting in colors. The fan is designed so that front and back show only typical romantic scenes. However, when the fan is opened in the reverse of normal fashion, a sexual group scene is revealed, involving eight different couples. Chinese genre school, mid-Ch'ing dynasty (early 19th century).

JAPAN

The sexual art of prehistoric Japan consisted, by and large, of the same phallic symbols and fertility images that primitive religion has produced everywhere. However, the Haniwa clay grave figures of that early period, which not infrequently feature prominent sex organs or even sexual intercourse, are amazingly modern in design and of great beauty and power.

These beginnings of native Japanese art were cut short by the introduction of Buddhism, which reached Japan in the sixth century. The new religion was skeptical of sex as part of the "transitory and illusory world of the senses," and though rich in religious imagery, it dealt but rarely with erotic subject matter. Nevertheless, Japanese Buddhism imported a whole pantheon of originally male deities from China and Korea which it promptly transformed into idealized feminine ones. Of these feminized gods, Buddhist artists produced many lovely and increasingly voluptuous pictures, as Christian art has produced equally sensuous ones of female saints and the Holy Virgin.

The most impressive of these erotic religious works are the "Nude Bentens," curious seated statues of the goddess Benzaiten. The oldest wooden sculptures of this female deity are from the thirteenth century and represent the goddess in explicit nudity, including the female sex organs in carefully outlined anatomical detail. No doubt these statues were originally meant to be clothed, but later centuries produced versions of Benzaiten in stone and porcelain which are still manufactured today and with the obvious intent of being provocative.

The ancient phallic worship likewise maintained itself despite the new Buddhist religion. To this day, popular festivals frequently feature phallic deities, and Japanese folklore and folk art abound in phallic references and representations. In fact, Buddhism itself, especially its esoteric branches, the Shingon and Tachikawa sects, developed sexual deities from Indian and Tibetan models and took over a good deal of phallic worship from Shintoism as well. These deities are usually shown with their female consorts in a standing embrace, but—whether as household gods or temple statues—are treated as "secret Buddhas" and are seldom displayed publicly. Thus the rather asexual mainstream of Japanese Buddhism always contained a strong undercurrent of Yin-Yang shamanism and Shintoistic phallicism, reflecting a highly positive and natural attitude toward sex which no official censure or suppression was able to eradicate.

It is therefore not surprising that the earliest Japanese shunga ("posture" or "reclining pictures"), of the seventh and eighth centuries, were sketches of Buddhist artists and artisans and that they were found in some of Japan's oldest temples. Sex knowledge too was evidently widespread at this time, at least among the educated classes. We know, for example, from the official Taiho Code of the year 701, that shunga-illustrated sex manuals were then in existence, for the Code stipulated that physicians were to study such illustrated texts. Almost six hundred years later—in 1288—another sex manual, the *Eisei hiyo-sho* ("Secret Essentials of Hygiene"), summarizing earlier Chinese texts, was duly presented to the throne, as was the custom with important works of art and learning.

Unfortunately, all of the oldest shunga scrolls have been destroyed by the ravages of wars, earthquakes, and fires. But what we know of them from literary sources and from the few non-shunga works left of that period leaves no doubt that they were extremely interesting works full of humor, "joie de vivre," and a high artistic quality.

One cannot talk about the earliest shunga without mentioning the Abbot Toba (1053–1140), one of the great painters of the period. A mid-thirteenth-century collection of semi-historical tales contains an interesting anecdote about this abbot which sheds an interesting light on one of the main artistic traditions of Japanese erotic art—the depiction of the male sex organ in highly exaggerated size.

The anecdote concerns an argument between Abbot Toba and one of his leading art pupils in which the pupil defends himself against what seems to have been an accusation by the master of having portrayed the male organ in more than its natural size. To this the pupil countered: "Let my Master consider the *osokuzu-no-e* [i.e., shunga] of the older masters: the phallus is always depicted large, far in excess of the actual size. As a matter of fact, if it were drawn only in its natural size it would hardly be worth looking at. Thus in its depiction is resort made to artistic license. And in my Master's own painting is this principle often seen."

Doubtless, this feature, often puzzling to Western viewers of shunga, goes in its true origins beyond the reasons or rationalizations set forth by Abbot Toba's quick-minded student. We must

see in it, rather, an indirect continuation of deep-rooted attitudes of awe and veneration for the male organ as the symbol of life and power, such as are expressed in Japanese phallic customs and worship.

Incidentally, most writers on Japanese art, if they discuss shunga works at all, fail to realize that the phallic emphasis in shunga is balanced by an almost equal emphasis on the female sex organs, which are also frequently shown in considerable magnification. As a matter of fact, entire painted albums and sets of woodblock prints have been devoted by various artists in different periods to nothing but the close-up depiction of the female sex organs—the best-known of all perhaps are Hokusai's twelve marvelous color prints "Elontsubi no hinagata" ("Models of the Vulva"). These rare prints emphasize the beauty of the female form, with special attention to those sexual parts which some prejudiced Western artists have considered too "unesthetic" or ugly for pictorial representation.

At any rate, the anecdote concerning Abbot Toba seems to indicate that not even ancient Japan of the Heian period was entirely free from such prejudices. But the story also confirms that shunga were already an established art form in Japan between the eighth and the twelfth century— a time when medieval European art was almost totally preoccupied with death and religious sado-masochism.

The question has often been raised by Western scholars as to what extent shunga were originally meant to be educational guides to sexual happiness and to what extent they were simply to awaken or heighten sexual desire. It seems to us, however, that this is just the sort of question which could never have occurred to the Japanese mind: to them, sexual knowledge and sexual desire are inextricably bound together, so that one could never seriously consider the one without the other.

It has also been said that the earlier shunga were motivated more by educational considerations and that the later shunga are more deliberately lascivious or aphrodisiacal. Maybe so. But it is even more likely that the later shunga merely appear more provocative to us in the twentieth century, while the cruder and more primitive early shunga may have had just as much erotic appeal to their own contemporaries. There is, for instance, a reference to shunga in *The Tale of Genji* which seems to bear out this point of view: it tells the story of Prince Niou's painting of some erotic pictures for his sweetheart, the Princess Ukifune, to console her during his absence—a clear hint that they were to have an aphrodisiacal effect.

But while there was from the outset an obvious educational as well as libidinal quality to Japanese erotic art, there is also ample evidence of a strong and abiding interest in erotic humor. The first shunga scroll cited by name in Japanese literature, "The Phallic Contest" (*Yobutsu-kurabe*), ascribed to the Abbot Toba and dating at least from the mid-Kamakura period, deals with the satirical and ever recurring theme that even the best endowed and most potent male is no match for the sexual potential of Woman.

Later periods produced many scrolls with variations on the same "phallic contest" theme, as well as "windbreaking battles," humorous treatments of Sumo wrestling, of court life, of the samurai (warrior class) and daimio (politicians), of the alleged amorous adventures of a certain Japanese empress, of the "life of the poets," or even of the gods themselves. In short, a robust sense of earthy humor has always been a marked feature of Japanese erotic art. There are even deliberately humorous touches in a high percentage of pictures where the dominant appeal is obviously meant to be erotic—as, among many others, in a woodblock print by Shunsho (1726–1793), which depicts a passionate intercourse scene on which a cat comments with angrily arched back, "What a noisesome pair! And just as I was having such a nice nap!" Or in a print by Hokusai which shows a man and woman in the sexual act, but includes a couple of copulating mice in the foreground and in the background a cat cleaning itself imperturbedly.

One of the greatest achievements in the technique of the painted horizontal picture scroll (*makemono*) was undoubtedly the "Brushwood-Fence Scroll," the lost original of which dates from the twelfth century. There are several later copies or versions of this scroll, one in our own collection, from which we can get a fair idea about its style and content. It tells the story of a princess who was chosen to become the Vestal Virgin of the Grand Shrines of Ise. To prepare herself for this high office she was to spend the two prior years in another shrine in ritual purification. But fate willed that she was instead to experience another kind of initiation—namely into the mysteries of sex, thanks to the presence of a certain notorious rogue who had been assigned as one of her own Imperial Guards.

The "Brushwood-Fence Scroll" follows the princess's seduction step by step from the first hours of this torrid romance: the princess sitting on the veranda in the moonlight, her robes opened in disarray, affording a full view of her private charms to the roguish guardsman, who is hidden behind the fence; next we see her submitting to cunnilingus and finally engaging with the man in a variety of intercourse positions.

This scroll, based on a historical event that seems to be well authenticated, represents the earliest known shunga work to devote itself entirely to a specific love story.

By the sixteenth century, most shunga artists had completely abandoned the idea of story-telling. The scrolls became standardized on a set of scenes, usually twelve (one for each month), which showed various positions of intercourse or techniques of lovemaking, but with no continuity or story line.

Despite this loss of narrative mood, Japanese erotic art did not reach its highest development until the Edo period, 1600–1868. (Edo refers to the place, originally a small fishing town, which was to succeed the venerable old city of Kyoto as capital of Japan and which was to become the Tokyo of today.)

In the beginning of the seventeenth century, there developed in Japan a new style of painting, ukiyo-e ("floating-world pictures"). It devoted itself to the depiction of everyday activities of the average person and no longer only with the life of the rich and the powerful. No wonder, then, that this new style should lend itself especially to the portrayal of man's erotic life. And it was the new well-to-do middle class of merchants in Edo who were the chief patrons of this art—just as they were the chief supporters of the Yoshiwara, the red light district, with its thousands of courtesans who, incidentally, were also the favorite models and subjects of the ukiyo-e artists.

In those days Edo was a kind of boom town with a population predominated by male bachelors, hence the great demand for shunga, as well as for paid female companionship. While an endless stream of poor country girls, drifting toward the bright lights of the city, supplied the necessary new faces for the Yoshiwara, the invention of woodblock printing made it possible to "mass produce" shunga pictures and illustrated books in quantities of, say, one or two hundred at a time.

This lucky coincidence of technological progress and the right economic conditions, as well as a favorable social climate, made possible the development of an erotic art form of a variety, richness of fantasy, and technical perfection never equaled before or after. Painted shunga scrolls continued to be produced for the wealthier connoisseurs, but now colored woodblock prints and illustrated books began to appear on the market, offering erotic fare varied enough to satisfy the most jaded tastes. And yet, these daring themes, when presented by the great masters of the new ukiyo-e style of art, become so transformed by their artistic skill that beauty of form, color, and composition make one almost forget the erotic subject matter.

Some of the early ukiyo-e books were, as one might expect, guides to the intricate workings of the increasingly more elaborate courtesan quarters. At first, these guides did not include shunga as such, but consisted mainly of descriptions of the various "tea-houses" and of their female enter-tainers, including their physical assets, character, and economic requirements. They were illustrated with portraits of the courtesans as well as general Yoshiwara scenes, i.e., the streets filled with a motley crowd of clients milling about or taking in the sight of the girls, seated behind latticed house fronts. Gradually, however, these guides tended to become more and more erotic, featuring not only what went on in front of the houses, but also the doings inside of them—a perfect setting for the depiction of an almost unlimited variety of sexual scenes.

By this time, the Japanese, who had always regarded sexual happiness as a basic human right and prerequisite for mental hygiene, came to focus their interest increasingly on its "recreational" aspects and sensuous refinements. In this respect, Japanese shunga of the later periods—from the painter Sugimura (ca. 1680's) through Kunisada, Kuniyoshi, and Shozan, to Kyosai in the mid-nineteenth century—have a not insignificant message about population control to convey to our own generation, which has yet to decide whether civilized human life is to continue on this planet through drastic measures of population control, or whether the human race shall breed itself right out of existence—or at least out of all that now makes life worth living.

The unparalleled development in erotic art and literature during the Edo period did not, how-ever, take place without generating a conservative reaction on the part of the Japanese "Establish-ment." While earlier masters of the shunga print—notably Moronobu, Kiyonobu, and Masanobu—

had enjoyed complete freedom from censorship of any kind, late in the year 1722, in the midst of Sukenobu's prime period as a shunga artist, the Japanese government at last began to concern itself with the production of erotica. A number of censorship laws were enacted at that time, aimed actually not so much at erotic material as such at publication of any books or prints without a government license—the idea being to prevent the dissemination of ideas critical of the Tokugawa government, of the court, of the military, and of the established order in general. Only indirectly did these laws also condemn erotic literature and art (as well as Kabuki theater and various other popular pleasures, together with luxury editions, and so forth).

All of this anti-fun legislation was not terribly effective in a society in which for the first time broader segments of the population were beginning to taste of pleasures hitherto reserved only for the privileged few. Still, from time to time the new laws were enforced more strictly by one "reform" government or another, a fact which may account for the practical disappearance of the large and impressive shunga album prints during the second quarter of the eighteenth century (though prints tended to be smaller in size during that period anyway, to avoid the anti-luxury part of the law, which seems to have been more rigorously enforced than that against erotica).

From then on, as is the case in contemporary Western society, periods of strict government censorship, including a certain degree of suppression of erotica, alternated with long periods of relaxation, during which shunga books seem to have been sold openly in book stalls.

Nevertheless, the mere existence of such laws had at least a definite psychological effect on the artists and the public alike. Throughout the first half of the eighteenth century, the publication of shunga tended to become more surreptitious and, consequently, also somewhat less numerous. At the same time, contrary to its intent but similar to what happened during the Victorian period in England and elsewhere under these conditions, the official disapproval of erotica seems to have had a rather stimulating effect and made people all the more eager to acquire that which was forbidden. One may safely assume that at that time the price of real shunga must have increased sharply, while artists and publishers resorted to the production of a new kind of semi-erotic art and literature (like *art gallant* in France) that had hitherto hardly existed in Japan.

This new type of near-erotic art, revealingly called abuna-e ("dangerous-pictures"), did not feature intercourse scenes as such, but specialized instead on the semi-nude female form, similar to our "pin-ups," a subject which had up to then hardly been considered erotic at all. It led to the production of endless variations on themes that are all too familiar to Westerners accustomed to conditions of censorship: bathing, boudoir, and toilette scenes, pictures of women with upraised or disarranged clothes in windy or rainy weather, diving girls, breast-feeding, summer "cooling off," and the like.

Pictures of this sort usually stop short of showing pubic hair or sex organs, as is also true of their Western counterparts. In fact, this particular detail would seem to have formed the dividing line between genuine shunga and abuna-e, just as it still serves this function in Western art wherever censorship is a factor.

Though the nude and semi-nude developed in Japanese art as a direct consequence of censorship, it would be wrong to assume that abuna-e (which flourished from the 1750's through the 1770's) were in any way inferior in quality to real shunga. The same masters, from Toyonobu, Harunobu, Shunsho, Masanobu, and Koryusai, on to such later artists as Kiyonaga, Utamaro, Eishi, Eisen, and Kunisada, who produced some of the finest shunga were also responsible for the best in the semi-erotic abuna-e genre. Moreover, these semi-erotic pictures from the later ukiyo-e period, that is, from Utamaro on, strike one, perhaps just because of their obvious self-conscious restraint, as even more provocative than actual shunga.

Fortunately for the development of shunga, there were periods of greater official tolerance. The mid-1760's, for instance, ushered in one such period, thanks—alas!—to the influence of the free and easy ways of corrupt court favorites such as the notorious Tokugawa adviser Tanuma Okitsugu, who was finally deposed in 1787. In this fashion, sexual freedom and eroticism are often unhappily associated with political corruption and economic exploitation, as was the case in Chiang Kai-shek's China or Battista's Cuba—a circumstance which has furnished the new "revolutionary" governments with a convenient excuse for the enactment of anti-sexual legislation and censorship.

Be that as it may, the last decades of the eighteenth century led in Japan to a revival of the ukiyo-e style of art, aided, on the technical side, by the development of full-color printing. Once

again, therefore, we find artists like Harunobu and Koryusai openly signing their shunga prints with their true names, instead of pseudonyms, as in periods of greater suppression.

Of the later ukiyo-e artists, two of the most outstanding and best-known in the Western world were undoubtedly Utamaro and Hokusai. Utamaro (1753–1806) was known even in his own time as the leading shunga artist of his generation. First studied by Edmond de Goncourt in the late nineteenth century and published by him in Europe, Utamaro influenced several leading Western painters of that period. He was especially superior in the representation of the female form. Until then, most artists had depicted female anatomy primarily from their own experience and intuitive imagination. Utamaro, however, was one of the first to use a life model—a feat not easily achieved in traditional Japan, due to the emphasis on female modesty. He is said to have gotten around this problem by using his own younger sister in sketching the preliminary designs for the bodily positions of the women in his shunga works.

During Utamaro's lifetime there occurred in Japan two new waves of censorship, the first in the year 1790. Of the second, in 1804, Utamaro became a tragic victim, just two years before his death and almost by accident. Actually, it was not his erotic or shunga work that led to his arrest and brief incarceration, but the unauthorized publication of a set of prints that offended the government by their satirical inferences. Nevertheless, his bout with the law had a profound psychological effect on this true genius of the woodblock print and cut his work short long before his time.

Hokusai (1760–1849) also lived to witness still another wave of censorship, in 1842. But by that time, the aged master was no longer seriously affected by it, having produced during his lifetime at least two or three sets of large shunga albums (notably the "Models of the Vulva") and over a dozen erotic picture books.

Like Utamaro before him, he employed a life model for his female figures and one of his closest kin at that—his daughter O-ei, a talented painter in her own right who is said to have assisted him to a large extent (possibly even with "Models of the Vulva") and who has an important shunga œuvre in her own name.

Both Utamaro and Hokusai had a decided penchant for the bizarre, a feature of Japanese art in general. To Utamaro we owe, for example, the famous underwater scene in which a woman is having intercourse with a couple of water spirits, and Hokusai designed the equally fantastic and brilliantly executed print of an octopus making love to a woman in which that multi-phallic animal is using his many tentacles to stimulate every erogenous zone of his female partner.

After Utamaro and Hokusai, the most prominent among the last generation of outstanding ukiyo-e artists are Kunisada, Kuniyoshi, Shozan, and Kyosai, all working during the first half of the nineteenth century. Most collectors of Japanese prints are, in our opinion, wrongly prejudiced against this late period. True, once the grosser anilin colors make their appearance around the 1850's, the subtlety of the earlier natural coloring is gone—though lovers of pop art and psychedelic coloring may find in these late prints an appeal to which previous generations have not been receptive.

For variety of erotic subject matter, the later ukiyo-e masters can hardly be surpassed, having profited from the rich tradition of the seventeenth- and eighteenth-century artists and thus having been able to go beyond them in boldness of composition, accuracy of anatomical design, and employment of perspective.

If we have dwelled at some length on the popular ukiyo-e school of pictorial art, it is because this art form lent iteslf particularly well to erotic subject matter and because ukiyo-e prints (either in the form of album prints or as book illustrations) constituted the greater part of shunga. But, as we have noted earlier, the painting of shunga was only one of the many normal functions of the Japanese artist. It is therefore not surprising that nearly all Japanese painters at one time or another did such works, either for their own amusement or, more often, on commission.

Literary sources leave no doubt that a surprising number of the great names of the eighteenth- and nineteenth-century Bunjin-ga and Shijo schools were known for their shunga, and this included such artists as Taigado, Okyo, Goshun, Buncho, Kyosai, and Miss Shohin. A study of the shunga work of the non-ukiyo-e masters is rendered difficult, however, by the relative scarcity of such items.

Finally, the Japanese also produced some remarkable erotic works in other media. Outstanding among these are the *netsuke,* small carvings in wood, bone or ivory—little three-dimensional wonders of miniature art with marvelous tactile as well as plastic qualities which really must be examined in the palm of the hand to be fully appreciated.

There are, of course, Japanese sake cups with erotic decorations, but they cannot, in our opinion, rival with the subtlety and perfection of their Chinese prototypes. On the other hand, the famed ceramic Hakata dolls, which either feature erotic bas-relief on the underside or show the female nude, with fully formed genitals visible under a brief garment, are a distinct Japanese art form that can hold its own in competition with the best in European ceramics.

In modern Japan, shunga have until very recently played only a minor role. During the Meiji period (1868–1912), the last of the final generation of ukiyo-e artists sometimes produced—despite strong government censorship—shunga works of considerable merit. They mostly romanticized Old Japan in the form of paintings of old customs, including at times shunga subjects in the traditional style. Thus we were able to collect a very fine, large-sized painted shunga scroll by Nakamura Tei-i which he did on commission as late as the 1930's, as a wedding present for a major Zaibatsu family.

During the last few years, however, a few Japanese artists have begun to abandon the traditional styles, using the silk-screen and other modern techniques, along with new approaches to painting and woodblock printing. They have produced a type of distinctly Japanese avant-garde shunga that holds much promise for the future. It is, however, impossible to expect a true revival in the art of shunga painting until a more tolerant official attitude makes efforts in that direction once again more rewarding to the artist.

We expect such a development to take place over the next few years as Japanese shunga are becoming increasingly known and appreciated in the Western world. By this detour, they will undoubtedly become again appreciated in their country of origin. When that happens—and to a certain extent it is taking place already—the contemporary Japanese artist will be able to make the kind of significant contribution to modern erotic art to which he is so uniquely qualified by dint of his rich cultural background. *

*The material on Japanese shunga in this essay is greatly indebted to the unpublished study "The Shunga in Japanese Art," by the principal authority in this field, Dr. Richard Lane.

308—Painted scroll; a scene from one of the few complete shunga scrolls extant from the earliest ukiyo-e school (1640's). (See also pp. 68–69.)

308

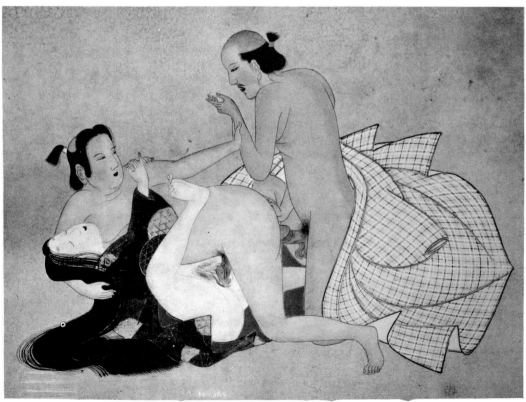

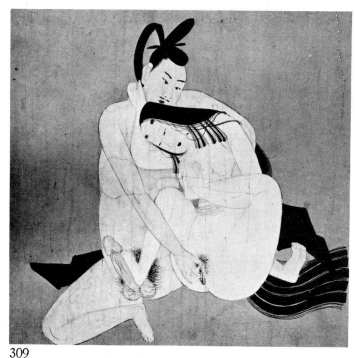

309

309—Painted scroll (detail); Tosa school, Momoyama period (late 16th century), when the traditional Tosa painters were beginning to create the first ukiyo-e. The subjects were generally courtiers and court ladies, but the flavor of the work presages the full-fledged ukiyo-e of a generation or two later. 310—Sugimura Jihei, painted scroll (detail), late 1690's. 311–312—Two scenes from the Brushwood-Fence Scroll (Koshibagaki-Zoshi); the earliest truly erotic scroll known in Japan. The original, now lost, dated from the 12th century. These are details from a copy of the year 1800, painted by the artist Keitoku. (See also pp. 68–69.)

310

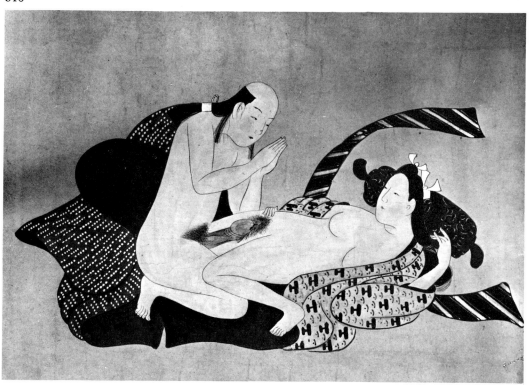

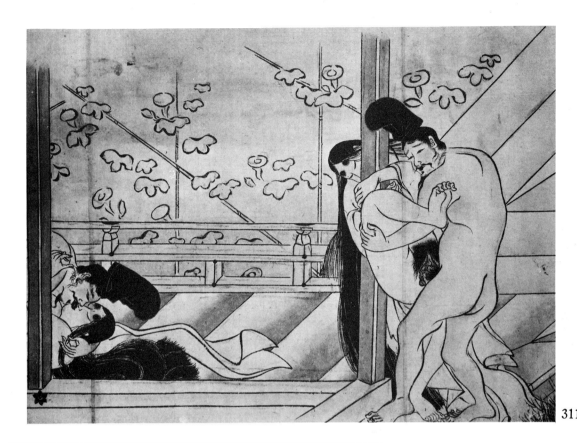

311

312

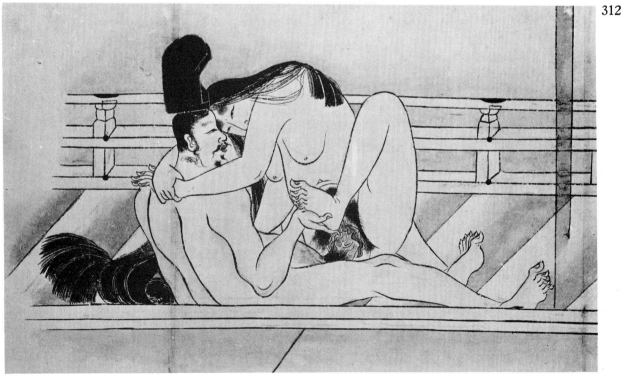

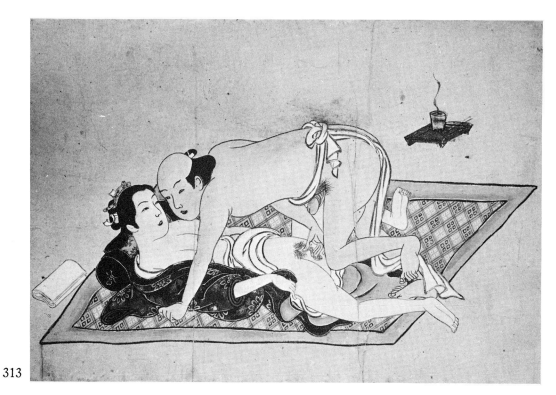

313

313–314—*Nishikawa Sukenobu (1671–1751), a leading ukiyo-e artist of Kyoto; two scenes from painted scrolls. 315—Detail from a shunga scroll of twelve scenes; in the style of Eiri, early 1800's. 316—Painted scroll of an elderly masseur's erotic adventures; Taisho period, ca. 1915.*

314

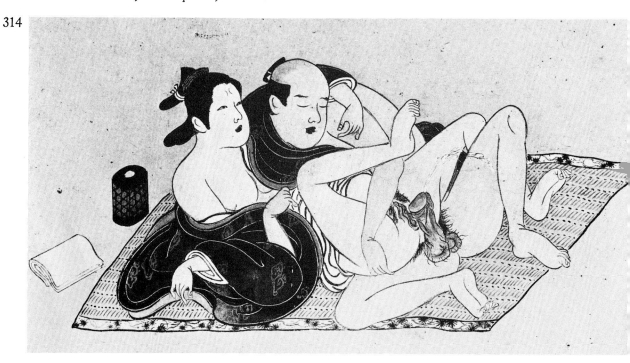

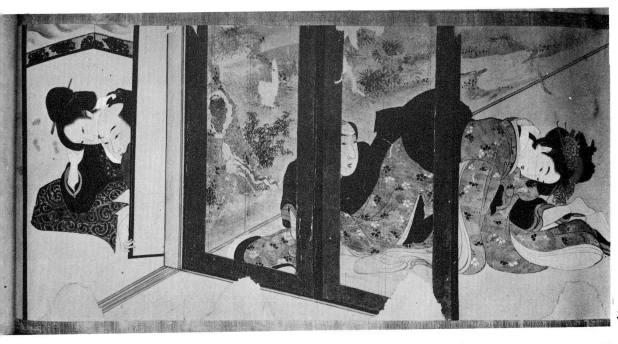

315

316

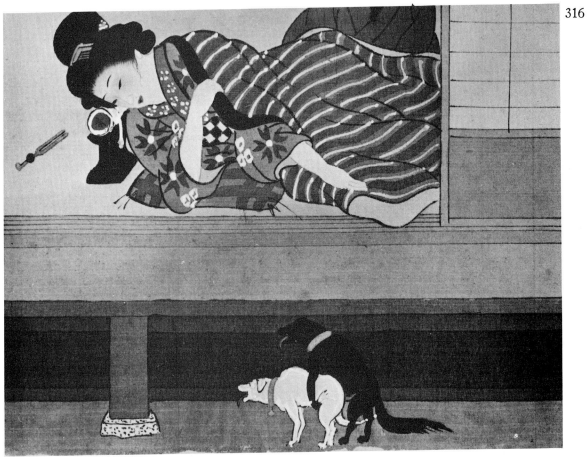

317

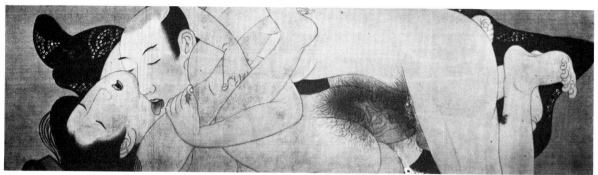

318

317—One of an unusual pair of small painted scrolls by Maruyama Okyo (1733–95). 318—Settei, Okyo school; painted scroll, 1780's. 319—Painted scroll, Osaka ukiyo-e school, early 1800's. 320–321—"Dokyo and the Empress," picture scroll in colors on paper. This is a Meiji copy of a classic of Japanese erotica on the subject of the historical love affair between the priest Dokyo and the 8th-century Empress Shotoku. In a contest of phallic size at court, various courtiers line up and display their weapons, but the young monk Dokyo proves the winner. A sketch of his phallus is brought to the Empress, and later Dokyo himself arrives. At the end, the lovers' used tissue paper is gathered for presentation to the shrine deities, while Dokyo lies exhausted. Due to the historical subject, this scroll was severely suppressed in modern times. 322—Picture scroll in colors on paper; amusing depictions of Japanese daily customs viewed from the phallic angle, by an unknown literati-school artist of the Meiji period (school of Taiga); unsigned, late 19th century.

319

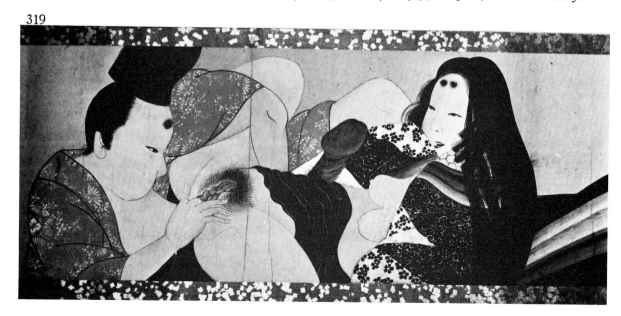

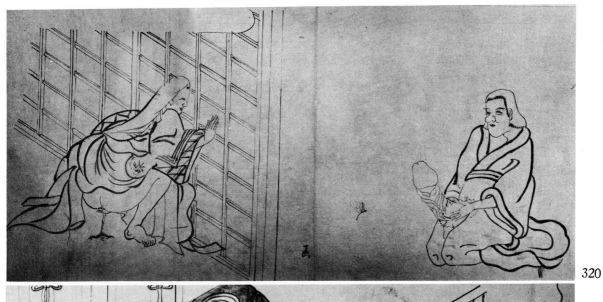

320

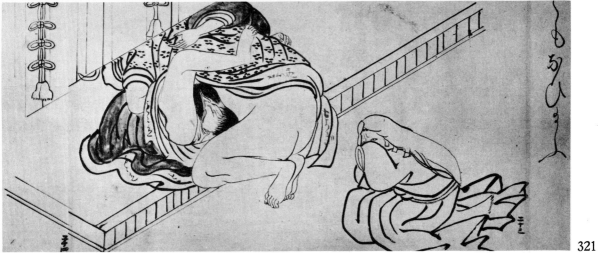

321

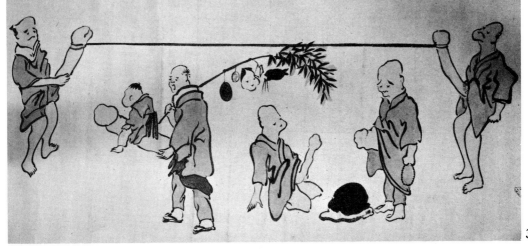

322

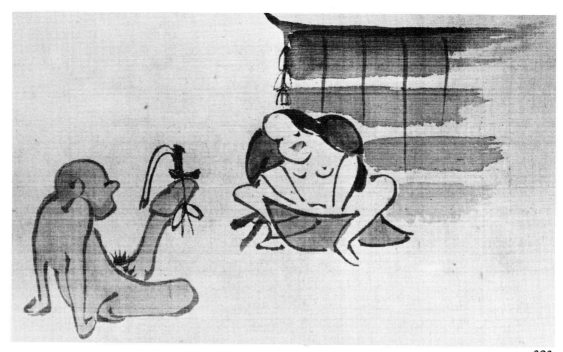

323

324

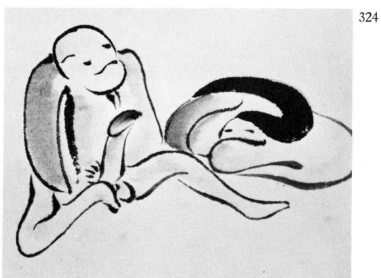

325

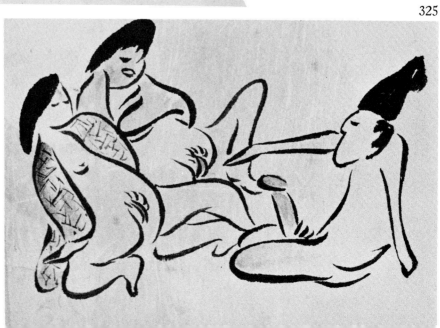

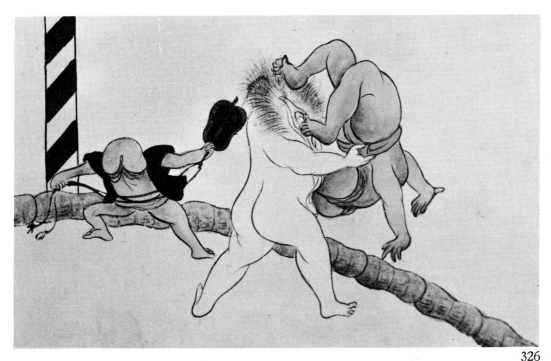

323—"Erotic Tales from the East" (Daito Keigo), a scroll version of the famous tale, by the master of Nanga painting Aoki Mokubei (1767–1833). In this scene, the Empress is seen attending to her libations, while admiring her lover's member, which she has just knighted. 324–325—Two scenes from another version of "Erotic Tales from the East," by the Osaka artist Kema Namboku; painted album, ca. 1920. 326—The battle of the sexes seen as a Sumo wrestling match, with a phallic umpire in background; painted album, late 19th century. 327—Another Sumo wrestling match, by the Tokyo genre painter Seiki; painted scroll, ca. 1900.

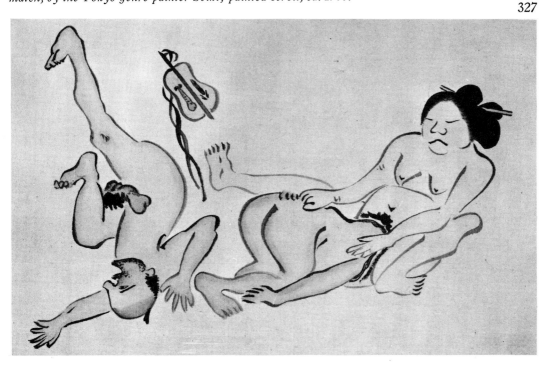

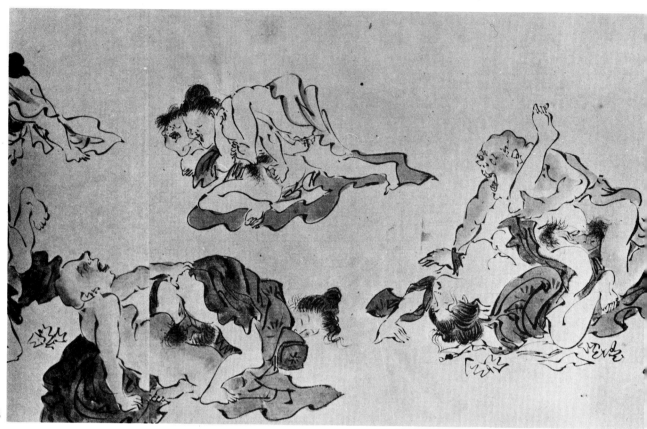

328

329

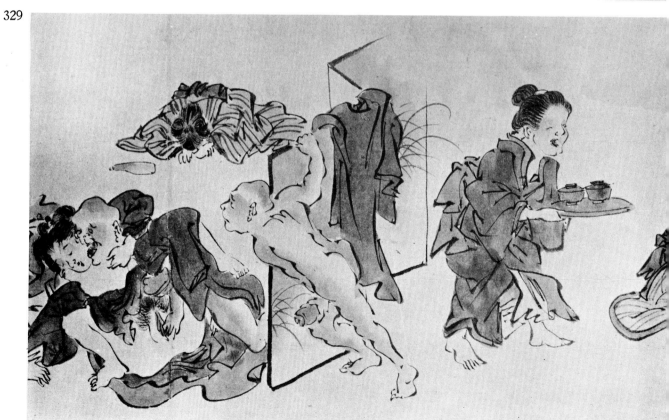

328-329—Shofu Kyosai (1831–89), two scenes from his painted scroll entitled "Blind Men's Fucking Contest." 330–331—Two scenes from one of Kyosai's earliest ribald works. The painted scroll depicts a windbreaking and phallic contest between two groups of courtiers in the old Kyoto Imperial Court. Fig. 330 shows the athletes with their trainers and sponsors in their den before the measuring events; in Fig. 331 the athletes demonstrate their phallic prowess (see also p. 71).

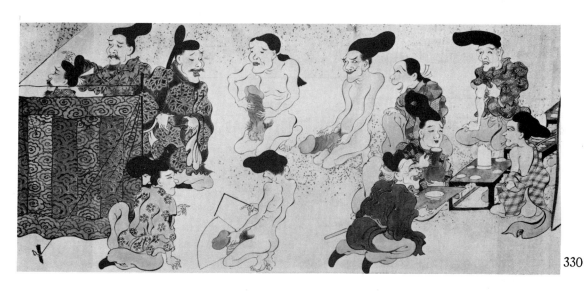

330

331

332

332–335—*Four scenes from a painted scroll by Jichosai, an 18th-century master of satire. Shown is his parody of the "phallic-contest" theme (see also pp. 78–79).*

333

334

335

336

337

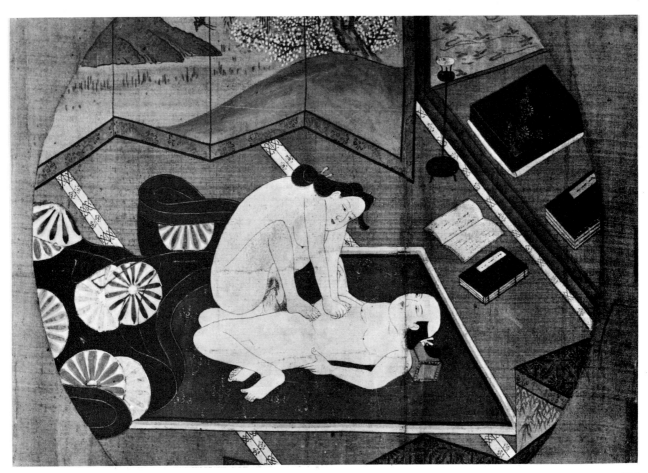

338

336–337—Methods of Animal Copulation (Juchiku koketsu-ho), *an early medical treatise on animal copulation and breeding. The animals discussed and illustrated are the horse, deer, rabbit, bear, fish, dog, cow, chicken, and cat. Dated Kanei XVII (1640), the study was prepared for the Daimyo Odagiri, Lord of Mikawa, by his Chief Physician, Genten. The illustrations are the work of the physician himself. 338—Yoshida Hamber, painted scroll, Kyoto ukiyo-e school, late 17th century.*

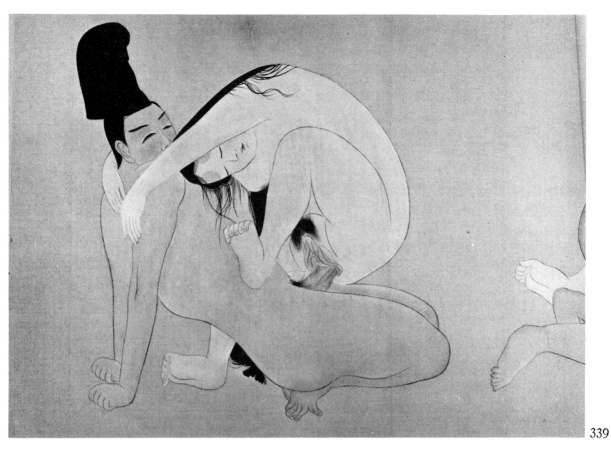

339

340

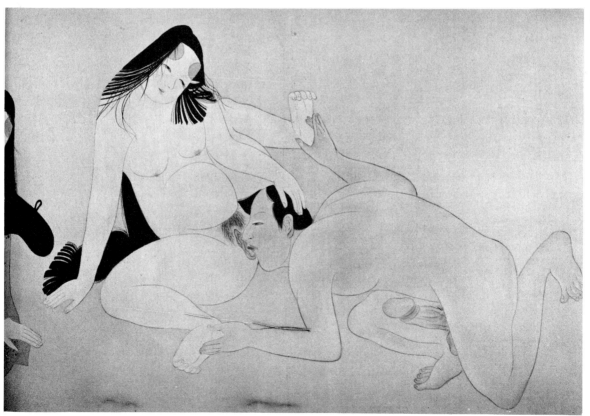

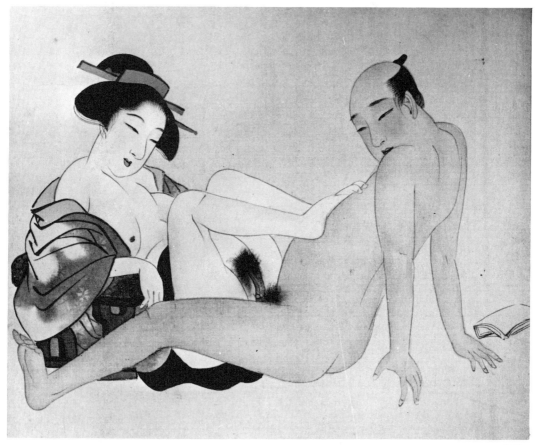

341

339–340—Nakamura Tei-i, two scenes from a painted scroll, ca. 1930. 341—Painted scroll, Hokusai school, ca. 1830. 342—Detail from a painted scroll, ukiyo-e school, mid-17th century; this scene shows a boy and girl with a young priest.

342

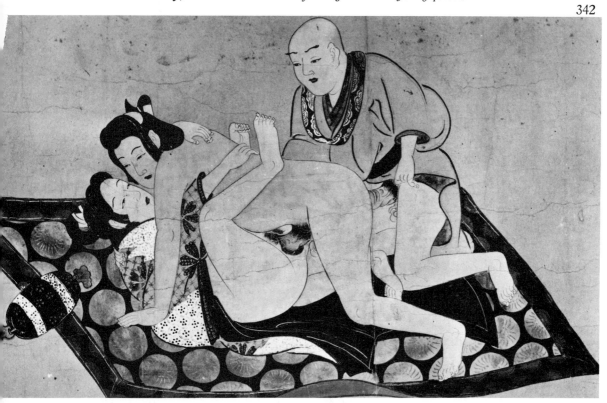

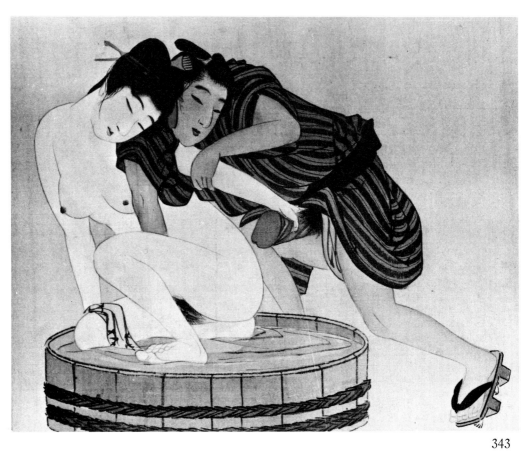

343

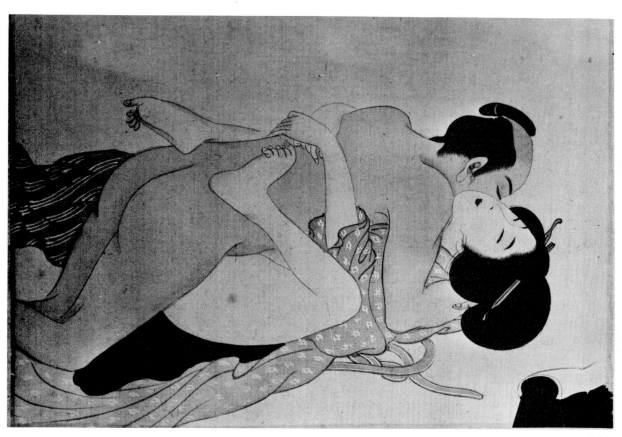

344

343–344—Two scenes from a painted scroll, Hokusai school, ca. 1830.

345

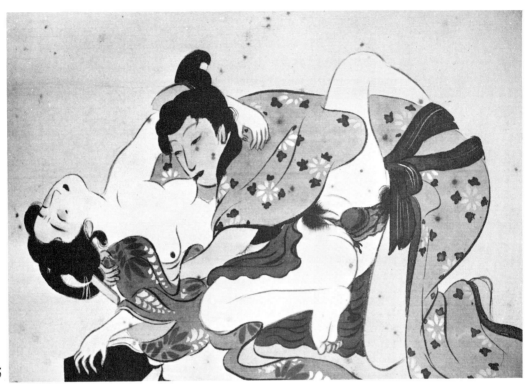

346

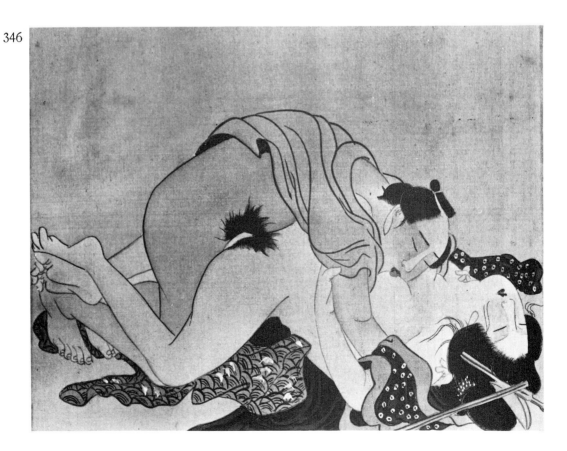

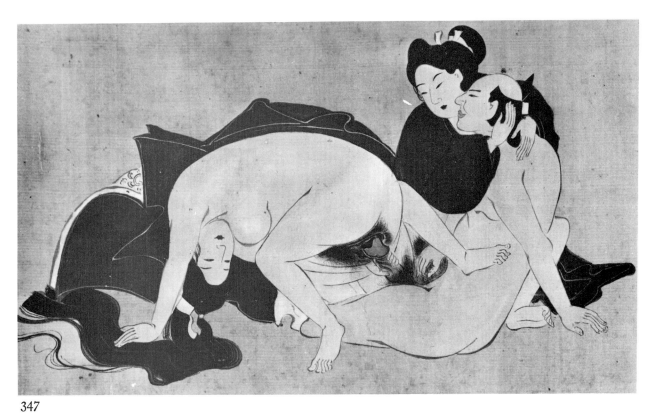

347

345—Painted scroll, modern ukiyo-e school, ca. 1910. 346—Painted scroll, Hokusai school, ca. 1830. 347—Painted scroll, ukiyo-e school, ca. 1630. 348—Painted scroll, Hokusai school, ca. 1830; detail here shows a woman with three suitors who have placed strings of coins on their penises to test their phallic strength.

348

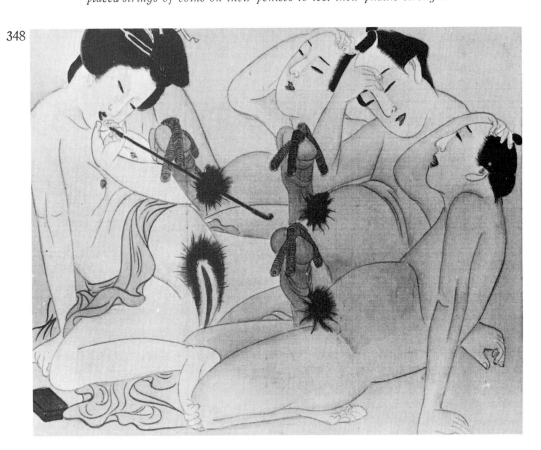

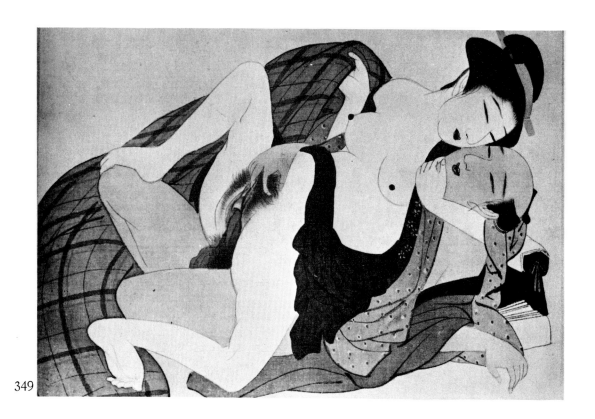

349

350

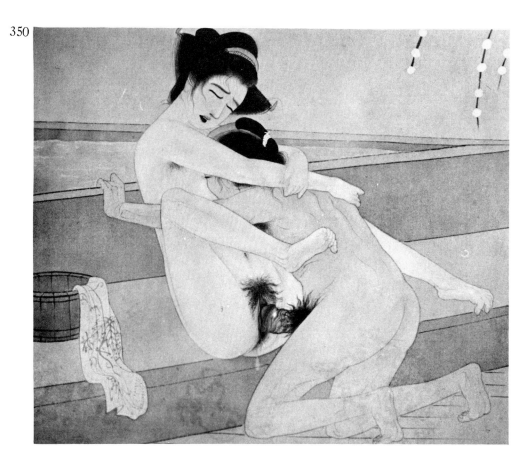

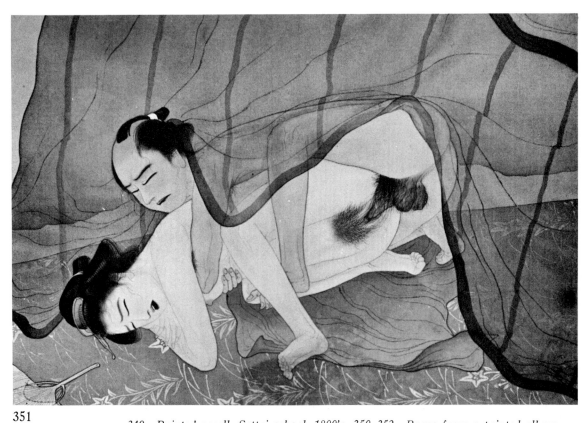

351

*349—Painted scroll, Settei school, 1800's. 350–352—Pages from a painted album
by Uemura Shoen, a leading lady painter of modern Japan (1875–1949).*

352

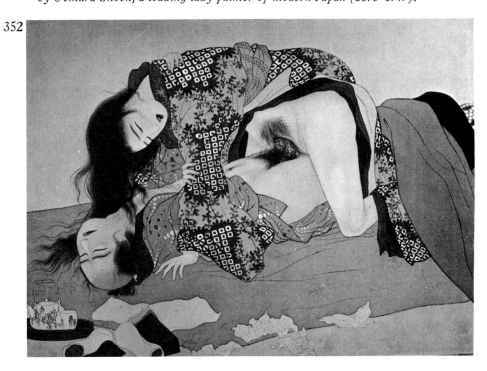

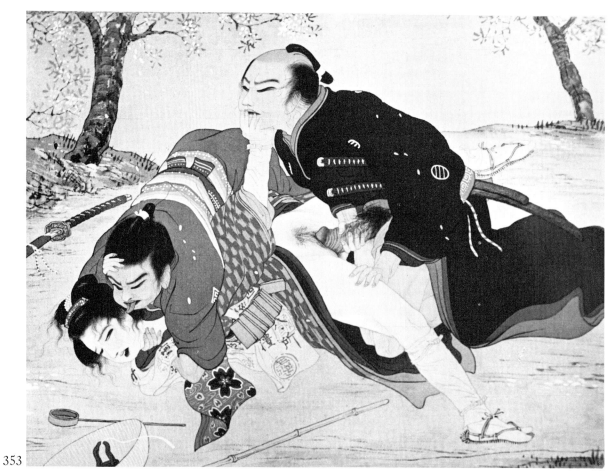

353

354

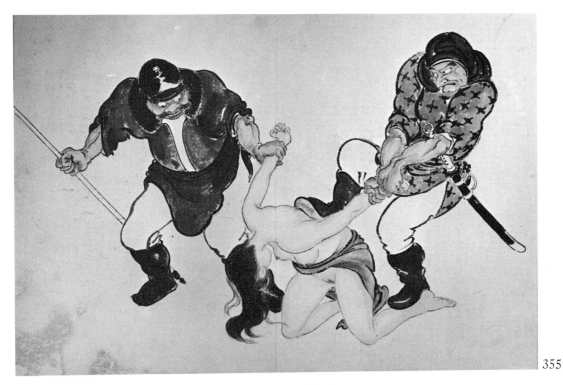

355

353–354—*From a painted album by Uemura Shoen. 355–356—Two scenes from a painted album by a modern master (ca. 1930); the album contains seven scenes of* **sexual sadism** *under the guise of the 14th-century "Mongol Invasion of Japan."*

356

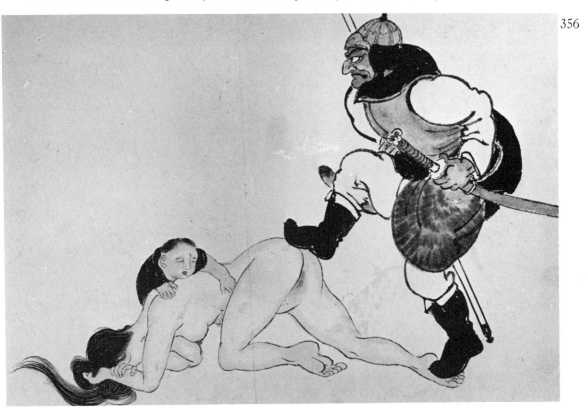

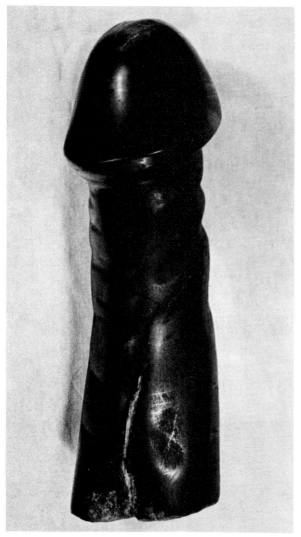

357

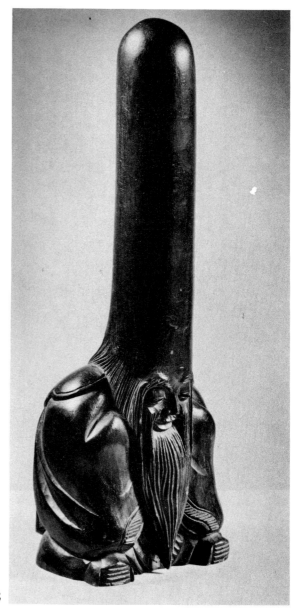

358

357—Go-Shintai (Honorable God's Body), a phallic deity of polished hard stone, meant to be mounted in a small wooden shrine. Such figures are rarely sold, as they are the sacred objects of the Shinto shrines that venerate them. This figure was in a private shrine in the old licensed quarter of Kyoto which went out of business with the abolition of legal prostitution in the late 1950's. A very rare object; 17th century. 358—Wood sculpture, Meiji period (late 19th century); the God of Longevity, Juro, traditionally depicted with long head. 359—18th-century harigata (dildo), carved from bekko (horn). This is the type of dildo employed by the wealthier commoners in the Tokugawa period, as well as the middle-rank samurai families, for self-gratification among neglected ladies. The highest court and samurai classes often had more elaborate dildoes made of ivory with gold ornamentation. 360—Harigata made from horn. Allegedly from the collection of the Tokugawa daimyo court (late 17th century), in original box of the period. The box bears the inscription "Property of Her Ladyship's Wardrobe Office."

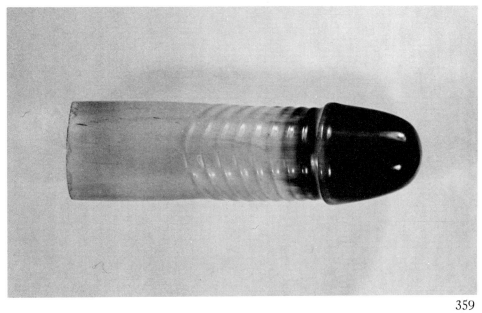

359

360

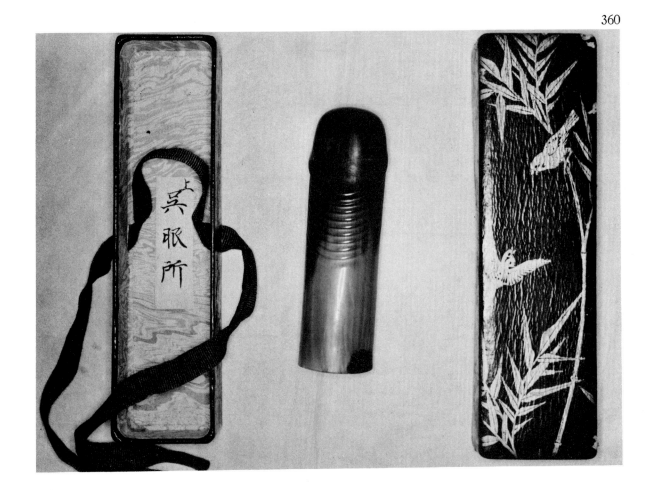

上吳眼所

291

361

362

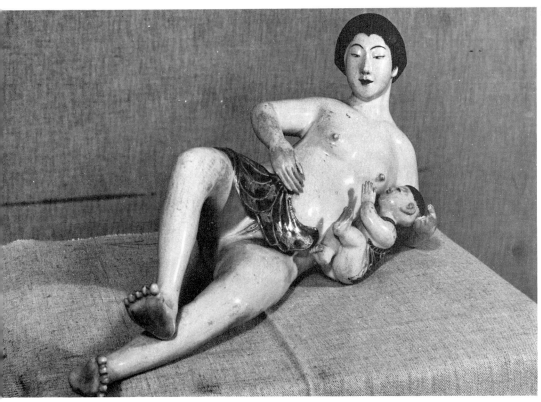

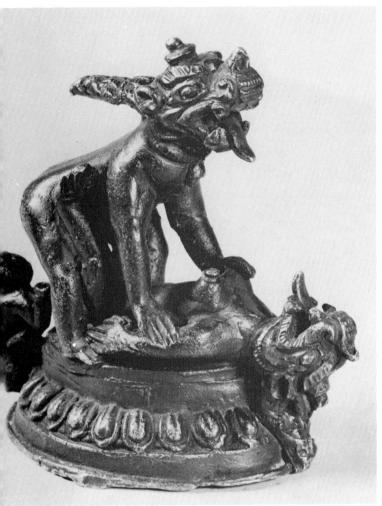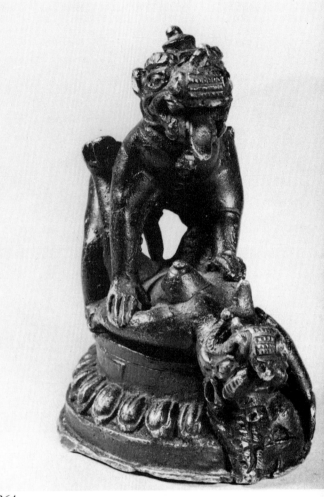

363 364

361—Phallic deity (Go-Shintai), a large wooden phallus, hand carved, about 3 feet high. This is one of the shrine deities of the famed Agata Shrine at Uji, near Kyoto. In former times, these were paraded about the streets during the annual Night Festival. 362—A rare example of an erotic Hakata doll; 19th century. 363–364— Two views of a Tantric bronze, used as a cult object by the underground Buddhist Tachikawa sect; 18th century.

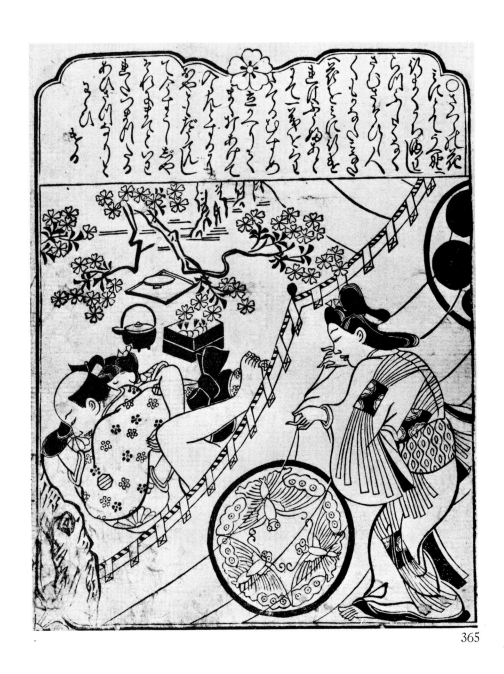

365

365–366—Hishikawa Moronobu (1618–1703), woodblock prints, early ukiyo-e school; preceding the development of color woodblock printing.

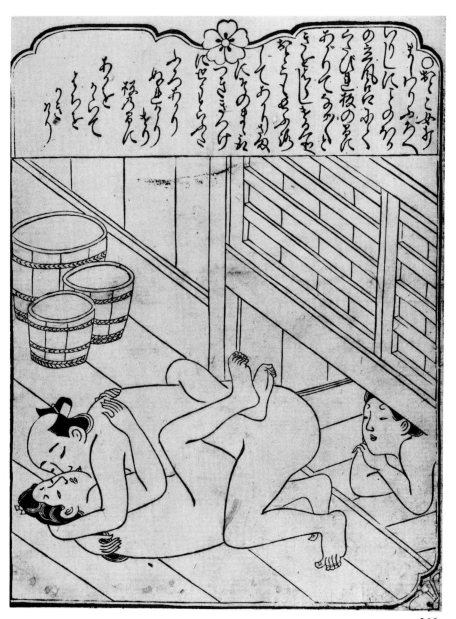

○おとこより
まへうしろ
いりにいそのかゝ
のふる風らにゆく
ろびひゝ板の見
あぐりてうぐと
きとゝもうしきちも
てうこりみれ
にりのまゝふみ
にせてゝゝゝくゝ
つきぎのう
うゝゝゝり
ぬこうり
なりそり
おろいらん
ひとゝ
うらそ
ともと
つきと
なり

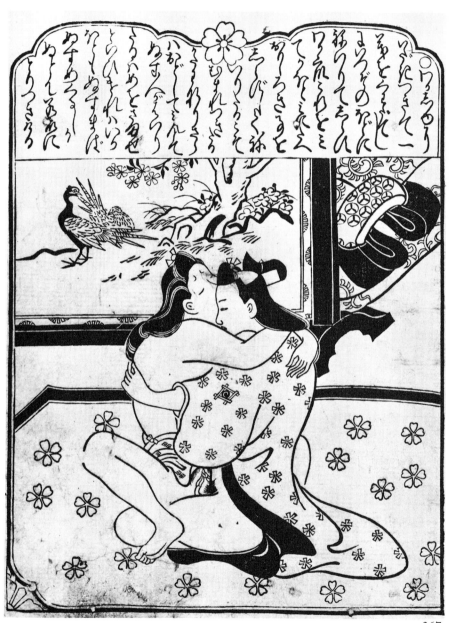

367

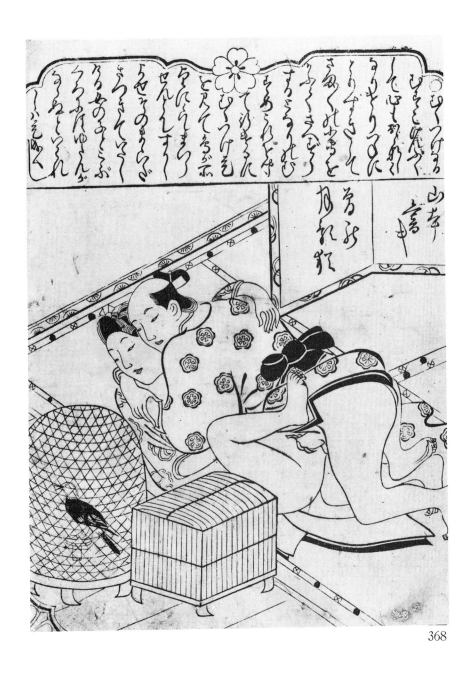

368

367–368—*Moronobu, woodblock prints.*

369—Woodblock print; the couple is reading a shunga book and smoking a long-stemmed pipe. 370–371—Painted manuscript, ca. 1940; style of Sukenobu; in Fig. 370 a couple imitate another couple in the water; in Fig. 371, an upper-class couple watch a woman servant and a porter in the courtyard. 372—Suzuki Harunobu (1718–70), woodblock print entitled "The Shell Game" (Kai-Kasen).

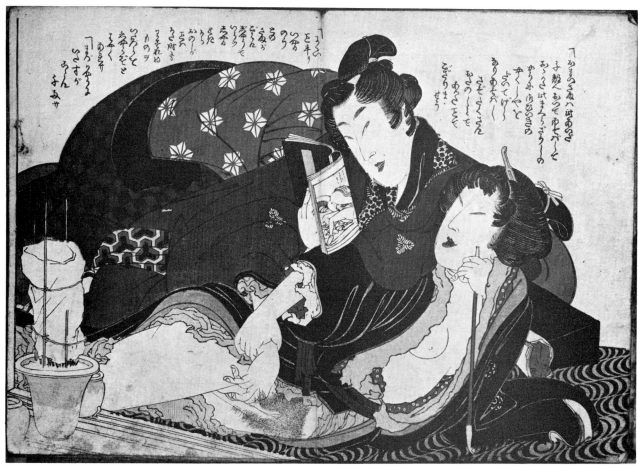

369

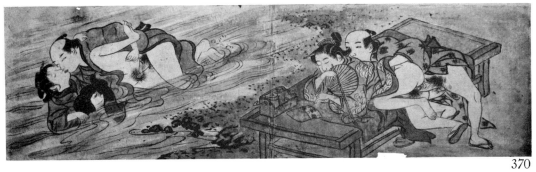

370

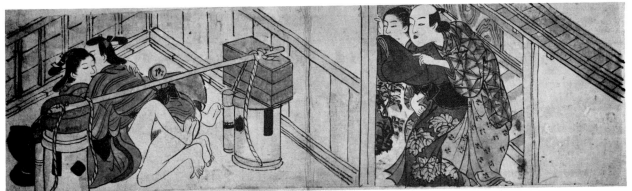

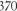

371

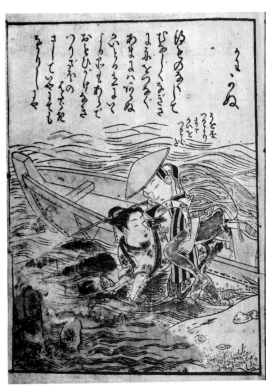
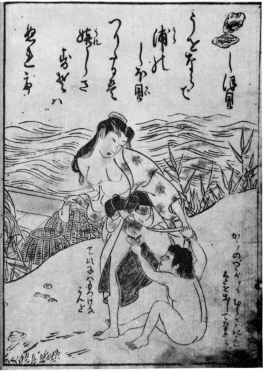

372

373—Woodblock print from a book entitled Sandai Makura; *Kiyomitsu style, 1760's.*
374—Goshichi, ca. 1820, woodblock print from a book about the private life of the
poetess Komachi, nicknamed "The Uncut Hole" because she refused all lovers.
375—Shunchosai, woodblock print, 1770's. 376—Keisai Eisen (1791–1848), wood-
block print, 1820's.

373

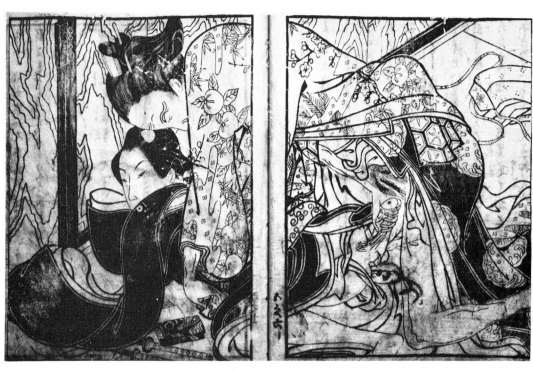

374

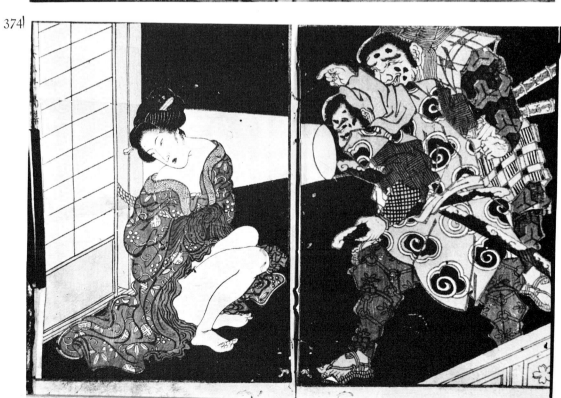

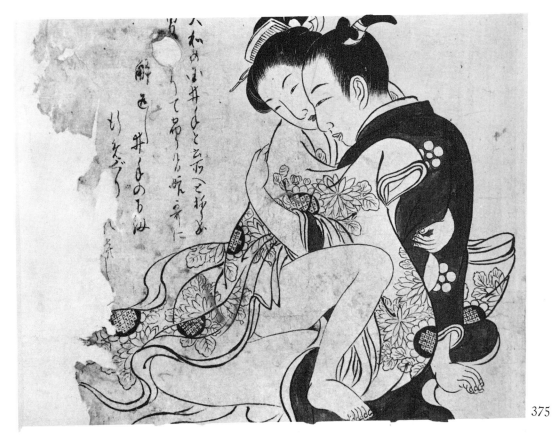

375

376

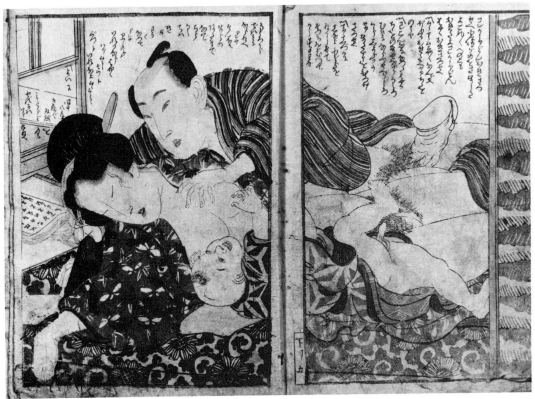

377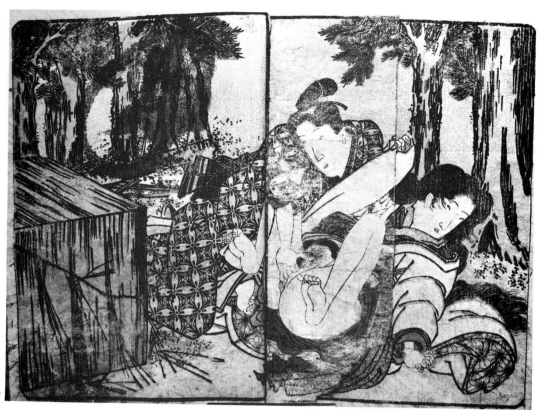

378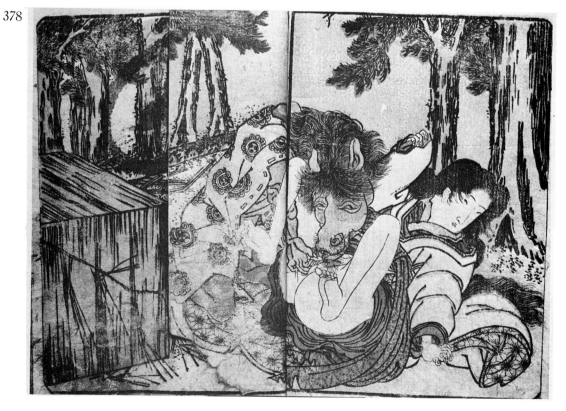

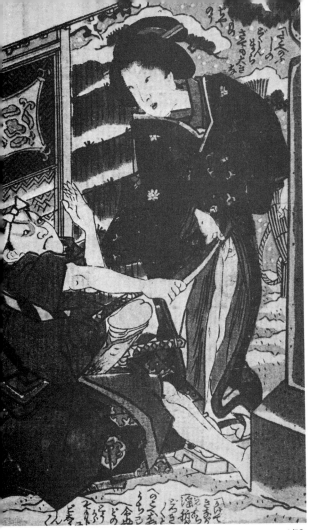 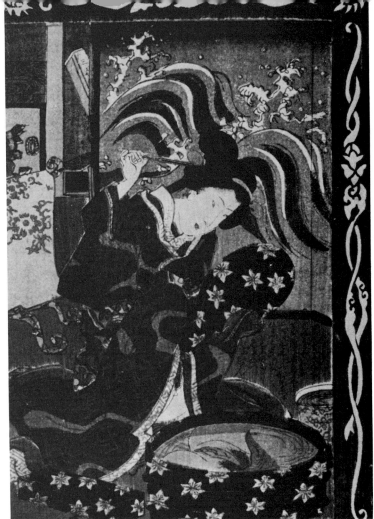

379 380

377–378—*Eisen, woodblock prints from the book* Hitomi Gufu, *1830's. A flap in the center of the print can be turned to reveal a cunnilingus scene with a mythological animal (Fig. 378), apparently representing the woman's fantasy during foreplay with her human lover.* 379–380—*Shozan, colored woodblock prints, from the book* Yamato Bunko, *ca. 1840. In Fig. 380 the lady is admiring the reflection of her private charms in a pan of water.* 381—*Shozan, from a printed book,* Ryogoku Miyase (Wrestling Souvenirs), *ca. 1840. The bamboo screen in the picture is attached as a small separate print and can be raised to reveal a second scene inside the boat.*

381

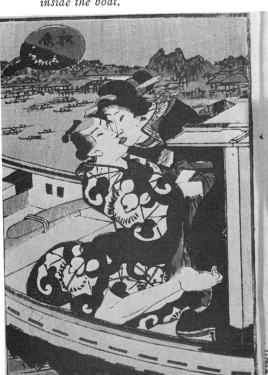

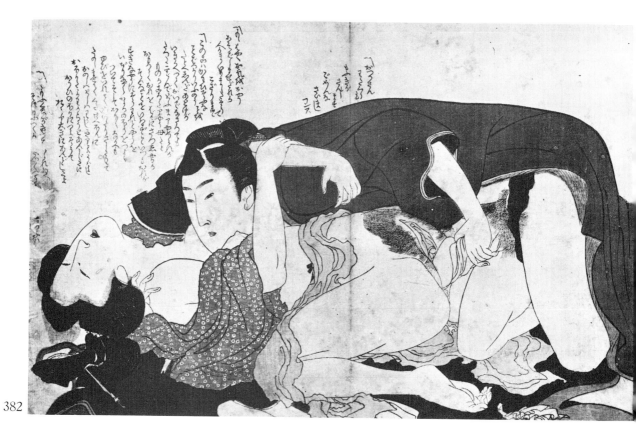

382

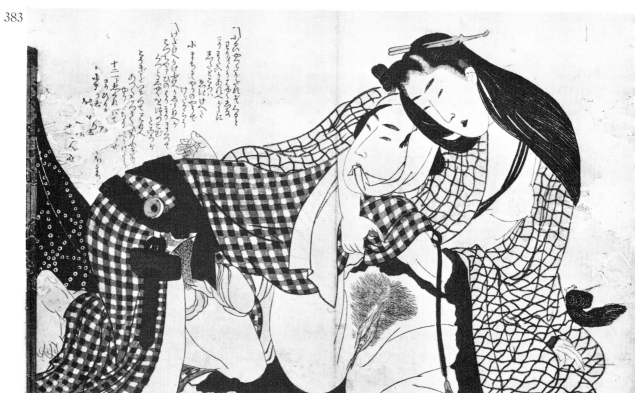

383

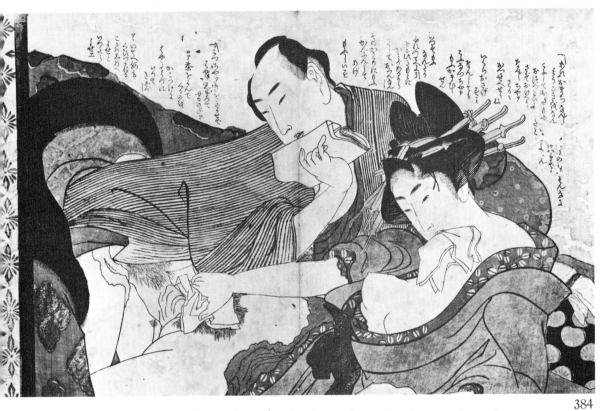

Katsushika Hokusai (1760–1849), colored album prints. 382—Lovers of equal social standing. 383—Bourgeois girl and lover; the man is using a teasing technique to heighten and prolong the lady's pleasure. 384—Yoshiwara courtesan and lover; the couple are wiping themselves between bouts without disengaging. 385—Geisha and lover, with erotic book nearby.

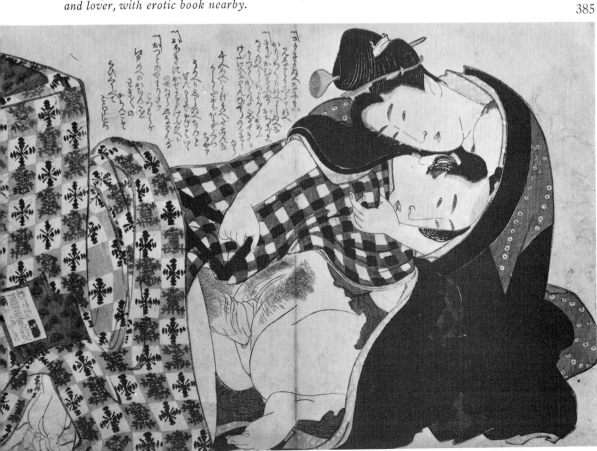

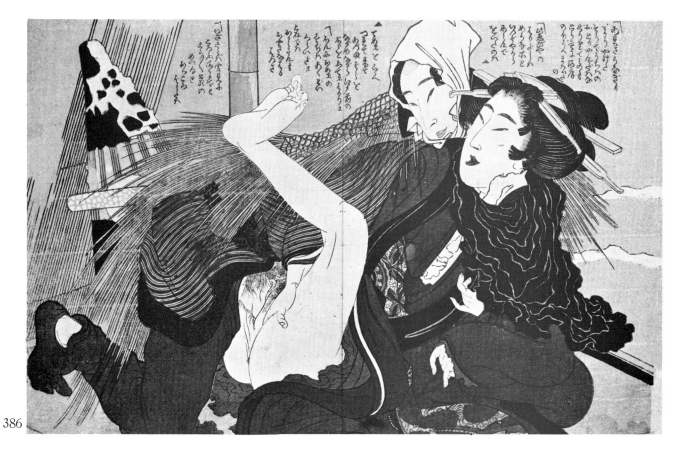

386

387

388

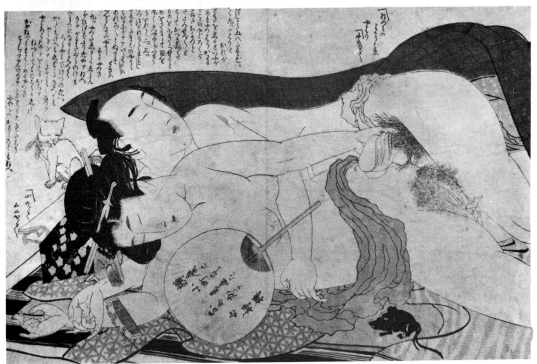

389

386—*Hokusai, colored woodblock print, geisha and rustic lover.* 387—*Vaginal Album, an album of paintings in color on paper; ukiyo-e school, ca. mid-19th century. Shown here is one of twelve paintings. The album's title is "A Little Affinity for the Flowers Red," and includes text that describes the characteristics of the vulvas concerned.* 388—*Kunisada, woodblock print from the book Shunshoku Bidan, 1840.* 389—*Hokusai; this woodblock print features the artist's cat and a pair of copulating mice, thus adding humorous touches, a favorite artistic device in shunga works.* 390—*Utamaro, woodblock print, late 18th century; two views of a courtesan, from a guide book to the prostitute quarters.*

390

391

Utagawa Kunisada (1786–1864), woodblock prints. 391—From the book Tsyu No Karobine, *1856; a street scene in the Yoshiwara prostitute quarters of Edo (Tokyo). 392—Geisha and her attendant trying to serve tea to an impatient client, 1850. 393—A couple enjoy a shunga book, 1860's. 394—From the book* Kari-Makura *(The Borrowed Pillow), ca. 1850; the giant member of a man is seen bursting through the wicker basket from which he has been watching the love scene.*

392

393

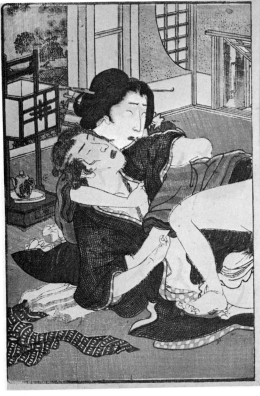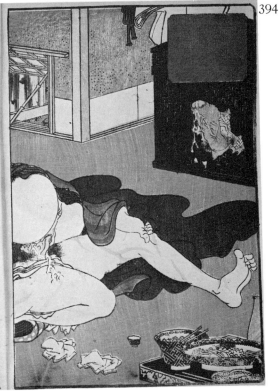

394

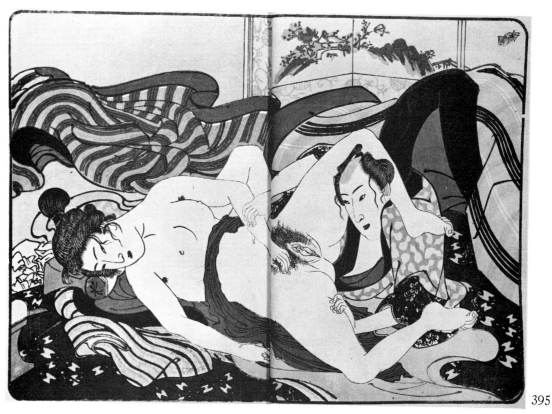

395

396

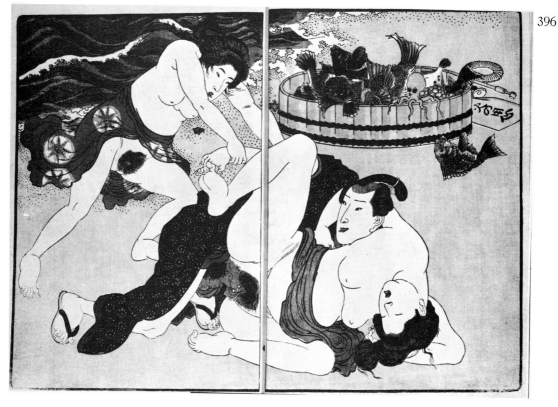

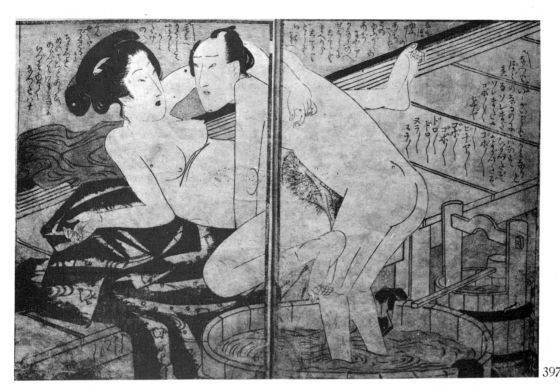

397

395—*Kunisada, woodblock print from the book* Komoncho, *early 1860's.* 396—
*Kunisada, woodblock print, 1860's; jealousy scene between two fishing girls and
their lover.* 397—*Woodblock print of a bath-house scene.* 398—*Woodblock print
of lovers engaged in a tongue-kiss, a rare practice among the Japanese, who con-
sider kissing a sort of sexual deviation allowed only at the height of passion.*

398

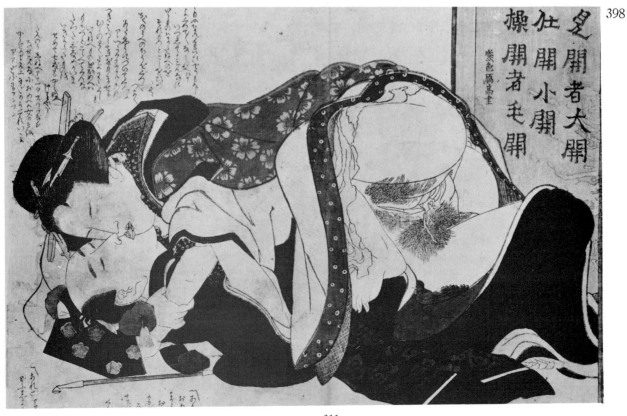

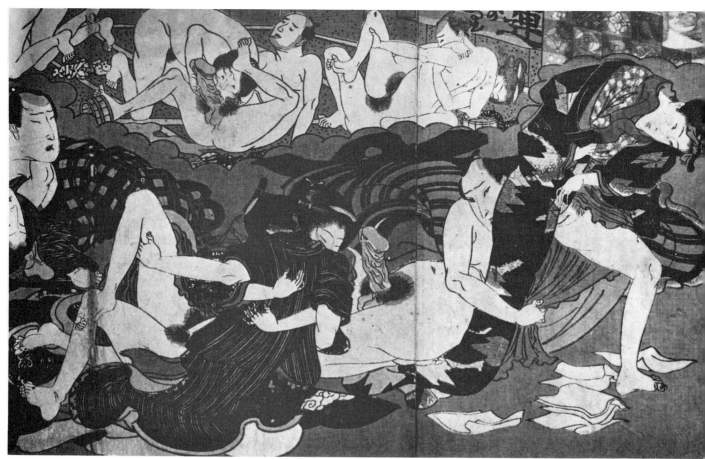

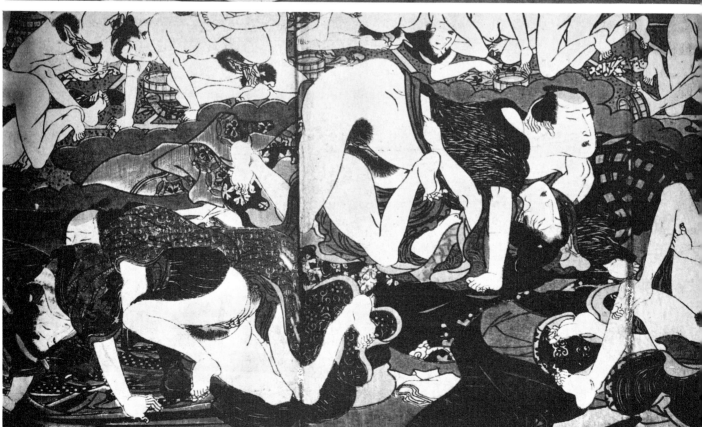

399–400—Kunisada, woodblock prints, 1850's; orgy scenes.